The Holy Barbarians

by LAWRENCE LIPTON

Novels

BROTHER, THE LAUGH IS BITTER

IN SECRET BATTLE

Poetry

RAINBOW AT MIDNIGHT
A Book Club for Poetry Selection

PACIFICA: Inferno Records

JAZZ CANTO: Volume One. World Pacific Records

THE HOLY
BARBARIANS

by Lawrence Lipton

Julian Messner, Inc. New York

Published by Julian Messner, Inc.
8 West 40th Street, New York 18

Published simultaneously in Canada
by The Copp Clark Publishing Co., Limited

© Copyright 1959 by Lawrence Lipton

Printed in the United States of America
Library of Congress Catalog Card No.: 59-7135

Venice West Picture Essay by Austin Anton, with additional photographs by William Claxton, Harry Redl and Robert F. Skeetz.

Pictured on the jacket are painters John Altoon (left) and Tony Lanreau with coffeehouse waitress Maggie Ryan at the Altoon studio in Los Angeles.

For Nettie

PREFACE

When the barbarians appear on the frontiers of a civilization it is a sign of a crisis in that civilization. If the barbarians come, not with weapons of war but with the songs and ikons of peace, it is a sign that the crisis is one of a spiritual nature. In either case the crisis is never welcomed by the entrenched beneficiaries of the status quo. In the case of the holy barbarians it is not an enemy invasion threatening the gates, it is "a change felt in the rhythm of events" that signals one of those "cyclic turns" which the poet Robinson Jeffers has written about.

To the ancient Greeks the barbarian was the bearded foreigner who spoke an unintelligible gibberish. Our barbarians come bearded and sandaled, and they speak and write in a language that is not the "Geneva language" of conventional usage. That their advent is not just another bohemianism is evident from the fact that their ranks are not confined to the young. Moreover, the not-so-young among the holy barbarians are not "settling down," as the nonconformists of the past have done. Some of them are already bringing up families and they are *still* "beat." This is not, as it was at the turn of the century, the expatriates in flight from New England gentility and bluenose censorship. It is not the anti-Babbitt caper of the twenties. Nor the politically oriented alienation of the thirties. The present generation has taken note of all these and passed on beyond them to a total rejection of the whole society, and that, in present-day America, means the business civilization. The alienation of the hipsters from the squares is now complete.

Presenting the picture in this way, as a kind of evolutionary, historical process, I must caution the reader at this point that it is merely a preliminary formulation of the picture, a simplification. When I met Kenneth Rexroth for the first time in Chicago back in the late twenties he was as beat as any of today's beat generation. So was I. So were most of my friends at the time. If some of us remained beat through

the years and on into the fifties it was because we felt that it was not we but the times that were out of joint. We have had to wait for the world to catch up with us, to reach a turn, a crisis. What that crisis is and why the present generation is reacting to it the way it does is the theme of this book.

I have chosen Venice, California, as the scene, the laboratory as it were, because I live here and have seen it grow up around me. Newer than the North Beach, San Francisco, scene or the Greenwich Village scene, it has afforded me an opportunity to watch the formation of a community of disaffiliates from its inception. Seeing it take form I had a feeling of "this is where I came in," that I had seen it all happening before. But studying it closely, from the inside, and with a sympathy born of a kindred experience, I have come to the conclusion that this is not just another alienation. It is a deep-going change, a revolution under the ribs. These people are picking up where we — left off? — no, where we began. Began and lived it and wrote about it and waited for the world to catch up with us. I am telling their story here because it is *our* story, too. My story.

<div align="right">LAWRENCE LIPTON</div>

Venice West, February 9, 1959

CONTENTS

The Holy Barbarians

PART 1

Slum by the Sea

IT IS SUNDAY IN VENICE. NOT THE VENICE OF THE PIAZZA SAN MARCO and memories of the Doges. Venice, California, the Venice of St. Mark's Hotel where the arched colonnades are of plaster, scaling off now and cracked by only a few decades of time, earthquake and decay. This is Venice by the Pacific, dreamed up by a man named Kinney at the turn of the century, a nineteenth-century Man of Vision, a vision as trite as a penny postal card. He went broke in heart and pocket trying to carry his Cook's Tour memories of the historic city on the Adriatic into the twentieth century.

The oil derricks came in and fouled up his canals, the Japanese moved in and set up gambling wheels and fan-tan games on the ocean front, and the imitation palaces of the Doges became flop joints. The Venice Pier Opera House, where Kinney dreamed of Nellie Melbas warbling arias and Italian tenors singing Neapolitan boat songs, went into history instead as the ballroom where Kid Ory first brought New Orleans jazz to the West Coast. And the night air was filled, not with the songs of gondoliers, but with air-splitting screams from the roller coasters of the Venice Amusement Pier.

All that remains of Kinney's Folly are a few green-scum-covered canals, some yellowing photographs in the shop windows of old storekeepers who "remember when," and the PWA mural that decorates the Venice Post Office, in which the oil derricks are superimposed on

15

the colonnades in a montage that is meant to be at once ironical and nostalgic. As for the Doges, the Doges of Venice are a gang whose teen-age members sometimes scribble the name on fences, smear it on shopwindows and even carve it into walls and bus seats, defacing private property and earning themselves the epithet of juvenile delinquents.

The sea-rotted Venice Amusement Park Pier has long ago been torn down, leaving a land's end, waterfront slum where there was once a fashionable resort, then a wide-open gambling town, then a wartime furlough spot for the sailors of the Pacific fleet and, till a few years ago, a bonanza for bingo operators.

Civic virtue, domiciled far away in hotel suites and suburban ranch houses, closed the bingo games. The luxury hotels along the beach-front promenade, too costly to tear down at present-day wrecking prices and not profitable enough to warrant proper upkeep and repair, stand like old derelicts, their plush and finery faded and patched. In their dim lobbies sit the pensioned-aged playing cards and waiting for the mailman to bring the next little brown envelope. Pension Row. Slum by the sea. Two, even three, one-story houses on a narrow lot, airless and lightless in a paradise of air and light. Night-blooming jasmine amidst the garbage cans.

To this area of Los Angeles, as to similar areas of other large cities, have come the rebellious, the nonconformist, the bohemian, the deviant among the youth. An unrentable store, with its show windows curtained or painted opaque, becomes a studio. A loft behind a lunchroom or over a liquor store becomes an ideal "pad" where you can keep your hi-fi going full volume at all hours of the night with no neighbors to complain. If you're a UCLA student shacking up with a girl friend, for love or just to save on the rent, you can find here a ramshackle three- or four-room cottage "in the back," preferably administered by a bank for some estate or by an agent for some absentee owner. As long as you are prompt with your rent payments no questions will be asked. As likely as not your neighbors will be Mexican-Americans who will not complain about your bongo drums as long as you do not complain about their three-families-in-a-four-room shack, seven-children-two-dog noise fests and their Saturday night all-night open-house drunk parties. If you can't sleep you're welcome to join them, but the chances are you won't because you'll be noising it up in your own pad, with your Chamber Jazz Quartet record offering poor decible

competition to their television Hit Parade. Nobody is going to call the cops because they'll only drink up your liquor and make a pass at your women, and besides, they're too busy rounding up winos to clean up the drunk tank and the jail cells on Monday morning, taking the strain off the paid labor and saving the taxpayers' money.

The aged and the young. And the misfits. All the misfits of the world — the too fat and the too lean, the too tall and the too short, the jerk, the drip, the half-wit and the spastic, the harelip and the gimp. All the broken, the doomed, the drunk and the disillusioned — herding together for a little human warmth, where a one-room kitchenette is an apartment and the naked electric bulb hangs suspended from the ceiling like an exposed nerve.

Here, working couples with children find the run-down apartments and tumble-down shacks that the realtor has to offer. To them, too, it is Land's End. After being turned away in other parts of town with "No children, no pets," they stagger finally into Ocean Park and Venice, foot-sore or with an empty gas tank, ready to rent anything with four walls and a roof, even if the walls are paper-thin and the roof leaks and the toilet is stuffed up. "Wait till you see how I'll fix it up," says the wife with a tired little smile, and Dad has visions of puttering around Sunday morning with a paint brush and turning this time-rotted ruin into the American Dream Home of the magazine color pages.

The young who come here have no such dreams. The aged, living in the sealed-in loneliness of their television sets, will leave them alone. The working couples, fatigued after a night on the graveyard shift at nearby Douglas Aircraft, will nod over their beer and listen to the jukebox in the waterfront taverns. If books, painting or music, or all-night gab fests are more important to the young than the mop and dishrag, nobody will read them any lectures on neatness in a neighborhood where it is no crime to leave the beds unmade and two days' dishes in the sink. Nobody will turn to stare at beards and sandals or dirty Levi's on the beach where a stained sweat shirt or a leather jacket is practically formal dress.

Venice, U.S.A. Venice West, a horizontal, jerry-built slum by the sea, warm under a semitropical Pacific sun on a Sunday afternoon.

The doorbell rings. The regular week-end invasion has begun: all the impatient young-men-in-a-hurry, the lost, the seekers, the beat, the

disaffiliated, the educated, diseducated, re-educated, in quest of a new vision; visitors from all over America passing through and stopping off to dig the Venice scene or come to hole in for a while in a Venice pad; young girls in flight from unendurable homes in other, fancier, parts of town, hiding their fears behind a mask of defiance, or trying to look "cool" or act "beat"; Hollywood writers dropping in to refresh their souls, hoping, perhaps, that some of the creative energy of dedicated artists will somehow rub off a little on them, maybe to do a little brain-picking, too, something they can turn into The Big Money; squares from Beverly Hills and San Fernando Valley ranch type houses looking for the shock of nonconformism, which is their own kind of "kick," or on the make for girls; newsmen and radio people on the prowl for "experience," or just plain hungry for a taste of intellectual honesty and artistic integrity, a kind of go-to-church-Sunday soul bath; ex-Communists with every kind of ideological hang-over coming to argue themselves out of something or into something or back to something; politicals, apoliticals, pacificts; interviewers coming to interview and interviewees coming to be interviewed; silent ones who come to sit and listen, to "dig" the talk and the jazz — and stay to eat, and listen some more and sit, just sit, till everybody else has gone and they can explode in a torrent of pent-up talk about themselves, their lives, their loves, their despairs, or make a quick touch; and always the parade of weekday office and factory workers, Sunday refugees from the rat race, panting for a little music and poetry in their lives, hoping to meet "the one" who will lift them out of the quiet desperation in which they move. And the poets . . . and the painters . . . and the camp followers of the Muse freeloading and tailchasing on the lower slopes of Parnassus. . . . The clowns, the make-believers, the self-deceivers — and the mad. The talented mad. Like "Itchy" Gelden who was gentle and innocent mad. Or Chuck Bennison who was make-believe mad. Or "Angel" Dan Davies who was ecstatic, self-righteous mad. . . .

"All raging and sniffy and crazy-wayed"

Angel Davies was the first to drop in that Sunday. He stood there swaying for a moment when I opened the door, head thrust forward, with that sideways weaving motion of his like a wrestler sparring for holds. He wore his shy, angelic smile. This was evidently his day to

come on like a raging angel, demanding to be loved or be damned to you. With a nod for his only greeting, he hunched in, laid a binderful of poems on the floor and sat down with his arms hung loose like a relaxed chimpanzee. Weaving and waiting.

I put a Charley Bird Parker record on and let it spin for a while, opening a three-way circuit of communication. It was a ritual. I lay down and waited for the magic circle to form, closing the circuit. This time Bird made it for us. Sometimes it was necessary to make two or three tries — Miles Davis, Dizzy Gillespie, once I even had to go all the way back to Bessie Smith for the magic spark. Angel leaned back, closed his eyes with a postcoital sigh and began to talk.

"The body finds the foods it needs, Larry, and so does the soul. Coleridge needed opium and Wordsworth needed Nature. Nature would not have written *Kubla Kahn* for Coleridge and opium would not have written the *Intimations of Immortality* for Wordsworth. They found what they needed. Now, what made them need these things and at what point in their development it could have been changed — that I don't know. But there came a point where it couldn't be changed. There came a point where you couldn't say about Bird, "Too bad he's on horse, too bad he's got satyriasis, too bad he's a lush, too bad he's trying to kill himself.' There came a point where you couldn't even say, 'Too bad he's dead.' Because that's what he needed. He sought it and found it. And the same thing with Dylan Thomas."

"Would you settle for their final end if you could perform what they performed — would you make such a bargain?"

"I'm willing to settle for *any* end, for myself, if I can make it that way, like, you know, that's just part of the bargain. There is no choice. The choice, at some indefinable point, was made to attempt the performance. Whatever end is implicit in the attempt is chosen at that time. I have a recurring image of my end, and I have always been obsessed; I have seen myself, my horror image of my end, and I don't think it is something that is going to happen, but if you say to me, 'What's the worst way you could end up?' then I see myself as Maxwell Bodenheim. And before I even knew he existed I saw myself on Skid Row, I mean the end was . . . this is . . . and . . . if this *is* true, if that horror image is true of me, like if that's where I'm going to end up the way I'm going, well that's where I'm going to end up. It's horrifying, it really gives me ickies, but if it's part of it, if it really is, there's no

choice. And that's similar, I guess, to the way Bird ended, I mean it's equivalently ickie. So I guess, yes, I would accept it — but not to do what they did, because I don't want to write poetry like Dylan Thomas', but *he* wanted to so he accepted it. The end is implicit in the beginning, Larry, that's all."

I remembered Kenneth Rexroth telling about the last time he saw Bird Parker. It was at some pretentious jazz concert. "He was so gone — so blind to the world — that he literally sat down on me before he realized I was there. 'What happened, man?' I said. 'Evil, man, evil,' he said, and that's all he said for the rest of the night. About dawn he got up to blow. The rowdy crowd chilled into stillness and the fluent melody spiraled through it." The way it was spiraling through us at this moment from the record of "Slim's Jam." And I remembered Allen Ginsberg telling me about the time Gregory Corso sneaked into the hospital at midnight and sat by Dylan Thomas' bed watching him die, till the nice, efficient, antiseptic nurses caught him at it and shooed him out.

And I thought of my own answer to the same loaded question, "Why did they do it, did it do anybody any *good?*" — meaning, "Wouldn't they have done better to join a party or sign protests and petitions against the Bomb?" My answer: "When the Bomb drops it will find us writing poems, painting pictures and making music." By which I meant, I suppose, pretty much the same thing that Rexroth meant when he wrote, apropos of Bird and Dylan, "Against the ruin of the world, there is only one defense — the creative act."

Tanya had come in by the back door and now she came out of the kitchen where she was helping my wife prepare some food. Tanya Bromberger, pink pants and silver toenails, a chick with free-wheeling hips and no cover charge — I must have been thinking of Tanya when I wrote those lines from my poem on Bird Parker. Tanya had overheard our conversation about the Bird. She had never known the Bird but she knew nearly everybody who ever worked with Bird. Not that sex was all she had to offer jazz musicians. She had told me once: "The only chance for a woman to establish a genuinely good relationship with these guys is to genuinely share their enthusiasm for the music. Just on her sex she can't do it. You can't make it that way." Tanya knew her music. But it was pot we were talking about now — pod, if

you want to be fancy about it, but every user I know calls it pot. Pot
and horse. Every conversation about Bird inevitably leads to a dis-
cussion of heroin and booze and sex. Tanya knew a lot about all of
these things. And on sex she was Einstein and Colette rolled into one,
if Einstein doesn't mind. Maybe neither of them minds — now.

"Most junkies have very little sex drive," Tanya said flatly. "As
Negroes and musicians say, 'It takes your nature away,' that's what they
say. It takes away the sex drive and it renders them impotent, so that
a lot of them go in for deviations, what people might call, quote, per-
version, unquote, like oral copulation. So much of their life is spent
just trying to get the drug, or trying to get the money to get the drug,
that what little is left usually goes to music and very little to sex or
anything else."

Angel got up and wandered off into the kitchen to put on his little-
boy-hungry act with Nettie, which was always good for an outsize
sandwich at least, with all the trimmings. Tanya slid off the chair onto
the floor, working her way over to the divan where I lay, talking all the
way and balancing a beer and a cigarette with one hand.

"Like Tex — you remember Tex when he was here with the Ray
Cullen band — he was no good when he was all tore up, like when he'd
just fixed or something, but between fixes, coming down, he was good,
one of the best sex partners I ever had. I met him through a musician
friend of mine who was at the time a heroin addict and one of my very
best friends, a wonderful person, I mean we were just like *this*" — with
the thumb of one hand in the fist of the other and that throaty laugh
of hers that always went with the gesture — "and they were going to
make a joint purchase — you can buy the stuff cheaper in quantity —
and Tex had my friend's car and so he was stranded at Tex's motel in
Hollywood. And he asked me would I drive over and pick him up. And
by the time I got there Tex had brought the car back and my friend
had left so I was alone with Tex who I had met a coupla nights pre-
viously, you know, just how do you do, when I was out with a gambler
and pimp friend of mine who's also a jazz fan and he likes to smoke
pot — and opium when he can get it. So I reminded him that I had
met him the other night and we got to talking and he asked me if I
had a car and I said, yeah, and he asked me would I drive him down
to the club in about an hour."

Tanya paused just long enough to take a drag on the cigarette and a gulp of beer out of the can, all with the trick five-finger manipulation that she brought off so well.

"I said yes and so the way it started out his treatment was a little condescending — chicks, you know, they have a tendency to be a little condescending especially with women, like there are a lot of white women who have a musician craze on, you know, without any real feeling or understanding of the music, and so I felt a little of that condescension but it didn't bother me. I was just relaxed and we talked and I drove him down to the club and always I make an attempt to be very truthful and be very much myself with these people. Bullshit they see through and they're not interested in it. And so I just would say what I thought about most anything and usually it takes them aback and they're a little surprised at the unconventionality of it or something and yet they feel drawn to you, too. I don't remember what we talked about but whatever it was it evoked some interest in him so when we got there he said, 'Hey, come on in and have a coupla drinks.'"

Angel was back with a Poor Boy sandwich crammed in his mouth, dropping crumbs all over the place and still playing his small-boy-hungry act. He sprawled out full length on the floor and started sketching Tanya and me on a big drawing pad of mine that he'd picked up off the end table. Angel took all the arts for his province, except the art of dance and maybe ceramics, though you couldn't ever be sure about Angel; he'd try anything if only for kicks, and besides, what was it about *any* art except to just cut in and blow, man, just *blow*. If a little mayonnaise dripped onto the paper you just rubbed it into the drawing with a deft thumb — crazy, man, crazy.

Tanya was too wound up in her story to notice anything. "So I went in and wound up staying till two o'clock in the morning. And during the course of the evening someone came up to him and asked for some dolophenes which are kick pills to alleviate the discomfort of being without heroin when you're sick. And I said, 'Oh, you got some dolophenes, let me have one,' and he said, 'Do you need it?' and I said, 'No, I don't, I just like to take them for kicks now and then, I get a crazy high off of them,' and in the meantime he'd seen me go into my purse a couple of times after bennies and I'd given him some bennies and he gave me a dolophene and as the evening wore on we were just

sort of closer and closer and more friendly in our conversation. And
at two o'clock he asked me to drive him back to his motel and I did
and then three or four musicians came by and there was some heroin
there and they proceeded to fix up in the bathroom to get straightened
and we were just talking mostly about music and musicians and the
ideas I expressed agreed almost completely with their own feelings.
And these people are very partisan. There's a terrific resentment among
them against the commercial jazz musicians. They feel their music is
the right music, the good music, and I happen to agree with them so
we got along real well. Pretty soon everybody left and it was about
four o'clock in the morning."

I looked over to where Angel was scrawling and smearing like
crazy on the drawing pad, his head and shoulders weaving back and
forth to appraise the effects. He was sitting up yogi fashion now and
sort of jabbing at the paper and slashing at it; the half-eaten sandwich
was on the floor beside him and he was picking at it with smudged
fingers and sucking the mayonnaise off of them in an ecstacy of art,
lox and salami, grunting and groaning as he worked away at it. Tanya,
feeling that my attention was wandering, moved up closer to the divan,
laid her head on the covers and tugged gently at my leg as she talked.

"There were twin beds there, so I asked Tex if he'd mind if I stayed
over instead of making the long trip home and went to work from
there, and he said 'Not at all,' and so he got out a pair of pajamas. I
put them on in the bathroom and came strolling out and this guy — like
he had just fixed, you understand, and by all logic he should be
knocked out, cooling — he was pacing around the room like a caged
animal, tense. And he said, 'I don't know how to figure you out. You're
a weird girl.' This is what everybody tells me, you're a weird girl. And
I said, 'There's nothing to figure out,' and then he starts asking me,
'Let me get in that bed and eat you up,' and I said, 'Ah, some other
time, I'm tired, it's late,' and I was really tired, like I just wasn't in the
mood right at that moment. But I liked him, I liked him real well. So
finally after much fidgeting and tossing and turning he settled down
and we both went to sleep in our respective beds."

"Make with a halo around her head," I said in Angel's direction, but
I was only kidding and she knew I was kidding. Angel paid no atten-
tion to my remark nor to Tanya's bite of mock punishment on my bare
leg. (It was a hot afternoon and I was in my shorts.) Angel's lack of

humor is as complete as that of a newly canonized martyr in an early Christian painting. The nearest he ever gets to it is a smile, and that's usually a smile of pity or condescension or the small-boy-hungry smile of utter helplessness. He saves his rare laugh for the exultant, belligerant Mr. Hyde side of him, and then it's startlingly out of proportion to its source, like a mouse laboring and bringing forth a mountain.

"I wasn't playing hard to get," Tanya went on, in a purely rhetorical disclaimer, "and, like I'm not modest, either, dig? — and in the morning when I changed from his pajamas I dressed right in front of him and all that, which doesn't stem from just a lack of modesty but also I think I was trying to titillate or stimulate him, too. I'm honest enough to admit that. And we started running around together — after all, he didn't have a car and I started driving him to his connections to pick up heroin. I had sex with him the second night. On the way down. Also it turned out that his connection was somebody I knew, an old friend of mine who had been in jail about five years, and when it turned out I knew this guy, well, it sort of heightened my prestige with him, that I was no square by any means. About the second day I was with him he offered me a fix — did I want to do up? — and I said no. He never approached me about it again. One time at my apartment he took an overjolt and passed out. I was a little concerned about him after a while, so I went into the bathroom and there he was slumped over on the floor with his head against the tub, knocked out, bloody syringe on the floor, dirty spoon in the sink and all that, so I cleaned everything up and got it all stashed away and got him over onto the bed, and he was so grateful the next day, he was just gassed, no recriminations, no criticisms."

Nettie came in with glasses of cold lemonade and some sandwiches, so it was catch-as-catch-can on the floor, end tables and divan, while Angel labored over the drawing pad, now enriched with the drippings of lemonade, and Tanya went on with her story, with Nettie now for an added listener. Was Tex married? Nettie wanted to know.

"He's got a couple of wives back east and some children and a lawsuit with some minor girl," Tanya explained between mouthfuls of tomato and avocado sandwich, "but he wanted to run away from it all and stay in California and live with me. But it sort of petered out by the end of the two weeks he was here and he went up to San Francisco — he wanted me to go up to Frisco with him but I said no. He

was embroiled in other things and I was reluctant to keep up that tight of an association because he was pushing heroin to other musicians and there was this constant traffic and I felt it was just too close and that I would eventually get busted. So we parted real good friends and I've never seen him since."

Beat, Beard and Sandals

Angel Dan Davies had a problem. When his unemployment insurance payments had ended some weeks before and he had to start looking for a new gig, he tried to make it with the beard, instead of shaving it off as he had always been obliged to do before. After a few turndowns — "and the ad kept running in the papers, so I knew it *must* be the beard, like, what *else* could it be, man?" — he tried trimming it a little, then, as the turndowns continued, a little more, till he finally shaved it all off and landed a job as a shipping clerk. Now that three weeks had elapsed and the boss showed no sign of firing him for goofing on the job or showing up late for work or any of the other infractions that go with poetry writing, jazz and pot into the early morning hours, he was letting the beard grow again, and the boss was beginning to notice and look at him "with that look, dig?" — and a new crisis was in the making.

"Like, it isn't just the beard, Larry, it's the pressure of conformity, it's Who says I *can't* have a beard if I want it? or sandals if I want to wear them on the gig — like who *would?* — you could get your toes chopped off if one of those boxes ever fell on them — it's a matter of utility, shoes, but a *beard* . . . who the hell cares if I tote boxes and shipping crates with a beard? Is it as if the customers might ask questions, me stuck back there in that black hole of a shipping room off the alley and never seeing anybody except truck drivers, so what's the big crime, what the hell difference should it make to that square? So — I'm thinking — is it worth it, the gig, I mean? Or do I start trimming again, or settle for just the mustache like I did on that godawful car-selling gig, that I lost anyway when I didn't shuck the customers enough to please the crook who was running the car lot. I mean when does it *end* — ?"

"I don't know," I said. "How did it begin?"

"Begin? You mean *my* beard?"

"Yes, your beard. How, when did you first happen — "

"Oh, *that*, sure, I'll tell you when. Very simple. The first beard I started was for the Seder, the first Seder away from home, in my own home, like I was very religious at the time and it was a kind of ritual, you might say, and then I had to go out and look for a gig and I found I had to shave it."

"You were conforming with an ancient Jewish religious custom, isn't that right? So it wasn't nonconformism but conformism that started you on your first beard."

"Right. So it isn't conformism or nonconformism the squares are worried about — so what *is* it? Don't tell me — let me think. It's what they associate it with at the *time*. Right now beards are being worn by young people who reject the rewards of the goddamn dog-eat-dog society, who hole up in pads in the slums and listen to jazz music all night and get high on pot and violate all their sexual taboos and show up late for work in the morning or stay home all day if they've got a poem eating away at them to get itself written or a picture to be painted. It's putting all these *other* things *first* — man! *That's* what scares the shit out of them — "

The doorbell rang again, and it was Itchy Gelden standing at the door, peering in, fidgeting and scratching his crotch. "Like I don't want to bug you man, if you're busy. . . . I could come back later — " He caught sight of Angel and Tanya. "Hi, what's cookin'? Are we gonna blow some poetry, maybe?"

He knew it was Sunday, open house. This was just his way of playing shy, humble, the half-welcome guest. He shambled in, mumbling his little high-pitched murmurs, half-words, more for sound than meaning, and sat down quietly in a cool corner. Itchy scratched because he had no skin; he was open to the world as a turtle without a shell, sensitive to all the world's hurt and all the world's love. Naked to the world, winter and summer, in the briefest of shorts and splayed sandals, scrubbed clean by wind, water and sand, he was forever scratching away at himself like a louse-eaten crumbum. Dylan Thomas is said to have clawed away at himself that way. A fellow poet writing shortly after Dylan's death, and perhaps prone to oversentimentalize it a bit, explains his constant scratching as a gesture of protest against the limitations of the flesh; he pictures Dylan trying to get under his

own skin to the soul, the Self, a Hamlet gesture. What it might signify in Itchy Gelden I was to learn only gradually.

All snap judgments about Itchy were misleading. Who would have guessed, for instance, as he sat there limp and droopy, that he would suddenly come up with:

"It's like this, man, we need more awareness of the I. It's like — before I light up I'm drug with the ten thousand things. Instead of having this fractured awareness of it, like I'm here but I'm somewhere else too, wherever this one wants me or that one wants me. When you're looking at the present it's got to go into the past in order to get meaning, into the memory, into the network. So there's an alternation of being here and being there. If the alternation, if the pulsation is fractured, it begins to get static in it — that's what I mean you can't concentrate, because concentration merely means that you follow the song of yourself. You're listening and you're hearing the song and you're swinging along with it, whether it's e-m-c-squared of the Bird trying to make the magic circle." He was making a reference to some lines of mine about Bird Parker —

> I think he saw in four discrete dots
> The corners of a square and tried to find
> A central fifth round which to swing
> The magic circle. . . .

For music was Dave Gelden's bread and meat, as pot was the breath of life to him. "Like that's the scene, man. I'm a network. I'm a moving network of nerve endings. And jazz music gives forms to my mind, forms in sound, and I feel it's better than any psychoanalyst, because art is a healer, that's a part of its function, it's a connected universe, just like the words we formed out of the grunts and hollers, it organizes my universe for me — that's healing, integrating, communicating. And pot is like, well, it makes you aware, aware of the *present,* you come *alive,* you got eyes for the scene, man, and ears to hear with — like most of the time we're listening but we're not *hearing,* man. . . ."

I said, "The mystics talk about going into another plane of existence."

"But I'd want to be able to come back, every time. Back to this life, with *all* its insoluable problems" — this from Angel Dan Davies, who

had laid aside the sketch pad now and was rummaging through my record racks for something to listen to. "Like I want to take peyote, which, if it does what it is said to do, you go to a plane of existence where you leave these problems behind you, and I want to take peyote and I want to see what it's like there, but I want to come back — "

"Back to the insoluable problems?"

"That's right. I get my kicks behind those problems, Larry. I enjoy them. It doesn't horrify me that there's no answer to these problems."

"What happens when you take one of these problems and put it into a poem, with all your perplexities, do you feel that when you've written it out for yourself in a poem — what does it do for you?"

"It takes me to a plane of existence where these problems no longer exist — or maybe I should say, where these problems no longer matter. That's where I am after I finish a poem. I'm postorgasmic."

I remembered Dylan Thomas' answer to much the same question — "My poetry is, or should be, useful to me for one reason: it is the record of my individual struggle from darkness towards some measure of light," and "Whatever is hidden should be made naked. To be stripped of darkness is to be clean," and his statement that the poem is that moment of peace when the inner struggle is resolved, but momentarily only.

Angel Davies was insisting that he was not merely willing to return to the struggle, but would have it no other way. Perhaps Dylan would have given the same answer if he'd been pressed. For he *did* return to the struggle again and again, till he couldn't make the creative scene any more and, like a pregnant woman long past her time and in unavailing labor — no one has ever devised a Caesarean for poets — he died of it.

Some say it was the booze that finished him; some say it was women, "the old ram rod, dying of bitches," as he says in his poem *Lament*. The old easy answers. But whatever it is that finally finishes a poet, most poets are agreed that what triggers a poem may be any one or a combination of these things — booze, narcotics, women. Edgar Lee Masters, in his poem *Tomorrow is My Birthday*, "quotes" Shakespeare as saying just before he died that if he had a virgin in her teens instead of old Anne at home keeling her pots, he could go on to write plays that would eclipse everything he had already done, plays that would

be the wonder of the world. I mentioned the poem and Angel's comment was:

"Oh, yeah, I know just what he meant. If he had a swinging piece of ass to lay he could really write."

"He'd really swing. Would it make *you* swing?"

"Sometimes it does and sometimes it doesn't." He paused, sat down to think it over for a minute, then said slowly, thoughtfully: "I've been in a kind of quiet period now, the past few weeks I've written not very much, just a few things, and Margot and I have been making the wildest sexual scene of our marriage."

"You don't think the other chick — Rhonda — entered into that equation, do you?"

"No, because I was writing behind *that* scene, with her. That was stimulating me to writing. I wrote a lot."

"Do you connect the two, possibly that you sought the one in order to achieve the other? That has a bearing on the problem that Edgar Lee Masters raised about Shakespeare."

"I sought the one — Rhonda — because I sought a kind of love that I knew I needed, and not just to write."

Tanya smelled moral censure and leapt to his defense. The poet wasn't like other men. He was *entitled* to a change of venue whenever he felt he needed it — which I punned into a change of Venus, or venery — and there was a laugh all around, except for Angel to whom nothing is a laughing matter, least of all where he is concerned.

"No," he insisted, "the poet is no more entitled to a change of sex partners than anybody else. It's a question of the value of monogamy. And that's a question I just can't answer — again. All the important questions are unanswerable — at least *I* can't answer them. I say yes, by all means, nothing is better than a monogamy that's functioning. Maybe what Masters meant — Shakespeare's no longer worked. And I know this feeling. When this is true then the drive is always outside the relationship, because every human being seeks love, the poet maybe more so than others, yes, he's more *conscious* of his need for love."

"Does that mean that he's more justified?"

"He may be more driven, but I don't think that he's more justified, or unjustified. Like it's a problem I can't give a solution to, but it happens. I always say one thing about this — it *happens*, face it, don't lie about

it. Try to make it with one woman, monogamously, but when the drive takes you out of it, go, but don't lie, and don't hide it from yourself or from your partner. Whatever happens has to be accepted. It's not a solution, it's like a neurosis, it's a crutch that breaks. It's that kind of a solution, it's a sick solution."

Angel had his halo on, his martyr's halo, and lay back, eyes closed, arms outspread to receive the nails in his palms. It was Tanya's cue to enter the scene as Mary Magdalen — *before* the conversion.

"Like I *love* sex, and I don't see why anybody has to feel justified or unjustified about it, and, like the poet is only doing what *anybody* should do if he or she *feels* like it — if it's the honest, inner, *felt* thing to do. Anything else is *dis*honest, I think. *Most* often it's the *monogamous* relationship that's dishonest — if all the love has gone out of it, and all the sex satisfaction. What's so holy about it *then?* — I mean like they say 'holy wedlock.' Isn't that what we're *all* trying to get away from, like *you* always say, the Social Lie? And when it happens, like Dan says, it should be *open*. When I started having my first extramarital affair I did it *openly*, right in front of my husband — that was Richard, my second husband — with a friend of his, a white fellow that he knew. Long before that I had a feeling that we ought to split up. I was getting that urge to be free and independent and alone again. I discovered I was pregnant. I worked up until two weeks before the baby was born, we were so awfully poor. Richard had all these books in the house, every wall from floor to ceiling, every room — he was supposed to be in this book business, but he just couldn't bring himself to actually *sell* any of them — I found *that* out, like he loved books and he just couldn't *sell* them. And so we fought over that, and anyway, things were getting more and more hostile every day, the pressures were mounting. I wanted to get out of there and I didn't know what I could do. By that time Kathy was a year old and I felt that terrible trapped feeling that there was no way out. I felt that if I leave and I leave this baby I'll be miserable all my life, so there'll be no happiness for me. If I stay I'm miserable. So I tried to kill myself — and the baby. I was going to turn the gas on. And Richard came home. I had made a panicky phone call to him where I thought he might be and left a message before that, as a lot of suicides do, because they don't really want to die. And so he came home and he said, If you're that disturbed I think you should go to a mental hospital, and I agreed. He admits

now it was a bluff with him, that he felt they would tell me I was just overemotional and feeling sorry for myself, laugh at me and send me home. Actually, they encouraged me to sign myself in. So I spent three months in the County Hospital, in the experimental ward where they keep only twenty patients at a time — they're hand-picked — and I never went back to Richard after I came out of the hospital."

She looked over to where Nettie had settled down to her knitting expecting, probably hoping, to encounter some expression or at least a lifted eyebrow hint of reproof from that quarter — Nettie was, for Tanya, a symbol of placid wifely domesticity which she envied, pitied and despised by turns. All she saw was patient attentiveness, even sympathy. Itchy Gelden had been taking it all in but he just sat there nodding, whether in agreement or to some inner voice, who could tell, now or ever? Angel was still nailed to the cross. It was up to me, so I asked Tanya if the psychiatrists at the County Hospital had tried reading her any moral lectures.

"No," she said. "Not to go back to my husband and baby, or anything. Not a word about sex or pot or even heroin, which I'd toyed with one time — I mean I tried it but didn't become addicted. This wasn't the first time I'd had psychiatry, but this one was the first that I established any rapport with. I'd had one in Chicago, and three out here. The first time was when I was fourteen, my family took me to a clinic to try and find out the cause of my violent migraine headaches, and the doctors came to the conclusion they were psychogenic in origin."

Nettie spoke up to ask if the headaches had stopped and when.

"After I went to the hospital this last time," Tanya said. "I haven't had any in two years. I found out what it was. Anger. That I was afraid to vent. I was venting it on myself, actually. And then the second time I went to the psychiatrist was when the Community Chest forced me to, when I asked them for help. That was when I first came out here — I was so poor and it was before Korea and there weren't any jobs. And they found out I was going around with a Negro motorcycle rider and figured I must be crazy. And one of the terms of getting assistance was that I submit myself to their psychiatric clinic. I got into a couple of violent arguments with the psychiatrist and stopped going. I horrified him and he couldn't conceal it. He wanted to straighten me out. And then, the third time, I went to a private psychiatrist shortly before I went to the hospital. I knew I was sick and needed help so I went to

this guy in Beverly Hills that the obstetrician recommended. I couldn't afford to pay him. And I got angry at him because of the money. I felt, you know, You bastard, you don't really care about me or why else would you want fifteen dollars an hour? and so I couldn't go on with it. But here in the county I finally found a man who accepted me completely as I was, made no attempts to reform me or anything like that, made me get over my guilt feelings about my child and my husband and things like that."

"This psychiatrist, did he have any understanding of your point of view, of your political ideas, for instance?"

"His are similar. I think this is essential. I couldn't make it with a bourgeois psychiatrist. That's why this one was able to help me — I was able to really talk about things, things I'd never talked about before. He even helped me get over my resentment at being a woman. And that's why I don't really agree with Dan about monogamy, I mean for *me*. I mean, dig, I agree with Dan about being a poet and the need a poet has, his *special* need, and about being honest about it if it happens, and you need a change. But about monogamy, the whole idea in general, I find it stifling. Definitely. It dulls my sexual appetites. I told the psychiatrist once that sex in marriage becomes a regular routine, like having milk delivered at your door every morning, and he nearly fell out of his chair laughing. To me, every prolonged sex relationship becomes monotonous, routine."

It was at this point that Angel came down off his cross and went into his rabbinical role, about sex being holy and especially married sex, about the Shekinah presiding over the marriage bed every Sabbath eve, reminding me what I had said so many times about the community of lovers, about the primitive hierogamy — growing hotter, more accusing, by the minute. It began to dawn on me that he saw himself as the sole defender of a faith that I had proclaimed but had now deserted, walking away from the challenge — and, like Angel was always able to do, *believing* it, as he was able to believe almost anything if he got himself worked up to it enough. He was working around to where he suddenly remembered that he'd *always* known about it, about holiness and the hierogamy and community, how it all began for him, really, when he was just a kid and his parents sent him off to a Jewish summer camp —

" . . . and when I arrived there I found that I was already a camp

legend, and we talked out under a big full moon that summer night in the midst of woods on an open playing field like, and it was a scene of much warmth because — at that camp I got whatever concepts I now have of holy community — because religion was important there and it was very beautiful, Larry, and there was community, you know, *real* community. It was a kind of unreal situation because we were all away from our parents, of course — that's what enabled us to feel so free. . . ."

His voice trailed off into a kind of self-communion with his memories, or perhaps he was suddenly conscious of motives behind this sudden uprush of memories, motives that he was sorting out privately and trying to justify to himself, the saint in him interrogating the devil. Anyway, when he finally spoke again it was to announce, defiantly and in my direction, that he had decided to shave off the beard after all.

"*Everybody* is wearing a beard now — Tony, Chuck, Dave here, even you are starting a beard — or is it just that you haven't shaved for a few days?" He smiled his small-boy smile, sly and also shamefaced, and lapsed into silence again, to be alone with his secret triumph.

The Joint is Jumpin'

By the time Chuck Bennison arrived, red-eyed after an all night session at bassist Phil Trattman's pad exploring "other realities" with the help of pot and jazz rhythms, a poetry reading was under way. Angel Dan Davies was holding forth with his latest jazz-inspired "open line," free form pieces, Nettie was in the kitchen again preparing a buffet supper, and the chairs, divans, floor — every square inch of sitting, lounging, squatting and sprawling space in the house — were full up. Beer cans, lemonade glasses, wine glasses, ash trays, sketch pads and notebooks made for precarious footing. The doorbell kept sounding every few minutes as the party got really swinging, for it had gotten around that Les Morgan, the popular Negro trumpet man, might fall in sometime during the evening and maybe bring along a couple of men from his quintet for a jam session of poetry and jazz. I had talked to Lester early in the week and he had eyes to make the scene, but you never could tell about Les and his boys; they didn't know quite what to make of this poetry and jazz thing and besides, they might get hung up at somebody's pad and not show up till around midnight, if at all. Phil Trattman was due to drop in early in the eve-

ning with his bass, and a couple of the boys had brought bongo drums in the hope of sitting in with Les.

Chuck Bennison took me aside to tell me he had managed to get a few fugitive lines down on paper from a vision he'd had the night before; it had come to him in a trancelike state when he was far out on pot. "I don't know what it means, exactly, *maybe* it's something — like, who can tell? — but I'd like to try it out with Les and his boys, and maybe it'll come to me," he said, with that nervous cackle of a laugh that *sounded* like self-mockery but was just Chuck's way of being modest and offhand when he wasn't the least bit modest and couldn't be more serious.

Angel was punching out the lines of a poem; it was on the theme of love, universal love, and community, but the words rang like body blows as he boomed them out with his bass voice. No small-boy-hungry this bass voice of his, more like a bull elephant on the make — love, or else! — like verbal rape, and as male animal as a soaking sweat shirt after a tough scrimmage. Angel liked to make his poems *strong;* that's the way he liked to hear them described — *strong,* except on the rare occasions when he deigned to temper justice with mercy, and then he was barely audible. Nothing between a bellow and a whisper, that was Angel Dan Davies.

He finished with a bobbing of the head and shoulders that was more like take-it-or-leave-it than a bow to the applause, much as (I think) he imagined Bird Parker doing after blowing a wild far-out chorus that left his sidemen panting for the beat. Then he staggered over to where his wife Margot was sitting and, sinking to the floor, threw his head back in her lap and closed his eyes.

I decided to wait a decent interval before calling on anybody else to read, knowing they would all pay Angel the tribute of showing reluctance to follow him, a tribute that each expected for himself in turn and something, I had learned, that never failed to impress the listeners, reminding them, perhaps, of "the perfect tribute" of silence that followed the "Gettysburg Address." I piped a tape recording into the hi-fi, some lines that Carl Forsberg had blown the week before, improvised to bass and bongo rhythms, and wandered into the dining room where Chris Nelson was reminiscing about Carl Solomon, a little knot of people gathered around him.

"Carl Solomon, like he was already a legend when I was still living

in Brooklyn and I would drop in five six times a week at this lunch-room in Brooklyn and all you'd hear about was Carl Solomon. The different lunchrooms, like, they'd have their heroes. They had their tables, like Trotsky's table, and they had the poets' table and this and that table, and there were all these other tables where they had noth-ing and *anybody* could sit there. The legend got started there. I'd heard about him for a year before — he was at Psychiatric Institute where they had all these geniuses, one hundred and thirty-five IQ and over, twenty males and twenty females. That's when Carl Solomon met Allen Ginsberg and he said, 'My name is Kirilov,' and Ginsberg said, 'My name is Mishkin.' That's how they met. It was in this loony house, and they gave them window shades to paint on. There were a lot of fabulous painters there, like, a lot of New York people, like those Black Mountain people."

Was he working then on some kind of a gig, somebody wanted to know, and what, if anything, was he writing?

"It wasn't so much what he was writing, it was the things he *said*, man, like *crazy*, and everybody would repeat it. Yeh, he published. Under a different name, like Carl Goy was one of his pseudonyms, I remember, mostly for liberation and anarchist type magazines. Very exciting. Yeh, he had a job, he ghosted a Broadway column for a while and he lost the job when he copied too much — whole passages out of Joseph Conrad, when he would get bored with the job, so he got fired. And he wrote for a publishing house. Man, that was a hard gig to make. He never explained his relation to the publishing house and like he found an *in* there. He was a superadaptable type cat in a way, *one* way, and in another way he wasn't. Like you see the way my nose is bent over to one side, for instance? He broke that, Carl Solomon did. It was in some chick's place, and I was wild for the chick, and I had to show off for the chick, and he was there and she told me to get rid of him. It was a party, like the going home bit, and Solomon says, 'No, I'm staying here, what are you doing?' — and all I did I started shoving him out and we started fighting — over this chick, dig! — and he bent my nose. Once at a New Year's Eve party in Solomon's pad he showed me a clipping of himself as a kid. He was a child prodigy. He could remember every baseball score and every baseball player since the beginning of the game. He flipped four or five times, I don't remember how many times. Every time he was in I was out, every time I was

out he was in. The way I met him, at one time there was a very excit-
ing group of teachers at the New School — "

Somebody interrupted to ask, "What's *happened* to Carl Solomon?"

"I asked Ginsberg what happened to him and he said he'd had a
letter from Carl saying he couldn't write at the time but in the near
future he would. Ginsberg didn't know him too well, in fact. A couple
of times I went down in the Village on Saturday nights when I'd make
the rounds and I'd see them together and they'd be talking loudly
together. He was homosexual, you know. And Ginsberg, too, but in
a weird, intellectual type way. Because I know Helen Parker said she
was going to make him. In fact, in *The Trembling of the Veil* he says,
'Thank you, H.P., you took my cherry at 23,' or something like that.
Their homosexuality, I don't know, I feel it's weird, sort of — what I
mean, it isn't real, *really*. I've seen these guys from the sticks make it
in New York who don't know how to be homosexuals and they learn
from other fags how to be homosexuals. These guys are like this
intellectual type homosexual. They are well read and they know all
the things that the famous homosexuals have written in literature. But
these same guys, they still make it with chicks. Like Solomon with this
chick I was going to make, like he wouldn't leave her pad and like I
knew he was going to make her and so I tried to beat up on him. And
the funniest thing, he was like insane. Carl's a big cat, about six feet
or so, and this guy who was with me I asked him to help me, just
to pick up Carl and help me carry him out, like they do in night clubs,
you know, but this guy was scared, so I had to fight Carl myself. But
Carl isn't strong, he doesn't know how to use his body, but I've always
fought, so I could beat him up easy, you know. It's the funniest thing,
there was a moment there when everything snapped in Carl and he
just cooled down and said, 'Oh, well, you're just showing off, I should
have realized, I should never have caused a scene where you'd have to
show off to your girl.' This sounds logical, but only on his basis, be-
cause he was thinking of something else, like this insane chess player,
playing one game in his mind and another on the board."

It was getting a little hard to hear, with the bass and bongos going
in another room, the tape I'd left on, where Carl Forsberg was going
full up on his poem *Lines on a Tijuana John*.

In the beginning was the weapon
 a chinese character
 started the chain reaction
a thousand years passed
 a thousand mercenaries met
 in burnished war gear
in a wheat field
 to settle the divine right
 of muscling in
on the other mob's territory.
 We live at ground zero
cowards join the army for protection.
 Come closer, friends,
Just a few happy hints
 for survival.
 You've got to learn
new facts
 you've got to move
 towards simplicity
you've got to have humor.
 Now, this handy dandy jewel
I have in my hand
 I will give away absolutely free.
 It will resolve
the national debt
 it is the perfect answer
 to our slum clearance problem.
Now listen to this
 a do-it-yourself laparectomy set
 the hydrogen strophe
the best fallout possible.
 Think of the funny embryonic mutations
 generous, genial, genocide.
It's democratic too
 it'll take fragmented man
 everyone will move upward
in the free world
 equally
 in that final illumination.

Fun for the entire family
 if not entirely satisfied
 return the empty carton.
And here is a junior kit
 consisting of pencils and paper
 simple Dadaist images
 exploding
 can be assembled on the kitchen table
 in johns, in gigs,
 on mats
 in padded cells

And the bass and bongos going under it with a steady beat, with only occasional short breaks, all with a hum in it that my hi-fi was picking up and amplifying. Not that anybody cared; by this time there were a dozen conversations going with little knots of listeners around this one and that one.

One group was discussing different ways of making it without working. A man in his thirties — Chillie, they called him, I don't remember his last name — who was down from North Beach in San Francisco for the week end, was telling about some real *cool* cats he'd known:

"Like Shag — some of you may remember old Shag, he was around here a good deal of the time a few years ago — Shag walked into this department store one day, went up to the sixth floor where the sporting goods section is, hoisted a 24-foot aluminum canoe on his shoulder and went down the escalator and walked out. Another time he went into the same store and picked up a tape recorder and went over to the salesman and asked where the radio repair department was. The salesman said, 'We have no radio repair department here,' and Shag came out with, 'What? Why you've got to, I've got a guarantee on this box — I bought it here two weeks ago and it's broken already. I got a one-year guarantee on it and I want it fixed.' And the guy told him to leave it there and they'd ship it back to the factory and repair it there. Shag asks how long it takes and the guy says about two weeks and Shag says, 'Oh, no, I need this for my work, I need this in three days — can't you get it fixed for me in three days?' And the guy says it's impossible and Shag says, 'Oh, well, I'll take it to a local repair shop and get it fixed at my own expense,' like real *indignant* yet! Dig? — and he walks out with the tape recorder, a $250 tape recorder."

Chuck Bennison had insisted on going out and getting in more beer, and now I could hear him at the back door. I hedgehopped over legs, glasses and beer cans to get to the kitchen and give him a hand with it. Chuck wasn't having any himself; he was off it — beer, whisky or any alcohol whatever. He was just proving to himself and to those of us who knew what a lush he had been that he could offer it to others and let it alone himself. Also he still had enough of the square in him to want to show that he could throw a few bucks in the kitty for the party and not be a freeloader like these other cats. He was to lose this innocence as soon as the few dollars he had left from his last monthly paycheck at the downtown advertising agency he had walked out of three weeks earlier melted away.

On his first visit to Venice West he had arrived lushed and had a fit of the d.t.'s in the back bedroom, with Nettie and one or two of the girls trying to nurse him out of it — nobody else would have anything to do with him, they hate alcoholics. He met Delia on that inauspicious first visit, and she took him home to her pad and straightened him out and got him off the bottle and turned him on to marijuana, to salvage what was left of his liver and administer artificial respiration to the poet's soul in him.

Since then, Chuck had been trying to get hip to the ways of this new world and pursuing its rules and rituals with the breast-beating devotion of a new convert and what sometimes looked, to me at least, like the seriocomic assiduity of a college freshman aping his older fraternity brothers — except that these initiates were Chuck's juniors by five years or more, which is a lot in times like these when the life cycle of a "generation" is just barely a decade. His beard, a surprising pink in contrast to his straw-blond head hair, was already substantial but untrimmed. I guess he thought he was going the sandal boys one better by traveling barefoot; he looked more like one of those beach-comber Nature Boy health freaks than a real hipster, but his pale eyes, thanks to pot and Delia's nocturnal tutelage, already had that red-hued, heavy-lidded sleepless look that is to the pothead what the little sooty pop marks on the arm are to the heroin tyro.

In short, he had passed his entrance exams but he wasn't really *in* yet; he wasn't quite *with* it. For one thing, he couldn't listen to jazz without the novice's overdemonstrative emotionalism; he wasn't cool yet. Angel Dan Davies just barely tolerated him in his pad and even

treated him with deliberate and pointed coldness, a kind of hazing that Angel wasn't above administering to newcomers, for all his poems and protestations of universal love. Itchy Gelden was still giving Chuck the "just listen and try to dig it, man" treatment, and "like there's a reason for everything, man, and you can't expect to fall in from outside like a tourist and expect to make the scene right off — you got to pay your dues, man, like everybody else."

Like You Just Blow

Chuck was shaking like a leaf by the time he sat down at the reading stand, watching Angel and Itchy out of the corner of his eye, his voice tremulous with anxiety. But the poem was a proclamatory one, a defiant personal statement, and the very words themselves seemed to give him confidence as he went along. Les Morgan arrived in the middle of it, with his drummer and tenor man, and swung into the scene even before the drummer had gotten set up, which gave Chuck quite a lift, just to have a little music going behind him. There wasn't the slightest co-ordination between the poem and the music, either in mood or in rhythm — this was in the first days of poetry and jazz when *any* sound behind poetry was a novelty, exciting, a *gas*. Something was happening on the poetry scene in Venice West. We had talked about it for months and experimented with forms of poetry and music, but nobody knew, as yet, how to integrate the two art forms into something like a modern idiom that would lend itself to improvisation, at least on the musical level. There were those who insisted that even the poetry should be improvised. These were the fanatical jazz buffs who thought that the wordman had everything to learn from the jazzman and the jazzman could do no wrong. We were open for anything, ready to try anything.

During these brave beginnings Stuart Z. Perkoff came up with a long poem, an oratorio for the speaking voice, calling for several voices, a speaking choir of Hipsters, a Dealer, a Poet and a Chick. It was dedicated to the great jazz pianist-composer Thelonious Monk and called *Round About Midnite: A poem for Sounding*. Others named in the dedication were two fellow poets and painters of Venice West — Charles Newman and Tony Scibella. Now we were all set to try it out with music, with Tony as the Dealer, Charley and Chuck Bennison

in the Hipster roles and a talented Negro girl singer that one of the musicians had brought along speaking the Chick's lines. Stuart was to speak the Poet's lines. The musicians were given a very brief rundown on the poem and we were off.

<div style="text-align:center">

HIPSTERS

</div>

dig
this poet
sits at a piano
clanging fingers against each other
bonkdblonk bonkbonk

listens for an answer
clanggalingblonk
& listens

<div style="text-align:center">

DEALER

</div>

is he hip?
does he swing?
I've got dreams for his fingers

<div style="text-align:center">

HIPSTERS

</div>

he's been around before
at sessions up & down the street
always listening
always trying to dig

<div style="text-align:center">

POET

</div>

dreams I've got
who'll lay some fingers
on my hand

<div style="text-align:center">

HIPSTERS

</div>

the sound is the thing, man

<div style="text-align:center">

POET

</div>

if my left hand is dead
& my right hand is withered
& my arms are rigid
& my shoulders brittle
& my eyes are goofed
& my jaw hung up

tell me about the sound
like I listen
& hear what I can

The bass had laid down the beat and now the bongos took it up, a funky beat with Phil Trattman adding a few modern subtleties. I looked over at Les. He was moved, visibly moved and excited. The words of the poem had touched off something in him. He was trying to find the right kind of a riff to come in with.

<div align="center">HIPSTERS</div>

who'd he blow with before?
who does he dig?
what's his story?
who is he?
does he swing?

<div align="center">POET</div>

I've always blown
alone
in rooms & at the edge of everything

always alone in a circle of light
the words banging themselves out
into some sort of sound
& me, hanging on, trying to keep the beat
coming in once in a while
making it, not making it

me & the words alone in rooms
& at the edge

<div align="center">HIPSTERS</div>

dig, man
he wants to come in
 what does he blow?
 what does he blow?

<div align="center">DEALER</div>

down the street
not too far out
there's a chick

she digs wordmen, man
why don't you try to make it over there
& see if she can cool you

Les began to blow, a yearning, haunting theme, in perfect mood with the words. This was *it*. This was what we had been working toward for months. The way Les handled his horn reminded me once more that jazz began as a vocal art, that the technique of those early musicians was a vocal technique; they aimed to make the horn *talk*.

It was to be months, however, before any of us had a real grasp of the problems involved in this revival of poetry and music. Months of experiment and public performance. And that, too, is a part of the story of Venice West. A part of the whole picture of a disaffiliated generation trying to find a way of life that it could believe in, to find it and express it in music, in poetry, in prose, in painting and dance, as men have always groped their way to new values and to a new way of life through the arts.

2

Biography of Three Beats

The Embarrassed Man

NOTHING IS SO EMBARRASSING AS BEING HAILED ON THE STREET WITH
hearty familiarity only to prove unknown on closer inspection to the
greeter. A case of mistaken identity as embarrassing for the accosted
as for the accoster.

This is the story of Chuck Bennison's whole life — an embarrassing
case of mistaken identity. Others were always mistaking him for some-
one he wasn't. He even mistook *himself* for somebody else: in boy-
hood for the All American Boy; in young adulthood for the Man Most
Likely to Succeed; in marriage for the Model of Domesticity. And he
was wrong every time. "Not till I came to Venice West was I able to
know and be what I am, and be recognized for what I am."

After two years of close acquaintance with Chuck Bennison and a
playback of our tape-recorded conversations, I am not at all surprised
that people have continually mistaken him for what he isn't. Because
Chuck is not a person. He is a do-it-yourself kit of bits and pieces of
a personality in the process of *becoming* a person.

To playmates, schoolmates, college friends and, later, business asso-
ciates and social acquaintances, Chuck seems to have presented the
appearance of stereotyped conformity. As a boy he joined the Sea
Scouts, dutifully attended the Christian Science Sunday school and

44

participated in the usual sports. As a young man he dated the right girls and made the right friends. He was an exceptionally bright student who went to Colgate on a scholarship and then on to graduate work at Harvard and at Boston University. Chuck had no difficulty going into a career in advertising, finding the right jobs and being liked by employers and associates. The casual observer would have spotted him as the classical example of an up-and-coming young American on the make for a place among the power elite.

But here is where Chuck's resemblance to the classical example ends and proof of mistaken identity begins. He says he received "an excessive amount of love" from his mother and did not like his father — that is, until the last few years of the man's life (he died when Chuck was twenty-five). Now thirty-five, he has been married twice (both church weddings), divorced once, and is presently separated from his second wife. He has made periodic breaks from his jobs, disappearances that must have seemed inexplicable to everyone who knew him, withdrawals and returns that make sense only when he fills in the missing pieces —

"I would just up and go, that's all. Walk out and not come back. When I got fed up with it I'd go away somewhere. I'd go away where nobody knew me and just goof for a while. Or try to write. And when my money ran out I'd drift back again, with some plausible-sounding story, or, more often, I'd go to some place new and start again, well, where I'd left off more or less. I mean, I'd get the same kind of a job again — once I tried going into business for myself and it was successful for a while — but there would always come that time, you know, when I'd get fed up again with the whole thing, or they'd get wise to me, because you can't live that kind of a lie, keep up pretenses — false pretenses, really — for very long that way. Sooner or later they'd get hip to the fact that I'm an oddball."

"That could mean so many things," I remarked. "Even reading books or going to concerts, and certainly reading poetry aloud — any of these things are enough to mark a man as an oddball in some circles."

"Oh, no, many people that I've known do such things without — no, I figure that I'm subversive — basically."

"Subversive? On what values? You mean political, moral — ?"

"All kinds. All kinds of phony values. In any civilization, at any time, I think most values are phony, and I think my attitude toward the

values, the symbols of the state, marriage, sex, have always been subversive. I've been able to conceal these attitudes of mine with more or less success, but only, like I say, just so long. I've felt that all these social values, including religion and patriotism, are tawdry and phony things and have no moral value and I guess my contempt for them showed through sooner or later. And then there would be a crack-up. It was just a question of who would crack first, me or the people around me. Not that I didn't try. Religion, for instance. When I was in college I had a lot of conflicting ideas about it. I went to the Episcopal church services, to Catholic church, I even looked in for a while at a Jewish synagogue."

"What were you looking for?"

"I thought of the value of ritual, of devotion — an objective kind of devotion, perhaps — I don't know *what* I was looking for. Anyway, I didn't find it."

"Do you tend to make your own private rituals? Do you find yourself ceremonializing anything — ?"

"No, unless you could call my drinking a kind of ritual. Alcohol is used in some religious rituals I've read about." He laughed. He was joking, of course, and he knew I knew it.

"It wasn't till about four years ago that I was finally willing to face it — that I was an alcoholic. I'd read books about it. I adopted a diet that would permit drinking of a pint to a fifth of whisky a day. To me, alcohol had been roughly equivalent to oxygen. At first I took it at times when I felt I couldn't cope with things. That was during the period when I'd take, say, three drinks a day up to the period where I'd take, say, eight or nine, and then your aim sort of shifts to where you're after oblivion, blotting out your consciousness. I needed to be dropped down real hard before I could do anything about it. With the help of Alcoholics Anonymous I was able to stop drinking for extended periods of time. Sometimes when I fell off the wagon it was with frustration at my not being able to write — sometimes it was my sexual life, the extreme ambivalence that I feel toward women, and I suppose men, too, for that matter, the inability to face the pains of the world, especially the pains of my own conflicts."

Chuck had tried psychoanalysis, sporadically, when he had enough money to pay for it and sometimes even going into debt for it, but to no avail so far as his excessive drinking was concerned, although he

does claim that it helped him to understand some of his problems where mother, father, and family conflicts were concerned. For all her lavish affections, his mother never approved of any of the women in his life, neither the girl friends of his youth nor the two women he married. "She tried to, I guess, but she just couldn't." As for his father, "Before I was ten I looked up to him as a model and an idol, but I fought with him bitterly and I wanted to be defeated by him. This was one of the patterns I carried into my adult life."

His mother had made a considerable amount of money on real estate receiverships during the Depression. "I asked her for money at times, but the advice that went with it — I didn't want her advice. I didn't think there was any advice she could give me that would help me any. For one thing, there was so little she knew about me by that time, I mean about the things that mattered most to me. She has certain neuroses — like putting people under obligation — not only me but everybody. I don't think she was consciously aware of this, but that's the way it always ended up, so I've tried to maintain my own independence. It isn't easy to reject affection and money — even if it is sometimes reluctantly given, and you need it badly enough — and, well, at such times I guess I just played along with appearances, like I did with everybody and everything — till the inevitable crack-up. What is it Jean-Paul Sartre says in *No Exit?* — 'Hell is other people.'"

Hell is other people. This from a man whose search has been for a sense of belonging, a sense of community, a man who spent years of his life trying to adjust himself to the values of middle-class society.

His physical appearance should make it easy for him to belong. Blond, above average height, muscular, good looking, he might easily be picked by any fashion photographer as the model of a young business executive. As a boy, he must have looked like any normal teen-ager. Yet he regarded himself as a subversive in every way and his story, as it unfolded to me in successive interviews over a period of a year or more, bore out the self-characterization.

Even the fact that he showed up on his first visit to my house looking a bit shaky after a big Saturday night did not blur the picture for me on first meeting. It is Standard Operating Procedure, if not *de rigueur,* for advertising men, newspaper, radio, TV and other communications people to have a hang-over on Sunday morning. Or at least to affect a reasonable facsimile of one. His conversational manner had just the

right blend of *New Yorker* sophistication and upper-class bohemianism,
the Madison Avenue exurbanite gone slumming among the disaffiliates.
Only a shaving scratch left by a shaky morning-after hand marred the
good grooming of his face and hair. The rest was all gray flannel, only
slightly rumpled, complete with slightly off-beat tie and casual but
expensive shoes.

Today Chuck Bennison is bearded and barefoot; he has shaken off
John Barleycorn and taken on Mary Juana and burned all his gray
flannel britches behind him. He still puts more body English into his
jazz-listening than the cool cats approve of, but he is learning. He is
searching for the Self and finding God. "I'll never forget the time Dan
Davies came to my pad and wrote on the mirror: This is the face of
God you see."

With this sense of holiness goes, of course, a feeling of separateness.
It is not the *folie à deux* of embattled lovers; it is not the one against
the world attitude of the solitary hermit; it is *we* against *they*. *We*
against the Others. No attempt is made to define *we* or *they*. No defini-
tion is necessary. *We* is what this generation is all about, whether you
call it beat or disaffiliated or anything else. *We* is what its books are
about, the name of all the characters in those books and what those
characters do and say. Everything that happens to them happens to *us*.

"*They* are the Others, the Squares. They don't dig jazz. . . . They're
not with it. . . . They're putting on the heat again. . . . They killed the
story because it might lose them an advertiser. . . . They rejected my
book because it was controversial."

Looking back on his past as business executive and advertising copy
writer, Chuck Bennison says: "It all looked so logical at first, slipping
into place from campus to copy desk, from Ec 3 or Business Ad to
junior exec, or from Psych 4 to Personnel — like stepping from military
academy into West Point. Or from Eaton and Oxford into the diplo-
matic service — playing fields of Eaton and all that sort of rot. And
believe me, I *fitted in*. That's my curse. I fitted in to *everything*. Noth-
ing is so frustrating as to discover that you can do better than other
people at the things you have the most contempt for. And *look* the
part. When all the time I hated everything I was doing and everybody
connected with it. It was always a tossup whether I would one day
split a gut laughing or blow a gasket from sheer anger and frustration.

One day everything would look silly to me, like grownups playing at kid games, and the next day I hated myself and felt like a heel writing the stuff — lies . . . not just harmless lies, like this soap will make you beautiful or this hair oil will make you a Gregory Peck . . . but straight out-and-out lies that — well, you'd wonder that anybody could believe stuff like that . . . and yet the damn stuff sold merchandise. So that I never knew whom I had the most contempt for, myself for writing it or the people who believed it. Maybe that's one reason I've never been interested in politics — I've only voted once in my life and that was just to please my mother — somebody she knew was running for the school board or something — I figured if people, grown-up people, could believe the stuff I was dishing up to them in the ads I was writing, what sense did it make to let them vote on things they probably didn't have the slightest knowledge about — not that they ever really get a chance to vote on anything that really matters, and maybe it's just as well."

This nonvoting attitude is not to be confused with the self-disenfranchisement of the large part of America's eligible voting population that regularly fails to go to the polls. Chuck's attitude is more like a No Confidence vote. He is contemptuous of all politicians, and his feeling about the people who go to the polls to express a preference between one man or one party and another is a mixture of pity and contempt. Like everything else about Chuck Bennison, his political and social attitudes are in flux, constantly changing and shifting, far from fixed.

Political solutions? "What are they but election tactics, lies, deceptions, trickery, mass manipulation? All parties use the same tricks, so what choice is there between them?" Democracy? "It's just a big shuck, the biggest shuck of all. The only equality there can be is equality between equals," which calls to mind the cynical remark, "All men are equal, but some are more equal than others." Economic exploitation? "What holds the exploited to the exploiters? The same thing that holds the whore to the pimp. It isn't parasitism so much as it is a symbiotic relationship. They need each other, in the strongest way that anybody can need anybody in this world — neurotically. It's a sick relationship, sure, but there aren't any political solutions for it, any more than laws and prisons can cure prostitution." Revolution? "What revolves in revolutions is the dramatis personae of the play; the roles remain the

same and the relationships remain the same. Sometimes the *names* for things change, but the things remain the same. The prisoner *believes* in his bars."

Hung between alternatives — precariously hung, and in a perpetual state of imbalance — Chuck Bennison sometimes tries to make a virtue of indecision, a philosophy of polar opposites. Often this takes the form of wry, cynical humor. "Creditors? It's good to have creditors. You can always be sure *someone* will miss you when you're gone. . . . I think only good people go to hell. It's their reward for being good. Just as bad people always go to heaven. It's their punishment for being bad. The official truth is always a lie. That's why I'm always on the side of the underdogma."

One thing, however, remains constant with Chuck Bennison: Hell is other people. In Chuck's case this includes a mother who clings to him, resentful of the intrusion of all other women in his life; his first wife who gave him love, loyalty, community status and a gracious domesticity that enveloped him in an atmosphere of success and well-being, and stifled his every impulse to artistic creativity; a second wife who promised greater understanding of his needs, encouraged creativity — in his spare time — filled the house with upper-class bohemians, drank with him, promoted his business career, and ended up by filling his life so completely that there was no escape except desperate flight. "It got so I was never *alone!* To write anything of value a man has to be alone with himself once in a while."

Always Other People, including bosses who praised and promoted him and office associates who partied and plotted with him for business advantages — everybody always paying him the embarrassing compliment of mistaking him for somebody he was not and never wanted to be. Till he found himself one day, quite by accident, in Venice West, shacked up with a girl in a store-front pad and pounding away on a typewriter set up on a packing case. The beard, he will tell you, just grew naturally out of not shaving for a few weeks. "Just too busy balling and writing." Pressed on the subject — or is it that time has given him perspective? — he will tell you that the beard is really significant: "It's my letter of resignation from the rat race." What he means is, it has made him unemployable in a world he has left behind and is determined never to return to.

Dead End Quiz Kid

Some, perhaps, have nothing to go back to. The pad of beat generation living offers them the only congenial environment they have ever found anywhere. They have never known the hazards of Success. Chris Nelson is one of these.

"I quit school in the eighth grade. I went straight from eighth grade into reform school."

That is how Chris Nelson begins the story of his education. How did he happen to graduate to reform school? "My mother was one of those progressive types, progressive education and all that. She sent me to the summer school for kids that the University of Chicago was running. I used to sleep in the same bed with her when I was thirteen, fourteen years old. I got to the point where I was irritated by it and, well, I beat her up. Started slapping her around and she called the cops, and the cops put me away and she signed me away for reform school. I was there nine months. That was the one fight we had, and ever since then I've never been too friendly with her. I was aware that she was promiscuous, but not with women, just with men. She left my father when I was a couple of years old, I guess. According to his story she was unfaithful to him. You hear a story like that and you got to believe *something*. He's a real weak monster, my father. He could lie easily. Later I found out my mother was homosexual."

The rest of Chris's education is a story of public libraries, bookstore browsing and people.

"In Chicago I was going to the Blackstone Avenue branch of the public library all the time. I'd go in — like, I wanted to read all the books, starting with A, you know, and just go straight through. But I gave that up after a while. Decided it might take too long. I read all of Herbert Best, all of Ernest Thomson Seaton. What happened was, all these authors were always referring to all these other authors and so it blossomed out, so I'd read other guys. And now I can't stand those kid books. And that's what started me off and I got interested in drawing and I went to the Art Institute of Chicago and that started me off on drawing really seriously. I went there about a year. I went to the downtown library a lot, too. I'd take the El and go down and spend the day. I'll tell you how tremendous the influence of the library was.

I read *Leatherstocking Tales,* by Cooper? and I thought I was going to become the forest primeval all by myself. I set pins, in the bowling alleys, you know? and I made enough loot to get up to Ely, Minnesota — Ely being the last town on the border between Minnesota and Canada — and I stole a canoe and took off for Canada. About three weeks later they found me, black fly marks all over me and in the last stages of starvation. They nursed me back to health and sent me back to Chicago — and that's when I started slapping my mother around. After I got out of reform school I took off for Denver and spent a year there and then I joined the Army, thinking I could get the GI bill. In Denver I went to the Skid Row there and got me a bed for fifty cents a night. I set pins there, too. The cop who arrested me was an ordinary cop who was taking courses at Colorado State University in criminal psychology or something. He asked me if I was living with a fag or anything, or was I a dope addict. I was real sensitive at fifteen or six-teen because I knew this guy was trying to figure me out as a case history, since I'd read some of the books he had. He advised me to go in the Army because I could get the GI bill, and the advice was very good. I joined on my sixteenth birthday. That was in 1946."

At fifteen or sixteen Chris Nelson had read some of the books that an adult student of criminology reads — an indication of the type of education this Dead End quiz kid was getting. Spotty, precocious, advanced in some subjects, weak in the most elementary ones; this is the chaotic sort of self-education frequently found among bohemians and rootless hoboes in the jungles of on-the-go America, and among beat generation youngsters who can discuss the most erudite sub-jects knowingly — in the language of juvenile delinquents.

Of his service record, Chris says: "I never did get to see any action. I went down to Kentucky for Basic and then I was shipped to Japan for Occupation. Oh, as soon as I saw that Tokyo! I went AWOL for a month. They didn't get me at all. When I got back they sent me out like they was going to punish me. They sent me to Saipan, which was even more of a ball. . . . But that Tokyo! It was so absolutely foreign — I couldn't put my finger on any response at all, I couldn't figure it out. It just intrigued me, everything about it. Everything exotic about it appealed to me, like a prostitute giving me a flower. I had all these flower allusions from books I've read. You should have seen this pros-titute. She was going with this spade cat I knew, this Negro. I was

cutting in on him, in a way, but that was all right. Both of us had a very weak sense of possessionship. He didn't mind it very much. She gave me a flower when I was leaving. You wouldn't expect a thing like that to happen in the States — a prostitute giving you a flower. Like when I was down in Little Rock. I was trying to find nude models. So I thought the best thing to do was to make all the hustlers down in North Little Rock. I went down there and I sounded out about a dozen of them and all of them were indignant. One of them sent her boy friend out to have me busted. I almost had it, too, like this guy was big and I was little and far away from home. But you know how I got a model? I went to the wealthiest girl in town and got her. The biggest specialist in Arkansas, his own chick. She not only said, 'Oh, can I model?' but she offered other suggestions, too. Like sex, well, you know, she like to intimated so. But at the time I was going with my wife. I learned a very important thing. When you want to try something experimental, different, and shocking, do not go to a poor girl, because she won't stand for any nonsense. Go to a wealthy girl because she's so secure that she wants something that'll jar her up, you know. And she'll try the most fantastic things. Just think of what you can do!"

Chris Nelson was filled with awe over the possibilities, but he didn't explore or take advantage of them as others have. He married the girl he was going with, is still married to her, and they have three children, but he is still as beat as he ever was, despite family life and a regular job at a defense plant. His position in the Venice West community is ambiguous but secure on the whole. He throws parties at his house — which comes as close to being a pad as family life with children will permit — and he makes the marijuana scene on week ends. He might show up at work a little woozy on Monday mornings and miss a day occasionally, but he manages to hold onto his job.

A rich girl with a yen for "the life" is the fond dream of many a beatnik in San Francisco's North Beach or New York's Greenwich Village, but in Venice West the dedicated poverty of the artist is very serious. Not that some in Venice West *wouldn't* welcome such a windfall — on their own terms, of course — but they are pretty sure, I think, that there is no Poor Little Rich Girl in their future. Rich girls come to listen, and some stay for a while, but none to my knowledge has adopted "the life," or made any permanent union within it, legal or

illicit. But that it has a kind of fascination for them there is no doubt at all. Chris has an explanation for it.

"It's because of their security. Everyone has to outlive their environment. The way to outgrow it is to do the opposite of what you always have. Secure people want to shake themselves up. Like a lot of people who have rigid personalities often do dangerous things."

Evidently it doesn't work the other way round, however. I reminded him about this — that the opposite of his own upbringing and environment would be to marry a rich girl and settle down on a big estate, or make a fortune himself and settle down as a solid citizen. His answer:

"I'm not that careful a thinker, I guess. You gotta think for these things. I don't plan much. I'm sort of a friendly opportunist."

The question of poverty and wealth came up often in interviews. Most often it was confined to speculations on the best way to make out with a minimum of income, rather than with dreams of personal financial success or marrying wealth. The ideal aim is a viable, voluntary, independent poverty, preferably with a marriage or shack-up partner who is willing to work for a living, at least part time. Chris Nelson, who holds a full-time job and supports his wife and children and does his poetry writing and painting evenings and week ends, is the exception. Usually it is a working sweetheart or wife who is the chief provider. Where both write or paint, it is the wife who is the Sunday painter or writer. Separations when they occur are not due as a rule to dissatisfaction with this financial arrangement but to other causes. Dedicated poverty is taken for granted, so much so that it is seldom a subject for discussion. What *is* frequently discussed are ways of "making it." Tricks of the trade, you might say — the "trade" of getting by with as little commercial work as possible, or, ideally, with no commercial work at all. Very few have learned to make an art of poverty. Or to reason out its advantages. Kenneth Rexroth, the poet, is the exception. He remarked to me when I was visiting with him in San Francisco:

"Once you reject the lures of society you discover that living in poverty you live much better than other people. I have friends who are advertising men and publishers and what not on Madison Avenue and I eat better than they do and drink better than they do and live in a better house, and my car is just as efficient, and costs a great deal less to fix and I fix it myself. I live, essentially, a richer life than any-

body I know who is actually rich — and I am, in income, the poorest person I know. I don't know anybody that makes as little money as my wife and I make and have two children. And yet, I go better places and see and do better things, I read better books. All they know to do with their money is what they're told, and so they buy commodities which are all made of soy beans and read books which are all made of soy beans and go to plays which are all made of soy beans.

"The whole morality of poverty has been exhaustively analyzed by Christian theologians, Catholic theologians, that is — hardly by Protestants — and especially since the Franciscans. Poverty, of course, is obedience to the Commandments which forbid covetousness. Now it so happens that the patrons of the Third Order of St. Francis, which is the Order that lives in the world and marries, etc., are St. Elizabeth of Hungary and St. Louis of France who were respectively queen and king, so that the circumstances of one's own personal wealth, into which one happens to be born or thrust, are of little importance. I mean, the thing that is important is the detachment from one's own possessions and the lack of covetousness of the possessions of others. This is something that nowadays people simply don't understand at all. When you tell people that wealth or riches are an evil in themselves and that a rich man is *ipso facto* a bad man, they look at you as though you were crazy. And my wife once said that the universal sin of modern society is covetousness and it is so universal and pervasive that when modern people read the word covet in the Ten Commandments they're under the impression that it is some kind of ritual sin of the ancient Jews, like eating *trafe*. They don't even know what it is. A person must be completely detached from all the lures of society, so that it doesn't make a damn bit of difference to him whether he has a Cadillac or not. By and large the lures of society are unsatisfactory. There is no reason except empty prestige why you should drive two hundred and fifty horses to work."

Analysis like this would never occur to Chris Nelson or his wife. They drive a beat-up jalopy of uncertain age that looks as if they picked it up in one of those dumps where people illegally abandon junky old cars. Like Rexroth, Chris fixed up the car and keeps it in repair himself. Lately he has acquired an old motorcycle. So tenuous — or atrophied? — is his sense of possessionship, to use his own word for it, that when the cycle — he pronounces it to rhyme with chickle in

the manner of most motorcycle addicts — was stolen he simply neglected to report the theft to the police, and it was only by the rarest of accidents that it found its way back to him a few weeks later by a route that I have not been able to disentangle from his account of the matter. He told me about getting it back in the same smiling, detached way with which he had announced its loss. As for his car, I have known him to forget where he parked it and hitch a ride home with somebody and simply do without it till a friend found it and told him where he could pick it up. This is certainly a measure — a full measure — of the sort of detachment Rexroth was talking about, but it would never occur to Chris Nelson to analyze it or even to regard it as anything different or special.

Chris evidently took his army experience with the same blend of innocent naïveté and matter-of-factness.

"It was the first time I saw primitive people. A couple of weeks after I got to Saipan I went out in the boondocks and met some natives and they invited me home and I became very friendly with them. The natives were selling liquor — fermented coconut milk — to the soldiers. I don't know if it was all right or not for soldiers to visit natives in their homes, but I spent most of my time out of camp. I made roll call, though. I'd go out by myself or with a couple of flip artists. Filipinos, you know. A couple of them were artists. Almost all of them were high school graduates. The Army took the educated ones and put them in uniforms. They were a crack troop. I figured when they sent those guys back to the Philippines they were going to make doggone good Hukbalahaps. I knew when they got back they were going to have discipline; they were going to take orders and give orders. The Army made a few mistakes and this was one of them. They educated them a little too much," and he laughed. Chris has the only laugh in Venice West that is completely devoid of cynicism or bitterness. It is uninhibited, clear, almost ticklish. The laughter of a child.

Chris Nelson's story of army service is not the story of the Sad Sack. He got all the breaks that usually go only to the cagey ones who know how to play the old army game and the canny ones who know how to stay out of trouble. Yet he is neither cagey nor canny. He is the Innocent, in the classical meaning of the term, the wide-eyed simple one whom nobody tries to con for anything because he doesn't look as if he *had* anything, and whom nobody tries to draw into any deals

because he gives the impression of being entirely without guile. It appears that he escaped punishment and disciplining by his officers for things that would have meant the guardhouse, even court-martial, for anybody else. He got the breaks that usually go to children and fools. Yet Chris is far from being either a child or a fool. Here is his account of what he did with his GI bill.

"I went to the New School for Social Research in New York and used my GI bill up. About a year there, and that was a ball. When Rudolph Arnheim gave a lecture there was sometimes fist fights and after the bell rang people would stand around and argue with each other instead of going to the next class. He lectured on art, esthetics. He was very exciting. In fact, those fist fights were about art principles. Not many, but enough to stick in my mind that that class was pretty exciting. There was one class I used to sneak into where these sociologists or something used to get some guys from Greenwich Village, old Italians who could play the goatskin bagpipe and another guy with the flute or something and one guy with the drum . . . anyway, they wouldn't play because nobody had any wine. So they sent a guy out to get wine, and all these guys with white shirts and ties and chicks with their expensive clothes and modern earrings . . . they all had to drink a white Dixie cup full of wine, and they were making faces and all. And then they'd play. That was the whole atmosphere of the New School. The music was repetitive, not exciting. I liked the atmosphere, it was tremendous. Bob Gwathney was an art teacher there, Dowinsky was teaching psychology . . . and Feran in music. It was a living ball. There was Arnheim, he was teaching Gestalt psychology. He set me onto the psychology of perception, like little boxes and squares and each thing having a balance. Gestaltists don't believe that these things operate in space. That's an artist's idea. The idea, a two-dimensional idea, that two things can balance and still have a violent opposition, was exciting to me. When I went on to Hoffman it came in pretty good. It like opened up new things. While I was going to the New School I was also going to the Art Students League.

"This art interest of mine, it really got going in the Army. Those Philippine flips were sign painters for the Army and on the side they were doing these paintings with, you know, sign-painting paints, and I started doing that, too. Earlier, when I was a kid I was doing charcoal drawings only . . . of models. These flips were always drawing

their home town, see? — coconut trees and everything like that. I started doing that too, I copied their work. That was when I was in Saipan. When I was in Tokyo I had copies of the woodcuts of fifty views of Mount Fuji, and a very good copy of 'The Courtier,' by I forget who. But it wasn't till I got to the New School that I found out what a ball art could be."

From art, psychology and the New School for Social Research to the studios and cafés of Greenwich Village was only a step, and Chris Nelson took it in stride. Greenwich Village in the late forties.

"One thing about the Village, it had a tremendous tradition, and that was the first thing that hit you. There were people who *knew* the tradition and they were the important people. They hung around in groups and coteries. People made up hipster jokes about them. People playing recorders, playing Baroque music, playing Bach and Vivaldi. There was a folk music group, mostly Stalinists. There was the Tree of Life that was by the Circle at Washington Square where all the junkies hung out and all the hustlers. And the Waldorf Cafeteria was the Paris sidewalk restaurant thing of the time. And all the old anarchists . . . there was an anarchist hall on Broadway. There was the Spanish anarchists, there was the Catholic anarchists who had a soup kitchen down near the Bowery on Christy Street. Like I made that Bowery scene just before I flipped. I flipped four or five times, I don't remember how many times. The Bowery was the only place in town where you could go any time of the day or night and get a piece of bread and some soup. A lot of young people were there. The anarchist group was the most powerful group at that time. It was the intellectual force of the Village — and it fell apart suddenly. A lot of people went into dianetics and Reichian things.

"Once by mistake I went to that anarchist hall too early, before the party started, and I saw those old people left over from the Spanish Civil War, an old lady and a whole mess of old men and I had a girl with me and one guy gets up and snaps out, 'What do you want?' and this old lady gets up and says, 'Don't frighten these young people away. Why do you always have to frighten them away?' It was surprising to actually see someone who fought there in Spain. I met a couple of guys in the Village who made the Spanish War. They were waiters. One was del Rio, he had a steel plate in his skull and told stories about the Catalonian fighting and stuff. The Village has actually

moved east. Even when I was there. The Village is too expensive. Toward the East Side there's a lot of people who live in poverty and won't ever get out of it. That's more like the right kind of an atmosphere, I think."

A neighborhood where the poor live, the poor who are resigned to their poverty, the best environment in which to live "the life." This is a cardinal principle which the beat share with the bohemians of the past. Among the beat generation young the problem of making a living is personal; each meets it in his own way, but among the older bohemians of Greenwich Village in the late forties, at least among the anarchists, some attempt seems to have been made to organize it along co-operative lines. Chris tells about it.

"There was a place called Co-operative Messenger Service up in Chelsea and a bunch of wild men ran it. They didn't make very much money but they undersold the commercial messenger services. They had a printing press up there and they printed poems and stuff. There was a guy, Dick McCoy, who was very important back there. He was a constant writer, like Tuli Kupferberg was a constant writer. Dick, for instance, could show you a poem — 'Sonnet No. 317.' Dick and a friend hitchhiked down to Washington once to see Ezra Pound. When they came back they had been busted somewhere in Jersey. I understand that Pound wouldn't see anybody except some Fascist anti-Semite and Negro baiter. Dick was making it with Teena Robinson, a very beautiful Village girl. Teena was that chick who started the boy-style modeling. She was built like a boy, a very beautiful boy thing. This was in the forties — it's died out now, now everything is big tits. Teena was the first of the boy-girl group. This Teena, she was a weird chick. She'd sit for hours by the window and she'd say, like — 'I just saw my Death walk by' — and sit for hours like that looking out at people, and she wasn't high at the time either. Teena had the most beautiful body I've ever seen on anybody. There was one girl who had a prettier face, very active in the anarchist group. She had an ugly body but what a face! My girl was a model, too. I met her at the New School. Lived with her for four years. Modeling was a good way to make a living, for males, too. I modeled a little myself. A photographer would pay fifteen bucks an hour, an artist three. If it was a friend, an artist friend, we'd model for each other free."

Chris Nelson is not an actively productive poet and he paints very

rarely, though he draws, sketching on a tablet with pencil or charcoal frequently at parties. He has notebooks filled with such sketches, constituting practically a pictorial history of beat generation people and places. Such notebooks are characteristic among the beat, notebooks filled with poetry and prose as well as drawings. The notebooks go with them everywhere and always, even when furniture, clothing and even books and records are left behind or sacrificed at sale to friends or dealers for the price of gas or bus fare to the next port of call; they are the most cherished personal possessions.

When the beat make the westward trek, it is usually the last port of call. Very few go back to the Middle West or the east coast except for brief visits. Asked if he thinks he will ever go back east, Chris Nelson replied, "What's there to go back to?" For most of them, as for Chris, there is nothing to go back to, no memories of former financial or social successes. To paraphrase Billy Graham's well-known slogan, they made the decision for the Muse long ago. Some of them would not even think it necessary to paraphrase it. For them it *is* a decision for God, but in a way that Billy Graham, judging from his pronouncements on the beat generation, finds sinful and un-Christian. Their disaffiliation is a rejection of the values of all organized religions. It is anti-clerical. Even when they embrace Catholicism, as a few of them have done, it is a Catholicism that no church council has ever proclaimed as dogma or belief, a Catholicism that would shock their confessors if they ever discussed it with them, which they never do. It is a rejection of the moral and social values of even the most liberal and radical. The Venice West people sometimes define it as "the revolution under the ribs."

Second-Generation Radical

Chris Nelson is a second-generation, progressive school product. Tanya Bromberger is a second-generation radical. So much of the literature of radicalism in the United States is still written by and about men and women born around the turn of the century that one is apt to forget that their offspring have now come of age and are living their own lives. Tanya was born in 1929, the year of the great stock market crash, and brought up in a Communist household during the Depression years. Her story is significant for comparison and contrast, throw-

ing into sharp focus the difference between the Marxist thirties and the new alienation of the fifties.

Tanya's first sixteen years were spent in Chicago. Her parents were Jewish immigrants from eastern Europe. There were two other children, both boys. Her father, a secondhand furniture dealer, was self-educated, but very well read, and the house was full of books. "I attribute all my interest in books to that," Tanya says. "He had hundreds of books. As a younger man he had been politically active, read Jack London, knew a lot of the 'muckraker' writers, like Upton Sinclair and Lincoln Steffens, some of them personally. He got my mother into the Movement. Then, while I was growing up, he retrogressed completely to a bourgeois businessman. When I was thirteen I joined the YCL, the Communist youth group. He tried to bully me into quitting it. That was the first breach between us."

The intensity with which radical parents strive to indoctrinate their children can be compared only to the "home training" of orthodox religious faiths. When, as in Tanya's case, the parent loses his faith, he tries to reverse the process. When he finds that he has done his work too well, his wrath is just as great, if not greater, that the wrath of the parent who remains true to the faith and finds his children straying from it.

By 1945, when Tanya was sixteen, the "united front" honeymoon of the New Deal and the radical Left was over, Winston Churchill's "Iron Curtain" speech at Fulton, Missouri, was only a year away and the rumblings of the Cold War were already being heard by those with an ear for political thunder. It was the year when Franklin Delano Roosevelt died and the long wake began, a wake that for many Left Wing and liberal New Dealers is not over even now. They have reluctantly left the graveside and given up hope of a Rising, but their faith in a Second Coming remains unshaken. Tanya's father was not one of these. By 1945 he had already joined the ranks of the "tired radicals." According to Tanya, "he had not only lost faith in radical political solutions, he had lost faith in his fellow man. He felt that the way to a better society had been put before the people and they had refused to accept it. They were unworthy of his efforts, his sacrifices. People were only getting what they deserved. They hadn't listened to him and now they deserved whatever they got."

Political attitudes, however, are easier to change than social con-

nections. If Tanya joined the Young Communist League her reasons for doing so were probably as much from the pressure of propinquity as the results of parental indoctrination. The Young Communists were probably the only young people she knew well enough to feel at home with. Now her father objected to her joining the one circle where she had any sense of belonging. "He was horrible about it," Tanya says, but he had no objection to her marrying a young man whose family "were very active Communist people." He himself had made no new friends outside Communist circles, despite his defection from the party, preferring to stay and argue interminably with his former comrades, as so many ex-Communists do, rather than exile himself among the heathen. Ex-Communists are rarely ex-Marxists; they are people who have simply lost faith in party strategy or tactics and moved to the Left rather than to the Right of party policy. As Tanya says, her father felt no one had listened to his wise counsel and he had withdrawn to his tent in a sulk. But he had not withdrawn from the argument nor from his circle of Communist friends and acquaintances. Where else could he hope to find people who even understood what he was sulking about?

Tanya met Ben at a YCL meeting. "He was just a *nebichle*," a Yiddish word for any pathetically ineffectual person, a "poor thing." "Ben was not an active Communist like the others in his family. He was lacking in any definite personality. He was good natured, but he was not an activist or an enthusiast about anything, a very lukewarm sort of a guy. At the time I married him I felt I was his intellectual superior and this intensified over the next two or three years and eventually I had nothing to say to the man. He never read a book in all the time I knew him, he worked as a mechanic — which I have no snobbery against people who work with their hands, you understand — but it was more in our recreation, the fact that we couldn't enjoy anything together. We quarreled mostly over my friends, my so-called bohemian associates. It threatened our marriage."

This was Tanya's first reference to bohemian associates. What she probably meant was the bohemian fringe of the Communist movement, not the beat generation young people she knows today.

"He felt that their way of life was so unconventional that it threatened our relationship and he tried to forbid me from seeing them, which was just a repetition of the family pattern, another father

authority. My marriage to him had been just a device to *free* myself from parental authority! In fact, I would have preferred to just go off and live with him some place, but I was sixteen and my parents would have sent the police after me and brought me home if I attempted anything like that. Besides, I was too unsure of myself and my rebellion against them at that time. I wanted to have sexual relations with Ben before our marriage and he was the one who refused, saying that, well, you know, we should have something to look forward to when we got married. He was ten years older than me, about twenty-six, and had been through four harrowing years in the war. I was sorry for him; he was the first fellow I ever went out with and I talked him into getting married because I wanted to get out of the house. I think even then I realized that I was probably just selling myself into another kind of bondage. In fact, I wasn't too enthusiastic about the marriage myself. I broke the relationship off shortly before we got married and it was only at my family's urgings that I finally agreed to the marriage. Anyway, we got married and moved to New York. My family was glad to get rid of me. I was not only a psychological and a political problem to them, I was an economic problem. They were foreign born, trying to make something out of a little business, and what little money they had they wanted to use for educating their two sons rather than me. Of course I'd been supporting myself since I was thirteen. My father got me my first job — in a factory. I got fired for talking too much. It was piece work and they wanted quiet, and you know how I like to talk. After that I worked in groceries and supermarkets, as a cashier. So I was really self-supporting, but just the same I felt they were glad to get me out of the house. My father got a certain amount of compliance from the boys, but I was a rebellious child, and it became a battle of wits between him and me."

The boys, it seems, were given greater freedom than Tanya was. Freedom is a word that comes easily to the lips of anyone who has grown up in a radical household. In Tanya's case it meant sexual freedom. "It was a kind of double standard," Tanya says. "The boys could stay out later at night and do all sorts of things I couldn't do. As far as sex was concerned, my father began to look at me suspiciously when I was twelve years old. I admit that the intent was there, but I wasn't able to do anything about it. Anyway, the idea originated with him, not with me. He was unfaithful to my mother and I think maybe he

saw in me a great many of his own personality traits, so he was suspicious of me and we clashed, as far back as I can remember. He told me the whole blame for misconduct in sex always is on the woman — it's always her fault — and that no man ever marries any woman he has possessed." She laughed. "I think that was *his* way with women, so he generalized it into a law of nature. My mother never talked to me about sex. I'm sure she was faithful to my father. But he talked to me about sex many times, and not very delicately, if you know what I mean. He's actually a foulmouthed man. You see, he had lost faith not only in men but in women. He felt women were usurping man's place in life, taking over men's jobs, that they were more reactionary, more complacent, more easily exploited by the bosses. He said that since women had gotten the vote things had deteriorated more rapidly. He also had violent race prejudices. I haven't spoken to him in five or six years."

Such strong antipathies between parents and children often have sexual undertones. Tanya admits that she has had incestuous dreams and fantasies about her father. "When I was a child he used to fondle me a lot and sometimes he would bite my arms till they bled and my mother would get mad and snatch me away from him. I don't think she understood what was going on. I don't think he knew either. He'd heard of Freud but he'd never read him. Maybe he thought it was just fatherly love. He used to beat me up a lot, too, for my own good, of course, but looking back on it I suspect he got more pleasure out of it than he let on."

An incident that occurred three years after her marriage, when she tried to leave Ben, throws light on this aspect of the father-daughter relationship.

"Ben went straight to my family and told them I was going to leave him. They sent my big brother to bring me over to the house and my father took me outside to the car to talk to me alone and proceeded to beat me up . . . and he became hysterical and started to cry, telling me he was having an extramarital affair and that the woman was an intelligent, passionate woman and that my mother was a nothing and devoid of sexual feeling and that if I would cast off my restraints and leave my husband he was going to do the same and leave my mother. I think he had some idea I might go and live with them — him and the other woman, or something. He went on about how he had sacri-

ficed his life for his three children, that he always wanted to be a writer and he'd given up his ambitions to work for three kids and a wife. I said, 'Well I don't have any children and all I want is to be free from Ben and go my own way.' My mother had a very serious heart condition at the time. If I left Ben my father might leave my mother and I was afraid that might kill her. I was sure that if he left my mother for another woman she would die, and I believed he really meant to do it. It was a kind of blackmail. So I went back with my husband, telling him on the way home that it was just coercion that made me do it, saying, 'If I ever despised you I despise you all the more now.' And so I stayed with him two more months and I kept thinking about it and I realized I was only nineteen years old and it was now or never, and that I was going to try and find myself some happiness. That's how I came to feel. So I just took off and left. I left two automobiles and a houseful of furniture and everything else. I packed a bag and got a bus to California."

She was never unfaithful to Ben, Tanya says, but sexually the marriage was unsuccessful from the start. "We were very incompatible sexually. I think that the last year and a half we lived together we didn't have any sexual relations at all." Looking back on it she thinks her faithfulness to Ben was more from fear, inexperience or just plain lack of opportunity than any sense of virtue. "What a person is will show itself in their sexual behavior," and Ben was a "poor thing" in this as in everything else.

Litigation over money or property rights played no part in Tanya's divorce. From her point of view, the less the state, police or the courts are brought into things, the better. Everything in the house had been bought with their joint earnings, yet she made no claim to any of it. "I didn't want anything of his," she explains. "I wanted to be very ethical about it and just take what was mine and go, so that he could never say I had taken anything that wasn't mine. I left — and my dad never left my mother. Now he claims it was a joke." Since she had no money of her own, she borrowed money from a friend, "a political friend," to make the cross-country trip.

About money, Tanya says, "I've never even gone out with anybody that had money in my whole life. I guess I just don't like in men what brings success in this society, financial success. I've always had an antipathy toward financially successful men. I think the reason is that

I smell a certain conformity in them that I can't stomach. They're so full of clichés and platitudes. They may not even know they're mouthing platitudes, or they may know better but they're afraid, because to act upon what they know would make them poor and outcast; so they say, well, you know, it's too bad, but we have to go along with things as they are."

Personality, good looks, social graces — it is not, Tanya insists, that she is unaffected by such attractions, but that all of them are outweighed by the factor of conformism. A Leftist is more acceptable than a Rightist, even when all other things are against him. Nevertheless, nonconformism by itself is not enough. "There are a lot of nonconformists that I don't feel drawn to sexually."

Music, particularly jazz music, plays a large role in her emotional response to men.

"I'd say that through the years it has come to this, that if I really like a person and they are uneducated in jazz I usually attempt to turn them on to it, as the expression goes. So much of my own recreation comes from music that if they are going to spend much time with me it's a necessity. I have friends who are not interested in jazz, but I don't see much of them."

The circle of jazz music tends to become a closed circle. Note that Tanya speaks of "turning on" people to jazz. This term, used by marijuana and heroin addicts, seems to Tanya quite appropriate when applied to jazz, as if jazz, too, were a kind of drug addiction. In many cases the jazz and drug circles intersect. This was so in Tanya's experience.

In her case, too, there was the added factor of still another closed circle, the circle of Negro and white intermarriage. It was Richard who turned her on to marijuana as well as jazz. Richard was everything that Ben was not. Richard was strong, handsome, well versed in books and jazz music, and sexually exciting.

"Richard is not the first Negro fellow I went with. I had Negro friends in Chicago. I had dated Negro fellows but I had never gone to bed with them — or any other man except Ben — till I came out here. I didn't feel free back there — I think it was the distance, really, that made the difference, two thousand miles or so from home. It gave me a feeling of really breaking home ties for the first time, a feeling of release from the family.

"I came to Venice to stay with a cousin who was living here and

going to UCLA. I started going out places with her and meeting people, and began going with a Negro fellow who was completely non-political and nonconformist in his own way. He rode a motorcycle and I was riding with him on this motorcycle and wearing boots and Levi's and entering into a life I had known nothing about and which held some kind of a fascination for me. It was very thrilling — the speed, the feeling of independence it gives you. There is a feeling of detachment from the whole environment when you get on a motorcycle, when you go fast, and also because these people were outlaws to a certain extent and they were always having trouble with the police. Well, anyway, I had been close friends with a friend of his who was married to a white girl who was living in the same apartment building I was living in. They were split up and this Negro guy became good friends with me, trying to get me to approach his wife for him, to effect a reconciliation. And that's how I met Richard; he was a friend of Richard's. He told me a little about Richard, all uncomplimentary. And then I met Richard at this beach party of the IPP (the Independent Progressive party, headed by Henry Wallace). I didn't see him again for a while till I ran into him in a junk shop one day. He was looking around for secondhand books, we both were, and I bought him some coffee and we got to talking. It wasn't books, though, that brought us together at first. It was politics. We got into a political argument the first day we met because I was at that time what you'd call a Left Wing deviationist, and he had been expelled from the party shortly before we met. I think it was on account of marijuana. They told him they could not afford at this time to be linked in any way with vice or narcotics. That he was jeopardizing the party, and he agreed with them and accepted his expulsion.

"He was still a rigid party liner when I met him and he kept looking for a label he could pin on me. He called me a Menshevik and a Trotskyite and all those things, which I wasn't really. He was still going to a lot of party affairs, although he wasn't a member any more, but the party people didn't like me or the ideas that I put down — the deviationist sounds I was making.

"It was Richard who turned me on to jazz and also on to pot. Of course I'd played the piano and the cello, too, for years and studied classical music and harmony and theory, and I found that pot enhanced my listening to any kind of music, classical or jazz. I wasn't

for or against jazz. But then I began to hear jazz frequently, *constantly*. Night and day. On recordings mostly, at first. Richard brought a phonograph and he sort of moved into my place without my permission — and first he brought over a pair of house slippers and this phonograph and some records. I was working at the time for the Bank of America, but I was living in Venice so it was possible for him to move in like that without any trouble with the neighbors. Oh, yes, there *would* have been trouble, perhaps, but I and my landlady, I had her sort of under my domination. Actually she was an elderly Jewish woman and I bullied her. Also Richard made himself useful around the place, did a little plumbing for her and a few other things and endeared himself to her. She was happy to see me settle down on one guy instead of the streams of men in and out of my apartment. So she didn't really object to his staying there."

While the Negro, if he has intellectual tastes and is acceptable in hipster and beat generation circles, may visit freely in the Venice West pads, he meets with the same treatment from Venice landlords and landladies as he would in any other comparable urban area. It is easier for him to find quarters in a slum than elsewhere — streets peopled mostly by Mexicans and low-income whites with large families who are barred from other areas of the city by no-children restrictions or prohibitively high rentals.

Any existing tolerance on the part of landlords, however, does not extend to mixed Negro and white sexuality, even in holy wedlock. Tanya's Jewish landlady was a rare exception. Perhaps she was won over by Richard's gentleness and charm, but I suspect that his occasional free-of-charge odd jobs around the house had something to do with it, too. If neighboring landladies asked any questions she could always tell them he was the janitor or handy man.

Tanya lived in a free union with Richard for about a year and then decided to marry him. "After I left my first husband I said I would never again marry anyone until I'd lived with him for quite a while. We were married by the Reverend Fritchman in the Unitarian church. Richard doesn't have any religion and I never had any. My father is a militant atheist or agnostic. I guess I would probably call myself an agnostic. But Richard and I used to go to the Unitarian church because we both liked Stephen Fritchman's sermons. They have arts festivals there every year, poetry readings and plays and things like that. Be-

cause of his progressive ideas Fritchman can't even leave the country, you know. He's had his passport lifted and everything else like that. So when we decided to get married this was the only place I could think of, so I went and talked to Fritchman and he said he would marry us. Christmas morning we went to his church and were married."

Six months later they moved into a big apartment hotel in another part of Los Angeles, a run-down place in a mixed neighborhood tenanted by prostitutes, musicians, dope dealers — "and the vice squad," Tanya adds, with a wry smile. "Two vice squad guys had taken an apartment there, *sub rosa*, to spy on everybody. The musicians spotted them right off, but some of the others didn't. One prostitute got busted. I liked the atmosphere, everybody visiting freely back and forth. It was something like a social life and I got along well with everybody, better with the men than with the women, as I always have, and best of all with the musicians. Some of these people were heroin addicts, some were marijuana smokers, but I got along with all of them. Everybody was pushing as well as using more or less. Well, they weren't really dealers, the building was too hot for that, but they'd get together and make a joint purchase. Richard dealt in pot while we were there. So did I. I worked all the time on a job, but Richard wasn't working and I really didn't earn enough on the job to buy groceries and everything and go to the movies and buy books and records, and keep ourselves supplied with pot and all our friends that kept dropping in. The first time I smoked pot and the first chance I got at heroin I took to them like a duck to water. I had found my element."

Venice West:
Life and Love Among the Ruins

ITCHY GELDEN WAS GETTING MARRIED. THE GIRL, GILDA LEWIS, WAS A new chick in the sense that she had only recently made the inner circle of the "community," although she had been living in Venice for two years or more and dropping in at the more open, public type parties. Poetry readings and such. She and Itchy had been making it for several months in a store-front pad and she thought it would be nice if they got married. Angel Dan Davies had volunteered to write the marriage service, a hymeneal ritual poem, and the wedding ceremony was to take place on Venice Beach, at night.

It wasn't anybody's idea in particular, a poetry wedding service by the ocean at night; everybody had heard about such unofficial ceremonies. Tanya Bromberger told of a couple she knew that got married on top of a mountain somewhere in Idaho — "alone, just the two of them, a million miles from nowhere, man, was *that* a gas!" Chris Nelson said he'd always thought it would be great to get married in the Fun House on the Ocean Park Amusement Pier, but his wife wouldn't go for it. Gilda herself had suggested a Buddhist temple wedding at first; she knew somebody who had gotten married in the Buddhist temple in Los Angeles — the man was brought up a Catholic and the girl was Jewish, and they didn't want a priest or a rabbi, so they settled for a Buddhist ceremony. But Itchy wanted something closer to the kind of primitive ritual we had been discussing so much lately and

everybody agreed that in Venice it had to be the ocean, what else? Hadn't the Doges of Venice married the sea every year with a ring? Crazy!

We were walking along the seashore, Itchy Gelden and I, on our way to Angel's pad. The Venice ocean front — land's end for the old people who came to it, and the promise of a fresh beginning for the young who could accept the challenge of sea as Itchy and Gilda were promising themselves to do. Not in the sun but at midnight, for the night seemed more in keeping with the pagan, lunar thing they wanted their love-union to be. Morning weddings, noon weddings, that was for squares. For the hip, for the cats, nothing but midnight would do. They were the night people.

Itchy looked out across the sandy beach and blinked at the bright sunlight over the ocean. The light of day or any bright house-lighting hurt his eyes — a common complaint among pot heads and other narcotics users — yet despite the example of many jazz musicians, he was not wearing sunglasses. He was in one of his barefoot, barebreast Nature Boy moods, and any kind of glasses seemed unnatural.

"You know what?" he said. "It's gonna be like going back home to mama to ask for her blessing. I mean the *real* mama, the ocean, the mama of the whole race of man. And this bit of me *marrying* the ocean with a *ring*. You know what this *is*, man? It's the old Oedipus bit, ain't it? Incest! But, hey, man, I just happen to think — what is it gonna be for Gilda?" He puzzled over that for a minute. "Yeh, I know, she's marrying her old man, the old man of the sea. Crazy!" He walked along silently after that, and I could see that he was pondering the solemnity of the idea and the godlike feeling it gave him to think he was cast for such a role. He had come out of his usual slouch and was walking ramrod erect. He must have felt ten feet tall, and he wasn't potted up, either.

When we got there, Angel was just putting the last touches to the epithalamium that was to conclude the marriage service. Itchy wanted to see the whole thing but Angel had mislaid some of the pages — he had been tossing them over his shoulder onto the floor as they came from his typewriter and they had gotten buried somewhere under a debris of soiled sweat shirts, old magazines, books, scrap paper, scribbled notes, half-nibbled sandwiches and the children's toys — but he was sure they would turn up in time. Margot was going to straighten

up the whole pad as soon as he could get her up out of bed. He was afraid she was flipping, sleeping twelve, fourteen hours a day, and saying and doing the *craziest* things, "you know, *far out* — but, like, man you got to come *back*," and Margot wasn't coming back enough. More and more she was losing contact with reality — and it scared him. When Itchy started to poke around in the mess on the floor in an effort to find the missing pages, Angel flew into one of the screaming rages he liked to affect.

"Don't touch a *thing!* I know just where everything is, damn it!"

He did know, too, for he was there on the beach at the appointed time with his manuscript intact. Margot was with him, looking fresh and rested and no more disturbed mentally than anybody else in the party.

I later learned that Gilda had made a last-minute attempt to interest a young "liberal" rabbi in reading the marriage service Angel had written and the rabbi agreed, but when he asked about the marriage license and was told there wasn't going to be any, he declined. Gilda and Dave agreed that her three legal marriages and his two were enough of a compromise with conventional mores and the unnatural self-assumed powers of the State.

The marriage rites were impressive, very moving at times, and Angel read the service in a voice that fitted the moon-and-sea mood of the occasion and sometimes matched the decible-count of the surf.

Here was an atmosphere that no State would ever think to provide. Churches have their dramaturgy, their stage settings for such occasions, and poetry of a sort, but it is always a room-confined, set-piece kind of thing. Here it was no rule book routine. We were observing Ezra Pound's advice to poets: Make it NEW! It was a full moon, but a moon that had never been full before, not like this. Taken as a totality it was a scene that had never been enacted before and would never happen again. It had the uniqueness of *presence*. Stars. Moon shadows. A unique moment in time. Far off on the southern headlands the lights of moving traffic marched in slow processional, and to the north, the highway lamps of the coast road to Malibu were strung like tiny pearls, clear out to the Point.

Angel's lines were like the liquid arms of the sea herself, embracing the land, advancing, wavering, withdrawing. His voice intoned the lines and the sea answered him. The original idea had been that the

bride and groom would be naked for the occasion and that was the way it stayed in the script, but it was a cold night so they settled for bathing suits with wraps over them for added warmth during most of the ceremony. The "rebirth baptism of love" in the sea that the service called for was a shuddering few seconds of foot-splashing in the surf. But it was all there in the poem and everybody was satisfied that the word — the magic word of the ritual — was all that really counted. Only the ring ceremony was carried out with literal observance of the text. The ring, as Angel had prescribed in his poem, was a wreath of flowers. The inshore sea wind blew it back onto the sand on the first two tries but Gilda picked it up on the third try and managed to fling it far enough out into the sea to satisfy the requirements of the symbol, although there was a good deal of discussion afterward about whether there was any significance to the fact that it was Gilda and not Dave who had finally consummated the sea-marriage, and what that signified psychologically, and what it portended for their future.

The closing epithalamium was a little too long and by the time it was over the fog was rolling in and everybody was dripping wet by the time we got back to Angel's pad, where the wedding party was to be celebrated. At the last minute it was discovered that somebody had goofed and forgotten to go after the can of marijuana that was waiting to be picked up from the connection in East Los Angeles. After frantic telephoning from the corner drugstore telephone booth — Angel's telephone had been disconnected for nonpayment of his bill — Tanya and Richard were located and promised to pick up the pot, ending what had threatened to become a major crisis. They didn't show up, though, until around two o'clock.

A minor crisis earlier in the party was getting Gilda's aunt and uncle and a couple of teen-age cousins to go home before the party got going. Gilda had impulsively invited them to attend the beach ceremony, perhaps in a belated effort to give *some* look of legitimacy to the proceedings — after all, Gilda was still more of a candidate than an initiate and had conventional hang-overs from the past. We were all surprised when they showed up; nobody was aware that Gilda had any relatives on the West Coast. They were no trouble at all at the service, except that Auntie cried too much and at all the wrong times, but after all, they were squares and it was hoped they would get in their car and go home after the ceremony. Instead they tagged along to Angel's

pad. Auntie made herself useful right away, picking up the children's toys off the floor where they were a peril to life and limb and tidying up the place a little. It took the combined strategy of all the hipsters present to deal with the situation before Gilda's relatives were finally chivvied out of the pad without hurting their feelings too much or spoiling the party for the bride.

Now the phonograph was turned full up — Auntie had been turning it down every time she got near it, certain that nobody could want music on *that* loud. The occasion seemed to call for funky music. Usually, it was Thelonious Monk, Chico Hamilton, Miles Davis and the Modern Jazz Quartet at Angel's pad. That night it was Louis Armstrong, Coleman Hawkins, Stuff Smith. Richard had promised on the phone to bring along some old Bessie Smith seventy-eights and other old-time blues greats.

I picked up Angel's marriage poem and started to read it. It read pretty well on paper, even without the emotions of the scene, the moon and the sea, and the sound of the waves. Itchy had squatted down on the floor beside me and was picking up the pages as I laid them aside, reading them, too.

He shook his head admiringly. "The good God sure enough laid his voice on that cat," he commented. "It swings, like a good piece of ass. He must have been loaded for sure when he wrote this passage" — and he read aloud the verses that had accompanied the ring ceremony. In Itchy's high, almost falsetto voice, the poetry lacked the force Angel had put into it.

"Does pot help *you* to write?" I asked him.

"Yeh." He smiled. "Mary Juana is my muse."

"But you've written without pot, too."

"Yeh, man, like I've got piles of the stuff. Like I've written in the johns in the airplane plant. I used to sit in the johns writing poetry on toilet paper."

"When I was around your age," I said, "we used to work for a while, at anything, and save all we could — buying time, we called it. You didn't think it was wrong, stealing time, writing on the boss' time?"

"It wasn't stealing. I was just getting my own. I was born in theft. In the congregation of thieves. The arch thieves are the ones who put down the most bullshit. Now I make it any way I can and the hell with it."

The conversation turned to the events of the evening and, as usual,

to religion. There had been no religious training in Itchy's home. Neither his mother nor his father went to synagogue. The first time his mother spoke to him about religion was only recently and then she came up with some stuff about Jesus and the saving blood of Christ that she had picked up from one of those "Mission to the Jews" street corner preachers. The missionary had used some badly garbled Hebrew words and said he was once a Jew and now he was saved. She not only believed him but she knew so little about the Jewish religion that "she got an idea like this cat was a *rabbi!* — and this was the religion of the real ancient Jews of the Jerusalem temple that she'd somehow missed out on. Like I guess she feels she's getting real close to death, and it shook her. But she always was superstitious, like Tolstoy's peasants, you know. Like she says, 'I had a dream last night' or 'I had a dream last week.' She believes that because she dreams something and it comes true she has seen a vision. The vision of a seer or something. She feels like because she had three children and none of them have become great — in her value system — she has to reinforce her ego and say like 'I'm a seer' or 'I'm in the know,' like 'I'm *somebody*.'"

"And your father —"

"Well, my father was like a sort of a hype, in a way. The kind of a cat who thinks like the animals — the family man goes out and hunts and he brings back the meat for the family, like the food and the clothing and the loot to go for vacations in the country, and shit like that. He didn't make any loot in the synagogue, so what's the percentage in going to the synagogue?"

His parents' value judgments, he went on to tell me, were strictly money. " . . . like, she has the viewpoint like you can't be straight unless you got loot. Like if you haven't got loot you are going to be hassled —" he paused, turning the thing over in his mind. "Like it's true, it's real. You *are* hassled if you haven't got loot. But what do I have to do to get loot? I got to hustle."

Hustle is a word Itchy always uses for work, any kind of paid-for work. Notice that it is a word borrowed from whores and pimps — who, in turn, borrowed it from pedlars and door-to-door canvassers. (During the boom twenties it lost its derogatory connotations and was being used quite honorably for all selling.) To Dave Gelden it apparently meant what it has always meant to the hoboes — something not necessarily evil in itself, something that might be all right for other

people, if they liked working, but for him a necessary evil to be endured only if there was no way out of it. Working was something you did to make living possible, and if you did too much of it too often you had no time for living, so what was the sense of it? Then it was like rehearsing for a play that would never be played; there was never any real worthwhile pay-off, only promises that would never be met, "a real shuck."

"My mother wants me to change, everyone wants me to change, everyone wants to make the world in their own image. Like if you don't pick up on their kick — well they *try* to hip you."

I asked, "Do you think Gilda is going to try and change you, make you hold down a steady job and have children?"

He shook his head to stop me, to let me know I was saying the wrong thing in the wrong place; then he got up and motioned to me to follow him. The sound of music and talk was deafening — more and more people had been dropping in for the party — but when he opened the bedroom door where the two Davies children were sleeping, they didn't even stir in their sleep. They had been conditioned from birth to sleep through anything, once you got them to sleep, which wasn't always easy. What Itchy had to tell me was something of a secret. He shut the door behind us and his voice was almost a whisper as he went on.

"You see, the first chick I ever fell in love with, like that was her scene. Her mother first sounded me on it, like, 'Why don't you try writing? Look at all the money there is in it.' Like if I made it with the big magazines or a book maybe I'd be a good provider for her daughter. She'd been reading those success stories, I guess, about rich, famous authors. Even poetry — why not, didn't Edgar Guest make it? Like she'd seen pictures of this palatial pad the cat had in a swanky Detroit suburb, right in there with the automobile magnates. I was twenty-two then and this chick she was seventeen or eighteen. She wanted me to be a writer, too, but like she wanted a family, too. So I got this state job and the first crack out of the box — hah! *box*, get it? — she's pregnant. So I just walked out of that hassle. I was real broke up behind that scene though. I felt very drug, like I thought of killing myself. I hated myself. Like I felt here was a chick that really dug me and I couldn't make it with her. So the next time I got married — "

"How soon after was that?"

"It was about two and a half years ago and the scene was like the

first chick — she got a quiet divorce and kept the kid and all — and this new chick she was a doll. I could do anything I want, go to school on the GI bill — I still had it coming to me if I wanted to pick up on it — or work or not work — she had a good job, so — crazy! Only one thing — she didn't want any children. She was very possessive, see, and maybe she didn't want any competition. Anyway, I really dug this chick and I didn't want to lose her. So — I went to a doctor and had myself sterilized."

A burst of Bessie Smith blues through the closed door told us that Tanya and Richard had arrived with the can of pot. Dave leaped up and I followed him into the living room. Everybody was already busy rolling the brown-paper cigarettes. Tanya was showing somebody how to roll a cigarette with one hand, a trick she said she had picked up from a cat in Phoenix who had it from a cowboy hobo who still rolled his own from a Bull Durham sack.

It was a ritual, like the Indian tobacco pipe, and everybody was expected to take at least a ceremonial suck on the weed, but I was exempted from it by a kind of special dispensation. I was the shaman of the tribe — this was the title Angel had bestowed on me and that made it official. I had once shown Angel an illustration in Jane Harrison's *Prolegomena to the Study of Greek Religion*. It pictured Dionysus "as the Athenians cared to know him," said Miss Harrison, and she went on to describe the picture. "The strange mad Satyrs are twisted and contorted to make exquisite patterns, they clash their frenzied crotala and wave great vine branches. But in the midst of the revel the god himself stands erect. He holds no kantharos, only a great lyre. his head is thrown back in ecstacy; he is drunken, but with music, not with wine." No castanets or sacred baskets for Dionysus, no wine. He could get drunk on poetry and music. Then and there Angel decided that the shaman was a member in good standing of the fraternity of pot even if he never turned on with the gang.

Along with others I hung around with in the twenties, I had indulged in marijuana, but in those days it was a Saturday night party kick. It was legal and you could buy it anywhere. Muggles we called the marijuana cigarettes, and tea, and most of the boys who used it on weekdays as well were painters. They said it heightened their color sense. I sampled opium, too, in those days, and liked it, but I knew what hazards it held and was satisfied to let it go at that. I have always

been able to get high on poetry, music or sex stimulation — just good conversation is often enough to make it for me — so that I have been able to fit right in with alcoholics and narcotics addicts of any kind without having to take the stuff myself.

Soon the air was filled with the sweet narcotic smell of pot and everybody was swinging. None of the boozy sentimentalizing that makes the parties of lushes such a bore, nor the brooding or belligerence that afflicts heavy drinkers. Sitting around cross-legged on the floor rolling their sticks of "tea," they looked like a ring of kindergarteners playing with finger paints.

You would never think anything so innocent looking as this could be illegal, but consciousness of the heat breathing down their necks was never wholly absent. The heat, the fuzz, at any moment there might be a rap at the door. If the stuff was found in your house you were responsible under the law, even if you were not a user yourself and only indulging your guests. The penalties were always being made more severe and judges were meting out stiffer sentences. If the cops happened to find a roach on some juvenile delinquent who had staged a holdup or committed some stupid act of violence, the whole thing was promptly blamed on marijuana and the police cracked down all over town. You might be sitting around with friends enjoying the hi-fi or listening to somebody read his poems and the next thing you know the cops could arrive and hustle you off to jail as a criminal. There had been such incidents recently, so the air was charged with a sense of danger that night. You could sense it under the gaiety, though unusual precautions were taken. The doors were kept locked, the window shades drawn. When enough cigarettes had been rolled, Angel carried the rest of the can of pot outside and concealed it behind some loose boards under the house. That way, he figured, it couldn't legally be said to constitute evidence of possession or "on the premises."

Everybody had a different notion of the legal technicalities involved, and about what to do in case the heat showed up. How to dispose of a roach — some said you could swallow it without any serious harm to your insides. Some were for tossing the evidence of "holding" out the window, the way some users were reputed to have foiled the fuzz by tossing marijuana cigarettes out of cars when they were stopped by traffic cops. You were clean, they said, as long as they didn't find it *on* you, as long as you weren't "holding."

Everybody present had heard all these theories before. It was old stuff but it gave them a sense of readiness to talk about it. Verbalizing the possibilities seemed to act like a kind of homeopathic magic against anything happening. Once it had been talked about they dismissed it from their minds. All except the bride who had herself a crying jag in the kitchen — "What if we should get busted tonight and we had to spend our wedding night in jail!" Chuck Bennison made a funny crack about the Law robbing poor Itchy of *jus primae noctis,* the right of the first night, with his virgin bride, and that sent her into an uncontrollable laughing jag. All very uncool. Just what you'd expect of someone only beginning to make the scene and not hip yet to what being cool means.

That was Tanya's verdict. "If you want to belong you've got to expect to pay your dues. It's very unhip to bawl and carry on about it, even *before* it happens. The squares and their cops are always out there, laying for us. The squares are afraid of pot. They've got it tied up in their minds with the breaking down of inhibitions and taboos. They're afraid of poetry, which they connect up in their fears with free love. They're afraid of jazz. To them it means — like Bessie Smith was singing in that blues song you just heard, *Empty Bed Blues* — it means the kind of sex that 'almost takes my breath away' and 'makes me wring my hands and cry' and that ain't nothin' like the square way of lovin', man. It isn't their dimity curtain, candlewick bedspread kind of love. Like my hip doctor told me yesterday, "What are the three most overrated things in the world? Home cooking, home fucking and Mayo surgery.' I don't know about Mayo surgery, but man he sure hit it right on the other two shucks."

Holiness? Crazy, man! But you can flip your wig on it.

For months Angel Dan Davies had been turning himself inside out in a search for the "original meaning" of communal love and the concept of holiness. With the driving intensity that marked all his spiritual and esthetic adventures, he had been re-examining all his basic assumptions, his relations with everybody he knew — "Is it really love or am I just shucking myself?" — and delving into his own past in a kind of autoanalysis. And drawing everybody around him into it with him. The solitary labors of the soul were not for Angel. He had to have

others suffering with him, taking the same risks and sharing with him his moments of vision. He thrived on it, but his wife Margot was beginning to crack up. The long, sleepless night hours of orgiastic sex and spiritual self-examination were too much for her. More and more every day lately she showed signs of losing touch with reality. At first, Angel had been reporting to me that Margot was at last beginning to see eye to eye with him — *inner* eye, that is — and this was saving his marriage, which was always on the verge of breaking up. That she was beginning to understand him at last and to share his quest of the numinous, his search for love and holiness. But now it had gotten out of hand. She was saying and doing things that scared him. For one thing, she was turning elsewhere for the answers, away from him to others, and this was a bad sign.

I knew what he meant. Margot was waiting at my door one morning when I returned from picking up my mail at the Venice Post Office. She looked like the wrath of Medusa, flushed and manic, her flaming red hair in a tangle, her eyes bloodshot with a wild look in them. Her voice when she spoke was strangely, frighteningly calm, childlike, a little-lost-girl voice — "Can I come in, please? You won't mind? I *had* to see you — "

I let her in and she threw herself on the living room divan at once and curled up in an embryonic posture. The light hurt her eyes, she said. I lowered the window shades. All she wanted to do was rest, she whispered. Just rest and sleep, "just to *be* here." I suggested a sedative but she shook her head and smiled dreamily, as if she were just on the point of dropping off to sleep.

I breathed a sigh of relief. It wasn't going to be such a mess, after all. I went into my study to read my morning mail and answer a few letters perhaps. When I tiptoed back into the living room half an hour later for a look at Margot before settling down to work, she was sitting propped up against the cushions. Blouse, slip, bra and panties were scattered far and wide over the floor where she had flung them, in what must have been a piece-by-piece stripping act of solitary abandon. The only thing she had on was a short skirt and that was hiked up over her knees. She gave me a sideways glance and her face had the little-lost-girl look again, but her voice was tremulous now, desperate.

"You can help me, Larry. I *know* you can help me. Like you've been helping Dan. We've been making a swinging scene every night. *Far*

out! But I can't seem to come *back.* Like I do things . . . I don't know why I do them. And I just can't *stop!* You've got to help me come down . . . come *out* of it."

I picked her things up off the floor and laid them beside her on the divan, hoping she would take the hint. I was pretty sure Angel was running around all over Venice looking for her. These disappearances of hers had become frequent of late. Angel had told me about it, how he would come home and find she had gone off without leaving a note or anything, or how he would stir out of sleep in the early morning hours, after a night of pot, sex, Benzedrine and mystical self-searchings with Margot, to find she had gotten up without waking him and disappeared. Sometimes friends would call him up to tell him where they had seen her, or he would trace her to the home of someone they had both met only the night before perhaps. In a couple of cases it was Lesbians she had run off to.

Now I was getting the story from Margot. It poured out of her breathlessly. Sex was the creative principle of the universe . . . what were the vestal virgins but mystical brides of the gods . . . Bacchus . . . Priapus . . . Dionysus . . . the Shechina, the feminine emanation of Jehovah, hovering over the marriage bed on the Sabbath night . . . the agape, the early Christian love feast — what was it but communal love in its pure orgastic form . . . faked up by the Church into Christian fellowship with Sunday chicken and dumplings . . . the vaginal chalice and the phallic cross sublimated into empty ceremonials . . . and isn't it a fact that the gods were conceived of in their pure primitive form as androgynous . . . hermaphroditic? . . . and isn't it just a taboo, this prejudice against homosexuals and Lesbians? . . . and wasn't Henry Miller right when he wrote — and André Gide — and Pierre Gordon in his book *Sex and Religion* which I had loaned Dan to read and which they had dipped into together and talked about . . . how else was one to experience the numinous enlightenment . . . nirvana . . . satori . . . except by going far out? . . . the irrational . . . wasn't that the whole idea? . . . and how could you know in these other ways of knowing unless you explored your unconscious . . . disassociated . . . broke up, and through, and beyond . . . far out . . . through pain . . . through sex . . . through pot . . . Benezedrine . . . *anything* . . . *everything?* . . . since the whole idea was to experience *holiness* . . . the beatific vision . . . orgastic release . . . the crucifixion of the flesh . . . "but how do I

get *back* now? What do I do to slow up, to *stop*, to sleep? . . . "

It all had a familiar ring, but distorted. My own words coming back to me like an echo, but twisted, like sound under water might be imagined in the mind's ear. The early Christian agape, the love feast, transmogrified into a community gang-shag. The hierogamy, torn out of its tribal, communal context and narrowed to the bedroom proportions of a *folie à deux.* The asexuality of the gods distorted into multi-sexuality. And the omnisexuality of the primitive animistic religions divorced from all communal functions or utility and established as the rationale of a private ritual, a neurosis that could become dangerously psychopathic.

I tried explaining this to Margot but it was soon clear to me that she was already too withdrawn for any logical reasoning, although it was probably not too late for psychoanalytical therapy; but I was certainly not going to be the one to tamper with parlor analysis. Not in this case, anyway.

I gave her a book to read while I slipped out the back door and hurried over to Angel's pad. He had been everywhere looking for her and was frantic with anxiety. I told him what had happened and together we returned to my place. The divan was tidied up, smoothed down, the cushions shaken out and propped up innocently, almost primly, against the wall. There wasn't a sign of feminine clothing around, not so much as a bobby pin. And Margot was gone.

"But he'd been there, man, and he blew, and he flew, man, like high."

It was the mad season in Venice West. Things were happening and if you were really *with* it you couldn't show it any better than by flipping your wig. Or at least pretending to. Flips and more flips. And rumors of flips. "Did you know So-and-So was wigging?" "I was with So-and-So last night and, Oh, man, is *he* flipping!" It began to take on the aspects of an epidemic. If you were flipping you became the center of attention for a few days. Some couldn't resist the temptation to simulate the symptoms. It was no disgrace to be flipping. It was definitely the hip thing to do. Hadn't Carl Solomon flipped his wig? Wasn't Bird Parker a Camarillo case for a while? Hadn't Allen Ginsberg been to the laughing academy?

The square never flipped; he became withdrawn, a case of mental

depression born of boredom and frustration. Something he feared and couldn't face. What was there about the square's rat race or his tepid love affairs that was worth a stretch at Camarillo or Bellevue?

When the hipster went off the deep end it was a death-defying — no, a death-wooing — dive off the high board. It was poetry in action. Stuart Z. Perkoff catches the "far out" flip in his poem *Bird:*

> frenetic dancer
> weaving out of the darkness between
> the buildings
> blowing high & screaming in. . . .
>
> they relaxed him at Camarillo
> sent him out
> but he did not cool . . .
>
> what about that horror, man?
> what about that pain?
> what about that cat, like all the time
> trying to do himself in, lushing,
> hyping, insane fucking, no sleep
> no eat just blow blow blow
> farther and farther out tearing finger from hand,
> eye
> from skull, sound from throat, leaving bleeding
> chunks of Bird caught in the teeth of many
> sessions,
> what about that? . . .
> but he'd been there, man
> & he blew
> & he flew, man
> like
> high

The far-out flip is a gamble for high stakes. It is the descent into Hell. Orpheus in Hades. The cool cat may flip if he goes too far out, but he is expected to pull out of it, to come down from his high, to come back, just as the jazz musician always comes back to the theme on which he is improvising. The idea is the traditional one of the hero and his journey perilous.

Chuck Bennison was on a make-believe flip. Perhaps he felt that as

a newcomer to the scene it was incumbent upon him to exhibit the symptoms of contagion. It might hasten his complete acceptance into the inner circle of the initiated. Despite his abandonment of alcohol in favor of pot, he still felt that he was being treated in some pads like a novice, if not an outsider.

Like most converts, his zeal led him to overdo it a little. He would sit on the floor swaying back and forth to the beat of a jazz record, eyes closed, face contorted with agony-ecstacy. Then suddenly he would utter a cry, fall back on the floor, roll over on his face and stay there in a pretty good imitation of a catatonic seizure. When he came out of it he had stories of strange visions, "other levels of reality."

I was riding with Chuck one day, in a car he had borrowed from his mother, when he was suddenly smitten with the gift of tongues. At least that is what it might have sounded like to any true believer of the lunatic fringe religions, but I was able to make enough sense out of it to suspect that he was putting on a show for my benefit. What he was doing was improvising by free association, or rather free *dis*sociation. He was blowing a riff on a tune that was familiar to me, the Jungian archetypes. His hand on the wheel was steady, although the one he gestured with shook violently. When I had had enough of it I said, "Okay, cut out the crap, Chuck. Snap out of it," and he did, turning to me with a sheepish smile. I said no more about it, but he returned to the subject later, explaining that my demand that he snap out of it had "broken the magic circle." Chuck always had an explanation for everything. When he fell into contradictions he could explain that, too. "Different levels of reality . . . like, everything is true and everything is untrue, depending on the level of reality on which you happen to be at the moment." Some of our Venetians expressed concern over "poor Chuck" and there were times when I, too, thought he might be stepping over the line, but Nettie assured me he was all right. "As long as he continues to show up around dinnertime there's nothing to worry about," she said. "As the psychiatrists say, he is still oriented as to time and place."

The only time during the flip epidemic that Chuck Bennison failed to drop in around dinnertime — not that he wasn't always welcome — was when I asked him to distribute some posters advertising a poetry and jazz concert. That time he vanished for a week. When I got worried about him — and the posters — I started out to find him. It took

some shrewd detective work. When I did locate him the posters were still stashed away in the trunk of the car and he was contrite about his failure to come through on his little errand, but as usual he had an explanation. This time it was the Muse that had waylaid him. He had the poem to show for it, too, an opus thirty pages long and as dissociated and far out as anyone could wish. It was, like so much of Chuck's work, "only a preliminary outline." The completed work was to run to something like a thousand pages, divided into twelve major books corresponding to the signs of the zodiac, and these, in turn, divided into three hundred and sixty-five cantos, one for each day in the year with an extra canto for leap years, the whole to be illustrated with colored drawings on which he had been working like mad for days. That the divine frenzy should have taken possession of him so irresistibly — just when he had some posters to distribute — he explained very convincingly. He had now reached that stage in his enlightenment where *any* material or commercial demands on him set up a protective defense reaction that drove him even farther out in the quest for other realities. That night he showed up in time for dinner without any serious setback, apparently, in his quest of other realities.

When Itchy Gelden flipped, it was gently, innocently, like a child lost in fairy tale land. Normally his conversation was spiced with occasional moments of prophetic doom, condemnations of social injustice and political skulduggery. Now everything was holy. Everybody was a lost child with him in a wild and wonderful wilderness where there was neither good nor evil. He had passed beyond good and evil. He spoke little and slept much. He tiptoed around sniffing at flowers, gazing at the sea and sky, picking up driftwood and brooding over it like Hamlet over poor Yorick's skull, but more gently. He sought out all those to whom he had ever spoken a word in anger and asked their forgiveness, as if the world were coming to an end and he wanted to be right with God at the final judgment.

Both he and Chuck had been conducting seances of a sort with Phil Trattman at Phil's pad. Phil was having wife trouble. He hadn't touched his ax in months. (Any jazz instrument is an "ax" — in Phil's case, the bass.) He was stoned out of his mind with pot night and day, often forgetting to eat or dress himself or go out of the house to shop for groceries. The only thing he seemed able to put his mind to was bits of wire, string and metal. He was making mobiles. He wel-

comed the company of Chuck and Itchy, however. Unlike Itchy, who could sleep eighteen hours a day during a flip, Phil suffered from insomnia. Suffered is the wrong word for it. He reveled in insomnia. Chuck, too, was nocturnal. And the three of them were joined frequently by poet-painter Don Berney.

Picture the scene. If you fell into the pad after six o'clock in the evening you had to come in by way of a basement door in the rear, because the street entrance led through a plaster of Paris shop whose owner was so afraid somebody might sneak into her "studio" that she locked it up front and back when she went home at night. You had to go down a short flight of stairs in the rear and through a cellar to another flight of stairs that led up to Phil's pad in back of the shop. Aside from this and the fact that there was only one window, the pad was ideal. The rent was only twenty a month. Phil's arrangement with the weirdie who ran the shop was that he would help her mix batches of plaster which were too heavy for her to handle and act as night watchman. How he was expected to get into the shop at night if he ever heard a prowler or, for that matter, what there was for anybody to steal, outside of a few plaster Kewpie dolls that you could buy in any souvenir joint for a dollar, was never quite clear to anybody, least of all to Phil, who didn't care; and the proprietress was too lost in plaster and biblical numerology to give it any thought, I suppose. It was the biblical numerology that had brought them together in the first place. She offered Phil the back room at a low rental — she had no use for it anyway — as a kind of love offering to a kindred soul on the astral plane.

Phil had hung the peeling plaster walls with driftwood and old fish nets. There were two mattresses on the floor, *sans* springs, and a couple of small hassocks. He had never gotten around to providing bookshelves for his books, mostly paperbacks and thin quarterlies, so they were stacked up on the floor or set up against the wall with anything of proper weight and size for book ends. A three-burner gas plate set up on the soapstone top of an old commode was cookstove and heating unit combined, and the washbowl in the corner served as the sink. The cupboard where the chamber pot was once stored doubled as pantry and a place to stash away his few dishes and cooking utensils. The old-fashioned icebox rarely had any ice in it; Phil used it mainly

for his mobile materials, tools, paints and miscellaneous items. Not much for comfort, but the odds justified the ends, according to Phil's view, and the ends he had in view were not so much material as spiritual. The pad had no bath or shower but it had the only toilet in the place. Presumably the proprietress, who never used it, had risen above such material needs on her astral plane.

One of Phil's seances started on a cold, wet night with the whole ocean front fogged in, one of those impenetrable white fogs as thick as cotton batting. The open burners of the gas plate, all three of them full up and flaming like torches, made the big room as warm as a steam bath but short on oxygen. They also provided the only light there was, an eerie effect of flickering grotesques and tortured shadows. What the air lacked in oxygen it made up in marijuana fumes.

I missed most of the session — it ran on into the next two days and nights — but the Venice West poet Charles Foster, who was present and stayed on to the end, gave me a précis of the proceedings in the form of a poem outline "on the general theme: Knowledge and love are one, and the measure is suffering."

"Three a.m. Friday morning. Phil, working on mobiles, explains why he is afraid to flip out. Chuck says: 'If you're going to flip, man, flip. Make it!'

"The biblical Job. The Artist. Murder. The Androgynous Creator."

Most of the talk on the first night, I gather from the précis was on these topics. Only it isn't called talk in hip circles. It is "communication" and "relating." From what I heard of it before leaving, it must have been on a high level of awareness, as it usually is on such occasions.

"Hamlet. The Businessman. Psychosis. The Father. . . . Sex in thought and action. . . . Alcoholism as a way of life — to adjust to life — to ???. Oedipus. The Lover. Money. The Mother."

Some of this, Foster explained, was only in his own thoughts as the session went on, and in the form of notes to be worked into his projected poem.

"Thelonious Monk. Don attempting to accompany on drums. . . .

Three persons: the man divided within is thereby divided from others, & out of contact with the music.

"Huddy Leadbelly. Bongo drums. Modern Man.

"Saturday. Marijuana. Description of the sickness.

"Blow: what paranoid schizophrenia feels like: utter isolation from others & fear & suspicion of them . . . fear of self's actions . . . the walls . . . too many levels, too many thoughts, too many worlds & strange dimensions, too much reality — & it all shifts and changes too fast . . . the crushing weight of the *reality* of metaphor & the over-powering multiphastic simultaneous life of metaphor or symbol on all the levels . . . the fear; there is no place to find firm ground even for a second; no frame of reference . . . the physical sensations . . . suicide & murder . . . loss of any feeling of insight into the self . . . distorted memory of events right after they happen . . . impossibility of communication.

"Is this sanity or insanity; a distortion of the dynamics operating intra- & inter-personally — or a true understanding of them, for the first time? Even though George (Foster's name for the hero in the précis) is quite aware that he is in a state called psychotic, he is also convinced that his perceptions of the nature of normal reality are true. This is more painful to him than the acceptance of his perceptions as delusory would be. . . .

"Saturday night. Description of another dimension of aloneness — physical isolation. After some time, George goes to the stove to make coffee. Bread knife brings up ideas of suicide, self-mutilation & murder.

"George is able to get across to them the state he is in. They supply him with three things to help him hang on. (1) honesty, knowledge, love; they tell him frankly they don't know how he'll get back, if he ever will — but they know that the things he sees are real & they'll help in any way they can(2) they suggest he use the sharp weapon at his command — his talent with words — to tear down the fences in his path, and (3) they put Mozart on the box.

"Blow: Concerto for orchestra and solo typewriter. How the music puts together all the levels of metaphor into the symbols of art — how, by jesus, words can do the same: in the strange land of reality, the poem is the password.

"Blow: one or two of the 'nerves upon a screen' pieces, tied in with ideas about relationship of art & schizophrenia."

The précis goes on to other themes suggestive of the flipping experience and the "therapies" used to help one another during the experience. There is more about jazz, psychology, anthropology, science, the personal unconscious, the collective unconscious, the nature of reality — and God.

The flip epidemic went on for months, but the only one who had to resort to formal psychiatric therapy was Margot. She had herself committed to the County Hospital and spent a few weeks afterward in Camarillo State Hospital. Released for a week end to her husband and home, she "went over the hill," as the Camarillo inmates call it, and never went back. When investigators came around she hid out with friends, like a criminal on the lam. After a not-too-energetic search the state gave up and, I suppose, "released" her formally, on the books, as cured. There has been no repetition of her symptoms.

The last one to come out of it was Phil Trattman. Months later he was still "training a fly" he had befriended and was "communicating with." How he was able to distinguish this particular fly from the swarms that buzzed around his pad all the time (the single window had no screen), I was never able to make out. Finally one day he came bearing sad news. The fly had died.

After a decent interval of mourning Phil "came back." He returned to his bass fiddle and started making night club gigs again.

4

The Loveways of the Beat Generation

TO THE TOURIST TRADE THAT PATRONIZES THE ESPRESSO COFFEEHOUSES of Hollywood or San Francisco's North Beach, or similar areas in New York, Chicago and other cities, the beat generation seems to consist chiefly of teen-agers in search of thrills. In actual fact, the typical beat generation young person is more apt to be well past his or her teens. Teen-agers loom large to the outsider's view because they are still in school, most of them, and have the leisure to frequent the coffeehouses. When they get a little older and begin to shack up in places like Venice West, they are more likely to remain within the closed circle of their own group and are seen infrequently in public places.

In the loveways of the beat, age is not as important in the twenty-to-thirty bracket as it is in the middle-class marrying circles. If you have learned what it means to act cool and share the attitudes of the group, particularly the negative attitudes, that is, toward squares and the values of squaredom, you are in, you are with it. If you are a girl and your shack-up mate is five or ten years older or younger than you are, the chances are that no one will know or care. Most of the time no one is even likely to ask. This is especially true of the girls, who seem to hover in a kind of indeterminate twilight age between eighteen and twenty-eight. I know veterans of thirty and over who could pass for eighteen or twenty in square circles. This is partly due to dress and a

prescribed youthfulness in behavior, which is *de rigueur* in all "new" generations.

What are they like, these women of the beat generation pads? Where do they come from, how do they get here? And why?

Gilda Lewis: The Gypsy Syndrome

A common feature of many early nineteenth-century English romances was the heroine who at an early age ran away from home and joined a gypsy band, or was snatched by gypsies, or lured away from family or husband by a gypsy lover. In French romances it was the traveling carnival that provided the lure, or, in upper class romance, the theater. In the United States it was the gambling man, the river boat, or the circus. An essential part of the role was the willingness of the heroine to suffer for her man, to put up with violent fluctuations of fortune, to shield him from the Law, at the risk of her life, and, if need be, her honor.

Gilda Lewis' story reads for all the world like one of these romances, except that in her case the gypsy band is the beat generation and the hero is gambling with fame more than with fortune. At twenty-seven, Gilda has run through three husbands and several lovers, all of them heroes in the tradition of the gypsy romance, but a kind of gypsy that the novelists of the nineteenth century never dreamed of. "When I met my first husband," Gilda says, "I was attracted to him because he carried a book under his arm." The next thing about him that attracted Gilda was that he spoke to her before she spoke to him, without waiting to be introduced, and that he swept her off her feet. In Gilda's life the gypsy lover has always come carrying a book — or a musical instrument or paint and canvas — but he was no timid intellectual, palely loitering at the door. He stormed in and took over.

But Gilda is no early nineteenth-century heroine to be swept up and carried off in a swoon. The nuptial flight is always "a wild swinging scene." But then the suffering begins. This is part of the gypsy pattern, of course. She knows it and accepts it. Yet it always seems to take her by surprise. It is always somehow more sordid, more petty, than she had pictured it. When the affair breaks up, Gilda is devastated — till the next one comes along.

"I was eleven years old when I met this boy. My feelings were still

immature, of course, and my sensations, my physical sensations were —
what do they call it? — unlocalized. It was one of those young chase,
push and poke things. Under the staircase in the dark and behind the
house and in the garage, any place that was big enough to get under
or crawl into. And *breathless!* I still remember some of those scenes
better than things that happened a year ago or the day before yester-
day. Nothing happened, of course. We were both too young. And yet,
looking back now, *everything* happened. Everything that was ever
going to happen, only in pattern, like a mock-up, you might say, of
the real thing. To this day I could swear that we had orgasms. I
know *I* felt that way — it was all *over*, though, and not, like later on,
localized in the genitals. Even today, when I want to tell myself how it
ought to feel like, I think back to those days — and, do you know
something? — it sometimes helps to bring it on!

"Anyway, we left New York when I was fifteen and came out to
California. I went to high school in Los Angeles. When I was thirteen,
Martha — that's my mother, I never called her mother because she was
my stepmother — brought up the subject of my menstruation. She asked
me if I was a lady. I said 'What?' and she said, 'You know, are you a
lady yet?' That was her word for it, so you can imagine how much sex
education *I* got at home.

"Mine wasn't what you'd call a happy childhood. But what *is* a
happy childhood? I've never known anybody who had a happy child-
hood, have you? I wasn't really what you'd call happy till I was grown
up, out of the house and on my own. Did I say happy? Well — like the
poet said, 'in my fashion.'"

Gilda's mother died "before I could really get to know her well," and
her stepmother was "what I would consider a very reactionary person."
Why did her father, who was "a card-carrying Communist till 1935,"
marry a reactionary woman? "Well, he had two children who he felt
needed a mother, and she had three thousand dollars which *he* needed."
Martha was thirty-six when she married Gilda's father and, according
to Gilda, a virgin. Gilda is sure of that, although it was never discussed.
"I *knew*, that's all. I could tell by the way she acted." Gilda was eight
years old at the time and her sister twelve.

Her real mother "was completely surrounded by mystery. I was
never allowed to see any of my mother's family after she died. My
father had a falling out with her sister at that time. You know how

families are, like they blamed him for her dying . . . it was his fault
. . . it should have been him that died, not she."

Gilda was seventeen the first time she ran away from home. "I was
going with a guy at the time and I thought I might marry him. I was
fifteen and a half before I started menstruating and I thought maybe
something was the matter with me, being so late. I was always very
intense and maybe that — well, anyway, he was the type — a great
reader, he wrote a little, too. You see, I was coeditor of the school
magazine when I was twelve, and I remember writing stories way be-
fore that. Frank, that was his name, was the mental type. I used to
think I couldn't even have an orgasm with any other type person —
which is silly, of course, as I later discovered — but it's true in a way
even now. I mean, if he doesn't reach me up here first, there's nothing
happening down there. Like I'm on a mental kick. Artistic, too. Anyone
having anything to do with the arts, you might say. But *exciting.* He
has to be far out. Like he's *going somewhere,* far out — and fast, and
I can swing along with him. A lot of the young men I met were stu-
dents and also party men. It was a time when everybody was trying to
find their way into something. So Frank and I ran away together. . . ."

Her father found her and pleaded with her to come back home. He
said it was a disgrace to the family. "He was ashamed for his friends —
he said he didn't know how to explain a thing like this." She went home
with him. Three months later she was in flight again. This time with a
young painter who had a shack up in the desert somewhere. She
doesn't remember where. She doesn't remember his name any more.
"Ted, something. It didn't matter. It was wonderful — while it lasted.
I think he was part Indian, I mean American Indian. I'd met him only
the night before and the next day — just like that! I was ready to go
anywhere, where they couldn't find me and drag me back home again.
This time I left home for good and never went back."

The gypsy trail had begun for Gilda. Back to New York, now, and
her first love. Robert was interested in creative writing but he had
gotten a degree in advertising so he was working in an agency. He was
writing on the side, and also painting. He interested her in music. And
he was political, what the party people called "an intellectual." It was
Frank who brought her into party activities. "He wanted to marry and
settle down as a worker, have children and all that, but keep up with
his writing and his painting, too. It didn't work. He wasn't skilled or

trained for anything else. I became pregnant right after we got married. We had to live off the charity of his folks for a while. I managed to get low-paying jobs to help support us and we kept borrowing from his people. Finally I decided if I'm going to have a baby and freeze I'm going to have it in California. So we came here. He got a job and I had the baby, but then he was out of work for long stretches. When the baby was five months old we took him to New York and left him with Robert's family. The day I left my baby I decided that if I couldn't have my child I certainly didn't want this man. We separated."

Gilda consented to let his parents adopt the baby. On the way back from New York, hitchhiking, she met another man and lived with him for a while in Cleveland. They got married — she isn't sure but she thinks Robert got a divorce before that; he did afterward, she's sure of that — and she got pregnant again. This child, too, had to be given up for adoption by her in-laws. She doesn't know if she is still married to the Cleveland man or whether he got a divorce. By this time "I was making the party scene, marching in demonstrations, attending meetings. Her sister had married and gone the whole route back to the Right — "tract house, PTA and all that sort of thing."

"It was no longer possible for me to love any man with conventional ideas or live a conventional way of life."

Marrying Dave Gelden in a ritual poetry wedding was now her idea of the swinging scene. Party activity is a thing of the past. "If I were to describe my political position I would say I was an anarchist. My conflicts come in when I try to put value judgments on things. I've learned to live for the moment."

Gilda doesn't follow the news very closely, never reads a newspaper and rarely reads a news magazine. She keeps the door of the pad unlocked, on principle. If anyone broke in and stole anything — "like, what is there to steal?" — she would not report him to the police. She joined a church briefly when she was sixteen, the Methodist church, but has had no religious connections since then. The only thing she liked about it was the hymn singing. She thinks about going back to college and getting her degree, but it is hard to sit in a class and listen to lectures and to the silly questions students ask. "I guess I'm long past all that now. I just read. I read a lot." Looking back now she isn't sure that even the war against fascism in the forties made sense. "It

wasn't against anything, it didn't settle anything. The only ones I'm sorry for are the Jews Hitler killed." She isn't a pacifist, however. "I don't know *what* I'd do in case of war. People ask me, 'What would you do if a man broke in and tried to rape you?' He wouldn't have to break in. The door is open. And I'd rather be raped than put the heat on him. I wouldn't put the heat on anybody. Not from what I know about it now."

How did she happen to come to Venice West? "I heard about it and right away I knew *that's for me.* Those LIGHT HOUSEKEEPING signs you see everywhere, that's for me. The lighter the better. And better than that, a good car — well, one that doesn't break down too often — out on the open road and *going* somewhere. Preferably *with* someone, *away*. It doesn't matter much where *to* as long as it's *away*."

Three months after the "marriage" to Itchy Dave Gelden, Gilda Lewis was on the road again. East bound on Route 66 with Chuck Bennison. Back on the gypsy trail again.

Diana Wakefield: Handmaiden of the Muse

There are those who play a sacrificial role in the service of the Muse, vestal, if not virgin, servants in the temple. Their labor is a labor of love. They hold a job and come home to shop and cook, to clean house, launder, knit, wash the dishes and carry out the garbage. All for the privilege of living in an atmosphere of art, *any* art, and feel themselves part of the creative act. Living in poverty and disorder, trouble and insecurity, they see themselves pictured in glowing biographies of the future, the artist's faithful model, the writer's devoted lover, loyal through the years of obscurity and want, the "women in the lives of" men of genius.

Diana Wakefield has had such a picture of herself from the time she was twelve. A painter of mature years — she thinks he was forty or more but at the time everybody over twenty must have seemed middle aged to her — found her peering in wide-eyed at the door of his studio one day and invited her in. She became his model, first in poses of childlike innocence and, by degrees, in progressive stages of undress till she was posing in the nude. By the time she was thirteen she was mistress as well as model. All this secretly, without arousing the

slightest suspicion at home. Not even her closest friends in the neighborhood or among her schoolmates knew. How this feat of secrecy was accomplished is something of a story in itself.

"I would take my schoolbooks over to a girl friend's house, tell her mother I was going to another girl's house, stop there for a minute and light out for Melvin's studio. If my mother called up this one or that one I'd always been there and left. If she asked me any questions it was easy to pretend I'd run into some kids from school and we'd stopped somewhere for a soda. I used to go over to Melvin's two or three times a week. I was always careful to pick up my books and get home by five or so. Mother was very social. She was usually out playing bridge or shopping. She belonged to some organization, I forget what, and they had her licking stamps and addressing envelopes at least once a week. There never were any stories about me running around with boys, so she wasn't worried about anything. Dad? I don't think he even knew I was alive most of the time. I did my homework. I didn't get into any trouble. I was a model child."

The artist model relationship came to an end when the family moved from Cleveland to San Francisco. Diana was fifteen when she met George, a high school senior with a precocious talent for art and no idea what to do about it. "He wanted to paint, he wanted to sculpt, he wrote beautiful poetry and played the guitar pretty well." Before he could make up his mind his family made it up for him. His father, a wealthy contractor, decided to make an architect out of George, and when the boy graduated from high school he told him it was all arranged for him to put in a few years at a school in France. George rebelled against the parental will and broke with his family. That gave Diana her first chance to play handmaiden to the Muse. George set himself up in a studio in North Beach and Diana started seeing him there after school hours, as she had done with Melvin in Cleveland, posing and, for the first time, keeping house for an artist. Again it was a clandestine affair, but it was made easier now by the fact that her parents went back to Cleveland, leaving Diana with the landlady of the apartment house where they had been living, a sweet, motherly lady they felt they could trust. It was going to be only for a few months but it became a permanent arrangement when her father and mother separated. Her mother subsequently married somebody else and she hasn't seen or heard from her since. Her father continues to send her

a monthly allowance. She sees him once a year when she goes back to Cleveland for a few days. "It isn't as if I missed either one of them very much," Diana says. "We were never very close, anyway."

The sweet, motherly landlady turned out to be more of a madam than a mother. The cute young couples in the building — that Diana's folks thought were honeymooners — proved to be call girls and their boy friends. Pimps would probably be the professional name for them. Mrs. Trendel, the landlady had suggestions for Diana on how she could improve her financial position, but Diana had other plans. "I didn't want to antagonize her — she really was a sweet soul in a way — and I *had* to stay on in the place so my parents wouldn't get suspicious. I was in love with George and I wanted to help him. He wasn't taking a cent from his folks. He didn't even want them to know where he was. He kept moving around for a year till they got tired trying to keep track of him. Besides, it wouldn't be long before he'd have to go into the Army, anyway. We lived on what Dad was sending me and when we needed more I'd go out and find some part-time work after school hours. It got so I hardly ever got back to Mrs. Trendel's, except to pick up my mail, my monthly check from Dad."

The Greetings from the President of the United States came to George when Diana was two months pregnant. Diana was left alone in the studio with a pile of unfinished canvases and a problem on her hands. She decided to have the baby, come what may.

"I was afraid of an abortion, that's the truth. But it's also true that I wanted the baby. After all, it was his baby, too, and we had plans to get married when George came back."

George did not come back. He died of an infection in Korea. The pregnancy had ended in a miscarriage in the fifth month. "I kept it from him, about the miscarriage, till the end. I couldn't tell him. I think they sent his body back from Korea in one of those mass re-burials. His people never told me. They didn't even know I existed till they learned from the War Department that he'd been sending me part of his pay every month. I was saving it for the baby. His people didn't offer me anything and I wouldn't have taken anything from them if they did."

It was then that Diana hitched a ride with some friends and made her way down to Los Angeles and finally to Venice West.

Here the same pattern repeated itself. First it was Don Berney, the

poet-painter. Don's idea of a painter's mistress turned out to be something between a sainted Magdalen and a gun moll. Or rather, it was both by turns. One day it would be flowers and orisons at the shrine of the sainted Magdalen. The next day it would be blows and curses. The flowers were garden flowers filched from the neighbors, but no matter. They were presented with love and affection, and Diana accepted them in the spirit in which they were given. The blows and curses were harder to take, but they were just as sincere and just as well meant. At least that is what Don always succeeded in convincing Diana of afterward. Their reconciliations after such flare-ups were touching to behold.

"He doesn't mean it, really," Diana would explain when she turned up with a blackened eye. "Don is high strung. When things aren't going so well with his painting, or he gets a poem back from a magazine, he broods about it for days. Then all of a sudden he blows up, about everything, against everybody. And I happen to be around." Diana happened to be around one night when a gallery man who was there looking over Don's paintings had gone away without making any commitment, without so much as a word of encouragement. At three o'clock in the morning she was at our door knocking wildly and crying hysterically, "Let me in! He's after me, he's trying to kill me!" We put her to bed in the spare room and gave her sedatives. The next day she vowed she would never go back to him, got a friend to sneak into the pad and bring her some clothes, and went off to hide out with friends in Santa Barbara. A week later she was back with Don. I learned later that the real cause of the beating was that she had hinted about giving up her job for a while because she was exhausted from working all day and partying and potting all night.

When Don started gaining some success with his painting Diana left him. "He doesn't need me any more," she said, and moved in with Paul Mattingly, a poet who lived in a pad on one of the Venice canals, a solitary soul who was seldom seen at parties. It was a rat's nest of a place but Diana quickly turned it into one of the most beautiful pads in town. She even succeeded in bringing Paul out of seclusion, and the feeling of community began to show in his work, deepening it and making it more communicative. "Paul is going to be the greatest living poet in America," Diana boasted. That was like Diana. Whoever the god of her temple was at the moment was always the greatest, and she was proud to be in his service. But this god, like others in her life,

turned out to be made of clay. And in the worst possible way. There were long stretches of time when he was completely impotent. Paul had no objections to her finding satisfaction with others during such times, and Diana had no scruples about it, but it led to complications. She fell madly in love with a budding young jazz musician and went on the road with him when he joined a traveling combo.

Today she is back in Venice West shacking up with Tom Draegen, a talented writer who was one of the latter-day expatriates of Paris, Majorca and Rome. Tom has been trying for years to finish a novel on which he got a publisher's advance. He will do it, if he can kick the heroin habit. Diana is helping him do so.

"A man can do anything if he's got the right woman to help him," Diana says. "Tom is going to be the greatest novelist in America — maybe in the world. The Bible says love is stronger than death. I think it's even greater than heroin, and we're going to prove it."

Rhonda Tower: Daughter of the Regiment

That isn't her real name. A theatrical agent bestowed it on her and it stuck. From the apple orchards of Washington State to a private school for girls to Pasadena Playhouse to Broadway to the Champs Élysées to Rome, Vienna, Berlin and Venice, Italy, is a long, round-about way to Venice West, but that is the way Rhonda Tower made it. First as a dramatic student with money from home, then as a dancer with a theatrical troupe touring Europe, then as a student at UCLA working for a library degree and finally as a young divorcée with a monthly alimony check making it cool and groovy in the Venice scene.

You would never pick out Rhonda Tower as the finishing school product, which she is, or the typical beat chick, which she isn't. There is nothing typical at all about Rhonda. In her high heels and black formal she is the lady who is a tramp. In her toreador pants, bare legs and sandals she is any prowling newspaper photographer's idea of a movie starlet on a beach-front beatnik kick. Too beautiful to be casually approached by any Venice Sunday beach visitor, Rhonda is easily recognized by the secret stigmata known only to the beat generation initiate. Once she feels she can "relate" to you she will speak freely and frankly.

"I screw every chance I get. That doesn't mean I'm promiscuous. Like I don't get many chances."

Those who know Rhonda Tower have no trouble understanding such apparent contradictions.

Early memories include a doting father, a jealous mother, an Indian boy. "It's a real vivid scene. Like my mother put it up to my father to pick between us. You're going to live with her or you're going to live with me. You better make a choice. Just like that. Like there was a pairing off." Rhonda is sure she did nothing to provoke such an outburst on her mother's part. "It was intuitive on her part. You might say she had an intuition something like this *might* happen." Anyway, it was her first experience as the hypotenuse of a triangle, a role she was to play on one or two occasions in the future, more realistically. Of the Indian boy incident: "I was about twelve and the boy was the same age. It was exploratory, like I wanted to show myself to him. It was a sexual act, you might say, but it was never completed. I kept dreaming about him for years. After my divorce I went back home and I looked him up. We saw each other but nothing happened. We didn't swing out. Like he was scared. By that time I was making the movie scene. I was under contract to one of the movie companies and I was running around with a movie crowd. I was making money and like he didn't have any money. He had become conscious of the difference in our social status — not only money, I mean the racial thing. It made me want him all the more but it bugged him. He was so hassled about it that, well, he couldn't make it. I was real drugged about it. I wasn't making any love scene at the time. I would have made it with him wild like if we could have gotten started."

It was a dream that brought her back to her Indian boy, and she remembered it in detail. "It was after I was divorced and I remembered how he always came to my bedroom window — that was when I was in high school — and he'd call to me, and I'd get up and sneak out of the house. In the dream we'd be making a swinging scene out in the back yard and my parents didn't know anything about it. That's how the dream would go. Well, when I went back home I slept in the same bedroom and that night I could hear his voice sounding me, just as clear! 'Madelaine, Madelaine.' He was calling me, just like that. I got up in my sleep and I sleepwalked outside and I woke up there.

That was why I had to find him again. But after I saw him and nothing happened, I never have had the dream again."

Her marriage had been a good marriage. "He was kind and considerate. He made a good living. I was with him in the act. It went over big here and in Europe. His whole life was the stage and he's really one of the best. We got along fine — only there was one thing. I wasn't having an orgasm."

Her mother had had the same problem. "My mother never had an orgasm till she was about thirty-five years old. She didn't even know a woman *had* an orgasm. Like she had something wrong with her foot once and she went to a doctor and she was talking to him and he said like, you know, 'How's your sex life?' and so they got to talking and she realized like that she wasn't making the scene. She went home and started working on it and she had an orgasm. What a lousy lover my dad was!"

Her father, Rhonda explained, had a very strict religious upbringing. He was an only child. Sex had always been a problem with him. "He had so much guilt feeling about it that sex was always a hassle with him. Like my mother sounded that he had never come to her bed. She always had to go to my father's bed. She said, 'How would you like to live with a man and always have to go to him?'"

Her father is a doctor, and when she found she wasn't having an orgasm with her husband Rhonda went to him and told him about it, and said that it was ruining her marriage. "He said, 'Don't worry about it. It's better that way. You don't need to have it and you're better off not to have it, so forget it.' That's what he told me. Like that's how hassled *he* was about sex."

Psychoanalysis was no help. "Like it cleared up a lot of things for me, about my past, my childhood, mother and father feelings, things like that. But I still wasn't having an orgasm. And believe me I tried."

It was an affair with a beat generation poet that finally filled Rhonda's sail with a fair wind out of the Dry Tortugas.

"Maybe it was the poetry. Like it makes me feel warm, like I'm relating. I'm *with* something, you know, and it makes me feel warm and swinging. And music, jazz music. Like it loosens me up and makes me less inhibited. And with pot — man, crazy!"

After a year of psychoanalysis Rhonda says she is still quite inhibited

— at first. "Like it's hard for me to take the first step. I stay more or less outside of it. Poetry helps me to get into it more, and music and pot. That way it's a wailing scene."

In the Venice West scene, Rhonda Tower is the Colonel's daughter, the pride of the post, the daughter of the regiment. She is no hand-maiden of the Muse, yearning to wive, mother and nursemaid a genius to fame. Nor is she panting for a gypsy lover with whom she can hit the open road in a broken-down jalopy and suffer hunger or abuse. Rhonda is no pushover for a hard luck story or any emotional cripple looking for a crutch. "To make it with me a cat has to bring something to the scene, something that promises, at least, to lead to love." Like a keenly perceptive jazz musician listening for a sound, *the* sound, that he can improvise with uninhibitedly, freely, swingingly, at last Rhonda is developing the faculty of listening for the sound of love, the respon-sive chord. Some women possess it from the start, as a gift. Rhonda had to learn it the hard way.

Will she ever return to the stage? "I put that scene down when I got divorced. I realized that this was only fulfilling my mother's dream for me — for *her* — not for me. I swung over to my father's scene then. My father was always sort of the intellectual of the family. So I decided to go to college and get educated. I tried to make that scene and *it* was a shuck, too. Now I'm trying to find myself and make my *own* scene."

Barbara Lane: Refugee from Squareville

Barbara Lane's story is brief and single-pointed.

"It isn't art or intellectualism, it isn't genius that's got me hooked. It's the life. Do you have any idea what it's like — out there? Sure, it isn't *Main Street* any more. Sinclair Lewis' Gopher Prairie is a thing of the past. So is Zenith City, for that matter. Squareville is *modern* now. It's got network television and *Life* magazine culture. You can tune in the Metropolitan opera on the radio. You can stay out late and come home drunk once in a while without being hounded out of town. You can play around a little, if you're discreet about it, without too much talk. The drugstores carry paperback editions of Plato and Lin Yutang.

"But the tension! Wages go up three cents and coffee goes up ten. So they pipe sweet Muzak into the supermarkets and you go around in a

daze loading up that cute little chromium-plated cart without looking at the price tags. And let most of it rot in the refrigerator before you get to it. Last year's car is out of style before you finish paying for the tail fins. It's a rat race. Who's got time to laze around in the sand for an hour, or take a quiet walk by the ocean in the evening, or watch a sunset?

"Here I can get away from it for a while, at least evenings and week ends. I can do *without* things. God! — do you know what a relief that is? Not to have to keep up with anybody. Nobody to show off for. The people at the office, they don't even know where I live. I tell them I live in Santa Monica. That's close enough, and it sounds respectable. It's got the same telephone exchange as Venice, so nobody suspects anything.

"This is the one place I've ever lived where you can take your skin off and sit around in your bare bones, if you want to. Only the rich, surrounded by acres of land and iron fences, can enjoy anything like that kind of privacy. That's what I mean by being hip. And staying cool."

Barbara Lane is part time square and part time hipster, but her heart is in Venice West. "In town, at the office, I work. Here I live," she will tell you. "It's like having one foot on each side of the tracks. But that's the only way I can make it."

Barbara had everything, as they say. Family background, money, education, travel. When her family thought it was time for her to settle down with a good husband and raise a family, she went along with the idea. The man was her own choice; he was good to her, he provided well. They had all the right things, went to all the right places, knew all the right people. When she got pregnant she knew it was now or never. "I just picked up one morning and ran. I didn't know where I was going. All I knew was I wanted *out*. I didn't take a thing with me. The only place I could think to fly to was Mexico. There I got a divorce. And an abortion. I learned a lot in Mexico. I didn't have much money so I lived in a small town on the west coast. It was like dying and being born again. The only things I've found to like about America I found first in Mexico, strangely enough. I mean jazz music, good books, uninhibited sex, relaxed living. Like Jack Kerouac says in *On the Road*, Mexico is a whole nation of hipsters!"

Barbara returned to the States when her money ran out. She found Venice when the gas ran out. "I drove up with friends I'd made in Mex-

ico. Visitors from San Francisco. On Windward and Main, in Venice, we ran out of gas. It was a question of buying gas or staying where we were. I'd never seen Venice before, although I'd been living in Los Angeles for years. I liked what I saw. So did my friends. We found a couple of cheap rooms and moved in together. Slept three in a bed for weeks till we had enough money to get separate apartments. My friend, her boy friend and me. No complications. I got a job in a Beverly Hills lawyer's office and my friends went on to San Francisco. I stayed on in Venice.

"The only time I saw my ex-husband again — he spotted me in Beverly Hills one day when I was coming home in this beat-up old car I drive back and forth, and followed me all the way to Venice. I didn't know till he knocked on the door. Said he was still in love with me and would I consider coming back to him. When he saw the way I was living something clicked in him, like he was remembering something he'd always wanted and missed out on somehow, and do you know what? He wanted to move in with me! I said Okay, Bill — I was just testing him — Okay. But you'll have to leave all that other stuff behind, the way I did. The fishtail fins and the made-to-order shoes and Countess Mara ties. Those precious gold clubs of yours. Dinner at Mike Romanoff's. Those slick magazines we never read and used to leave lying around to be seen by our friends. All those nice opera records. The hunting prints in your den. And the goddamn phony spinning wheel lamp —

"He said 'Yes,' and I thought he meant it. That was a year ago and I haven't heard from him since."

Sherry McCall: Link Between Two Worlds

For the Venice West beatster, Sherry McCall is the missing link with the World War II forties. The twenties and thirties he can read about in books. But the home-front scene of the forties is still, for the most part, undocumented in print except in a few novels.[1]

Sherry McCall is beat from in front, as the bop jive boys of the forties would have put it. Sherry has *had* it. Everything. She was there when the passbook to a wartime shack-up was a book of ration stamps. At Sherry's place you can still hear the old 78 Alco record of Earl Robinson singing the song he wrote to Alfred Hays's *Porterhouse Lucy*, the black market steak.[2]

Temptation Smith is steak mad, and he says:
Steak! Steak! I got to have me red corpuscles.
I dreams of it. I wakes up in the middle of the night
and I talks to myself. And I say to myself,
It's a conspiracy. There must be a cow left over
from the last war. Look at me fingers, no calcium.
That's what I need, calcium. With fried onions!
Now this is my story and the meaning is plain
You can't ride to victory on the gravy train. . . .
Porterhouse Lucy, the black market steak,
Porterhouse Lucy, Lord the trouble she make.
Her kind ought to be feedin' Hitler's army.
You got a date with Mary Four Freedoms this very evening.
Besides, you ain't that hungry. . . .

Sherry kept away from Temptation Smith and Porterhouse Lucy. She skimped on sugar, collected junk iron in the scrap drives, bought Victory Bonds and Freedom Bonds, rounded up Bundles for Britain, and dreamed about the world of the Four Freedoms that was to follow the war to end war, the world that Comrade Stalin and Comrade Churchill and Comrade Roosevelt had agreed upon at Teheran and Casablanca. She still had the pamphlets and the clippings to show for it, and framed copies of Rockwell Kent's "Four Freedoms" drawings stuck away somewhere in one of the half-dozen trunks that cluttered up her Venice West bedroom.

In a North American Aviation plant Sherry met Johnny McCall. Johnny wanted to get a crack at the Nazis and Fascists, and when he was drafted he went, even though he might have gotten deferment because he was a defense worker. He was older than Sherry by a decade and had gotten in a few good licks against them in Spain as a member of one of the international brigades, but this time it was different. Uncle Sam and Uncle Joe Stalin were on the same side and the combination was invincible. Sherry and Johnny had been living together and a week before he left for basic training she married him. She had never married anybody before but at the time, she explains, everybody was doing it. It was the patriotic thing to do, the Progressive thing to do, and both meant the same thing in those days.

Johnny never got to fire a shot at either Hitler's or Mussolini's legions. The War Department somehow found out about his Loyalist

war record and sent him to the Pacific theater instead. There is a little packet of letters somewhere in that mess of stuff piled up in the bedroom and the last-dated one of them is from a war buddy of Johnny's. She doesn't remember now what became of the War Department telegram.

Anyway, all his books are still around, piled up on the floor and in the closets. An almost complete set of the red-covered books of V. I. Lenin. An old copy of *The Communist Manifesto,* heavily underscored and full of penciled notes in the margins. Volumes of letters and papers of the Presidents of the United States, which Sherry had given Johnny during the honeymoon of the United Front when Abraham Lincoln and Thomas Jefferson were saints in the calendar of the Communist Political Association and even George Washington squeaked into it on his Revolutionary War record. Everything Howard Fast had ever written, and Albert Maltz and Grace Lumpkin and Meridel Le Sueur and Sean O'Casey. And the Russian novelists and an anthology of proletarian poets and old copies of *New Masses, The Anvil* and *Partisan Review.* All mixed in with or buried under piles of old clothes, torn silk lamp shades, broken umbrellas, half-spilled-out boxes of Christmas tree ornaments, hatboxes crammed with old shoes, phonograph records, finger paints and medicine bottles. Children's toys in every state of disrepair were always scattered over the floors and a hazard underfoot.

Sherry had never married again but she had four kids, none of them her own. Two had been left with her and never called for, and two she had borrowed and never returned, as near as I could make out from her stories. Sherry loved children. Besides, they were the most effective insurance she had ever discovered against starvation. No county welfare department would ever let a mother and four children go hungry or homeless.

When Johnny McCall's buddy, the one who sent her the letter, came back crippled from the war, Sherry lived with him for a time on his GI bill in one of the UCLA housing units for veterans, his wife in name to make it cool with the VA's office. Since then she had lived with other veterans in similar arrangements. They were all Johnny to her and she was still Sherry McCall.

From veterans' housing shack-ups to Venice West was only a short step for Sherry. It puzzled her why she wasn't being received hospitably in the pads. They weren't so different, as far as she could see,

from the bohemians of the matchstick and tar paper apartments of veterans' housing and their informal, freewheeling domestic relations. Besides they needed her, she figured, to give direction and a social goal to their youthful revolt.

"A Stalinist. An unreconstructed Stalinist," was Angel Dan Davies' verdict.

Sherry never lost an opportunity to declare her adherence to the new Khrushchev party line, but to Angel, Stalinism was an incurable disease. "I went all through that with my mother and father," Angel said. "They brought me up to believe that the working class was the hope of the world and all the time they were falling for the Stalinist dictatorship. Like I've worked with the working class," he told Sherry, "right next to them, at the workbench and in the shipping room, and I've walked with them on the picket line and I wouldn't trust the future of the smog problem to them — let alone the hydrogen bomb. Let some slob of a newspaper publisher start a crusade against beards and sandals and I wouldn't put it past the people, these world savers of yours and my parents', to come and bomb us out of here, the way they're doing to the Negroes in the South right now. No, man, I'm not the people worshiper I used to be."

"But what are your values, your *positive* values?" Sherry kept asking all of them.

"Like I want to love everybody," Itchy Gelden told her quietly. "Even the haters and the war-makers — on both sides of the iron curtain. And maybe if I can love enough, and put it into my poems and into my paintings, maybe it'll spread out like. And if enough of us make it that way and it helps to transform a few people here and a few people there, then somebody on this side is going to refuse to make their fuckin' bombs for them, and somebody on the other side is going to refuse to fire their missiles for them — "

"And if they don't? — "

"Then we'll be the last ones who ever did anything positive about it and it'll be easier to die when the bomb drops. Like me, I'd rather die loving than hating, that's all, and I'm not any happier hating one side than the other side. Like *let 'em* put everybody in the Army, and let 'em occupy each other's countries, like they did after the last war in Germany and Japan, and in a few years they won't be able to aim a gun in *any* direction without hitting their own little bastards on the

street. Let 'em fight their fuckin' wars backward, starting with the occupations, man, and they'll never *get* to the shooting. . . . "

Sherry would throw her hands up in confusion and dismay and go back to her knitting. She was always knitting something for somebody. It was something she started during the war, for Johnny and his buddies at the front, and she has never been able to stop. That, and the fact that you could always be sure of a meal at her house — "It's on the county," she would say — endeared her to some of the beat, especially the youngsters who kept dribbling in from here and there, always broke and in need of a warm sweater in the cold, foggy winters by the sea or a hot meal now and then. There was always something they could find to wear or help outfit a pad among the household junk and wearing apparel Sherry had piled up all over the house — the accumulation of years of housekeeping with one Johnny or another.

The Electronic Ear:
Some Oral Documents

You make it any way you can

(The Scene: Angel Dan Davies' pad. Angel has just been served with an eviction notice, after six months nonpayment of rent. He is discussing the situation with Itchy Dave Gelden, Chris Nelson, Chuck Bennison and Dean Murchison, a visitor from San Francisco who was formerly a Greenwich Villager.)

DAVE: Man, what a drag. I thought the cat was satisfied with you painting the outside of the house for him.

ANGEL: Sure, man, but it's six months now. And I haven't even finished painting the place. Guess I got kind of hung up. Fact is I had to use up most of the paint painting my pictures.

DAVE: That comes first.

ANGEL: Naturally. But what I mean is, what do I do now? What do I tell the cat?

CHUCK: Tell him anything. Tell him you've sold a picture and you expect to collect for it next month, or something. Tell him your publisher is in Europe and owes you six months' royalties. He's a businessman, he'll understand a thing like that. You know, accounts receivable.

DAVE: You could take a thing like that to the bank, man, and get a loan on it — I understand.

ANGEL: Yeh, if you've got something to show for it. No kidding, what do I do?

DEAN: I wouldn't do anything. Sit tight. Take it cool.

ANGEL: But suppose — I don't want the heat coming around — they might not like some of the books I've got here, or smell pot or something.

DAVE: That's right. (*He broods silently for a minute.*) Did you say you had a roach stashed away somewhere?

(*Angel fishes around back of some books on the shelf and comes up with the charred half end of a marijuana cigarette. He lights up, takes a drag on it and passes it around. Dave has been going over a pile of jazz records. He finds what he's looking for and puts it on the box. Thelonious Monk's* Brilliant Corners.)

DEAN (*Stretched out full length on the floor, relaxed and reminiscent*): I lived in Manhattan once on nothing a week.

DAVE: What did you do, man, beg?

DEAN: No.

DAVE: You're an animal, man, you have to eat.

DEAN: Well, I scrounged a place to live. I lived in a different place every week. I would go to the landlord and say I want this place and I can't pay you any money till next week. I might have to hit ten or twelve places before I found a landlord who would let me live in the place and I would live in it for a week or so and when he came around for the rent I would be gone. I didn't have anything to move in and nothing to move out. I had two pairs of dungarees, two nylon shirts and a pair of sandals. (*Long pause*) But I wasn't happy. Didn't get a damn thing done. No painting, no writing, nothing.

CHRIS: I saw a cat once carrying a big cardboard box, and I said, "What you got there, man?" And he said, "I'm carrying my bed around on my back." He used to make it up to Hoffman's at the Red Barn, and sleep on the stairs. He said you shouldn't think ahead more than a half hour, you know, live in the present.

CHUCK: Like I say, *now* is the time. This is the only moment we have, *now*. Right at this split second. Past, present and future all in one.

ANGEL: You can talk man, like you've got it *made*. Your old lady's pad, you can always go back there. But I've got all this stuff here, and Margot laid up with the flu, and the kids. What'll I tell the landlord? —

DAVE: He's a Christian, let him share with his fellow man. Like they say — it's good for the soul.

DEAN: I wouldn't tell him nothin'. I'd move out and to hell with the joint. You've *had* six months of it. It's time to give some other landlord a chance. There's plenty of pads with FOR RENT signs hanging out.

ANGEL: Yeh, but you've got to be able to pay at least one month's rent in advance.

DAVE: I've got some loot. It's *my* next month's rent but I'll lay it on you, if you think that'll do it for you.

ANGEL: I already sounded him on that, but he wants all the back rent, six months. And besides, he's already served this eviction notice.

DAVE: Hey, I got an idea. I'll move into your pad and you can move into mine. And when the agent comes around my pad looking for the rent, tell him I'm working in Detroit, in one of the auto factories — expert consulting job, or something fancy like that — and I'll be back with the loot in a couple months, and you're taking care of the place for me so no one will bust in and damage his fuckin' property. If he raises a stink you can lay a month's rent on him —

ANGEL: But if I do that, what'll you do for rent to pay *my* landlord. He'll want at least a month's rent in advance.

DAVE: I'll tell him I'll finish painting the outside of the joint for him. It looks like hell now, half fresh paint and the other half peeling off like old wallpaper. He'll be able to rent it this way.

(*General approval of the idea all around*)

ANGEL: Hey, you know something? It might work!

(NOTE: *It did.*)

War for Survival

(*The Scene: Chuck Bennison's pad. It was once a small liquor store, later converted into a studio by a maverick architect who used it as a hideaway workshop for some wild ideas that more practical builders have since taken over and made fortunes on. He put a lot of work and materials into making the place livable, left it all behind him when he moved. Others left kitchen equipment, furniture and wall decorations, passing the pad on from friend to friend, but it still lacks bath or shower. It is late Sunday afternoon and Chuck has just gotten up after an all-night pot party. The*

*place is very untidy. From a shelflike mezzanine under the high
ceiling, which the architect used as a storage place and which has
since been made into sleeping quarters, reached by a ladder, came
soprano snores — some chick left over from the party, still asleep
there. Clem Peters, a young man recently out of college and now
making the Venice West scene, has dropped in to discuss a prob-
lem. He has just been called up for military service.)*

CHUCK: *(from behind the kitchen screen, puttering around with the
business of preparing breakfast):* So what's the problem, Clem, don't
you want to do your duty to your country? See the world? Prepare for
a future in a trade of your own choosing? What's the matter, don't you
read the army posters?

CLEM *(in no mood for banter):* I didn't sleep all night. I called up Dad
in St. Paul. I talked with Mom, too. They both think it's all right, since
there isn't any war on. It would kill them if I tried to make CO, you
know, conscientious objector, or anything like that. You were in it,
weren't you, during the war? I know it's something I have to make up
my own mind about but I thought if I could talk to someone. . . .

CHUCK: Just tell me what you've decided to do and I'll tell you all the
good reasons why you should do it. That's what you want, isn't it?

*(I can see Clem's haggard face working with exasperation. He
gives me a wry smile.)*

CLEM: I've decided to go to Washington and bash in Parson Dulles'
head with a Gideon Bible.

CHUCK: You can't. You're a pacifist.

CLEM: I've got a rich uncle who can get me out of it.

CHUCK: You can't accept it. Remember what you said about means
and ends.

CLEM: I'll take it on the lam. Hide out in Mexico.

CHUCK: Escape from reality? What'll your analyst think?

CLEM: All right. I've decided to kill myself. Know any good ways?

*(There is a knock on the door. I go to the door and let in Angel
Dan Davies. He throws himself on the floor mattress in a spread-
eagle posture of complete relaxation. I tell him about Clem's prob-
lem.)*

ANGEL *(to Clem):* Don't look at me. I can't give you any advice. Be-
sides, I'm a convicted felon.

CLEM *(startled):* Yeh, what did you do?

ANGEL: I refused to register. That was in '48. Then everybody said to me, "Why make a case out of it? The war's over. You might as well register." But I said no, so they threw me in jail. I was in six weeks.

CLEM: What reason did you give them?

ANGEL: I said it was against my principles. To register was to give assent to war. I said the more you give in to them, the more corrupt you become. You've got to draw the line somewhere, wherever you can. I still bought cigarettes and paid sales tax. I still rode the municipal subways — and some people I knew in New York at that time didn't even do *that*. I know a man in New York who lives on twenty-five dollars a month he earns as a janitor. Fifteen of it he sends home to his mother. The other ten he keeps only because he has like dentist expenses. He lives on garbage. On fruits and vegetables the markets throw out in the alley. He won't eat in anyone's house because he knows he can't offer food to *them*, they won't eat it. So he'll never take anything from you. Unless he is totally exhausted, then he'll accept a glass of milk.

(Chuck emerges from behind the screen with coffee and toast and a large platter of scrambled eggs.)

CHUCK *(with a malicious grin):* Milk, anyone? Garbage?

CLEM: Well, what happened. Six weeks, is that all? —

ANGEL: I decided to register and they let me out. They stopped bothering me, that's all. They didn't want me. They just wanted me to register. I was the first case under the second draft law in New York. They didn't know what to do with me; they hadn't received any instructions from Washington. CO's were supposed to be handled differently than under the old wartime law. All they wanted me to do was quietly register and get out of their hair.

CLEM *(eagerly):* Do you think I could — do you think it might work that way in my case if I? —

ANGEL: Who knows? Like, who can ever tell what the bastards will do? You've got to take your chances, man. First you got to ask yourself *why*.

CHUCK *(with a mouthful of eggs):* I got a suspicion the sonofabitch is one of those twenty-years-of-treason Democrats, like Harry Truman. He doesn't like Ike.

(Bob Rickles drops in, a quiet, soft-spoken young man who had heard about Venice West from Henry Miller and others up in Big

Sur and is making the rounds of the pads with an eye to settling down for a while. He gets the drift of the conversation and joins in.)

BOB: This friend of mine who's building a home in Big Sur told them that he would only go into the Army under two conditions. Either he would live by himself in a tent and only show up for exercises, when he had to, or that he must be sent into battle immediately, because he wanted to fight. He got out of it right away as a psychotic — schizophrenic with delusions of persecution.

CLEM: How did they figure that?

BOB: He had the hunter instinct in him.

ANGEL: *Crazy*, man! They wouldn't let him into the Army because he had the *killing* instinct! Too *much!*

BOB: They don't want to deal with people like that.

CHUCK: They try to conceal the killing part of it with all kinds of euphemisms. You don't shoot *people*, you accomplish a mission or take an objective. Even the gun they give you isn't a gun, it's a *weapon*. Gun sounds too much like gangsters.

BOB: Yeh, they try to pretty up the picture. This guy was too bald for them. Too frank. Anyway, it worked.

ANGEL: I understand the bed-wetting bit still works. And the homosexual bit still works.

BOB: I know another fellow — he had a much more difficult time, because he had to go through four hours of examinations, everything from Rorschachs to bending down and testing the tension in his rectum. But he was a student of psychology. He'd been giving such tests himself, so he knew what to do.

CLEM: Well, what happened to *him?*

BOB: He also got off. Schizophrenic with delusions of persecution.

CHUCK: You know, I think abnormal psychology should be a required course in all universities from now on. Because that enables you to know how to simulate these symptoms. It's just like the Stanislavski school of acting — you make it real to yourself so you can get it over to an audience.

BOB: Well, all these things exist within everyone — schizophrenia, delusions of persecution — it's only a question of degree and balance. It's like my friend said, he wasn't lying, he was just exaggerating.

CLEM: I don't think I could get away with it. Or any of these things. I'm just not a good liar, I guess — or exaggerator. I'd give myself away.

(Angel gets up, with a wave of the hand says, "Later" and leaves. Bob follows him.)

CLEM: I know it's really up to me, myself. What I mean, it hit me so suddenly I haven't had time to think, to ask myself —

(The chick has gotten up and is looking down from aloft. What she has pulled on over herself does not — and is probably not calculated to — conceal the fact that she has a very beautiful young body and isn't the least bit ashamed of it.)

CHUCK: Like it's a war for survival, like they say. You got to make up your mind which part of yourself you *want* to survive.

(The chick descends the ladder and nods to us. Chuck makes no move to introduce her. I get up to go and move toward the door.)

CHUCK: Wait a minute, I'm going with you. *(to the chick)* Marian, this is Clem Peters. Clem's got a problem. See what *you* can do for him.

(Chuck and I exit together, leaving Clem and chick alone in the pad.)

Would you rather be buried, cremated or eaten by cannibals?

(The Scene: Itchy Dave Gelden's pad. One of those slow-motion, cool parties is in progress, with low-decible, cool West Coast jazz on the phonograph, everybody relaxed, saying little and seldom and low keyed. You can sit for two hours on the floor, back propped against the wall, and as long as you keep your eyes closed most of the time nobody will violate your privacy. I couldn't guess how many are in the place. It is very dimly lighted by a few forty-watt bulbs subdued by almost opaque drawing-paper shades painted with oils in a somber key. It is one of the larger store-front pads, high ceiling and a closed-in mezzanine that serves as private sleeping quarters. Every foot of floor space is sleeping quarters, for that matter, for anyone who can't or won't go home or comes properly recommended from the pads of San Francisco or anywhere else in the country. Certain key pieces of knowledge or information will serve as credentials. The password is an easy familiarity with jazz and jive talk.

Richard, Tanya's husband, had a death in the family and the funeral was this afternoon. Most of the Venice West people knew the deceased quite well and some of them have received favors from him, but no one except Itchy Dave Gelden showed up at the funeral. Tanya is present. Richard is spending the evening with

*members of his family, and she is frankly puzzled. Why didn't
they come to the funeral? She turns to Angel Dan Davies.)*

TANYA: Like you're always saying *ritual*, how important it is for a cul-
ture that it should have its rituals. Isn't a funeral a ritual, too?

ANGEL: Now don't go getting hung up behind the scene, Tanya. It isn't
as if there was anything personal about it. We all loved Uncle Amos.
But like it wasn't *our* scene. Dave went — *(He turns to Itchy who is
lying face down on one of the mattresses, his arms over his head)* —
what was it like, Dave?

(Dave turns over slowly.)

DAVE: It was like — hell, man, don't bug me — *you* know what kind of
a scene it is — it was a fuckin' farce. It was a circus.

TANYA: A Baptist funeral. It wasn't nearly as much of a production as
a Jewish funeral I once went to.

DAVE: Jewish funerals are a farce too, a carnival, if you ask me.

TANYA *(to Angel):* If there had been time you might have written
something for it, Dan, like you did for Dave and Gilda's wedding.
(pause) No, I guess they wouldn't have wanted that.

ANGEL: I couldn't have done it, anyway. You can't write rituals for
other people, only for yourself and your own. Like every culture has its
own rituals and I guess — I guess we're a different culture. Maybe
that's it. (slowly, half to himself, with the awe of a new discovery) Yeh,
man, maybe that's it. We're a separate culture.

*(Bob Rickles gets the drift of it and moves over to join the con-
versation.)*

BOB: We were talking about that up in Big Sur just before I left. What
we would do for a funeral service if someone died, and nobody seemed
to know. Everybody pretended not to care, yet everybody was con-
cerned about it, as if *somebody* ought to do *something* about it. Like
is it better to be buried, cremated or eaten by cannibals?

DAVE: Buried wouldn't be bad if they just threw me in the ground and
I could be fertilizer — and being cremated like is just a waste of time
because why should they go to the trouble of burning me — and if I'm
eaten by cannibals at least I make food for somebody. Direct food. I
mean, it doesn't have to go through the metabolism of the earth.

*(Gilda has been lying beside Dave, seemingly uninterested in the
conversation. Now she turns over on her back.)*

GILDA *(to Dave):* But suppose it was somebody you loved.

DAVE: I would give it to a medical school probably.

GILDA: Even if it was somebody you *loved?*

TANYA: Don't you think you would feel any attachment? —

DAVE: I would feel revulsion if anything.

TANYA: But you'd go to the funeral, wouldn't you?

ANGEL *(coming to the rescue):* I would write a funeral ritual, and we'd *all* go to the funeral.

BOB: But what to do with the body, that's the question.

DAVE: What's the difference, man? It's a rock, a stone, or like I say, if it's — if the cat is a cannibal let him eat it — like that's *his* culture.

ANGEL: If a culture has a ritual, a real living ritual, it doesn't matter what you do with the body. The only thing that matters is what the living make out of it — out of the fact of death — and that means the fact of *life*, the meaning of life.

BOB: That's the question. That's what we were talking about up in Big Sur. We all agreed that what we needed was a funeral ritual, but what would it be like?

ANGEL: I don't know. Marriage is *one* thing. Mating. Love. I can do something with that. I can understand it. But dying — wow! — death — I don't know *what* I'd do with it. Like I don't even know what it *is*, what its function is supposed to be, for the individual, for society. Sure, I know all the answers, all the *old* answers, but I can't accept a single one of them, really, not mentally, not emotionally. And I don't know anyone — anyone I've ever talked with or read in a book — who knows any more. Unless he's so used to shucking himself that he'll accept anything, as long as he doesn't have to raise any of the real questions. Like everything they ever told us about death and the afterlife, about heaven and hell and all the rest of it, is just one big shuck. And I don't know even how to start thinking about it — so how am I going to *make it new?* How am I going to create a new ritual for it?

(In a far corner of the room one of the guests has started a little light finger tapping on a pair of bongo drums. Somebody else begins piping a tune on a recorder. The record on the box is allowed to run itself out and everybody is quiet, listening to the impromptu improvisations of the bongo and recorder. To me and those in our little circle it has the eerie haunting sound of a dirge. Only the words are missing.)

Anybody want to be God?

(The Scene: Same as above, an hour later. A Let's Pretend conversation game has started. It is a hipster adaptation of the Socratic dialogue with Talmudic and Scholastic elements in it, and the inevitable touch of Zen Buddhism. Chuck Bennison has joined the circle. He seats himself on a hassock with a lamp behind his head, the lamp shade simulating a halo.)

CHUCK: Dig me, man, I'm God!

TANYA: What have you done with Uncle Amos?

CHUCK: Ah, Amos, mah good and faithful servant. Walked upright before de Lawd. Loved mercy, walked humbly — how the hell does it go? Any of you cats got a Bible?

TANYA: Some God, he doesn't even know his own Holy Word.

ANGEL: Make up your mind, man — I mean God. Are you Jehovah, Adonai, Elohim — are you Spinoza's God or Hillel's or Aquinas' or Billy Graham's or Uncle Tom's? —

CHUCK: I resign.

(He yanks the lamp shade off the stand and plops it down on Angel's head.)

ANGEL: I don't want to be God.

CHUCK: You're elected. I make you Pope. Peter, Jesus, God. The works.

ANGEL: Then what are *you?*

CHUCK: I'm Satan, Mephistopheles, the Devil. I'm your alter ego. Everything is chaos, all the pieces are lying around in the big storehouse of Tohu and Bohu Incorporated and you're the Great Producer —

ANGEL *(shouting):* Liar, and Prince of Liars! You know it's all a big shuck. Like if I'm God *now,* I'm God of *Now.* Not yesterday or last year or the last millennium or fifty millenniums.

(He stands up and spreads his arms in a godlike gesture of command.)

ANGEL: I abolish Time. I abolish Death — no, wait, I take that back. Abolish death? Make everything — everybody — immortal? No. Like the idea is horrifying to me.

CHUCK: If you create death then you permit murder. Life feeds on life. You put the power of life and death in every man's hand, his own life and everybody else's.

ANGEL: Then I create Justice. Checkmate, Satan! Man is created with certain inalienable rights — how does it go? life, liberty and the pursuit of happiness.

DAVE: That's a shuck too, man. He's got life only as long as you, God, *want* him to have it, and in the end he always loses it. He's got liberty if he fights for it, and sometimes he has to give his life for it. Happiness? He doesn't even know what it is. Like the cat is drugged behind the scene nine times out of ten every time he tries to decide *what* he wants, what he really wants, to make him happy. It's a drag, man, a sad drag. Why don't you put all the goodies in his hand and say: Here, man, help yourself. You want to live forever? Crazy! And you, you over there, you want to die? — early, late — fine! Make it *your* way. Like everybody makes it his own way, the best way he knows how. *That* would be freedom, man.

(Tanya gets up and does a little marching dance, pretending to carry a placard like a striking picket and shouting "Freiheit! Freiheit!" Others take up the cry.)

ANGEL *(trying to make himself heard above the din)*: All right! All right! You've *made* it. It's all yours. I abdicate. Anyone who wants the job can have it.

BOB: Wait a minute. You can't do that.

ANGEL: Why not? I'm God, ain't I?

BOB: All right. Then you've got to have a reason — an infallible reason.

ANGEL: I abdicate because I don't believe any more. I'm an atheist. I don't believe in the existence of man!

CHUCK: Then the world is abolished and we're back again where we started. Man no longer exists — God has become an atheist and no longer believes in the existence of man. God no longer exists — there is no man to invent him. We're back with old Tohu and Bohu, Inc., again. Anybody else want to take a crack at the God business?

(As if in miraculous answer to his summons, the door opens and Ron Daley walks in — well, not just like that — he opens the door a crack and peers in, opens it a little wider and looks around, then he tiptoes in and stands by the door waiting for an invitation. We all know his habits and beckon to him to come in and join us. It is Ron's little private ritual. He is the Zen philosopher of Venice West. I explain to him what the game is and tell him the job of God is open. He sits down, gracefully, in his fairy way — not swishy, although he is homosexual — just gracefully — in the yogi posture.)

ANGEL: Go on, create a world.

RON: What for? What do you need it for, man? A Zen master once gave

this sermon to his monks: "You are all like those who, while immersed in the ocean, extend their hands crying for water."

(He takes a book from his pocket and reads.)

Zen recognizes nothing from which we are saved. We are from the first already "saved" in all reality, and it is due to our ignorance of the fact that we talk about being saved or delivered or freed. So with "escape," etc., Zen knows no traps or complexities from which we are to escape. The traps or complexities are our own creation. We find ourselves, and when we realize this, we are what we have been from the very beginning of things.

(Other conversations in the room break off and everybody moves over to join our circle. Ron continues reading passages from his book.)

We think Nature is brute fact, entirely governed by the laws of absolute necessity; and there is no room for freedom to enter here. But Zen would say that Nature's necessity and Man's freedom are not such divergent ideas as we imagine, but that necessity is freedom and freedom is necessity. . . .

Our inner life is complete when it merges into Nature and becomes one with it. . . .

The whole universe which means Nature ceases to be "hostile" to us as we had hitherto regarded it from our selfish point of view. Nature, indeed, is no more something to be conquered and subdued. It is the bosom whence we come and whither we go.[3]

(He puts the book back in his pocket. Dave gets up and puts Art Pepper's Modern Art record on the box. The circle breaks up into twosomes and threesomes in a low conversational buzz. The bongo drums pick up on Art Pepper's rhythm section with lightly tapped counterpoint. Everything is cool again.)

The man with the gun

(Scene: Ron Daley's pad. A made-over garage. Ronny has fitted it out with redwood panel walls and laid straw mats over the cement floor wall to wall. Two mattresses on the floor are covered with Japanese fabrics and strewn with cylindrical and three-cornered cushions of pastel colors. The bookcases are boards and glass bricks. Two lamps hang from the ceiling, parchment lantern shades of modern design derived from the Japanese. The components of the hi-fi are unenclosed. In one corner, a triangular private shrine

holding a single rosebud in an Oriental vase, over it a rice paper print of the Buddha in contemplation, a Buddha of Zen simplicity. Partitioned off with bamboo and rice paper screens is a tiny kitchenette, all the utensils neatly hung on the wall, copperware, shiny bright, and the dishes set up on the shelves, a spartan kitchen, clean, monastically clean.

Ronny is lying on the bed, swathed in bandages. He was brutally beaten up by vice squad officers during questioning at the police station after a raid on the Casbah, a gathering place for homosexuals, and is out on bail. Gilda Lewis has moved in to do nursing duty. She is busy in the kitchen making some broth for Ronny. He is telling me about the incident. His voice, always low and modulated, is almost a whisper.)

RON: It wasn't like anything I had ever experienced before, Larry. His eyes were hazel, with little golden flecks in them. I must have been pretty high at the time and I guess he was, too. But it wasn't the pot altogether, I'm sure of that. It wasn't physical so much as it was spiritual, something inside us — or outside, out *there*, who knows what it is, really? — drawing us together. And he was talking. Art. Music. Philosophy. Poetry. I can't recall what he said, exactly. It wasn't what he was saying. It was a kind of spiritual *presence*. I felt as if I had finally found someone who was like that other dark side of me, *myself*, and I was looking at myself as in a mirror. And discovering myself — in ways I had never known before. I'm sure it isn't a unique experience. Others must have known it — I remember vaguely having read about such a meeting once in — was it Shelley? Or something in Gide?

(Gilda comes in with a cup of broth. I help to prop him while she spoon-feeds him, slowly and very gently. His face is badly cut up under the bandages. The doctor told me as he was leaving that he might be badly disfigured for life. After the broth he continues with his story. So far he has said nothing about the police beating, only about the young man he met at the Casbah that night and what happened before the raid.)

RON: There was something in his voice that I remember. It seemed to be coming from somewhere far out. And I was enveloped in it, like a palpable thing. Like he was an extension of myself . . . the mystical being. . . . the Other . . . Narcissus' reflection in the pool come to life and assuming an existence of its own. And yet separate and different in some wonderful, mystical way. . . . Something I had always dreamed might happen to me. . . .

(He goes on like this for some time, his voice trails off into silence. He may be asleep. About the police beating — nothing — now or at any time since then, to me or anyone that I know of. Angel Dan Davies is at the door with Dave Gelden and Rhonda Tower, the chick Angel has been making it with lately. They take off their sandals and leave them at the door before entering, as Ron always does. Rhonda has bad news. The prominent lawyer she knows has refused to take Ron's case.)

RHONDA: You could have knocked me over with a feather. Like I was sure he'd take the case. He's taken other cases where there wasn't any money. Liquor cases and labor cases, things like that. But when I told him how the vice squad goons beat up Ronny and the homosexual thing — man, he just flipped. What kind of a friend was I, trying to drag him into a scene like this!

DAVE: Like I told you, you were wasting your time going to a cat like that. He's a square, man, and you don't catch a square sticking his neck out.

RHONDA *(to me):* Do you know any hip lawyers? *(I shake my head and smile)* See, you've got to go to a square in a case like this, whether you like or not. They've got you over a barrel.

GILDA: Even the doctor was afraid to come — when I told him what it was, and *where* it was.

ANGEL: It's like money. Did you ever try sounding a square for money? He'll take you to a fancy restaurant and spend ten bucks but you can't sound him for money to buy food for your wife and kids. They'll buy you drinks in a bar — but sound them for a buck to buy groceries and they'll act like — they're embarrassed — they'll hem and haw and Christ! — you'd think you'd asked them to take their pants off in public or something.

DAVE: That's what it *is*, man. Like they can't admit it, even to themselves, that there's such a thing as real starvation in the world. Or like this lawyer — the cat can't face it, that a couple of cops will beat up on a cat just because he's a homosexual. They've got to prove it to themselves and to each other that they're real he-men.

RHONDA: Do you suppose the Civil Liberties Union lawyers might do something? —

ANGEL: The Liberals? The political cats? They're the biggest squares of all — when it comes to *sex*. Homosexuals yet — wow! We got to find a lawyer who isn't prominent, or political or social. Some shyster who's

mixed up in the rackets, maybe. He's the only kind that'll have the guts to mix it up with the cops in a police-beating case. He's beat, in a way, so he doesn't have to worry what the country club boys or the PTA is going to say about him. He doesn't have any illusions about justice or civil rights or the Constitution.

RHONDA: I know a prostitute that works up on the Strip —

DAVE: Now you're talkin'. Get ahold of this chick and she'll know what to do, who to go to.

ANGEL: Like when I was on the road and I landed in a town broke, I learned one thing: never go to the local minister or the rabbi or the social agencies. All they'll want to know is who you've got back home that they can ship you back to — if somebody back home is willing to wire them the money. Go to the first whorehouse you can find and talk to the madam, or to some saloonkeeper in the slum part of town. I remember a whore in Terre Haute once —

DAVE: They're the *original* hipsters — the outlaws, the outcasts. The square, like he's got all these official lies he's got to believe, the school-book story and the church story and all that shit —

(*Ronny stirs a little. Angel lights a stick of tea and holds it to Ronny's lips to take a drag on. Ronny smiles and tries to nod his thanks. It hurts.*)

DAVE (*looks over at me and shakes his head*): Like I told you, Larry. The squares talk about their religion, their laws, their justice, their charity, but sooner or later it always turns out to be the man with a gun on his hip.

6

Venice West:
And All Points North, South and East

THINGS WERE HAPPENING EVERYWHERE NOW. IN SAN FRANCISCO, IN NEW
York, Chicago, New Orleans, Seattle. And people were converging on
Venice West from everywhere to tell about them. One day it would be
somebody down from San Francisco for the week end with a story of
weird and wonderful happenings in a cellar cafe or some hillside pad.
The next day it would be a pair of young visitors from Chicago who
had hitch-hiked across the country leaving an unfinished semester at
the U. of C. to dig the Venice West scene. Or a teacher on a moral
holiday from one of the denominational colleges intent on mastering
the *mystique* of the metaphysical orgasm. Or a refugee from Harvard
on a beatnik binge, lured by talk of the West Coast Renaissance.

Tom Draegen, for instance, had made it all the way from Paris and
Majorca by way of New York. Tom was a Dubliner who had knocked
about in the London literary scene for a year or two, where with
Dylan Thomas he made the rounds of the pubs and parties, and then
joined the beatster fringe of the international set on the continent.
In New York he had no trouble gaining entry into the circles of the
Upper Bohemians. They were junior executives of the advertising
agencies and other "power elite" professionals of the communications
industries and the young women who held down research jobs and

fancy secretarial positions. Week-end beatsters — "beatnik" didn't fit them, since there wasn't the slightest tinge of pink in them — who had discovered the Hipster Jazz Apocalypse ten years late and were reviving the bop talk of the early forties, presumably with the help of glossaries clipped from old copies of *Life* and *Esquire*. Tom told of their hipster parties, affairs that made Paris look like a Sunday school picnic. Usually held in a posh apartment, that was some pansy decorator's idea of a beat pad, they were more like the orgies in a Cecil B. DeMille movie, he says, than anything on the beat scene.

Up in San Francisco the big news was poetry and jazz at The Cellar in North Beach. Kenneth Rexroth and Lawrence Ferlinghetti were reading their poetry there with a jazz band and packing them in.

In Chicago a disk jockey named Ken Nordine was improvising — or so it seemed to his listeners — bits of poetic prose and clever narrative pieces with jazz music, not in the hipster idiom but in something of the same spirit. He called it Word Jazz and there were rumors that he would soon be bringing out an LP recording of it.

Down in New Orleans, R. Cass had been publishing *Climax, a creative review in the jazz spirit* since 1955. He was running a club which he called The Climax Jazz, Art & Pleasure Society of Lower Basin Street, a hangout for poets and musicians, with an art gallery attached to it, to raise the money to keep the magazine going. He wrote me once that the police had raided his club because Negroes had been seen mixing there with whites and he was having trouble making bail and lawyers' fees; but issues of *Climax* continued to appear.

The grapevine brought stories of things happening everywhere: off-campus beer parlor sessions in Seattle with English profs from the University of Washington making the literary beat scene in the tradition of the Wandering Scholars of the University of Paris; campus cats and beat pads and shack-ups around the University of Chicago where the *Chicago Review* was publishing my essays, and Henry Miller's, and other off-beat work that was beginning to attract nation-wide notice;[4] a maverick crew of scholarly rebels at Harvard bringing out *i.e. The Cambridge Review* and shaking the ivy walls. The first stories were beginning to appear in the newspapers. Nobody knew what to make of it, whether to treat it like another goldfish-swallowing craze, juvenile delinquency or a Communist plot.

Squares in Beatville

The squares had discovered beatville and were beginning to sniff and nibble around the edges.

In New York it was the Madison Avenue exurbanites and the newspaper and magazine editorial and art staffs. Some of them were beginning, trimly and discreetly, to sprout beards and go to work in elkskin shoes, the lap-over Indian moccasin kind that no beatnik could ever afford to buy. The girls had to save their new beat look for week ends when they could go the limit with a way-off-the-shoulder, studiedly careless but conspicuously expensive get-up. It was the old Gilded Bohemia of F. Scott Fitzgerald all over again — on a tax-deductible expense account. But it was trying to talk beat and act cool.

In Chicago it was, outside of the campus cats, a café society scene gone beat in *Playboy* fashion. It was hi-fi and high fashion, with a touch of Bug House Square and the old Dickle Pickle Club in it. But brought up to date, modernized, the *Holiday* magazine look.

In San Francisco the squares had discovered North Beach and were learning how to look beat without going too far out. Here, too, it was a week-end kick. Students from Berkeley were driving in on Saturday nights to sit around in basement jazz spots, a girl here and there going so far out as to show up with her hair and eyebrows sprinkled with silver dust and a fairy smoking a long panatela cigar. The old zany touch in the new "crazy" version. They went for funky jazz — Turk Murphy and Bob Scobey — with its flavor of Old New Orleans, Storyville as they imagined it, with all the horror and heartbreak left out of it.

In Hollywood it was beginning to be taken up, like everything else in film circles, as a fad. The press agents were getting into the act, dressing their starlets for the publicity pix in briefer-than-ever briefs and in poses copied from the "Playgirl of the Month," reading Sartre's *Existentialism* or Camus' *The Rebel*. Everybody was trying to look, off screen, like James Dean and Marlon Brando. The sale of bongo drums was booming on Hollywood Boulevard. Staying up all night with jazz on the hi-fi, pounding the bongo drums and running around with beat characters was beginning to show up in the courts as grounds for divorce in filmland, dictated to the lawyers by alert press agents, I suspect. *The Man with the Golden Arm* had been made into a movie

and there was talk of a dozen beat generation movies being planned, if the writers could "lick the story," that is, keep the narcotics angle within the Code and make Existentialism entertaining.

In Venice West there was as yet no Hollywood invasion. There were no "spots" to go to; the pads were private and the smell of the Hyperian sewer emptying into the Pacific was too much for the Hollywood crowd when the wind was from the south. But that didn't keep out the non-Hollywood squares, the Left squares, refugees from witch hunts and loyalty oaths, or the university squares, lured by reports of a Renaissance, hoping that some of the creative energy that was loose in Venice West might rub off on them.

Bloomsbury Boy Among the Beat

The English departments of small colleges and the off-the-main-campus branches of state universities seem to throw off a mutation that can be described as the Bloomsbury strain. Like all hothouse variations it is a product, not of natural selection, but selective breeding.

Painfully thin of face and figure and brittle-looking but deceptively stout like bone china, Grant Flemming made his first appearance at a party in Don Berney's pad. In the subdued light only dim forms were visible, sprawled on the floor-low divans in a tangle of legs, arms and rumps. Everybody except Chris Nelson, who was sketching away furiously in his notebook, was digging the poetry that Don was putting down, with Tony on pots and pans, Angel on bongos, Chuck on conga, Ron Daley on recorder and Itchy Dave Gelden at the grand piano that the former occupant had left in the pad with three overdue rental payments due on it. It was a free-blowing jam session with nobody paying any attention to what anybody else was doing, and Itchy, who had abandoned formal pianistic technique at the age of seven after three lessons, pounding out palm and fist dissonances and elbow glissandi while Phil Trattman took it all down on the tape recorder he had just gotten out of hock.

Nobody paid any attention to the newcomer till Grant tried to start up a conversation with Chris Nelson. Above the din, Angel's keen ear detected the accents of the square, and he laid aside his bongos long enough to get an earful of what the stranger was putting down. He didn't like it. When Don finished blowing his poem, Angel had a word

with him in the kitchen and when they came back the whisper was passed around that if anybody was holding they had better not turn on till after the square could be gotten out of the pad. He might be a narcotics agent. Unaware of what was going on, Grant tried to engage others in conversation — only to meet with stony silence. He had expected to find these cats cool, but not this way. After one last stammering, stuttering attempt he got out of there and walked the ocean front all the rest of the night talking to himself in a paroxysm of choking chagrin that more than once boiled over into tears.

By morning he was down with a bad cold and running a temperature. A girl at the aircraft plant where Grant worked found him three days later, half out of his mind with fever and scribbling away on a pad of paper, the bed littered with tin cans and bread crusts.

When I saw Grant Flemming again — I had met him only fleetingly at Don's party — he was standing at our door, shifting from one foot to the other, uncertain of his welcome, and clutching a manuscript in his hand. Nettie promptly administered her usual first-aid remedy, coffee and sandwiches. The manuscript he had to show me was plainly a product of emotional confusion and high fever, but that seems to have been just what Grant needed to break through the "good writing" of English Lit to something like the beginnings of immediacy of speech and the "open" free-swinging style that is prized in beat generation literature.

"All the time I was writing it I thought I was dying," Grant told me. He had only the barest inkling of what was happening to him and he was afraid of it. He understood, vaguely, that what he wanted was a loosening up, but he was afraid of coming apart in the process. His fears were not unfounded. More than once in the weeks that followed he was on the point of cracking up. At such times he would put down the whole scene as a dangerous madness that led only to disconnected impressions and unfinished fragments. And unsuccess. He wanted desperately to see something of his in print besides the one or two schoolboy exercises his campus quarterly had published. The academic hangover was still strong in Grant. He wanted, if possible, to be published in a university literary quarterly of solid reputation. That would be success, and where was he if at twenty-two he hadn't even had a short story in *Hudson Review* or the *Virginia Quarterly?* Early success is in

the Bloomsbury tradition and Grant saw himself as a latter-day *Yellow Book* man. Post-Joycian, of course, and with a touch of nostalgia for Henry James. But somehow hung up on the notion that Jack Kerouac had something for him, too, if he could only find out what it was — without flipping his wig. Christopher Isherwood had been his shining example of a free prose style under proper control while he was at college. Now he was uncertain and confused. "I feel British," he would say in moments of confusion. "I feel there's solid ground there. I think I could pull myself together and get something done and *finished* if I suddenly found myself by a miracle set down in the middle of literary London." But he was bent on making the beat scene first. After all, it was his generation. It puzzled him why he was still regarded as a square by most of Venice West, even though they were convinced by now that he wasn't the heat. Somehow he *had* to make it, to cross over —

In Sherry McCall, who stood with a foot in both worlds, Grant found the bridge.

Nothing he ever learned in any history course at the university prepared him for the shock of this redheaded delayed-action bomb out of the wartime forties. What she had for him to read and what she had to tell him came through to Grant like the discovery of Dead Sea Scrolls out of an underground past. His college years spanned the loyalty oath period. There had been hints dropped in class about the united front years preceding the Cold War, but guardedly. Now the missing pieces were fitting together in his mind. Fascism had become an all but unmentioned word in college history courses in the state-supported universities; and Grant recognized in this fact the clue to much that had puzzled him in the anti- and apolitical attitudes of the beat generation. It may have been a war against fascism to Sherry and her friends, to Johnny who died fighting it on some Godforsaken rock in the South Pacific, but that wasn't General Motors' war, nor the Pentagon's, nor was it the version that was being dished up in the loyalty-oath-bound history classes.

The Bloomsbury boy who might have fitted into the Mauvre decade — which somebody described as pink trying to be purple — was turning a bright, shocking pink under the tutelage of Sherry McCall, and when he checked his discoveries against the attitudes and opinions of the beat, arguments ensued that sometimes lasted all night. It was all

very upsetting and for a time Grant was ready to settle for "a plague on both their houses." But even this proved an unsatisfactory solution for him.

Grant's conflict was still unresolved when Sherry suddenly announced one day that she was leaving Venice and going back east. There were rumors that the mother of one of "her" children had turned up and wanted the child back. Whatever the reason, it called for a quick departure. There was no room for all Sherry's household goods in the trunk and on the floor of the getaway car. Would Grant mind storing it for her in his apartment? It was only a one-room apartment and hardly big enough to hold a tenth of the stuff, but Grant coveted the upright piano that went with the deal. He had taken piano lessons years ago and thought that if he could brush up on his playing a little he might be able to make the jazz scene with Don, Angel and the other boys. He went out and found a tiny three-room apartment on one of the Venice canals. The stuff filled up the two front rooms completely and most of the kitchen and even spilled over into the back yard, but he had the piano. By stepping over a few hatboxes and sliding in behind a stack of packing crates he could get to the piano and practice his scales again. The new apartment cost more that he could afford — he had quit his aircraft plant job by this time in accordance with his new political attitude — and there was hardly room in the place for his typewriter and bed. Weeks passed and there was no word from Sherry. He was stuck with the stuff. Karl Marx and V. I. Lenin now lay in one untidy pile with his own copies of James Joyce, Jack Kerouac, Henry Miller and William James. It was a mess. A perfect picture of his own dilemma.

Before he could grapple further with the problem, the Army called him up for military service. He talked it over with everybody in Venice West and finally decided to accept the President's invitation. It was *one* way out.

The Coming of the Hip Square

At the opposite pole of the educational breeding grounds of the state universities is Black Mountain College. Founded in North Carolina in 1933 as an experimental school combining academic work with student

community life on what the encyclopedias describe, discreetly, as a co-educational basis, its alumni have now gravitated mostly to the East and West coasts. When the college was disbanded in 1956, many of its current students made the westward trek to San Francisco and Los Angeles, and two of its teachers, Charles Olson and Robert Creeley, became controversial but influential figures in the literary circles of the beat generation. (Jonathan Williams' Jargon Press in Highlands, North Carolina, has published much of their work, as well as that of other writers related to them in style and spirit.)

Manual labor and handicrafts were stressed at Black Mountain College and some of its alumni are now engaged in such occupations as landscape gardening, weaving, book designing, home building and similar pursuits. Others follow the beat pattern of working for a while, then living off unemployment insurance as long as they can and pursuing one or another of the arts. Politically they could be said to resemble the Owenites and other community-founding sects, but morally they would have been tossed out of such communities. It is in their way of life that they resemble the beat generation and merge with them, but not without friction. For some of the beat regard them as squares — hip squares. Here is an account of how the Black Mountain boys came upon the beat scene, as recorded in an interview I had with Allen Ginsberg and Gregory Corso on their visit to Venice West in 1956.

GINSBERG: Last year Robert Duncan went to Europe where he met Robert Creeley in Majorca. He had been in correspondence with Black Mountain, with Olson, who had been friends with and in correspondence with Creeley on *Black Mountain Review*. Creeley picked up on Duncan and threw Duncan on Rexroth. Creeley is a hipster and very cool, like all hipsters, with an elliptical style and very great intelligence. He dug Jack Kerouac, so he got some stuff from us for the next issue of the *Black Mountain Review*. From Kerouac and me, a chunk from Gary Snyder, prose from Duncan, a piece of Burroughs'. Now we're all friends, but not organized as a literary movement. Essentially it's just friendships, connecting the West Coast with what has been happening on a lower type level at Black Mountain, through academic, disciplinary Olson and Creeley, so there was a connection between the sensibilities of the West and the East there, for a while.

Olson dug Kerouac immediately. Then Black Mountain College closed about three weeks ago and the last remaining students arrived in San Francisco with their beards —

CORSO: Mental gangsters.

GINSBERG: Well, you know, it's a beautiful thing, basically, a great thing, but —

CORSO: It's a question of enthusiasm. They want to be cool, but intellectually cool.

GINSBERG: Diabolical, beautiful love. Actually I think they're hung up on authority, like Ezra Pound.

CORSO: In other words, they're hip squares.

GINSBERG: But they're very intense and beautiful.

CORSO: Hip squares. Wherever there's awkwardness there is not coolness.

LIPTON: Are they sexually uninhibited?

GINSBERG: Pretty much so, I think. Like crazy. They're cocksmen. Their method of teaching is like an attack on the defenses but not like Dostoevski, not like Alyosha and Mishkin. It's more like Ezra Pound. It's also suicidal, they're all suicidal. Always getting hit by policemen, getting their hands cut by barbed wire, getting lost in deserts in Arizona.

CORSO: I've never liked the way they live. That's why I'm against them. They stand apart.

GINSBERG: They're cool; having rejected everything they've become unable to utter anything except in the most roundabout way. Except Creeley. He doesn't say anything except what he absolutely knows — simple — like on a basic, simple level, very short, epigrammatic, elliptical, like —

I went out.
Got a beer.
Ran into a milk truck,
 by God.
You won't understand me till you
run into a milk truck.

CORSO: A great lack of enthusiasm. Deliberate lack of enthusiasm.

GINSBERG: Yes, except that they're so open, like Creeley likes Jack be-

cause he's so open. He's also invulnerable, because he's so open. That's why he likes Duncan. And in Jack Kerouac, like he's found a way out of the impasse. And it comes to a great extent from Olson's influence. Because Olson is like a great hip intelligence.

CORSO: No. It's aggression. It's terrible. It's an aggression against themselves and nothing else. It's like the cool musicians, the cool blowing of bop several years ago.

GINSBERG: Like the most elliptical, hard, personal and, in a sense, suicidal, but also beautiful. Because like there was no compromise. It was intensely idealistic. A natural outgrowth of bop. Bop killed itself. Bop committed suicide. Like Mallarme. And so did poetry.

The Black Mountain hipster touches the beat generation scene only peripherally, the way the juvenile delinquent touches it, or the professional criminal. I am not speaking here of the literary influence of *Black Mountain Review* and the writers who cluster around it. Their influence on beat generation writers remains strong and, on the whole, beneficial. I am speaking of the students who have not yet succeeded in finding any place where they fit in outside of the abandoned Black Mountain community and are hovering around the fringes of beatland. They are not numerous enough to be conspicuous anywhere. And where they have found entry easiest to make is in San Francisco's North Beach and New York's Greenwich Village. In Venice West we have seen few of them and those few have soon gravitated to Hollywood, where the pickings are richer, or back to New York or San Francisco. As hip squares, their tastes and many of their lifeways are hipsterish, but their values are bourgeois, or perhaps I should say a caricature of bourgeois values and, like all caricatures, greatly exaggerated and distorted.

Hoods, Junkies and the Illegal Sex

Other squares who, for one reason or another, try to make the beat scene are small-time hoodlums, heroine addicts and homosexuals. None of these can be actually a square, of course, in the sense in which a normally adjusted person living a conventional life is a square. They are square only with relation to the lifeways and values of the beat generation. If beatville is heaven, it is easier for a hood, a junkie or a

homosexual to get into it than a banker, a professor or a Cub Scout den mother.

In Venice West the hoods hang out at the Wind Blue Inn. From the outside it looks like any other ocean-front saloon. There is nothing arty about it inside either, to justify the rather poetical name it goes by. The proprietor is a Lesbian, a strapping bull-dyke who can wield a barrel bung as lustily as any bartender. Big Fanny runs the joint with the help of a girl friend who looks like a depraved angel with a halo of honey-gold hair and eyes that might have been transplanted from Lucifer's eye bank. Big Fanny has a taste for the higher things of life and when she discovered the holy barbarians she encouraged them to drop in for a beer and sit around at the tables she put in for their benefit. Fanny herself is sustained by Cosmic Vibrations and a daily quart of Three Star Hennessy. In the holy ones of Venice West, Big Fanny could feel the vibrations of the Infinite right away. "I knew you were tuned to the music of the spheres," she told Itchy Dave Gelden. "I can feel the vibrations."

Itchy called it horseshit but he liked the atmosphere of the place and introduced his friends to it. Most of them soon dropped out when Fanny started proselytizing them, but among those who remained patrons of the place was Tom Draegen. He had no more use for Big Fanny's vibrating God than any of the others, but he found the hoods who frequented the joint an excellent source of wine and heroin.

Tom was still working on The Book. It was Diana Wakefield who called it that, the capital letters were in her voice when she said it. Diana had been working to keep Tom going on The Book but late hours and absenteeism had gotten her fired from one job after another. Now she was pregnant and having a miserable time of it. The hoods were keeping them in wine and cigarettes, slipping Tom a few caps of heroin now and then, and once in a while a fin or a sawbuck when the pickings were good.

Hot merchandise was also available at the Wind Blue Inn. For their writer and artist friends it came cheap and sometimes for free. Tom Draegen and a Black Mountain alumnus who did most of his goofing at Tom's pad were the only ones who availed themselves of such favors. An occasional hot typewriter offered the most tempting favor but the cool cats turned it down. Nothing with serial numbers on it. Besides, it might turn out to have been heisted from one of their fellow writers in the neighborhood and would have to be turned back anyway.

The hoods loved to hang around the painters' pads, gape at pictures and watch the artist working for hours on end. It fascinated them. Poetry readings were more of a chore for them and usually they picked up a copy of *Mad* and leafed through the cartoons while the reading was in progress, waiting for the real part of the party to begin. They went for pot but left the stronger stuff untouched, although they were not above using their connections to get a little horse for Tom now and then.

The Book grew by a page or two from month to month but Tom's monkey grew by leaps and bounds. Diana was hooked on the stuff, too, by this time. Office work or any other kind of regular work was out of the question now. A girl at the Wind Blue Inn told Diana about a strip job that was open at one of the Reno night clubs. This was how Tom and Diana finally made it back to New York. Tom and his Black Mountain alumnus friend, who had to get out of town anyway because the police were after him for a few dozen traffic tickets he had ignored, lived off Diana's strip act salary and, for a nest egg to get to New York on and to finance the habit after they got there, they peddled Diana's after-the-show hours to Reno tourists at from five to twenty-five dollars a throw.

For the send-off before they left Venice nobody was around except Itchy Gelden, who loved everybody and denied no one. All the rest had put Tom and Diana out of the pale long ago. The hoods had given them up, too. They were too hot by this time to be seen around with. When Itchy left the pad Tom went down to the Wind Blue Inn to see if he could promote Big Fanny for a bottle of something to take along on the long trip to Reno.

"I was figuring you might put it on the cuff for a few days," Tom lied, buttering it up with his most engaging smile.

"Where the Inner Power is at work there is no need and no want," Big Fanny told him. "For God knoweth our need even before we ask. And supplies our every want, if we will only tune in with the vibrations of the Infinite." Fanny never was a soft touch when it came to business.

"Cut out the crap," Tom said, "all I'm asking is a few cans of beer or something —" Nothing but cash on the counter could break the spell of the Infinite.

"Okay," Tom said, "you can take the whole damn joint and stick it up your ass. We're cutting out of this town."

"Just you wait and see. When you get your ass in a sling you'll come

running to God, and what do you think He'll say to you? He'll say go
fuck yourself, that's what He'll say," Big Fanny called after him. And
returned to her contemplation of the Infinite.

The Illegal Sex

After a narrow escape out of a rear window of the K-9 Club in East
Los Angeles when the joint was raided by the vice squad in a roundup
of homosexuals, Chippy Rosland fled to a shack on the Venice West
canals because it looked like a good hide-out where no squad car would
ever think to come prowling. It was then that Chippy discovered the
beat generation and took up painting. He wrote poetry occasionally,
too, but he kept it to himself, feeling it wasn't good enough to show yet.
Among the beat, Chippy found complete acceptance on a no-questions-
asked basis for the first time in his life. Was he hip? Was he cool? Or
was he just another square trying to make it in Beatville? Chris Nelson
had an answer that echoed the feelings of everybody in Venice West.
"Like nobody can belong to an illegal sex, man, and be a square. He's
the *beatest* of the beat!"
Even the fact that Chippy worked as a lathe and turret man in one
of the defense plant machine shops was not held against him. As a
member ex-officio of the beat generation he was not bound by all the
rules of the tribe.
Chippy didn't have to be turned on to pot. It was as widely used in
homosexual circles everywhere as it was among the beat. And the jive
wasn't exactly a secret language to Chippy. He was even able to intro-
duce a few good additions to the beat vocabulary. All that was neces-
sary to turn his place into a beat pad was to persuade him to throw his
Maxfield Parish prints out in the trash and put some drip and smear
abstracts that Angel and Itchy gave him on the walls. Chippy was al-
ready an intellectual, a homo intellectual. He kept the radio tuned to
the FM classical music station, went to symphony concerts and owned
an almost complete collection of old 78 Dwight Fisk records, including
Minnie the Wayward Sturgeon and *The Colonel's Tropical Bird*. Before
long he was listening to Dizzie Gillespie, too. And Thelonious Monk.
Prudently keeping a foot in both worlds.
Today Chippy exhibits his water-color abstracts along with the paint-

ings, junk sculpture and collages of the beat in the saloons, where it is too dark anyway to tell a daub from a masterpiece.

LIKE, ART, MAN

is the way the most recent saloon show was advertised, and Chippy had three water colors in it. In fact, Chippy was the only artist in the exhibit who got an offer of money for one of his paintings. He was offered a dollar for it by an art lover who happened to drop in and recognize its merits. Chippy turned down the money, preferring to give it instead as a love offering to a handsome young blond boy he met in the place and now has shacked up with him at his pad on the Venice West canals.

The Juvenile Delinquents

"Everyone has to go to jail *some* time in his life," remarked a fifteen year-old girl I met at Angel's pad one afternoon. She was playing hooky from high school for the day and had just come back from visiting her boy friend in the County Jail. He had been busted for pot and they were also trying to hang a car-stealing rap on him. "They" were the heat and this was the bond that this chick felt with beatland. The beards puzzled her, and the poetry was so much baby talk to her. She had enough of that at school. One book was the same as any other to her. Pot was baby stuff, too. She had been on horse since she was thirteen.

What drew her to the beatniks was the way they understood her attitude toward her family and elders in general and the fact that they didn't think she was a bad girl. The fuss that parents and older people made about sex seemed silly to her. Virginity? She and her girl friends at high school had a word for it. "Big issue about a little tissue."

As a juvenile delinquent Myra Flores belonged to the cool cats who could be seen coming out of Venice High after school hours and piling into a car — integration was no problem here — white, Negro, Mexican. They didn't hang around street corners; they drove fast cars in car pools that were also clubs of a sort. The Mexican girls were popular with these boys. Sometimes the blond girls dyed their hair to look like Mexican chicks. Their cars were not souped-up hot rods, that was for squares. Their clothes were sharp. Every penny they could beg, borrow

or steal went into clothes. They drank wine and smoked marijuana. They didn't talk much. They were physical in their relations, fondled each other a lot and watched television by the hour. Looking older than their years was very important to them. It meant that they could pass for twenty-one without an I.D. card in the taverns.

Rarely can a girl like Myra Flores make the beat scene except as a place of refuge or a drop-in lay, but a J.D. like Willie Frank can make it for quite a while on nothing but an ability to say little, listen much and play it close to his vest, which passes for cool as long as he doesn't make any false moves. Willie fell into Venice West from a town in New Jersey where things had gotten too hot for him. He had smoked pot since he was fourteen, graduated to horse not long afterward, and served a term in jail back east.

The beat and the juvenile delinquent are only kissin' cousins. They have the same enemies, which is the slender thread that sometimes unites them in temporary alliance. Both are outlaws, speak a private language and put down the squares, but in beat circles the J.D. is regarded as a square, a hip square in some things, but still a square.

He is a square because his values are the conventional American values: success, the worship of things, the obsession with speed and devil-take-the-hindmost attitudes in everything. They are "sharpies" always looking for angles. They believe everything they read in the ads. The "kick" they are looking for when they "borrow" a car for a night is the kick of making "a majestic entrance" in front of a chick's house. The juvenile delinquent wants a Ford in his future, but he wants his future right now. He can't buy it so he steals it. "My old man waited," one of them remarked to me, "and what did it get him? He's fifty and he's still driving a '49 Chevy."

The names they give their gangs are indicative of their hunger for social status. In Venice West it's The Doges. Some of them pronounce it "dogs" but they know it means something like The Man of Distinction. (Wasn't "putting on the dog" once a slang synonym for distinctive? If one gang names itself The Counts, the gang in the next block goes it one better with The Dukes. Such pretensions are abhorrent to the beatnik.

Their "social protest," which is a common theme in liberal magazines trying to "understand" the J.D., is so much double talk in the beatnik's opinion. They are not victims of the society, they are its fruit and

flower. The J.D. in a stolen car, dressed up in his sharp clothes, seated beside his chick and smoking the cigarette that is the choice of men who demand the best, is the ironic triumph of the adman's dream. They are not likely to yield to the lures of communism. In fact, many of the J.D.'s of past generations are now among the society's most successful businessmen. Their only protest is that it takes too long.

The vandalism of the juvenile delinquent is directed against symbols of authority, like the school. If he finds school too confining or oppressive, or too boring, the beatnik finds ways of "beating the system." He cuts classes as often as he can but he keeps his scholastic average high enough to stay out of trouble. He doesn't go back after school hours and wreck the classroom or waylay a teacher and slug him for giving him low marks. Any show of violence among the beat generation, when it does occur, is rare enough — and significant enough — to become legendary. Such a legend is the one you hear frequently about Carl Solomon. "It was at Brooklyn College," says Allen Ginsberg. "Some square lecturer was giving a lecture on Dadaism, and Carl pelted him with potato salad." Which is exactly what any Dadaist would have done. That Carl was expelled for it is only further proof that the lecturer *was* a square.

The violence of the delinquent is usually directed against older people. The beatnik would not commit such acts of violence. He would write a poem about it.

Only a newspaperman with his feet stuck in a slot at the rewrite desk could possibly mistake a J.D. for a beatnik. The newspaper stereotyped vandal is a composite of "teen-ager," "juvenile delinquent" and "beatnik," a convenient composite since it simplifies headline writing and makes every youth crime story a rewrite of the familiar dope fiend, sex fiend, youth-on-the-rampage yarn. All the reporter has to do is change a few names and places. The J.D. doesn't mind the publicity. It gives him status. The only thing Willie Frank objected to in the news stories about him and his gang when they were busted for drugs was that the papers misspelled his name and even mixed up names under the pictures. "DOPE RING SMASHED" was a little too grandiose a headline, Willie thought, for a twenty-dollar haul of pot, but it gave him a glow just the same.

Related to the J.D.'s, but two or three cuts above them in education and family background, are the young sons and daughters of the rich

from the "right" side of the tracks. When they arrive in Venice West it is in their own Jaguars, with a few boxes of avant-garde books and jazz records, looking for the beatest pad they can find on the beatest street in town.

The Beautiful and Beat

Judy March was one of them who came to beatland by way of an Auntie Mame progressive school childhood, a dramatic and dancing school girlhood and a jazz and espresso coffee shop postgraduate course. At nineteen she was already two abortions ahead of all her schoolmates, had made the Lesbian scene for kicks, and was ready to try pot, poverty and holiness. She had read about Venice West in the newspapers and heard about it in the coffee shops. At a poetry and jazz session in Cosmo Alley she met Sally Collins, another beat-struck chick, and the two of them decided to make a team of it in a Venice pad. The décor of the pad they set up was a cross between sorority house modern and New Orleans whorehouse.

Both girls are beautiful, Judy in a delicate, cameo way and Sally in a dark, sinewy, athletic way. Together they present a toothsome double threat that would be cause for panic among the women of any other community, but not among the chicks of beatville. Where beauty has no scarcity value the competition is greatly diminished. As for sex, where availability is the rule, not the exception, other talents have a chance to figure in the courtship of the young. Judy paints and sings folk songs and is able to accompany herself on the guitar. Sally has a flair for dressmaking, makes her own clothes and likes to make clothes for her friends.

Their original plan was to get jobs in or near Venice West, working part time and pooling their earnings. The rest of the time was to be spent in study, the arts and partying. Neither girl had any difficulty in getting jobs. Employers took one look at them and hired them on the spot, whether a position was open or would have to be created by firing somebody. But there always seemed to be a catch to it. The boss expected something more than gratitude. Judy promptly quit the first job she got, a good one, when the boss tried to press money on her — she had left home with only a few dollars and was broke before payday — and made life miserable for her when she refused his money and the

proposition that went with it. Judy wasn't angry about that; she was sorry for the man. "If only he hadn't been so vulgar about it, standing there with the money in his hand —" Judy was used to seeing money conspicuously displayed. That was one of the things she was running away from.

Between dates and parties they boned up on Zen and cool jazz and talked about Existentialism all night. They read Kenneth Patchen's poems aloud to each other and passages from Henry Miller's *Tropic of Cancer*. Day and night their pad resounded with rhythm and blues and smelled of Chanel No. 5. They were making the scene but the larder was chronically empty and there were no dining-out invitations to be had from the beatniks. The boys would bring a few groceries in a bag and a few marijuana cigarettes and they'd make an evening of it that way, but for a substantial meal Judy and Sally still had to accept dinner invitations from their square boy friends in Hollywood and Westwood.

When Christmas came Judy went back home for the holidays and did not return to the pad. Sally stayed on in Venice West, shacking up with a square who had a steady job but wanted to make the scene in beatville.

The Evidence: Heard and Seen

There is more to the "case history" of a human life than any interview can reveal, however skilled the interviewer may be and however frank and self-searching the interviewee. Without the evidence of things seen, the evidence of things shared and experienced, the oral evidence, even in the most confessional interview, is incomplete.

Who would guess, for instance, that Tanya Bromberger, who says monogamy is a bourgeois shuck, is a perfect madonna of a mother? The love and care she lavishes on the child of her mixed marriage — "What's mixed about two people getting married?" she would probably ask — matches anything I have ever observed in "respectable" circles. Diana Wakefield is vocal in her praises of any man who is the genius of the moment in her life, but her critical judgments where art and literature are concerned are shrewd and unbiased. She loves her man, not for what he is, but for what she thinks he can become. To him she can be unmerciful in her criticism, but let anybody else utter the slightest criticism and she will take his head off. Angel Dan Davies will repeat

"I don't know" with every show of humility when you ask him questions, but let anybody else pretend to know the answers and he must prove that person wrong if it's the last thing he does. Christlike in word and often in deed, Dan is capable of ruthless vilification when he thinks somebody has not given him his due or failed to live up to the expectations he has built up in his own imagination. And the next week or month, perhaps, he will swing around to the other extreme of unquestioning faith and affection.

Rhonda Tower, for instance, describes herself as too cool to be taken in by any would-be artist looking for a meal ticket, yet I have seen her playing dinner host for days on end to some broken-down beatnik who isn't capable of reciprocating with a lay, let alone love. Once it took all the self-discipline she could muster to keep herself from running off with a visiting poet who had nothing to offer but a great love, a broken heart and a shared life, equal but separate, with his wayward common-law wife and the kids he loved and couldn't leave.

Chris Nelson is often voluble in his criticism of beat amorality, especially in matters of personal responsibility, like repayment of loans. Yet one in need — even a stranger whose only credentials are a sheaf of unpublished poems and an empty pocket — can find food and lodging at his pad.

And gentle Dave Gelden, who vows he loves everybody, even the squares, will fly into a tantrum when he is ever so mildly reproached for falling down on a promise or failing to show up on time. For Dave, the right to goof transcends all other rights. "Like, I goofed, man," is the unassailable defense in all matters of equity and etiquette.

Yet in many things that most respectable people lie about, the beats are often pathologically truthful. Even when it means losing an advantage or failing to gain a favor. I have known them to lie for each other in matters where they would never dream of lying for themselves.

To anyone except an insider, the reasons which a beat generation person will give for anything are far from the real reasons. This has been true of all alienated generations, but it was never so true as it is today when the alienation is virtually all-inclusive. It is the code of the outlaw. Suspicion of the square is normal. He may be a narcotics informer. Even the most reasonable proposal from a square is likely to meet with "Okay, it *sounds* all right. What's the shuck?"

A seasoned disaffiliate can pick a potential beat chick out of a bevy

of squarejanes as expertly as a veteran trainer picks racers out of a
stable of fillies. How he does it is a mystery which it would be blasphe-
mous to divulge to the profane. Common lechers from squaredom are
always trying to get the beatnicks to play bird dog for them, but pimp-
ing of this sort is discouraged in beat circles. To play talent scout for
a squarejohn is the rankest kind of treason. "Where do you *find* them?"
the squarejohn asks in amazement, looking over the strikingly good-
looking chicks in espresso shops. "Could you fix me up?"

He knows that to the square he is only a "character." He has been
portrayed that way in the newspapers and magazines, by the same
pen-prostitutes who make "characters" out of all intellectuals, and
whores out of all women who are beautiful and speak with a foreign
accent. The nearest the square ever comes to members of the beat
generation is in the espresso coffeehouses, the café society of the beat.
He sees them sitting quietly over a cup of Italian coffee, listening
with rapt attention to a piece of cool jazz music on the hi-fi, and con-
cludes that being cool means a sophisticated pose of indifference and
nothing more. He sees young couples in low-voiced conversation, not
even holding hands, and decides that the younger generation is either
frigid or prematurely satiated with sex. What he sees in these places
doesn't fit in with what he has read in the press, so he is vaguely irri-
tated and, at the same time, eaten up with curiosity. Something is being
kept from him, he feels. He would feel better if he were being verbally,
even physically, challenged. What hurts is that he is being pointedly
ignored.

His impression of the situation is substantially correct. To the dis-
affiliate of the beat generation who drops in for a cup of coffee, a game
of chess, conversation or music at the espresso coffeehouse, the square
is a slummer from squareville. He sees him as a dupe — or a victim —
of the rat race. More likely a victim, or else why would he be hanging
around a beat joint? He is probably someone who is driving a three-
thousand-dollar car to a sixty-five-dollar-a-week job — after withholding
and deductions. He is fed up, perhaps, with the middle-class culture bit
and is looking for something more satisfying than quiz programs, radio
opera and *South Pacific*. Maybe he's a step farther out. He goes in for
bucket chairs and shipping-crate modern architecture. He reads his
Time from back to front, and "The Talk of the Town" in *The New
Yorker*. He may even be having his first doubts about the neon chrome

artyfake Disneyfication of America, but the chances are he still falls for the shell game swindle of "the highest standard of living in our history" while he tosses all night in debt-infested dreams. At best he might be squirming in that circle of hell which is reserved for those who do violence to their own nature in an effort to conform out of fear of being different. He is looking for something. He doesn't know what it is, but he wants it bad. Yet he isn't ready to pay the price for it. You can see that in the way he looks around him at the pictures on the wall, at the beards and sandals, at the chicks. He thinks all it takes is the price of a cup of capuccino and a fast lay in a beat pad.

PART II

7

Down With the Rat Race:
The New Poverty

THOSE WHO SEE THE AMERICAN BUSINESSMAN AS THE FOUNT FROM whence all blessings flow, enterpriser *par excellence*, organizer of Progress, job-maker, charity-giver, endower of churches and universities and patron of the arts, who has given us the highest standard of living in the world, have never been able to understand why the figure of the businessman has fared so badly at the hands of the intellectuals. As for the businessmen themselves, the early industrialists were never worried about their reputation with the intellectuals. Many of them were only semiliterate, and while they were quick to retaliate against sticks and stones, whether thrown by labor or by their competitors, they were merely contemptuous of words. But the growth of advertising as a formidable weapon opened the businessman's eyes to the possibility that while he was watching out for sticks and stones, words might break his bones.

It was not until after the Depression, the New Deal and World War II, though, that the public relations men and the advertising men were able to arouse the businessmen to active retaliation against the treatment he was receiving in novels, plays, radio and films, and even in the churches and classrooms. During the Depression he had to lick his wounds in bitter silence while he heard himself called a "malefactor of great wealth" by that "traitor to his class" Franklin D. Roosevelt. He had to suffer in silence while detractors were being entertained in the

147

White House and providing verbal ammunition for a New Deal that looked to him like nothing more than a "hate business" conspiracy which his political spokesmen have since rephrased as "twenty years of treason." It is little wonder that his pent-up resentments should have taken the form of a vengeful "house cleaning" after the war, not only of political officeholders but of the New Deal's intellectual and literary friends as well.

Hand in hand with the loyalty oaths and investigations has gone a widespread propaganda campaign on the platform and in the press against all intellectuals, a campaign in which friendly highbrows are regarded as only a little less dangerous than unfriendly ones and potentially treasonous. The halfhearted and timorous "wooing back" of the egghead that began with the successful Soviet orbiting of Sputnik I is confined to scientists and technicians, and is concerned, characteristically, with *buying brains* rather than encouraging the intellectual to think straight and speak out plainly.

The word intellectual has never been altogether free from suspicion in the United States; calling a man a brain has been fightin' words for a hundred years. Intellectualism is, needless to say, equated with leftism, a proposition that has at least the merit of being half true, but not in the way *they* mean it. It is even equated with modernism in art — unless it can be turned into window displays, high fashion fabrics, liquor ads and clever television commercials.

But the businessman had a bad conscience long before he ever became a target of the intellectual. Profit, which is the basis of business, has been under a cloud for centuries, certainly since the time of the prophet Hosea and probably long before him. Among the Church Fathers there were not a few who echoed the words of the Hebrew prophets against malefactors of great wealth, well before "That Man" in the White House blasted them on the radio.

And when Dave Gelden speaks of writing poetry in the lavatory of the airplane plant on the boss' time and on the boss' toilet paper and says, "It wasn't stealing, I was just getting my own," he speaks out of an old and honored tradition. He speaks for the few who *can* reject the rewards that a business civilization offers those who are willing to help it sell its ideology.

Moneytheism is everywhere, in everything we see and read and hear. The child is indoctrinated with it from birth, not in the schools, which

try to counter it with the humanities — as much as they dare — but in
the large school of experience where most of our education is received.
It is only after a long process of diseducation and re-education that
one sees it clearly and sees it whole — the price-wage shell game, the
speed-up treadmill, the Save!-Spend! contradictions dinned into our
ears night and day, the heartbreaking brutalities of class-made law,
lawyer-made law, judge-made law, money-made law, and the unspeak-
able vulgarities of hypocritical religion, the nerve-shattering Stop! and
Go! Hurry! and Go Slow! Step Lively! and Relax! warnings flashing
before our eyes and bombarding our ears without letup, making the
soul a squirrel cage whirligig from the first stimulant in the morning till
the last sedative at night. The rat race. A rat race that offers only two
alternatives: to run with the hare or hunt with the hounds.

Disaffiliation: The Way of the Beat Generation

Disaffiliation is a voluntary self-alienation from the family cult, from
Moneytheism and all its works and ways.

The disaffiliate has no blueprint for the future. He joins no political
parties. He is free to make his own inner-directed decisions. If he fails
to vote altogether, that, too, is a form of political action; half the eligi-
ble voters of the United States normally fail to do so. In his case it is
a no-confidence vote.

The disaffiliate doesn't like the smell of burning human flesh, whe-
ther it come from the lynching tree, the witness chair or the electric
chair.

Having read history from the bottom up as well as from the top
down, he knows that culture moves both ways, interactively, and there
are times — the present is one of them — when the cultural top is at the
economic bottom.

He is not against industrialization. He is not against "things," mate-
rial things as opposed to spiritual things.

Why, then, disaffiliation in an era when *Time-Life-Fortune* pages are
documenting an American Way of Life that is filled with color-matched
stainless steel kitchens, bigger and faster cars, electronic wonders, and
a future of unlimited luxuries like television-telephones and rocket trips
to the moon? Because it is all being corrupted by the cult of Money-
theism. In the eyes of a Nelson Algren it is all a "neon wilderness." In

the eyes of a Henry Miller it is all an "air-conditioned nightmare." Because, as Kenneth Rexroth has put it, you can't fill the heads of young lovers with "buy me the new five-hundred-dollar deep-freeze and I'll love you" advertising propaganda without poisoning the very act of love itself; you can't hop up your young people with sadism in the movies and television and train them to commando tactics in the army camps, to say nothing of brutalizing them in wars, and then expect to "untense" them with Coca-Cola and Y.M.C.A. hymn sings. Because underneath Henry Luce's "permanent revolution"— the New Capitalism, the People's Capitalism and Prosperity Unlimited — lies the ugly fact of an economy geared to war production, a design, not for living, but for death.

If the disaffiliate is on the side of the accused instead of on the side of the accusers, it is because the accuser *has* his spokesmen, a host of them, well paid, with all the mass media at their command and all the laws and police on their side.

Where the choice is between two rival tyrannies, however pious their pretentions, the disaffiliate says, not a plague but a pity on both your houses.

The Art of Poverty

The New Poverty is the disaffiliate's answer to the New Prosperity.

It is important to make a living, but it is even more important to make a life.

Poverty. The very word is taboo in a society where success is equated with virtue and poverty is a sin. Yet it has an honorable ancestry. St. Francis of Assisi revered Poverty as his bride, with holy fervor and pious rapture.

The poverty of the disaffiliate is not to be confused with the poverty of indigence, intemperence, improvidence or failure. It is simply that the goods and services he has to offer are not valued at a high price in our society. As one beat generation writer said to the square who offered him an advertising job: "I'll scrub your floors and carry out your slops to make a living, but I will not lie for you, pimp for you, stool for you, or rat for you."

It is not the poverty of the ill-tempered and embittered, those who

wooed the bitch goddess Success with panting breath and came away rebuffed.

It is an independent, voluntary poverty.

It is an art, and like all arts it has to be learned. It has its techniques, its tricks and short cuts, its know-how.

What is poverty for one may be extravagance for another. The writer must have his basic library, the composer his piano, the painter his canvases and tools, and everyone must have at least a few of the books he wants, if only in paperback editions, a few good recordings and some objects of art, if only in prints and cheap imitations.

It all depends on what the disaffiliate values most. Kenneth Rexroth, for instance, has a scholar's library that may be worth ten thousand dollars — all of it shelved in packing cases set up one above the other to serve as bookshelves — in a fifty-five dollar slum apartment. A composer I know has a microfilm library of the world's best music that is matched only by that of the Library of Congress and perhaps a few private collections, and stints on food and clothing almost to the point of beggary. Each must work out the logistics of the problem to fit his own case.

The writer as disaffiliate has a special problem of his own. He may not have much control over the size of his income — a book may flop or it may be a runaway best seller — but he does have some measure of control over how much he spends. And how he spends it. And where he lives. For, as Nelson Algren has expressed it, "Scarcely any way now remains of reporting the American Century except from behind the tote-board. From behind the TV commercials and the Hearst headlines, the car ads and the subtitles, the editorials and the conventions. For it is only there that the people of Dickens and Dostoevski may be found any more."

Behind the billboards lie the slums. Here one may hold his standard of living down to the level of a dedicated independent poverty with some measure of ease and self-respect. It is a way of life that is obligatory only on the truth-telling artist but it is a good way of life for him; it helps him keep the long, lean view. He will go farther on less if he learns how to travel light. In the slum he will learn that the health of a civilization should be judged by the maxim laid down by one of humanity's greatest physicians: "Inasmuch as ye did it not unto one of

these least, ye did it not unto me." He will learn what Diane Lattimer (in George Mandel's novel, *Flee the Angry Strangers*) meant when, at the last, out of the depths of her agony and pain, she said: "Come, sit in the Cosmopole. You don't need anything in this world; only poverty is holy."

The Logistics of Poverty

The dedicated independent poverty is an art, but it is also a science of survival. It has its strategies and logistics.

Those who choose manual labor soon find out that, so far as the trades are concerned, breaking into the ranks of labor is neither easy nor cheap. Joining the proletariat is like trying to join an exclusive club and often quite as expensive, what with trade union initiation fees and numerous qualifications and restrictions. For the most part the beat generation disaffiliate is confined to the fringe jobs in the labor market, like small house painting jobs if he is an artist trying to find part-time work to pay for his colors and canvases and keep some canned goods in the larder. Some painters in the Los Angeles area have occasionally found cartooning jobs and sculpting on a part-time basis in the studios, particularly at the Walt Disney Studio. Ceramics has provided some income for artists, as well as costume jewelry designing, free lance or in the employ of some small businessman. Frame making can be a source of income. And some artists do not mind teaching a few hours a week at some art school or as private tutors.

In Venice West some have made it for a while as typewriter repairmen, postal employees and arts and crafts teachers — "occupational therapy" — in mental hospitals, or attendants in the mental wards, or psychology assistants giving Rorschach tests. In San Francisco they sometimes ship out with a crew for a few months and come home with a bank roll, or join a road construction gang in Canada or Alaska. Allen Ginsberg financed a trip to North Africa and Europe that way. The lumber camps of the Northwest sometimes serve the same purpose for a while. Some part-time jobs are to be found as laboratory technicians, X-ray technicians and the like, if one is willing to spend a few months preparing himself for the job.

In New York there are jobs that offer an opportunity to work in odd-hour shifts, much desired by the beat, as art gallery guards, deck hands

on ferryboats, and for those who seek solitude and plenty of time to think, goof or write, the job of barge captain is the answer. Those who are polylingual or have traveled abroad can find part-of-the-year employment as travel guides, either self-employed if they have a little organizing ability or in the employ of travel agencies.

In Greenwich Village there are some who make it by doing hauling in small trucks, and some by delivering packages and messages. New Yorkers also find good pickings at the many openings and *premières* in art galleries and other places — to say nothing of pickups, but for this racket you have to own at least one good party suit, unless you can pass for a painter or an interesting "character." New York is also good for free-lance manuscript reading jobs for publishers and part-time jobs reading proof for publishers or printers. Musicians who are making the beat scene do copy work for composers and music publishers, or compile "fake books" containing melodies and chord symbols, with or without words, and peddle them to commercial musicians in a kind of under-the-counter deal, sometimes on the union hall floor and other hangouts for musicians in New York and Hollywood.

In Venice West and elsewhere there is always the possibility of an occasional hitch with the gas and electric company as a meter reader. There is clerking in bookstores and now there are a few jobs in espresso coffeehouses. For those who live near a university there is library work on an hourly basis. Landscape gardening is a year-round possibility for West Coast beatniks. Some of them have made it as counselors for juvenile delinquents, in the employ of the city or county. The job of shipping clerk is a popular one. When you have saved all the money you think you are going to need for a while, you quit and pass the word around to your friends to go there and apply. In this way a job is "kept in the family," just as the pads are kept in the family by being passed on from one tenant to the next, with the landlord often none the wiser — or richer.

Job opportunities are always more numerous for the girls, of course. They can always find work in dress shops and department stores, with the telephone company and the telephone answering services. As doctors' reception clerks and dental assistants. If they have had some dancing school they can find part-time jobs as dancing teachers in private schools and summer jobs in girls' camps. There are any number of office jobs a girl can fill. There is manuscript typing and other free-

lance typing work. In Los Angeles some find jobs as script girls in the TV and movie studios. Comparison shopping and the *sub rosa* job of starting whispering campaigns in the subways for commercial products is strictly for the "angle-shooters" among the Village chicks in New York. Modeling is open to those who have the face and the figure for it. The job of B-girl in the taverns is very much sought after because it pays well and the hours are desirable, but rarely do the chicks of beat-land double as call girls or do a week-end stint in the whorehouses. That is a monopoly of respectable working girls and housewives in need of extra money to support their families or expensive tastes in clothes and cars. It is no part of the beat scene.

The musically inclined among the girls seek jobs in record shops and with music and record publishers. The artistically talented among the chicks sometimes make it as dress designers, window dressers and interior decorators, but here they run into competition with the beat homosexuals. Homosexual writers and artists are the most hard put to it to find — and hold onto — employment of any kind.

If all else fails there are always the foundations, the Huntington Hartford Foundation near Venice West, where one can find food and shelter for three months (renewable for three months longer) if he is judged eligible and comes properly recommended, and, on the East Coast, Yaddo and the McDowell colony. Some have been the recipients of Guggenheim fellowships or other grants.

There are windfalls now and then. An industrial firm or a university will let it be known that it needs guinea pigs for some research test, like the sleep tests at the U. of C., or some other research problem. One beatnik I know made it for some months as a sweater. He sweated so many hours a day for a cosmetics firm testing a new product.

And there are the standard jobs for itinerants and occasional workers —cab driving, dish washing, bus boy work, filling station work, and, for the girls, jobs as car-hops in drive-in restaurants or waitresses. In Venice West there are jobs for girls on the Pacific Ocean Park Amusement Pier. Some of the younger chicks who are still going to college — or can keep up a reasonable appearance of doing so — get money from home. If you are older and have children to support and no visible means of support, the county will come to your aid.

With all that, there are still many problems. Poverty is not easy to manage. It requires some planning and some conniving. The pressure

is toward conformity, with regular working hours and consumer spending in ways and in quantities that will make the American Way of Life look good in the Labor Department reports and the Department of Commerce statistics. Buying a secondhand suit for five or ten dollars at a Windward Avenue uncalled-for clothing store or a three-dollar secondhand dress at an East Side rummage shop does nothing for the statisticians or the Chamber of Commerce.

Sponging, scrounging, borrowing and angle-shooting are too undependable as a regular source of income, and street begging takes too much time, as Henry Miller has shown, with inspired documentation, in *Tropic of Cancer*. Pushing pot is too hazardous and peddling heroin is a one-way ticket to the penitentiary, if not to the grave. Shoplifting is only a stopgap measure at best. It is an art that takes long practice to master if one is to make a living at it, and is better left to those who have a talent for it. One amateur I know found herself confronted one day with an ideological, if not a moral, problem. The supermarket where she sometimes shoplifted a quarter of a pound of butter — more as social protest when butter prices took a sudden jump than from any actual necessity — was being picketed by strikers. Out of sympathy with the striking union she went across the street to the little independent grocer and did her shoplifting there till the strike was over.

Inheritances sometimes provide a few valuables to be divided among the needy in true communal fashion. Somebody who has wigged out and been committed to a mental institution for a while, or been busted for pot for the third or fourth time and sent up for a long stretch, will leave behind a pad with household effects, furniture, clothes, books, phonograph records, pictures and hi-fi equipment. The accepted practice is that such stuff becomes community property. If a cat moves out of town he sometimes wills such things to his friends quite informally rather than try to tote them with him or go to the expense of having them shipped. When he comes back he will find any pad open to him, or can divide his guesting between several of his choosing. It is the traditional hospitality of the poor, one of the few traditions of the square that the beat honor scrupulously.

"Why don't more of them simply marry rich women?" I heard a square ask one evening at a party in one of the Venice West pads. Chuck Bennison took it upon himself to answer.

"It's a full-time job," he said.

8

Cats Possessed:
Ritual and the Beat

THERE ARE MANY THINGS THAT SEPARATE THE CATS FROM THE SQUARES but the first thing that is noticeable when they meet — and not always the easiest to understand — is the beat attitude toward sex.

Sex among the beat is not only a pleasure, it is a *mystique*. As in all mystery cults, words are important — and significant. "Joint" is a place, as it is in squareville, but it can also mean the penis or a stick of marijuana. "Work" means sexual intercourse. (A job is a gig.) Once you are out of your teens you don't usually dance. You *never* dance in any public place. That's for squares. As long ago as the twenties dancing was considered "dry fucking" by the *cognoscenti* who regarded it as something for subteen-agers only. Nothing is cornier, or will date you more quickly, than talking about "a piece of ass." That went out with "dumbbell" and such cute Winchellisms as "heart interest" and "carrying the torch." In fact, Winchell was never *in* at all, as far as the young of any generation was concerned. "Honey" is shunned as corny. "Dear" is out, even in private talk among beat lovers. Usually only the chick's name is acceptable, or some inspired and original nickname, but it's got to be good. "Baby" is taboo, except among the Negro beat and in blues lyrics. "Hot" is still used for chicks, but only if she is "cool." If she is cool she is "crazy in the sack." Not in the "hay," that is corny, only in the sack. "Hot" is one of the few words that the beat share with the square in the sex department. But the beat use it in a special sense. As in jazz

156

music, it means trancelike, the hypnotic "warm all over" feeling that Rhonda Tower described.

Domesticity has the same effect on sex that it has on animals. It makes both tame and awkward. The beat prefer to think of themselves as cats. Cats have never been domesticated sexually. Don Marquis' "archy and mehitabel" stories made into a "back alley opera" with music by George Kleinsinger and Carol Channing in the role of the wayward mehitable who couldn't make it as a domestic house cat and found her way back to alley promiscuity is a favorite record among the beat.[5]

Propriety has always been galling to some Americans. Henry Adams in his letters complains about Boston of the 1870's: "Everything is respectable, and nothing amusing. There are no outlaws." Later, in Japan, he was "a bit aghast when one young woman called my attention to a temple as a remains of phallic worship; but what can one do? . . . One cannot quite ignore the foundations of society." In Samoa some native girls, making sure first that he wasn't a missionary, turned him on to a fermented coconut drink called *Kawa* and put on a dance. "Five girls came into the light, with a dramatic effect that really I never felt before. Naked to the waist, their rich skins glistened with coconut oil. Around their heads and necks they wore garlands of green leaves in strips, like seaweeds, and these too glistened with oil, as though the girls had come out of the sea. Around their waists, to the knee, they wore leaf-clothes, or *lava-lavas*." On another occasion he witnessed the *pai-pai*, a Samoan strip tease in which the dancer, "showing more legs and hips every time, until the *siapa* hangs on her" finally lets it fall "in full view, then snatches up the *siapa* and runs away."

But it is not to Henry Adams that the beat of today look for the sexual *mystique*. It is more likely to be Henry Miller. It is a metaphysical impersonalism that constitutes "cool" sex among the beat generation today. To the square it may sound cold rather than cool — "unfeeling" is the way it was described in one article I have seen — but there is little likelihood that the doubting square, as long as he remains a square, or the writer of the article either, will have any opportunity to check his opinions against experience. There is no impersonal approach to the metaphysical impersonalism of the cool fuck.

The generation of the twenties went in for heavy necking. Gifts and "going out together" played an important part in courtship. Such nice-

ties are considered square among today's beat. Their courting is as un-sentimental as a blues ballade. It is an attack *in depth*. The soul must be engaged as well as the genitals. Speech plays as much of a role in the act as it does among the squares, but it is apt to be earthier. The four-letter words are taboo among the beat. They are taboo not in the puritan sense of forbidden but in the Samoan sense of sacred. In the sexual act, the beat are filled with mana, the divine power. This is far from the vulgar, leering sexuality of the middle-class square in heat. This is not to say that every beatnik is a hierophant of the metaphysical fuck and every pad a temple of the hierogamic ritual act. It is the ideal. The grail at the end of the Quest.

To the indignant or shocked square the initiate of beatland would say, "Go on, fight it. If you fight anything hard enough you'll end up in bed with it. Remember Jacob and the angel, and maybe you'll be blessed."

"I Hold a Beast, an Angel and a Madman in Me."

"I hold a beast, an angel and a madman in me," Dylan Thomas once wrote of himself, "and my enquiry is as to their working, and my prob-lem is their subjugation and victory, downthrow and upheaval. . . ."

If Angel Dan Davies stays up all night with wine, pot, sex, music or talk and gets fired from his job the next day, or Chuck Bennison goofs off and shows up three days late to an appointment, they have some sort of justification, if they think they need any, in the example of Dylan Thomas. "After some terrible drunk," says critic John Daven-port, "he (Dylan) would come to, somewhere out in the country. Ut-terly exhausted, nervous, there he would be, suddenly stuttering, diffi-dent, fumbling in his pocket — 'I don't know if you'd mind — of course you haven't the time' — and dragging out a poem for you to read. There he was, with his dirty, curly hair, probably wearing someone else's trousers, those nail-bitten fingers as if they were stretched out for a five-pound note — then he produced some beautiful thing like this."

The point is, he produced "some beautiful thing like this." For this, nothing was too much to endure, for him or for anybody who happened to be involved with him. Theoretically, at least, there is always this beautiful thing to hope for and struggle for, whatever the cost.

Beast, angel and madman, "and my enquiry is as to their working," said Dylan Thomas, "and my problem is their subjugation and victory, downthrow and upheaval." Surely he was referring here to something more than whisky, women and panhandling the price of a meal. D. H. Lawrence's life was also an "enquiry" into good and evil, ecstacy and madness, an "enquiry" that led him to the ends of the earth, to primitive cultures, to self-searchings, in a pursuit that was also a flight. Of the Pueblo Indians he wrote:

> (To the Pueblos), everything is alive, not supernaturally but naturally alive. There are only deeper and deeper streams of live, vibrations of more and more vast . . . (And) the whole effort of (the Indian) is to get his life into direct contact with the elemental life of the cosmos, mountain-life, cloud-life, thunder-life, air-life, earth-life, sun-life (as in the sacred races). To come into immediate *felt* contact, and so derive energy, power, and a dark sort of joy. This effort into sheer naked contact, *without an intermediary or mediator,* is the root-meaning of Pueblo religion.[6]

That was in the early twenties. If Lawrence were alive today he might be seeking his "natural" not supernatural god in Zen Buddhism, along with the beat generation. To them, too, everything is alive, not only the natural forces like air, sun and thunder, but the machines that man himself has made. Here is the transcription of a tape recording of Allen Ginsberg and Gregory Corso telling about an experience on their trip down the coast from San Francisco.

CORSO: It happened in front of the Carmel High School. We were by a traffic light, waiting to hitch a ride. And these great mechanical monsters began to move!

LIPTON: Making magic out of the commonplace?

CORSO: But the commonplace *is* what we see. This is the fantastic thing. We finally *see* it. And some of us, through cowardice, call it visions, hallucinations. But what we see is really *real.*

LIPTON: Then the magic *is* the real?

GINSBERG: Yes, in the sense that it's what we actually think of. We were standing and looking at the red and green traffic signals. Then we both suddenly realized — Gregory pointed it out, we were both high — the essential monstrousness of the thing. You know how a face looks, a

head with blue and green lights blinking on and off.

CORSO: That it was capable of moving. And that people had created it, thinking it was inanimate. See — they don't know the monster is moving.

GINSBERG: The eyes, everything. Monstrous.

A traffic signal moves. It isn't *like* a human face, it *is* human, monstrously human. "What we see is really *real.*" Corso rejects the notion that it is an illusion; he says it is cowardice to call it a vision, a hallucination. "The commonplace *is* what we see," it is fantastic and it is really real. Asked how he pictured the Muse, Ginsberg replied, "I think of it as numen, the numinous." In the numinous experience the thing seen is the real; it is the thing itself experienced, *seen, known,* in its "true" nature and essence.

It is all part of what Carl Jung has called modern man in search of a soul. This spiritual search is not confined to the beat generation; it is in such waters that Monsignor Sheen has been fishing for years. But it is not peace of mind or positive thinking or reconciliation with tradition or the Church that the beat are seeking. It is something deeper in the human psyche and farther back in the history of the numinous experience, farther back and farther out, than any church of our time has to offer. It is not a creation of priests, ministers or rabbis, not as organized religion is now constituted. The anticlerical bias of the Renaissance in Italy, France or England was a love feast compared with the loathing with which the nonconformist American, whether of the twenties, the thirties, the forties, or the disaffiliated today view the churches, their priests and ministers and all the workings of organized religion — including the churches of India, China and Japan and Zen Buddhism itself. Organized church worship and ceremonial of every sort is religion "shorn of its hair and balls," as Chuck Bennison will tell you. It is not even "the opium of the people," as the Communists insist. It lacks the properties of a proper narcotic. Everything narcotic or hypnotic has been squeezed out of it, along with the sex, the poetry, the art, till there is nothing left in it but watered-down weak tea for wine and the sweepings of the chaff for what may once have been the living bread of the spirit. To their last breath, churches, like empires, have one primary aim: to preserve and perpetuate themselves. They are not self-liquidating institutions. The first oath every new pope takes is never to give up

any of the powers of the papacy, even if it means his death; and one recalls Winston Churchill's remark that he did not become the king's first minister to liquidate the British Empire.

The beat see themselves as outlaws from the Church, something like the first Christians who also lived in pads of a sort, in the slum quarters of slaves and outcasts, and were hunted down by the officialdom of the church and the empire and its fly-cops. When they say "ritual" they are not thinking of the overblown and pompous ceremonials of the cathedrals, or the unintelligible mumblings of the synagogue, or the book-reviewing pulpits of the Jewish Reform temples, either. Or evangelistic camp meetings, or Billy Graham and his show business theatrics and publicity stunts. They have read their anthropologists and historians and are trying to cut back to something like primitive root sources for the meaning and function of true myth and ritual, before it was taken over by rulers and clerics and organized and institutionalized and wrung dry of every esthetic pleasure and every orgastic joy.

It is during the Christmas season that the disaffiliates are more confirmed than ever in their rejection of institutionalized — and now commercialized — religion, and yet they are faced with a moral dilemma. It is the birthday of the Prince of Peace and they are not opposed to peace. For once in the year the word love is heard in the streets and they are not against love. Christmas is a time that tries the souls of the beat, confronting them with decisions and choices and temptations to compromise. Whether to go back home for Christmas. Whether to accept the invitation of a family in squareville whose son or daughter had made their acquaintance in one of the espresso cafés. Whether to give gifts. Whether to buy Christmas cards and mail them to old friends *back there*. Or make their own, with a little artistry and good taste, leaving out the pious clichés and the corny tinsel. Whether to set up a Christmas tree, which is, after all a pagan, not a Christian, symbol — as pagan as Priapus or the Muse. Why would it be so uncool to set up just a small tree, a plain white one maybe, or better yet, to make one out of driftwood and miniature mobiles and maybe invite a few friends in just for the hell of it? A little wine for the belly's sake never did anybody any harm, even if it *has* lost its mana in the empty ceremonials of the churches and been further debased in the unspeakable vulgarities of office parties. Or would it be cooler just to ignore the whole thing?

Venice sculptor Stan Winkler solved the problem by setting up his Christmas tree in the form of a Holy Rood made of agonizingly gnarled and knotted driftwood. He and his wife Ella stayed up late on Christmas Eve fitting it out with painted clay replicas of Gold Coast figurines, Ashanti miniatures, early Christian saints, cubistic Philippine statuettes, Iroquois masks, the dancing figures of Borneo and some Kachina dolls they had brought back with them from the Hopi pueblos. Stan had sold something at his recent show and Ella still had her job, so they roasted a fifteen-pound turkey the next day and invited everybody who was hungry in for Christmas dinner. The party lasted through the night and well into the next day, with Art Blakey and The Jazz Messengers' *Ritual* drum record on the phonograph, the bongos going all over the place and Stan putting on his own version of a primitive wine dance, pounding a conga drum under his arm. A corroboree of clowning, protest and reverence characteristic of the holy barbarians.

The Gospel According to Anthropology and Prehistory

On the bookshelves of the beat pads you will usually find one or more of the books of Sigmund Freud, Carl Jung, Ernst Cassirer, Susan K. Langer and Maud Bodkin, in paperback editions or expensive hardcover copies that were purchased at the sacrifice of food, perhaps, or filched from bookstores or borrowed from a public library and never returned. Some of the beat are familiar, from college courses or library reading, with Oesterly and Elie Faure, Konrad von Lage, Andrew Lang, Franz Boas, Paul Radin and Melville Herskovits. They all have paperback editions of the books of Margaret Mead and Penguin books like those of Gordon Childe on prehistory and ancient cultures are on their shelves and Leonhard Adam on primitive art.

Not a few among them have had the experience of going back to the Church — it is usually Catholicism — in their search for the numinous, but they have always come back to the anthropologists, who occupy among the beat today much the same position that the writings of Freud did among the Secessionists of the twenties. From their reading of church history they know that the sacred dance was banished from the Church, just as Athens imposed similar bans and restrictions on the goat plays and the mystery religions. Just as the dancing prophetic bands of Israel were viewed with suspicion and hostility by the priests.

Official historians and scribes "glossed" the myths into false history and turned the sacred dance into temple pageantry. Robert Graves has made a career of such historical-literary-mythological detective work and his books are widely read among the younger generation of today, both here and in England.

The so-called Cambridge School of classical anthropologists were among the first in our time to give some attention to the role of art and the artist in relation to myth and ritual. The ethnographer with his pencil poised to note the symbolism and the psychological implications of tribal dances, verbal rituals and music also contributed to our knowledge of the subject. Bronislaw Malinowski is perhaps the most perceptive of these chroniclers, although the approach, if not the methods, had already been employed by H. H. Marett who, more than E. B. Tyler and J. G. Frazer, deserves credit for the first clear insight into ritual and myth. H. H. Marett approached "the sacraments of simple folk" as something to be learned, not something to be dissected and classified with scientific detachment or, as has too often been the case, with Protestant Christian bias. To possess what you inherit you must earn it, Marett said, and some of the investigators in this field have emulated his humility. Malinowski, reminding us that religious ritual "does something infinitely more than the mere sacrilizing of a crisis of life," that it transmits to the initiated not only a knowledge of his duties, privileges and responsibilities but "above all a knowledge of tradition and the communion of sacred things and beings," goes so far as to add that anthropology should also be a study of *our* mentality in the light of Stone Age mentality.[7]

Ritual is the sacramentalizing and socializing of the crises of life: birth, puberty, marriage, conception, pregnancy, sickness and death. The community, through the rituals, helped the individual to meet these crises of life. It helped him to be born, taught him how to live, love and work, heal his sicknesses and, at the last, gathered at his bedside and helped him to die. From the first birth through the rebirth of Initiation to the final Viaticum, ritual gave meaning, beauty and dignity to every critical event of life. This was its purpose and their function.

Myth is the god-making process by which the community metaphorizes its aspirations, *"le désir collectif personifé,"* the collective desire personified.[8] Myth gives the individual and the group a sense of origins,

roots, and a sense of continuity. In the arts, myth is at one and the same time the conserver of tradition and the material out of which new myth is forever being created to fill new needs. As the old gods die their rituals die with them. The historic process of god-making has been going on from the remotest beginnings to this very day. In between periods of relative stability there is always a twilight of the gods, bringing with it chaos, conflict and *Angst*. We are in the midst of such a *Götterdämmerung* today.

Religious ritual, if it is not to sicken into the private rituals of neurosis, must have a mass base, at least within the limits of a socially integrated group. The lack of such basic rituals in our time is a subject of intermittent concern in the public prints. The churchmen, of course, see no lack of ritual. They have it, packaged and priced for mass consumption, in spiritual emporiums that come more and more to resemble department stores where every day is Christmas. In religious surveys four-fifths of those questioned say they believe the Bible is the "revealed word of God." Americans are buying more Bibles than ever before. Nevertheless other surveys show that fifty-three per cent are unable to name even one of the gospels, and a panel of twenty-eight prominent Americans, asked to rate the hundred most significant happenings in history, ranked Christ's Crucifixion fourth in a tie with the Wright Brothers' flight and the discovery of X rays.[9] Allowing for the pious fraud that winks at faking up the figures to the glory of God and his churches, the membership attendance figures of organized religion are still impressive. Evidently Bibles are bought and seldom read and people go to church but come away from sermons and services without being transformed. They are still hungry and searching for ritual cleansing and spiritual illumination, according to most studies emanating from nonclerical (and often enough from clerical) sources. The tendency, increasingly, is to look elsewhere, outside the churches, for signs of an American mythos and a mass ritual.

Every so often an inspired cultural anthropologist, usually one of amateur standing, discovers an American mass ritual that everybody else has overlooked. It might be baseball, or football, or basketball, if attendance figures are any criterion. All have their heroes, who might well pass for gods, or their high priests and apostles who spread their gospels in the sports pages of the newspapers and on radio and television. "What's the score?" might well pass for a "God be with you"

greeting among the faithful, and serve as a badge and a ritual bond. I have even heard it seriously argued that the football cheering sections and their stylized antics are comparable to the response of the congregation, and the *agonia* on the gridiron, with its marked yardage lines and goal posts, is the modern counterpart of the stations of the cross and the Holy Rood.

Whatever the merits of the argument, the beat generation isn't buying. Neither the church ritual nor the sports ritual. Except among the teen-agers who sometimes admit to occasional church attendance — "to please mother" is the usual explanation — I have yet to find one beatnik who has found, or expects to find, any ritual salvation in the churches. The beat are not to be found in the baseball stands or tuning in on the play-by-play on radio or television. They never know who's ahead in the pennant race. The World's Series, which one of our new theologians analyzed, in a liberal weekly, as something culturally homologous to the tribal religious celebrations of the fall equinox, leaves the beat spiritually unmoved and unregenerate. They are likely to take their theology in matters of church and sports from *Mad* magazine rather than *The Christian Century* or *Sports Illustrated*.

The Way of Wit's End

On one occasion when we were having a party at the house, a well-educated woman of our acquaintance was having an animated discussion with a young man of nineteen. I could see by her expression that she was shocked. Later she came over to me and said, "Do you know what that young man just said to me? One plus one doesn't make two. One is one and two is two and three is three, and any connection there may appear to be between them is illusion, a mere convention of time." She was not only mystified or indignant — there was something in her manner that suggested a suspicion that the young man was poking fun at her for being a square — but she was horrified. "Why, do you realize what that means?" she went on. "It means that nothing is the cause of anything else! It means there is no continuity at all to life, or thinking, or human relations. It means there isn't any such thing as progress —" and so on, on and on, getting more and more indignant by the minute.

I took Alan W. Watts's *The Way of Zen* off the shelf and pointed out this passage for her to read:

Zen is a liberation from time. For if we open our eyes and see clearly, it becomes obvious that there is no other time than this instant, and that the past and the future are abstractions without any concrete reality. Until this has become clear, it seems that our life is all past and future, and that the present is nothing more than the infinitesimal hairline which divides them. From this comes the sensation of "having no time," of a world which hurries by so rapidly that it is gone before we can enjoy it. But through "awakening to the instant" one sees that this is the reverse of the truth: it is rather the past and the future which are fleeting illusions, and the present which is eternally real. We discover that the linear succession of time is a convention of our single-track verbal thinking, of a consciousness which interprets the world by grasping little pieces of it, calling them things and events. But every such grasp of the mind excludes the rest of the world, so that this type of consciousness can get an approximate vision of the whole only through a series of grasps, one after another. Yet the superficiality of this consciousness is seen in the fact that it cannot and does not regulate even the human organism. For if it had to control the heartbeat, the breath, the operation of the nerves, glands, muscles, and sense organs, it would be rushing wildly around the body taking care of one thing after another, with no time to do anything else. Happily, it is not in charge, and the organism is regulated by the timeless "original mind," which deals with life in its totality and so can do ever so many "things" at once.[10]

"Why that's Tao!" she exclaimed. It developed that she had read translations of Tao literature as long as twenty years before and now she recognized the connection, for Chinese Taoism is indeed one of the streams of thought that went into the making of Zen Buddhism. Further conversation revealed that she had read sporadically in Indian Buddhism and was familiar with Vedanta and Yoga. It simply hadn't occurred to her, however, that these were anything but subjects of study for cultivated people to pursue, to make interesting conversation about, certainly not to take seriously as something to act upon, as a way of thinking or living. What shocked her, in short, was that this young man was making it *a way of life*.

"She's a square," the young man told me afterward. "She *knows* all about it — up here —" tapping his forehead — "but she doesn't *dig* it,

man. Like you got to swing *with* it or you get hung up on the *numbers*,
man, on the little black dots and all that corn, and you *never* make it."

"The problem," says Watts, "is not simply one of mastering different
ideas, differing from our own as, say, the theories of Kant differ from
those of Descartes, or those of Calvinists from those of Catholics. The
problem is to appreciate differences in the basic premises of thought
and in the very methods of thinking, and these are so often overlooked
that our interpretations of Chinese philosophy are apt to be a projec-
tion of characteristically Western ideas into Chinese terminology. This
is the inevitable disadvantage of studying Asian philosophy by the
purely literary methods of Western scholarship, for words can be com-
municative only between those who share similar experiences."

Our educated friend had read the books but she had never done any
of the things the young man had done. He had packed a rucksack and
gone off by himself into the desert and up the coast to the wilds of the
Big Sur country, and given himself over to meditation for days at a
time. He had listened for it in the music of Bach and the music of jazz,
with equal attentiveness and absorption. He had sought for it in sex
and pot. He was young, only in the beginnings of the quest, but he had
a pretty good idea what he was looking for and it wasn't all gathered
from books. There were birds in his experience, and deserts and moun-
tains and danger and fatigue. He knew he had a long way to go. After
all, he was only nineteen!

But he was "on the road." He was already one of those holy bar-
barians "who drove cross-country seventy-two hours to find out if I
had a vision or you had a vision or he had a vision to find out eternity,"
to quote a line from Allen Ginsberg's *Howl*.[11] He will tell you that what
he understands by "the beat" is the beat of jazz, the heartbeat, the
beat in the beatific vision — anything *but* the construction of beaten or
defeated that the squares, in their mortal fear of freedom, have put
on the word.

> The general tendency of the Western mind (says Watts) is to
> feel that we do not really understand what we cannot represent,
> what we cannot communicate, by linear signs — by thinking. We
> are like the "wallflower" who cannot learn a dance unless someone
> draws a diagram of the steps, who cannot "get it by the feel." For
> some reason we do not trust and do not fully use the "peripheral

vision" of our minds. We learn music, for example, by restricting
the whole range of tone and rhythm to a notation of fixed tonal
and rhythmic intervals — a notation which is incapable of repre-
senting Oriental music. But the Oriental musician has a rough
notation which he uses only as a reminder of a melody. He learns
music, not by reading notes, but by listening to the performance of
a teacher, getting the "feel" of it, and copying him, and this
enables him to acquire rhythmic and tonal sophistications matched
only by those Western jazz artists who use the same approach.[12]

The aim, of course, is wholeness, personal salvation, in a word, holi-
ness, and the artist has always been in search of it, one way or another.
The Dada movement which began in Zurich in 1916 and quickly spread
to Paris where it became the basis of surrealism, sought to break up the
habitual linear habits of thought by a deliberate derangement of the
senses, the sensibility and what not, a misguided search that ended in
a blind alley because it remained within the framework of duality, "the
opposites." Thus we find André Berg talking about responding "utterly
but successively to the contradictory appeals of the sensitivity," Tristan
Tzara trying to make it by "unaccustomed caresses, touching the soul
at points where it has not been touched before, shaking it and stirring
it with new griefs and happy hazards," and Jacques Vache wanting "to
shape the personal sensation though the aid of a blazing collusion of
rare words — not often, eh what?" he adds, and any of our young
barbarians with even a smattering of Zen could tell him today, "not
ever, man, not *ever!*"

For the Tao,[13] the Way, is not to be found by dividing the mind into
subject and object, trying to observe itself, any more than the eye,
which sees, can see itself. Watts offers an analogy: "We have two types
of vision — central and peripheral, not unlike the spotlight and the
floodlight. Central vision is used for accurate work like reading, in
which our eyes are focused on one small area after another, like spot-
lights. Peripheral vision is less conscious, less bright than the intense
ray of the spotlight. We use it for seeing at night, and for taking 'sub-
conscious' notice of objects and movements not in the direct line of
central vision. Unlike the spotlight, it can take in very many things at
a time. There is, then, an analogy — and perhaps more than mere
analogy — between central vision and conscious one-at-a-time thinking,

and between peripheral vision and the rather mysterious process which enables us to regulate the incredible complexity of our bodies without thinking at all We are not suggesting that Westerners simply do not use the 'peripheral mind.' Being human, we use it all the time, and every artist, every workman, every athlete calls into play some special development of its powers. But it is not academically and philosophically respectable. We have hardly begun to realize its possibilities, and it seldom, if ever, occurs to us that one of its most important uses is for that 'knowledge of reality' which we try to attain by cumbersome calculations of theology, metaphysics, and logical inference."

The "other ways of knowing" that we of the West have been seeking, then, are not to be found by deranging the senses or playing tricks with the autonomic nervous system, but by learning how to use the peripheral vision we already possess. The way to get release from the rat race of the ten thousand things is to *let go*, for it is not "they," the "things," which are bedeviling us, it is we who are *clutching* them. "When we have learned to put excessive reliance upon central vision, upon the sharp spotlight of the eyes and mind, we cannot regain the powers of peripheral vision unless the sharp and staring kind of sight is first relaxed. The mental or psychological equivalent of this is the special kind of stupidity to which Lao-tze and Kung-fu-tse (Confucius) so often refer. It is not simply calmness of mind, but 'nongraspingness' of mind." It is the "stupidity" of the Sacred Clown, the Holy Fool.

Much of the behavior of the holy barbarian toward the square, so often incomprehensible and frightening — when it is not revolting — is of this character. For the square is by definition the unreleased, the rigid, the rectilinear. He is always busy, he is always in a bind. He never lets himself alone. He never lets himself "go," so that he is never "gone," in the swinging sense of jazz. In the dance of life he remains the wallflower. And *hates* the hipster as only the wallflower can hate the dancer. Hates him and, secretly, envies him. If you want to see this mixed hatred and envy in action, read any of the attacks on the beat generation in newspapers and magazines.

"It is fundamental to every school of Buddhism," says Watts, "that there is no ego, no enduring entity which is the constant subject of our changing experiences . . . there is no real Self (*atman*) at the basis of our consciousness."

What, then, is this Self that the holy barbarian is constantly exploring? It is a search for the "Original Face." His basic, original nature. Usually it is only *after* he has explored every avenue of approach to it, when he is finally at his wit's end, and knows that he doesn't know, that he is ready for enlightenment. It is only then that he can begin to swing with the beat.

"God's Medicine": The Euphoric Fix

THE EUPHORIA THAT THE BEAT WHO USE MARIJUANA ARE SEEKING IS NOT the wholly passive, sedative, pacifying experience that the users of the commercial tranquilizers want. On the contrary, they are looking for a greater sense of aliveness, a heightened sense of awareness. Of all the euphoric, hypnotic and hallucinogenic drugs, marijuana is the mildest and also the most conducive to social usage. The joint is passed around the pad and shared, not for reasons of economy but as a *social ritual*. Once the group is high, the magic circle is complete. Confidences are exchanged, personal problems are discussed — with a frankness that is difficult to achieve under normal circumstances — music is listened to with rapt concentration, poetry is read aloud and its images, visual and acoustical, communicated with maximum effect. The Eros is felt in the magic circle of marijuana with far greater force, as a unifying principle in human relationships, than at any other time except, perhaps, in the mutual metaphysical orgasm. The magic circle is, in fact, a symbol of and a preparation for the metaphysical orgasm. While marijuana does not give the user the sense of timelessness to the same degree that peyote does, or lysergic acid or other drugs, it does so sufficiently to impart a sense of *presence*, a here-and-nowness that gives the user a heightened sense of awareness and immediacy.

When the marijuana head (vipers, we called them in the thirties) or the hype turns on, he has the feeling of setting something in motion

inside himself. He feels the "jolt" as an automobile "feels" the charge at
the moment of ignition. It lights up, explodes. "Charge" and "explode"
are also terms used by the head and the hype to describe the kick of the
drug at the moment of "turning on." The energy charge is the kick and
the feeling of euphoria that follows is "cool," tranquilizing. When the
smoke comes in contact with the respiratory mucous membrane, in the
case of the marijuana smoker, the absorption is rapid. The effects are
felt immediately and last from one to three hours, depending on the
potency of the drug and the state of mind of the user.

Sometimes it is a heightened sense of self that is sought, rather than
the sensory experience of things outside the self. As Itchy Dave Gelden
expresses it, "It's like this, man, we need more awareness of the I. It's
like, before I light up I'm drug with the ten thousand things . . . you
can't concentrate," but when you light up you can "follow the song of
yourself. You're listening and you're hearing the song and you're swing-
ing along with it." At other times it is a heightened sensory receptivity
that is sought, a sharpened esthetic awareness, especially kinesthetic
awareness. Colors appear to be brighter, sounds sharper, more defined,
more easily picked out and followed through the chord changes of the
music. "I never really *heard* the music till I started listening with pot,"
is something you hear often in beat circles. "It's like switching from an
old-fashioned phonograph to hi-fi."

Some of the holy barbarians, particularly the poets and painters, have
found the cool world of heightened sensory experience in another
drug — peyote. Here is how Mike McClure, the San Francisco poet,
describes his sensations in *Peyote Poem*.[14]

> Clear — the senses bright — sitting in the black chair —
> Rocker — the white walls reflecting the color of
> clouds moving under the sun. Intimacies! The rooms
> not important — but like divisions of all space
> of all hideousness and beauty. I hear the
> music of myself and write it down for no one
> to read. I pass fantasies as they
> sing to me with Circe — Voices. I visit
> among the peoples of myself and know all
> I need to know.
> I KNOW EVERYTHING! I PASS INTO THE ROOM
> there is a golden bed radiating all light

the air is full of silver hangings and sheaths
 I smile to myself. I know
all that there is to know. I see all there
is to feel. I am friendly with the ache
 in my belly. The answer
 to love is my voice. There is no Time!
No answers. The answer to feeling is my feeling
The answer to joy is joy without feeling.
 The room is a multicolored cherub,
of air and bright colors. The pain in my stomach
 is warm and tender. I am smiling, The pain
 is many pointed, without anguish.
Light changes the room from yellows to violet.
The dark brown space behind the door is precious
 intimate, silent and still. The birthplace
of Brahms. I know
 all that I need to know. There is no hurry.
I read the meanings of scratched walls and cracked ceiling.
I am separate. I close my eyes in divinity and pain.
 I blink in solemnity and unsolemn joy.
I smile at myself in my movements. Walking
 I step higher in carefulness. I fill
space with myself. I see the secret and distinct
 patterns of smoke from my mouth
 I am without care part of all. Distinct.
I am separate from gloom and beauty. I see all.

SPACIOUSNESS

And the grim intensity — close within myself. No longer
 a cloud
 but flesh real as rock. Like Herakles
of primordial substance and vitality.
And not even afraid of the thing shorn of glamor
 but accepting.
The beautiful things are not ourselves
 but I watch them. Among them.

 And the indian thing. It is true!
Here in my apartment I think tribal thoughts.)

STOMACH !!!
There is no Time. I am visited by a man
 who is the god of foxes
there is dirt under the nails of his paw
 fresh from his den.
We smile at one another in recognition.
I am free from Time. I accept it without triumph
 — a fact.
 Closing my eyes there are flashes of light.
My eyes won't focus but leap. I see that I have three feet.
 I see seven places at once!
 The floor slants — the room slopes
 things melt
 into each other. Flashes
 of light
 and meldings. I wait
Seeing the physical thing pass.
I am on a mesa of time and space.
 ! STOM - ACHE !
 Writing the music of life
 in words.
Hearing the round sounds of the guitar
 as colors.
Feeling the touch of flesh.
 Seeing the loose chaos of words
 on the page.
 (ultimate grace)
(Sweet Yeats and his ball of hashish.)

 My belly and I are two individuals
 joined together
 in life.

THIS IS THE POWERFUL KNOWLEDGE
 we smile with it.

At the window I look out into the blue-gray
 glooms of dreariness.

I am warm. Into the dragon of space.
I stare into the clouds seeing
their misty convolutions.
 The whirls of vapor.
I will small clouds out of existence.
They become fish devouring each other.
And change like Dante's spirits
becoming an osprey frozen skyhigh
 to challenge me.

Tastes and personality traits apparently determine to a large extent what is experienced by the user of drugs. When Mel Weisburd, one of the editors of *Coastlines* magazine, submitted to an experiment with lysergic acid by a Los Angeles doctor who was investigating the effects of several types of hallucinogenic drugs, he saw "gigantic proletarian murals" and "a pillar of light against a blackened horizon, like an atomic blast" and at one point talked politics with the doctor.

"You know, Dr. Irving," I said, "capitalism and socialism make absolutely no difference at all. It's the germ plasm that counts. Don't let them fool you." "I know," Dr. Irving replied, "you're absolutely right," as if he had also overturned his soul, as if he had also run smack into a channel of yearning, dropping his ludicrous role as experimentor.

But there were also visions of the sublime and the supernatural.

We were on Olympic Boulevard which, like all six-lane boulevards in Los Angeles, was sick with nervous stop-and-go traffic. But now Olympic Boulevard was Olympia, a great Sunday-driver pageant moving in vehicular streams to and from the cities and beaches of beatification. And suddenly, with the logic of a heavenly-wise wish, who should appear but a guardian angel formed in the likeness of an old girl friend, high on a motor scooter. Her fresh wind-blown face radiated the quintessence of the power of recognition, the sublimest nostalgia imaginable. In our matter-of-fact glance, there was not only the recognition of a friend, but the pure principle of kindredness. I had an overpowering warmth for everyone I knew and with everything that lived. When we arrived at the park, we began walking towards it. "Yup, this is it!" I remarked as if marking the place of my ecstasy.

The air was unbelievably fresh. "Wonderful," Dr. Irving answered. "You're supernormal now, supersane." He patted me on the back. "Just breathe this air. Isn't it wonderful? Here, look at this tree. What do you think of it?" "Supernatural," I said and savored the word as if I understood it for the first time. The lawns, the wide sidewalk, the rows of leafless, sinewy sycamore trees, all of these underscored with living emphasis, the word. "Supernatural," no division in nature, no separation of myself from anything, everything whole, everything integral. And in this fulfillment of existence, all desire was lost. Imagination did not exist either, for that was an instrument of a falsely conditioned mind forced to manipulate pseudorealities, forced to endure the conflicts and the distortions of the flesh. Possession was ridiculous, for you possessed nothing. Vanity and egotism were frivolous for you were not an individual, but the infinite power of the germ plasm of the race. The body was a mere pedestal to hold experience. Death, therefore, was nothing, nothing at all, for life was indestructible. . . .

"It's like an orgasm," Dr. Irving suggested, "like an eternal orgasm." And yes, yes he was right, by everything that is holy and sexual. That constant feeling of abandon, of giving oneself up to a driving force that exuberantly fructifies in every living thing: that selfless exhilarating releasing flight: that cool, damp breast-milk feeling of satisfaction in my throat and lungs.[15]

Did Weisburd's experience with lysergic acid, in which life suddenly appeared to him like an eternal orgasm, where everything is "holy and sexual," work any transformation in his attitudes? A few months after the experiment he told me that it had changed his attitude toward his own writing, that he now recognized *two* ways of seeing and knowing, instead of one, but that he sees no reason not to continue working at a job even when it demands of him everything that he detests, because his lysergic vision has taught him that "everything that is, is necessary." In short, no transformation in lifeways took place. In this case, at least, pharmacy under controlled laboratory conditions with physicians and nurses in attendance (again, how like the square *that* is) has proved to be no short cut to salvation.

Apparently, the pharmaceutical fix can only *trigger* the vision, it cannot give it content. That must come from the individual himself, from his personality patterns and life experiences, just as the manifest content of the dream comes from the "residue" of the dreamers waking life. What distinguishes the holy barbarian from Sunday-go-to meeting

slummers in paradise like Mel Weisburd is that the holy barbarian *acts* upon his visionary experience. He doesn't just talk about it, or use it as a justification for continuing to live and work in the thickening center of the society's corruption. And this determination to act is nowhere more in evidence than in his use of the euphoric fix, not merely as "kicks," or a medical experiment, but as a social ritual.

On the level of the juvenile delinquent the use of narcotics in the magic circle is crude, tentative and entirely unself-conscious. In the case of a teen-age juvenile delinquent like Willie Frank, pot was a means of belonging, a matter of childish prestige. "I was about fourteen years old and still in grammar school and they opened up a little luncheonette right across the street from where I lived. There was a bunch of guys hanging out there and they were taking pot. I didn't know anything about pot or nothing, you know. I just started hanging around with them and idolizing them because I thought they were really something, a bunch of real smart guys, you know. I think it was a couple of months after I started hanging around with them I got accepted and they turned me on one day."

On the high school level, pot is a unifying group-force chiefly because it is illegal. It is a matter of guilty knowledge; in this case, not because it is a sin, but because it is a secret brand mark that holds the group together as partners in crime. How strong a bond this can be when it is sealed with sex.

It is only when one comes to consider its use among the holy barbarians of the beat generation that anthropological data on the use of narcosis in cult ritual becomes clearly relevant. Hallucinatory visions are sought in tribal cultures for various purposes, personal and social, for divination, for healing and other uses. Such visions are induced by fasting, by pain-producing practices (among Christians it would be called "mortification of the flesh"), or by hallucinogenic drugs, usually accompanied by dance, chanting and music. In the case of the drug-using rites it is the shaman who is the custodian of the tribal drug lore. The rite is performed under his supervision to keep it always within certain social controls. An example of such a rite is the peyote fiesta among the Tarahumare of Mexico.

A peyote shaman and from six to ten men go to gather peyote. It is a long journey, sometimes covering a full month . . . On arriving at the spot, everyone goes out to pick peyote . . . In the eve-

ning they erect a small cross and build a large fire around which they dance . . . For two nights the dance continues, part of the pickers dancing while the others sleep . . .

The return of the pickers is celebrated by a *fiesta* . . . At this *fiesta* the raw buds are eaten . . . The *dutubúri* is danced all night, and the dance of the peyote is performed around a large fire . . . Peyote is kept hidden in a cave under an olla, well guarded from the rats and human trespassers. Only the shamans can use it. The other people do not keep it. From time to time it may be offered food, drink, and cigarettes, especially just before it is removed from its container.

Those who have never eaten peyote fear it most. Should they touch the plant they believe they would go crazy or die. Those who have once eaten it at a *fiesta* need have no fear of it, providing they treat it properly.[16]

You can sense the excitement of these Mexican Indians as they go hunting for the peyote plant, a search not unlike Allen Ginsberg's "angleheaded hipsters burning for the ancient heavenly connection," but with more self-control, not, like Ginsberg's hipsters, "dragging themselves through the negro streets at dawn looking for an angry fix."[17] There is, however, a further similarity between them; the hipster who knows the connection (who the pusher is and where and when to find him and is trusted by him to make the deal) is respected and looked up to among drug users in beatland in much the same way that the peyote shaman who leads the peyote journey is looked up to. It is the element of shamanistic control that is lacking among users of marijuana or the hallucinogenic drugs among the holy barbarians.

As for the use of heroin or other habit-forming drugs, these can only be regarded as a corrupt misuse of drug-induced creativity which, of course, defeats its own ends, since it results in little or no creativity. Jazz musicians will be — and have been on many occasions — the first to attest to the artistic uselessness — to say nothing of the physical and psychological damage — of heroin. Most of them avoid it like the plague. Marijuana is, however, quite commonly used by jazz musicians. The demands made on the jazz musician for improvisation, hour after hour, results in pressures that may drive even the most creative genius to call on Mary Juana to help out the Muse.

Until quite recently, when a standing committee was set up at a

seminar on jazz and narcotics at the Newport Jazz Festival to study "the problem," the tendency among jazz critics and the magazines published for jazz musicians and their fans has been to ignore or at least soft-pedal the whole subject. If the name of a musician dropped out of *Downbeat* or *Metronome* for a few months, if no notices of his gigs or records were being published, you assumed that he had been busted and sent up for a stretch, or that he was sweating out a cure somewhere, or had simply dropped out of things for a while to try and pull himself together. Many jazz buffs liked it that way. Word got around via the grapevine and if you were in the know you were one up on those who didn't know. As for the musicians themselves, the users were inclined to treat it as a kind of trade secret, and the nonusers preferred to keep mum about it, too, asserting, if you pressed them, that it was a private matter and really had nothing at all to do with the music.

Treatment of the subject in the newspapers had been sketchy, partly because until recent years jazz musicians have not been sufficiently well known by most newspaper readers to rate news space, and partly because newspaper reporters are inclined to be friendly to alcoholics and, by courtesy, to other addicts. Besides, the newspaperman (and woman) is never strictly a square. He is a square with the corners rubbed off on the rough realities of life and sometimes even a round cat in a square hole. So the subject of jazz and drugs has remained one of those best-kept secrets that everyone knows and nobody talks about.

Except the beat generation, especially the youngsters, to whom the jazz musician is the shaman of the cult. Whatever he does and says is something to be talked about, often and at length. Tex, of the Ray Cullen band, is such a cult hero. "One of the most intellectual junkies I've known," Tanya Bromberger will tell you. "The guy who just makes the scene and doesn't have the actual power of the intellect to analyze it (the use of heroin), he will moan and groan every time he gets sick. This is the last time he's going to fix, he'll tell you. He's going to fix once more and then he's going to kick the habit. But Tex never talked like that. No fix was ever the last fix. He knew the real physical danger. The night his band closed a bunch were over at Tex's hotel room and did up, and one guy went out unconscious — and they can die from that. He'd been drinking heavily, which does not mix but produces a very bad reaction. Junkies have all kinds of home remedies. They throw guys in bathtubs, they've half drowned people, but he, Tex,

knows. He says, 'It's his upper respiratory system that's paralyzed.' He climbed up on top of him and gave him artificial respiration for twenty-five minutes, in the meantime asking for kitchen salt and water and a needle, which they shot into his arms — and right away you heard the lungs, a horrible gasp as the air rushed in. Tex really knew what he was doing. Other junkies risk their lives two, three times a day, using the drug without really knowing what it does. He's the heaviest user I know but he's the most intelligent. Also he has a ferocious loyalty to his fellow musicians. Like some guys would have rolled him out the door, let him die. He stood by him — and this was the seventh time the guy had gone out like that, he told me, and every time he's brought him around."

A story like that will go the rounds of the beat pads and become part of the Tex legend. Or the story of how Rock, another hero of the jazz and junk cult, kicked the habit. Here is the way Tanya tells it.

"It was the time Rock and his trumpet player, Mitch, were here and the heat was on and they were having trouble getting something and Rock finally got something from some girl and both of them fixed up. They had a recording date the next morning and they both staggered in real late feeling real bad. 'Oh, that was strong stuff,' they were saying. And that night they did up the third cap and the same thing happened. They fell sound asleep. Then Rock came over and told Mitch it wasn't heroin they'd been using, it was a strong sleeping sedative. Then it dawned on them that they'd been going three days without heroin and they hadn't been particularly sick. They hadn't felt good but there hadn't been any of those horrible withdrawal symptoms. And Tex said, 'Hell, this is *it*.' Only one of them kicked. Mitch went back on junk six months later. But Rock got the monkey off his back for good that way — with sleeping pills!"

Everything the shamans of jazz do is legendary material for the beat: the gargantuan user, the cat who kicked it, the martyr-hero who died of it. Dead, he becomes, like Charley Bird Parker, a cult hero on the order of James Dean and Dylan Thomas.

Bix Beiderbecke, the great cornetist of the twenties, made the Valhalla of jazz on alcohol. Buddy Bolden, the first of the jazz greats, made it posthumously. How he flipped his wig in the middle of a street band parade in New Orleans, cornet in hand, and never came out of it, is

another one of those hero legends. Huddy (Leadbelly) Ledbetter made it on a combination of booze and murder. Of course all of them were great artists of jazz or the legends would never have grown up around them in the first place.

The hip cats among the holy barbarians will tell you they have no desire for the heavy stuff, but their curiosity about it is boundless, and if you listen to them talking about it you will not fail to notice their admiration for jazz musicians who are known to use heroin in heroic doses.

The Little Flower's Report on the Tea-pads

Before 1944, when New York Mayor Fiorello La Guardia's Committee on Marihuana made public its exhaustive report, the drug had been blamed for every crime in the book. In a pamphlet issued by the International Narcotic Education Association (Los Angeles, 1936), it was called "a most virile and powerful stimulant" that produces "a peculiar psychic exaltation and derangement of the central nervous system . . . sometimes convulsive attacks and acute mania, and decreases of heart beat and irregularity of pulse. Death may result from the effect upon the heart."

This pamphlet went on to say:

Prolonged use of marihuana frequently develops a delirious rage which sometimes leads to high crimes, such as assault and murder. Hence marihuana has been called the "killer drug." The habitual use of this narcotic poison always causes a very marked mental deterioration and sometimes produces insanity. Hence marihuana is frequently called "loco weed." (Loco is the Spanish word for crazy.)

While the marihuana habit leads to physical wreckage and mental decay, its effects upon character and morality are even more devastating. The victim frequently undergoes such degeneracy that he will lie and steal without scruple; he becomes utterly untrustworthy and often drifts into the underworld where, with his degenerate companions, he commits high crimes and misdemeanors. Marihuana sometimes gives man the lust to kill unreasonably and without motive. Many cases of assault, rape, robbery and murder are traced to the use of marihuana.

In a column headed "HEALTH ADVICE," the New York *Daily Worker* had this to say about the "reefers."

> Smoking of the weed is habit-forming. It destroys the will-power, releases restraints, and promotes insane reactions. Continued use causes the face to become bloated, the eyes bloodshot, the limbs weak and trembling, and the mind sinks into insanity. Robberies, thrill murders, sex crimes and other offenses result.
>
> When the habit is first started, the symptoms are milder, yet powerful enough. The smoker loses all sense of time and space so that he can't judge distances, he loses his self-control, and his imagination receives considerable stimulation.
>
> The habit can be cured only by the most severe methods. The addict must be put into an institution, where the drug is gradually withdrawn, his general health is built up, and he is kept there until he has enough will-power to withstand the temptation to again take to the weed.
>
> The spread of this terrible fad can be stopped only when the unscrupulous criminals trafficking in the drug are rooted out.

The La Guardia Committee, staffed by a full complement of doctors, psychiatrists, psychologists and officers of the narcotic squad of the Police Department, and financed by the Friedsam Foundation, the New York Foundation and the Commonwealth Fund, began its researches in 1940 and reported four years later that "marihuana is not a drug of addiction," that "those who have been smoking marihuana for a period of years showed no mental or physical deterioration which may be attributed to the drug." Increase in the pulse rate and blood pressure was confirmed but "no changes were found in the circulation rate and vital capacity."

> Smoking marihuana can be stopped abruptly with no resulting mental or physical distress comparable to that of morphine withdrawal in morphine addicts. . . .
>
> In most instances, the behavior of the smoker is of a friendly, sociable character. Aggressiveness and belligerency are not commonly seen, and those showing such traits are not allowed to remain in "tea-pads."
>
> The marihuana user does not come from the hardened criminal class and there was found no direct relationship between the com-

mission of crimes of violence and marihuana. "Tea-pads" have no direct association with houses of prostitution, and marihuana itself has no specific stimulant effect in regard to sexual desires.

The marihuana users with whom contact was made in this study were persons without steady employment. The majority fall in the age group of 20 to 30 years. Idle and lacking initiative, they suffer boredom and seek distraction. Smoking is indulged in for the sake of conviviality and sociability and because it affords a temporary feeling of adequacy in meeting disturbing situations.

Providing there are no disturbing factors, as is the case in gatherings of small friendly groups or parties in "tea-pads," the regulated smoking produces a euphoric state, which accounts for continued indulgence. . . . The marihuana user acquires a technique or art in smoking "reefers." This involves special preparation of the cigarette and the regulation of the frequency and depth of inhalations. In a group of smokers, a cigarette circulates from one to another, each in turn taking one or more puffs. The performance is a slow and deliberate one and the cigarette, held in a forked match stick, is smoked to its end.[18]

The La Guardia Committee report is still the classic study of the subject and commands respect in all informed quarters, but the punitive statutes against marijuana are still on the books and are today, if anything, more savage and vengeful than they were in 1944. What is the reason for this attitude toward the marijuana smoker?

The animosity between those who do and those who do not — whether it be liquor, pot, sex or any number of other things — is almost as strong as the animosity between the Haves and the Have-nots. It may be that the two confrontations are not entirely unrelated. For one thing, there are more Do's among the Have-nots than there are among the Haves, and it is the Haves who make the laws. As Angel Dan Davies says:

"They can pass a law against anything and over night they've created millions of new criminals. Maybe it makes them feel good to think there are so many of us and so few of them."

Exclusivity is certainly highly prized among the Haves and the feeling of belonging to the small and select company of the virtuous and the righteous is probably a factor in prohibition and censorship of all sorts. In the case of marijuana it takes on added force from the

suspicion of the Do-nots that the Do's are enjoying satisfactions which they are, for one reason or another, inhibited from enjoying. This accounts for the wildly exaggerated stories of marijuana and sex and the fabricated horror tales about mania, insanity, thrill murders, rape and robbery.

So far as the marijuana cats among the beat generation are concerned, no proper understanding of their use of pot is possible without probing the psychological and social roots of its use and misuse.

The Psychological Factors: Pot and the Pleasure Principle

It is a sad commentary on modern society that a word like euphoria, which in Greek meant well-mindedness, cheerfulness, merriment, graciousness and glad thoughts, should have come to have pathological connotations and to mean in common usage something like a fool's paradise. Happiness pills is a popular name for the euphoric drugs. The word pleasure, too, has undergone a process of downgrading, in usage, at one time narrowing down in the puritan mind to sex and sadism in such expressions as "to take one's pleasure" of a woman, "houses of pleasure" for whorehouses and, in law, "at the king's pleasure," a phrase that referred to the sentencing of a convicted felon and could well mean anything from torture to life imprisonment.

It was Sigmund Freud who brought the word pleasure back into good odor again, but not without a sickroom smell clinging to it. Freud raised pleasure to capital status, with a double *P*, in The Pleasure Principle — "any given process originates in an unpleasant state of tension and thereupon determines for itself such a path that its ultimate issue coincides with a relaxation of this tension"— [19] a definition that the first American young generation to be influenced by Freud, the generation of the twenties, took very much to heart, even before he had fully formulated it. Most of them, judging from my own observations of the twenties, had discovered it on their own, without ever having heard of Freud. And subsequent generations of American youth went right on honoring the definition in the performance as well as in the breach long after Freud himself went *Beyond the Pleasure Principle*,[20] qualifying and refining and redefining what he meant by pleasure and pain and finally winding up with something he admitted even he couldn't explain.

When it comes to unpleasant tensions needing to be relaxed, the beat generation of today knows things that Freud and his generation never knew. Poetry, music and the dance have a long and honorable history as pleasure-givers, detensers and euphorics. They can be taken in varying degrees of concentration and in varying doses, depending on the education and sensibilities of the "patient." And the same is true of a euphoric such as marijuana.

On the lowest levels of pleasure enjoyed by almost illiterate young juveniles like Myra Flores or Willie Frank, it need yield only the simplest pleasures to produce a relaxation of tensions. Myra's mother works in a defense plant all day and her father in the kitchen of an all-night drive-in. She doesn't see much of either one of them, but when she does it is words and blows all the way — she has scars to prove it — an unhappy home situation that fits neatly, I think, into the "unpleasant state of tension" that Freud defined as a condition in need of relaxation. She finds relaxation in sex — "going steady" is no euphemism in Myra's set — and in drugs. In Myra's case it is heroin when she can get it, but most of the time she has to make it on pot, although she looks down on it as "kid stuff." From her friends I learned that while Myra's boast that she has been on horse since she was thirteen is technically true, it is mostly a boast, because the heavy stuff is much too costly for a kid of her age and she is still in the sniffing and popping stage. What Myra gets out of pot is simple but satisfactory.

"It makes me feel — like they say cool. Mellow like. It makes me forget my old man and my old lady, for a while. Like they hassle me all the time and — what would *you* do? what would *anybody* do? I go out with the gang and we have a ball. When I'm high and nobody is bugging me I'm easy to get along with, but nothing brings me down faster than to get home and find my old man drunk in bed with some broad and Mom at the factory — and all he can think of to do is bop me around just to show me what *will* happen to me if I rat on him — as if I ever would! I'm not *that* kind. Like all I want is both of them they should leave me alone. As long as I keep my nose clean and keep out of trouble — "

The case against marijuana is usually clinched, in the opinion of those who point with alarm, by the argument that it leads to heroin addiction. It might, but so might a broken romance or a business failure. In Willie Frank's case it was just the other way around. It was an

OD — an overdose — of horse that led him back to marijuana.

"So we get this horse and we go up to this guy's house and we jump in and Muzzy hits up, you know, he's got the worse habit, he hits up. And he hits up the whole thing and he gets blind and he starts nodding, you know, hanging. And this other guy hits up but he only hits half of it and he gets blind, he's hanging. So I said, 'I'm going to get high next.' So Muzzy says, 'What you gonna do, use all of it?' and I says, 'No, man, only half of it, it's powerful stuff.' So he wants to do half of it for me. So I'm sitting at the table and I hit up and like you usually take a draw back of the blood into the syringe, like they call jacking it, it doesn't really do nothing. But like this time I just shot it in there and it hit me right away. And I just went back like and pulled the spike out and I laid it on the table, like that. Then the cat sitting across the table from me says, he says, 'How do you feel, man?' and I said, 'Man, if I get any higher I'll — I'm not gonna enjoy it.'

"Just then my head started falling and I couldn't hold my head up, so I had to stand up, and Muzzy's there, he's cleaning the spike, you know. I said, 'Muzzy, I'm gonna fall out.' He's real small and I just fell on him, I fell out. Muzzy said I turned blue and my heart practically stopped. And they started shooting me up with salt and water and putting ice on me all over, you know, running ice all over me and they said it was more than a half hour before they could even get me up, you know. And they were walking me up and down, up and down in the parlor so I could come out of it. Well, the first thing I can remember is the girl and the guy got me there and were walking me up and down, up and down, you know. After a while I started walking myself and I finally sat down and I was so high I couldn't stand it and I couldn't get up again. I started to just go out again. So they get me up again and out in the air and I walked around outside. So everybody leaves and they go down and take us downtown. They leave me and Muzzy off quite a bit of ways from where we're going and we walked there. So I had to hold onto Muzzy's shoulder so I wouldn't fall down, you know, so I could balance myself.

"We get down to Main and Market and there's a bunch of guys hanging there and Muzzy starts talking to them. So I go to lean up against the wall there and I just started to fall down, you know. Then he would have to come over and stop me and get me going and I'd walk myself, you know. We were down there about an hour and I kept falling out.

It got so that I was falling out walking, you know. So he gets somebody to drive me home.

"I get up to the house and go in there and my mother's laying on the bed. Well, you know, I don't want her to see I'm high cause like, well, I told her I wasn't going to get high any more. She takes one look at me, you know, and she gets scared to death, she thought I was going to die. I was just chalk white and my eyes were up in my head somewhere and I just looked like I was dead, you know. I was high for three days and like you just can't sleep and before that stuff got out of my system I was high three days, and that was the last time I shot up."

Willie found that after the first few days of withdrawal pains the pot made it for him okay.

"We used to go up there (to New York's Harlem) and this guy Sam used to get the best pot you ever seen. It was Panamanian pot and I think that's the best pot there is. They were in great big bombers, man, like king size. They were a dollar a joint like but they were worth it. We'd get up there, this guy Frenchy and I and we were real comedians, you know, we were really something. That cat would put on a whole stack of records that made a story like, you know. Like all different singers but they just came out and made a story. And this guy, as the records would be playing, he would answer them, you know, like, the record would come on and he would talk back to the singer and man, it was a gas.

"One night these two girls are there and there are about eight of us in the place and we're all high. Like I'm sitting in this great big chair and it's like a king's chair, you know, with a great big curve in the back and everything. I'm sitting there and Frenchy comes over and says, 'So what do you think, Mr. President?' So we come on like we're having a council, you know, this guy was minister of the interior and this one is secretary of state or something, and this went on for hours and we're passing pot around, and we're sitting on top of the world. I mean like I was having more fun with pot than I ever was with horse any day.

"Like one night there was these two lamps in the place, you know, Chinese figures, and one was male and the other one was a female, you know. So Frenchy he would walk up to one and he'd say, 'What did you say?' and he'd say to us, 'Shh, I'm talking to the lamp.' And then he'd listen and he'd say, 'Oh, yeah,' and he'd start talking to the other

lamp, you know. Then the two lamps would be talking to each other and he would be like interpreting. One lamp would tell him something and he'd tell it to the other lamp. We'd be sitting there and listening and listening, you know, really hung up on what's happening with these two lamps and what are they saying. He'd say, 'None of that now' and we had to stop blowing pot at the statues because he said they got too high and were arguing with each other, you know.

"Oh, yeah, I'll never forget my first time getting high on pot with these guys. These guys were above us — more educated like and they got imagination, you know, and they could make up things — and I wanted to get high with them, me and Ollie and Sneezie. And Sneezie goes up and buys a pound of pot, you know, and we all go up to Frenchy's house. We're in Frenchy's kitchen, rolling pot, and pretty soon we all go into the parlor and he's got the radio on real low, no lights on, just a little red light. Nobody could see nobody. We're passing a joint around and all you can hear is puff, puff, puff and all you can see is the light from the cigarette. So this goes around I don't know how long and everybody is blind, you know. And then pretty soon you would hear a kind of snicker, then maybe the guy next to you would snicker and then the whole place would bust up and we'd all be in hysterics. We'd sit there and nobody could see nobody and everybody's laughing and snapping up and nobody's saying nothing. And it was a ball. But then you can be brought down. Like if Sneezie came in and turned on the light it would change everything. He just came in and turned on the light and it just knocked out the whole thing. Like a guy should come down easy, but some guys are sadists and bring you down hard."

What Willie had to say about pot and sex bears out the La Guardia Committee report.

"These two girls I used to get high with are in show business, you know, I don't know what they do. I never asked them or nothing, like they just came up to get high. They lived in the same building and they'd come up and they'd have like a housecoat on with nothing under it and it would fall open and nobody says nothing. There was a few times I did get high on pot where there was a situation where I'd think about sex and I'd just have sex, you see. It's perfectly possible. I mean, a couple of times I got high with these girls and they want to have sex and we got high and we had sex with both of them. If you're going to

a party with a bunch of guys and girls and everybody gets high and there is sex, well, you just do whatever is going on, that's all. When I was messing around with horse the only time I had sex was when I wasn't high, but when I was on horse it was out. Once I laid up with a girl when I was high on horse and it went on all night, we were at it from twelve o'clock till dawn, and it was fun, you know, but nothing was happening. You can't come to a climax."

Between the simple pleasures of make-believe councils of state, contagious laughter and talking lamps of these juvenile delinquents and the complex, modern, cool jazz, philosophical clowning and the poetry readings of the more sophisticated of the holy barbarians there is not so much a difference of kind as of degree. Their orbits intersect at the point where the conflicting, contradictory demands of everyday living become unendurable and something is required to relax the tensions. The square takes a Miltown pill, the pothead takes a puff of marijuana and the junkie takes a heroin fix. Here again it is a question of degree, of means more than of ends.

PART III

10

The New Apocalypse

A PROPHET CAME TO TOWN. RUMOR HAD PRECEDED HIM. HE WENT ABOUT in an aura of wine and marijuana with a retinue of disciples at his heels, all of them drunk or stoned out of their minds with poetry and pot. He spoke in esoteric riddles and obscene metaphors. Lord Byron had introduced the open collar, Walt Whitman the open road, this new prophet the open fly. Dylan Thomas had come amid Philistine rumors of "she-bears, witches on the mountain, exploding pit-heads, menstruating babies, hounds with red ears, Welsh revivalists throwing dynamite and semen in all directions," according to Kenneth Rexroth.[21] This new poet-prophet had the Philistines spreading breathless tales of bearded hermaphrodites speaking in secret tongues, jazz Saturnalias, manholes erupting piss, pus and corruption, and bebop poets careening madly down the San Francisco streets naked on roller skates.

People I knew in the Bay city reported huge throngs of youngsters crowding into poetry readings, carrying on like Elvis Presley fans at a Rock and Roll binge, shouting, stamping, whistling, doing snake dances in the aisles. A mailed announcement from San Francisco advertising one of these readings went like this:

> CELEBRATED GOOD TIME
> POETRY NIGHT
> Either you go home bugged or completely enlightened. Allen Ginsberg blowing hot; Gary Snyder blowing cool; Philip

Whalen puffing the laconic tuba; Mike McClure his hip hight
notes; Rexroth on the big bass drum.

Small collection for wines and postcards.

| Abandon | Noise | Strange pictures on walls |
| | Oriental music | Lurid poetry |

Extremely serious

TOWN HALL THEATRE

One and only final appearance of this Apocalypse

Admission free

A visiting poet from the East Coast, Richard Eberhart, had written
an account of these goings-on for the *New York Times Book Review.*
"Poetry here has become a tangible social force, moving and unifying
its audience, releasing the energies of the audience through spoken,
even shouted verse, in a way at present unique to this region."[22] He
attributed this activity in part to the establishment three years before
of the Poetry Center at San Francisco State College, but from what I
could gather from other sources and from a visit to San Francisco, the
Poetry Center there was not much different from the dry, droning
poetry readings at New York's Poetry Center at the Y.M.H.A. or any
similar place. The only time the San Francisco State College Poetry
Center was really swinging was when the poets of the new Apocalypse
took the stage and their disciples whooped it up. Then it was a real ball.

I was not unprepared for Allen Ginsberg's visit to Los Angeles, since
he had written me from San Francisco, but when he got to town Nettie
and I were so exhausted from all the poetry-reading parties we had
been throwing for visiting poets that I was relieved when the editors of
Coastlines, the L.A. quarterly, offered to sponsor the reading. I knew
they had no use for the sort of thing Ginsberg was writing or what we
were doing in Venice West (in fact, much of their magazine is devoted
to attacking it), but now that it looked like it might be attracting wide
public attention they wanted to get into the act.

The reading was to be held in a big old-fashioned house that was
occupied by two or three of the *Coastline* editors, living in a kind of
Left Wing bohemian collective household, furnished — what there was
of furniture, which wasn't much — in atrociously bad taste, nothing like
the imaginative and original décor of the beat generation pad, even the
most poverty-stricken.

I consented at their request to conduct the reading, "chair the meeting," as these people are in the habit of saying. To them everything is a meeting. In this case they got more than they bargained for. Allen showed up high — mostly on wine, to judge by the olfactory evidence — and, after an introduction by me, in which I tried to spell out something of the background of this "renaissance," he launched into a vigorous rendition of *Howl*. Launched is the word for it. It was stormy, wild — and liquid. In his excitement he tipped over an open bottle of wine he had brought with him, spilling it over himself, over me and over his friend Gregory Corso who was with him and was also scheduled to read.

Allen and Gregory had refused to start till Anais Nin arrived, and now that she was seated in the audience Allen addressed himself exclusively to her. He had never met Anais before and knew her only from Henry Miller's books. She had written the preface to Miller's *The Tropic of Cancer* in the Paris edition of the book. He was sure that Anais was one person who would be able to dig what he was putting down. For him there was no one else in the audience but "beautiful Anais Nin." That she had long ago come to the parting of the ways with Henry Miller and was making her own scene now, a very different scene from the one they had once made together on the Left Bank of Paris, made no difference to Allen. She was still, to him, the Anais Nin of the Henry Miller saga, a fabulous figure out of a still brightly shimmering past. Artistically, he felt, she was his nearest of kin, and Anais very graciously acted out the role he had cast her in that night.

The audience, except for Anais and the people we had brought with us from Venice West, was a square audience, the sort of an audience you would find at any liberal or "progressive" — how that word lingers on even though the song is over — fund-raising affair of the faithful who are still waiting for the Second Coming. Few of them had come knowing what to expect. They never read anything but the party and cryptoparty press. The avant-garde quarterlies are so much Greek to them. Most of them don't even know such magazines exist any more. They associate that sort of thing with the little magazines of the twenties which were swallowed up with the advent of *the* Movement, the *real* Movement (capital *M*), in the thirties and transformed into weapons in the class struggle. The few who *had* heard rumors of what was going on in San Francisco and Venice West were there as slum-

mers might go to a Negro whorehouse in New Orleans, to be *with*, briefly, but not *of*. But even they were not prepared for *Howl*, or for the drunken, ecstatic, tortured, enraptured reading Allen was giving it that night. A very moving performance, for all his tangle-tongue bobbles and rambling digressions. He was reading from the book, which had just came out, but he changed words, improvised freely, and supplied verbally the obscenities that the printer had in a few cases deleted.

As it happened, Allen and Gregory were not the only ones in the place who had been drinking. There was one other — in the audience. He was someone who had drifted in, having somewhere picked up one of the pluggers advertising the reading. At first he applauded Allen's reading — at all the wrong places and too loudly. Then he took to cheering, the kind of cheers that are more like the jeers they are intended to be. I watched him and it struck me that he looked and sounded like a brother Elk on the loose, or an American Legion patriot on a convention binge. When Allen got to the poem *America*, the drunken square was visibly aroused. He began to heckle. Allen ignored him and, at one point, interrupted the reading to ask the heckler, very gently, to hear him out and he would be glad to talk to him about it later and listen to any comments or criticism he cared to make. That, and disapproving scowls from some members of the audience who, being squares themselves — and sober — dislike anyone "making a scene," stopped him for a few minutes.

Gregory Corso now got up to read — or, rather, sat down to read — Gregory, unlike Allen, is the gentle, relaxed persuader rather than the shouter. At least he was that night. When the drunk started heckling him, too, he turned the face of an injured angel to him. When that failed he reversed himself and tried shock therapy —

"Listen, creep, I'm trying to get through to you with words, with magic, see? I'm trying to make you *see*, and *understand* — "

The square had an answer for that. "Then why don't you write so a person can understand you, instead of all that highfalutin crap?"

"You will understand," Gregory replied patiently, "if you open yourself up to the images. Try to get *with* it, man."

"You think you're smart, don't you?"

Gregory ignored the remark and went on with his reading. Nothing

could have angered the drunk more. It brought out the righteous citizen in him.

"Think you know it all, don't you? I know *your* kind. It's punks like you that are to blame for all this — all this — " he sputtered, unable to make up his mind which of the crimes punks like this were to blame for were equal to the enormity of the occasion. He tried again, gave up, turned a beet red and, to cover his chagrin, launched into a tirade of uninspired, stereotyped, barroom profanity, ending with, inevitably, an invitation to "step outside and settle this thing like a *man!*"

Gregory grinned. "Yeh, I know, you want to fight. Okay, let's fight. Right here. Not with fists, you cornball. That's baby stuff. Let's fight with a *man's* weapon — with words. Images, metaphors, magic. Open your mouth, man, and spit out a locomotive, a red locomotive, belching obscene smoke and black magic. Then I'll say: Anafogasta. Rattleboom. Gnu's milk. And you'll say: Fourth of July, Hydrogen bomb! Gasoline! See? *Real* obscenities. . . ."

The drunk was indignant. He was outraged. When he heard snickering in the audience he started toward the front of the room, menacingly, repeating his challenge to step outside and settle this thing — "You're yella, that's what. Like all you wise guys. You're yella —"

Ginsberg got up and went forward to meet the drunk.

"All right," he said, "all right. You want to do something big, don't you? Something brave. Well, go on, do something *really* brave. *Take off your clothes!*"

That stopped the drunk dead in his tracks.

Ginsberg moved a step toward him. "Go on, let everybody see how brave you are. Take your clothes off!"

The drunk was stunned speechless. He fell back a step and Allen moved toward him, tearing off his own shirt and undershirt and flinging them at the heckler's feet. "You're scared, aren't you?" he taunted him. "You're afraid." He unbuckled his belt, unzipped his fly and started kicking off his trousers. "Look," he cried. "*I'm* not afraid. Go on, take *your* clothes off. Let's see how brave *you* are," he challenged him. He flung his pants down at the champ's feet and then his shorts, shoes and socks, with a curious little hopping dance as he did so. He was stark naked now. The drunk had retired to the back of the room. Nobody laughed. Nobody said a word. The audience just sat there,

mute, staring, fascinated, petrified, till Allen danced back to his seat, looking — I couldn't help thinking at the moment with inward amusement — like Marcel Marceau, the great French mime, doing his hopping little David and Goliath dance. Then the room was suddenly filled with an explosion of nervous applause, cheers, jeers, noisy argument. Our hosts, the editors of *Coastlines*, had been having a huddle on the sidelines. Now one of them, Mel Weisburd, dashed up front and stood over Allen menacingly.

"All right," he shouted, "put your clothes on and get out! You're not up in San Francisco now. This is a private house . . . you're in someone else's *living* room. . . . You've violated our hospitality. . . . If this is what you call . . ."

He looked over at me as if to say, "*You're* chairman here, *do* something."

I rapped for order like a proper chairman and announced the next order of business. Gregory Corso would read another group of poems and then we would hear from Allen Ginsberg once more with his poems *Sunflower Sutra* and *A Supermarket in California*. Corso was all for leaving at once. "We'll go somewhere where we can get good and drunk — and take Anais Nin *with* us." But Allen shook his head and quietly put his clothes on, one piece at a time, in slow motion, smiling to himself with half-closed eyes. A sly, mysterious, innerdirected Buddha smile.

The reading went on amid general approval and with closer, more respectful attention than before. The incident had sobered up the drunk. When the reading was over he approached Allen and said, loud enough for everybody to hear, that he was sorry he had made such an ass of himself and where could he buy a copy of *Howl?*

Through it all Anais Nin, faithful to the role in which the poets had cast her, sat imperiously still, only slightly disdainful of the hubbub, like a queen on a throne.

Stuart Perkoff, who was present, later made the incident the theme of a poem —

THE BARBARIAN FROM THE NORTH
for Allen Ginsberg

Blind as roses
we sit in the evenings in rooms of our own choosing

rooms filled with intricacies of many delicately structured parts
which dazzle, and fascinate, and alter appearances and statements.

Everything with its own clear limits
Everything marked and classified
All aspects known
All new structors viewed with distaste

What are we to say, then of a man
who takes off his clothes in someone else's living room?
Are we to applaud?
What is his nakedness to us?
What do we care about his poems?
Do you realize that he is in the light?
How can I be expected to read!

He makes too much noise!
He says dirty words!
He needs a bath!
He is certainly

 drunk!
I hope he soon realizes, that this is, after all, now
and we have many wonderful things to amuse us

when we want to see clowns
we go to the circus.

is he gone yet? can I come out
now?

Transform the Audience

There is nothing wrong with entertaining an audience. The only
trouble with it is that "show business" has loused up the word for
any intelligent or honest-talking use. Likewise there is nothing wrong
with instructing an audience, except that the pedants have loused
up *that* one. In fact, there is nothing wrong with *any* of the common-
sense concepts of the relation between the artist as performer and the
audience as listener-spectator. It is the dishonest, meretricious use to
which the artist-performer's function has been debased that makes the

truthtelling artist bristle when anyone uses words like entertain or instruct in connection with "audience appeal."

The artists who can be said to be identified with the beat generation in one way or another lay chief stress on another function of the artist in his relation to society. He holds that it is not enough to entertain and instruct the audience, he must also *transform* it. When the San Francisco poet Robert Duncan visited Venice West — I should say at once that Duncan came not like the barbarian from the north in dirty dungarees and leather jacket, but more like an esthete, an exquisite in a long greatcoat with flaring sleeves that he wore over the shoulders like a cape, Oscar Wildly — he had some observations to make on this subject:

"At first there is no separation between the writing and the conception of the poem and where it is going to be delivered. Still, as it's written it is always aimed at the audience it is meant for. The poet must have some urge for a large audience, which is also a social urge. What that audience is to be is not clear yet — to me, at least — but that social urge must certainly be to transform the nature of the audience. Not only to find his audience, but the audience must find him, and finding his audience he would also find the ritual conditions necessary to transforming the audience.

"At the present time when we have poetry readings at a Poetry Center, rising out of universities, the poet's urge is disruptive, actually, of these institutions."

Duncan was, at the time, codirector, with Ruth Witt-Diamont, of the Poetry Center at San Francisco State College.

"Poets have not yet learned to distinguish between the intimate poem and its intimate audience and the public poem . . . Marianne Moore, for instance, is a personality so we treat her as such, but she's not in her poetry. We organize a poetry center like you would organize plays today, consumerwise. We insist that the thing we call the public should support poetry, but it shouldn't, because this thing called the public now is the thing the poet abhors. He wants people, the public, to be completely changed. We ask the city to support it civically, but we don't believe in that city, we believe in the other city that men have talked about from the beginning. If a meeting of people hearing poems can be transformed into that city, then the poet has his moment, otherwise he wanders away from such a reading never wanting to read in public again."

Here I wish to tick off a few highlights from my experience with the problem of trying to transform the audience.

AN OFF-CAMPUS READING IN WESTWOOD, California, before an audience of students, some of them English majors and young instructors. A few older women. The place, a studio in a remodeled garage, a collegiate version of a beat pad. Navaho Indian rugs on the floor. Van Gogh's yellow "Sunflowers" on the wall. Unusual winter weather for California. Outside, cold with coat on. Inside, frigid with coat off. No heating at all. My hands and feet are stiff, congealed, by the time I'm half through the manuscript of my (at that time unpublished) *Rainbow at Midnight*. The room is in darkness except for the gooseneck lamp by which I am reading. In the twenties it would have been candlelight, and I would have been cross-eyed with eyestrain by this time. It's a floor-sitting audience but a stiff, unrelaxed, uncomfortable one.

Rainbow is not just a collection of poems, it is a *book* of poems structured to build up a line of thought from start to finish. Not easy to follow at first hearing. It wasn't *my* idea to read it at one sitting. Three hours! But these are earnest young seekers and word had gotten around that this was deep stuff, steel-shot caviar for stout intellectual mastication. I should be flattered but my jaws ache just dishing up the stuff. I finally reach a good stopping place and call for a seventh inning stretch. I come back from the bathroom to find everybody still squatting there, with only the minimum change of posture to ease muscle strain. This is a well-educated audience. It has learned that culture comes high in effort, mental application and physical inconvenience.

The reading is not without its personal rewards. Out of the corner of my eye I can see the faces and by now I know just which eyes will light up at this or that passage, which ones will flash a quick sign of recognition at this or that allusion, which will register shock at a surprisingly heretical phrase on the next page, or a far-out metaphor.

I am numb in mind and limb by the time the reading is over. The audience creaks to its feet but not an honest groan in the crowd. Lively discussions are started. A nice elderly lady comes up to me, her eyes moist with tears, and kisses me on the cheek. She tells me the experience has opened new vistas in life to her. Is this one of my transformed ones? I listen in on one discussion circle and wander over

to another. It is English Lit talk. Where does *Rainbow* fit in? What category? I hear names dropped. Yates, Pound. T. S. Eliot. Joyce. Objective correlative. Free association. Vers libre. It reminds one of this and another of that. That indispensable correlation. Frame of reference. Opinions differ about the poems but everybody agrees it was a wonderful evening.

Not for me. All I want to do is get home to my warm, unesthetic-looking gas heater.

Afterthoughts: Wrong poem, wrong people, wrong place. Some poems require study before hearing and *Rainbow* is one of them. Although there are parts that are clear enough at first hearing, the structure and many of the metaphors and allusions require study before they yield their full meaning. The voice, the sound, *does* add a dimension to the meaning, but not until the other dimensions are already present in the mind of the listener. This is not true of all poems but it is true of a poem of any length or complexity. The wrong people, too, because college-trained young people come to a poetry reading as they would to a classroom. They come to be instructed, not to be entertained, much less to be transformed. It is like a lecture with recitation to be followed by criticism and discussion. The academic daisy chain: a paper on which you make notes for a paper to be read for others to make notes on and write a paper. No communication, no mutuality, no climax. The little old lady with tears in her eyes? I don't want to sound ungrateful but my guess is she was moved by all the wrong things and in ways that would have been embarrassing to me if I had taken the trouble to ask. It's like a heathen being converted by a typographical error in the Bible. I'd rather have a poem panned for the right things than praised for the wrong ones. Wrong place, because — well, let's put it this way: a bed of nails is no place for a love scene.

READING IN A TRACT HOUSE in Inglewood, a L.A. suburb, before an audience of teachers, psychiatrists, psychology majors, anthropologists and their wives. The interior décor of the house is plainly a protest against the tract house conformity of the exterior, but a polite protest, a private one: modern furniture modified by considerations of

comfort, nothing stuffy or overstuffed, but everything well padded. Lighting subdued but direct, nothing indirect or extreme, no home-crafted parchment shades or modernistic metal contraptions. Two sets of bookshelves. One in the living room, for the eyes of casual visitors, business friends and drop-in neighbors. Another in the bedroom for the eyebrow-raising kind of belles-lettres and the sexual esoterica of the professional psychiatrist's library. Everything in its proper place. Tonight my host is making an exception. He is bringing the bedroom into the living room for an evening. A live poet is going to read live poetry, that is, poetry that isn't in the curriculum; some of it isn't even in the books yet. "Go ahead, shock 'em," he tells me. "I've prepared them for you and they know what to expect, so" — with a sly wink — "don't disappoint them." He had met me once before in what was for him, and his wife, a delightfully shocking experience and he wanted to share it with a few chosen friends. He had gone out of his way to buy a few literary quarterlies containing poems of mine. "Give 'em *End of the Line*," he urges me, "and *I Was a Poet for the FBI. That ought to do it!*"

I open with *Inquest*.

> Lock the door. Let no one leave the room.
> A crime has been committed here. An old man
> Stricken on his bed, his face turned to the wall,
> A derelict six days dead and stiffening
> In a rented room. The headlines in their short
> And ugly words of violence report a miracle.
> This morning at the Mass the wine turned water
> And the bread to stone. Cold April comes.
> The fruit is still-born in the seed . . .[23]

I look around me as I continue — no darkroom-spotlight effects here, no floor-sitting, but I can see that the images are getting through to this audience. They are used to dealing with word-symbols. I follow with *I Was a Poet for the FBI*. The laughs come in all the right places but it is nervous laughter. I have trapped them into laughing, out of the repressed, loyalty-oath-bound recesses of their minds, at something they have been bound, bludgeoned and propagandized into fearing and respecting.

I continue with a reading of *End of the Line*. After the first four-

letter word a schoolteacher gets up and walks out. The wives move up
closer, with rapt attention. I know this is going to make trouble later
but what the hell, I'm not billing myself as a marriage counselor with
a proud record of practical adjustments and sensible reconciliations.
I'm here to make trouble all right, but not that kind of trouble. That's
only a side effect of the good medicine I'm putting out and you've got
to take your chances. Another patient is going over the hill, on a pre-
tense of using the bathroom, but I notice that he doesn't come back.
Instead I hear him in a loud argument with the schoolteacher out in
the patio. These tract house walls are paper-thin and their palaver out
there is disturbing the reading. There has been a good deal of drink-
ing and the pair in the patio are noisy-drunk by this time.

The reading is over finally, amid a buzz of excitement. The wives
want to know where they can get printed copies of the poems. The
husbands shake my hand approvingly but their hearts aren't in it.
They have reservations. Couldn't it — wouldn't it be even *more* ef-
fective with some things *hinted* at rather than — you know, more
subtle? But — Oh, yes, *they* want the poems, too. "I'd like to show them
to my secretary at the office," one confides to me, whispering. "She's
one of those prim kind." Another tells me — "I don't know what you'll
think — I'm a technician, working on missiles — after that poem of
yours, *The Ultimate Weapon.*" He wants a copy of *Rainbow* — and
will I inscribe it for him and his wife? I do. He repeats the bit about
being a missile-maker and insists on some reaction from me about
that. "What would you say to *me?*" "I would say to you," I tell him,
"what Walt Whitman said to the prostitute: 'Not till the sun denies
you, do I deny you.'" He is satisfied, chagrined, chastened. He has
done his penance and can go back to the shop with some vague feel-
ing of absolution. Or maybe it's a special dispensation. Anyway, he
wants to be invited to more readings.

I join the walk-outs in the patio. They both descend on me with
disclaimers of discourtesy. It was just too damn hot in the room. But —
and they suddenly remember a radio program I was on, being inter-
viewed on the subject of censorship — did I mean that there shouldn't
be any censorship laws *at all?* He is a high school teacher and has re-
sponsibilities to impressionable young boys and girls. *He* can take it,
nothing can corrupt *him*, but — the usual buts. I have heard it all be-
fore, but I listen and refer him back to the broadcast. I had answered

all those questions and he knows it, but he wants to go over the ground again. It gives him a chance to tell me again what an invulnerable purehearted, pure-minded Galahad he is.

An anthropologist has been in the kitchen lushing up the whisky all during the reading. As I leave he is politely apologetic about having missed the reading — which he had no trouble hearing through the kitchen door, of course — but he just doesn't believe poetry is intended to be read aloud. This from a student of oral cultures, some of which do not even have a written literature, but an extensive oral literature, much of it poetry.

At the door my host is sweating with excitement and self-congratulatory bravado. "You killed 'em," he says. "Some of them will never talk to me again, but the hell with that. They'll never be the same again."

Well, that was the idea.

Afterthoughts: But is it true? Will they really never be the same again? On the surface everything will appear to be unchanged. They will go back to their jobs, doing the same things, saying the same things. But it will be just a little harder for the salesmen of the Social Lie to sell them the old bill of goods. And when a crisis occurs in their lives, if the wife picks up and runs away with another man, or the husband gets tossed off the job for harboring dangerous thoughts, or when one of those black nerve crises hits them and they're fed up with the whole dumb-show or tired of the old rat race, a line of *Inquest* will come back to them, perhaps, or some image from *End of the Line* or some other poem or poet my reading will have led them to by that time, and they'll be ready for a try at the first mile, at least, of the journey perilous, God help them! I don't wish it on my friends and it's too good for my enemies, but luckily the decision is not mine to make. It's more like a contagion; only those who are susceptible in the first place will catch it anyway, and I am only the carrier, and they will become carriers in their turn, and in this way the audience is transformed.

But slowly. None of these people invited me to their homes for similar readings before their friends. Nobody had been asked to pay admission. The drinks were on the house. A few bought copies of *Rainbow* because I had some copies with me and was willing to auto-

graph them. I doubt if one of them would have gone to a bookstore to buy it or mailed a check to the publisher or gone a few blocks out of his way to a public library to pick up a free copy to read. Why should they? Poetry, all art, is a labor of love and the person on the receiving end is like a passive female, not unwilling to be seduced if you catch her in the right mood, but expecting you to make the first move, and often the second and third, too.

No, it is enough for the artist to say it, to do it, to live it. Contagion will take care of the rest. These poetry readings are one way of spreading the contagion.

Jazz, the Music of the Holy Barbarians

JAZZ MUSICIANS THEMSELVES ARE OFTEN PUZZLED AND SOMETIMES IRRI-
tated by the response of the holy barbarians to their music. This is
especially so among the jazz musicians who have made the university
circuit and the musical supermarket scene of the jazz festivals. Those
who have tasted commercial, financial success. They want to forget the
profane beginnings of their art, for "profane" is by definition "outside
the temple." The temple, to them, is Carnegie Hall, Brandeis Univer-
sity and a Victor Records' royalty check in four or five figures. They
are trying hard to persuade themselves it is the temple of the Muse,
not Mammon's, they are headed for.

The holy barbarians, on their part, often fail to discriminate between
the sacred ritual elements in jazz and the show that the "natives"
sometimes put on for the tourists — and the *Yanqui dólar*. The beats
are so hungry that they wolf down everything in sight, or rather in
hearing. The more knowledgeable among them, however, are aware
that jazz is the Dyonysian, not the Apollonian, beat in music. There is
a time and a place for both in the world and sometimes the world
needs one more than it needs the other because there is an imbalance,
a sickness of the human spirit for which the only therapy is a restora-
tion of the balance. The beat generation is seeking such a therapy in
jazz. This is not the first time a generation of the American youth has

turned to jazz as a therapeutic. It happened in the twenties, too, and the squares were scared out of their wits.

One cannot exaggerate the protest with which jazz was met when, in the 1920's, it had spread to Chicago and New York. Composers, critics, ministers of the church, laymen, pundits and ignoramuses had their fling. The storm was historic. An entire era was called the Jazz Age. Not only the sins of its *flappers* and gin-toting *lounge lizards* came to be blamed on this ineffably nefarious music, but also nearly all the woes of the postwar world up to and including the 1929 crash in Wall Street. Reverberations of the storm penetrated even to New Orleans, where the *Times-Picayune* rose hastily to disavow any connection of jazz with its native city.

Although many knew then that jazz had been played in, among other places, whorehouses and wine shops, and judged it accordingly, none knew that it was a fine art transcending its surroundings. Nevertheless, many of the people knew that it was their music, a music created for them by men using lack of formal musical education as the freeing factor in hot and spontaneous creation. The men wanted, needed, to create it; their fellows wanted, needed to listen, to dance, to respond to, and be freed by it.[24]

No one among the youth of the twenties that I knew held it against jazz that it was played in the whorehouses of New Orleans. We listened to and danced to the jazz bands at the Dreamland, White City or the Pekin Café in Chicago and took what we could. Nor did we feel any need to apologize to anybody for the flappers or the gin-toting lounge lizards. Many of these flappers, that Rudi Blesh seems to be trying to disown, were pretty hip to what King Oliver and his New Orleans Rhythm Kings were putting down in those days.

It was mostly gangsters and bootleggers and their molls who got to hear the best jazz of the period, along with a Negro audience and the bohemian underground among the writers. You were more likely to run into Kenneth Rexroth at a Chicago skiffle (rent party, shake and percolator were other names for it) than F. Scott Fitzgerald, or Carl Sandburg, for all his reported early savvy of jazz. At these rent parties we heard Chicago jazzmen like Jimmy and Alonzo Yancey, "Cripple" Clarence Lofton and Albert Ammons, and the barrel house and boogie-woogie of Pine Top Smith.

Hello Central, give me Doctor Jazz.
He's got what I need, I'll say he has.
When the world goes wrong
 And I got those blues:
He's the one that makes me
 Get out both my dancing shoes![25]

And there were plenty of lounge lizards who dug Meade Lux Lewis'
piano plenty before they slid under the table. Most of what is de-
scribed by the historians as the Jazz Age was a "blackface" imitation
of jazz. It was not the jazz we knew, the jazz of Lillian Hardin's piano
and Jimmy Noone's clarinet, or Johnny Dodds's, or the Creole Jazz
Band's at Dreamland and the Pekin Café.

It was only the wayward and irreverent of the twenties who dug
the real jazz of the period or had any opportunity to hear it at all, for
that matter, in places like Chicago's South Side Negro ghetto, or in
dives like Purcell's on San Francisco's Barbary Coast, where they
could catch Oliver and his band, or across the bay at the Iroquois Café
in Oakland. In Los Angeles it was Jelly Roll Morton at Leek's Lake
Resort; and in New Orleans at Lala's it was a new and promising young
jazzman, Louis Armstrong.

The upper-class bohemians of the period that F. Scott Fitzgerald
was writing about thought jazz was Paul Whiteman at New York's
Palais Royal or any "Paul Whiteman Orchestra" (it was a chain store
operation) on board some ocean liner. They listened to the first "race
records," too, but only for their sexy content, without trying to learn
something about the musical content of the blues. They dug it only
because it was hot, low-down and dirty, and a public scandal. When
the commercialized imitations of the blues came along, substituting
"suggestive" lines for the earthy directness and unsentimentalized sex
of the anonymous folk blues, it was all the same to them. They
couldn't tell the difference.

Kansas City, St. Louis and Chicago seem to have been the focal
points from which boogie-woogie spread out through the country, al-
though regional forms of it have been traced through the South from
Arkansas and Tennessee to Texas and Louisiana. The bohemian Left of
the thirties made much of Pine Top Smith and Meade Lux Lewis as
folk artists, and during the United Front wartime forties Negro musi-
cians of any sort in the hot jazz style were much sought after in Holly-

wood for fund-raising parties in democratic and progressive circles. Leadbelly (Huddy Ledbetter) and Josh White were always head-liners at these affairs. And, of course, there were always the folk sing-ers, Alan Lomax, Pete Seeger and others, the composer-singer Earl Robinson and a host of lesser-known artists. Hot piano or guitar in the blues changes were about the limit of any real understanding in Leftist circles as far as jazz went. These fitted their notions of a "col-lective" nonindividualistic folk art which, according to the prevailing party line, rose up spontaneously from the masses and was therefore free from the taint of capitalist commercialism. Ritual, healing, or spiritual catharsis was no part of their esthetic. If the stuff was sexy, well, that was just part of the earthiness that made it folksy, like the Peter Bruegel prints ("Peasant" Bruegel) which they hung on their walls.

What makes ritual efficacious as a personal or a group therapy is social consensus, the acceptance of certain symbols and their potency within the magic circle. All music is sacred and ritual in origin, but in European music these origins have long been "refined" out of it. In jazz they are still close to the surface. That anything can be orgiastic (in the Greek sense of *orgia*, secret rites practiced only by the initiated, as in the rites of Bacchus or the worship of Demeter at Eleusis) and still be sacred in the best sense of the word is a concept that the offi-cial culture cannot tolerate, especially in a predominantly Protestant society. Dance was always looked upon with suspicion by the priestly mind and finally banished from the churches. In Europe the drum, the basic dance instrument, has been used chiefly to "drum up" troops for military service and keep them marching hypnotically under orders. In Africa the drum has many and varied uses, including communication at a distance, but its use in the sacred dance (and the secular dance as well) has never been curtailed, except by European colonial authori-ties. In the United States the European attitudes prevail. During the last century in the South drumming was forbidden by the slaveowners, but in the woods under cover of night the slaves would meet and beat their homemade drums under washtubs to muffle the sound, nocturnal gatherings that recall the witchcraft meetings in Europe. "Despite this," says Rudi Blesh, "the tradition of percussive polyrhythms has persisted in the hand-clapping and stomping of the spiritual-singing in

the churches, in the jazz band, and, in one form or another, in all
Afro-American music."[26]

It is from its use with dance that music derives much of its kines-
thetic character, the feeling of muscle tension and the sense of move-
ment which is part of the esthetic pleasure in all musical experience,
particularly where percussion lays down the beat, as in the rhythm
section of the jazz band. The variety of rhythmical patterns that can
trigger kinesthetic response in the listener is very great, the most
obvious being those which produce a sound effect in nature itself, such
as a dog's trot, a running horse, the ticking of a clock, the heartbeat, a
person walking, ocean waves, thunder. Less obvious but none the less
rhythmical are the seasons, the morning, noon and night tempos of
everyday living, childhood, youth, maturity and aging, and the suc-
cessive steps of the sexual experience.

In more abstract music sex can be as cool and complex as the meta-
physical orgasm or the hours-long mating of the hero gods and god-
desses in Wagner's operas. In jazz, where the very name of the music
is still identified by millions as a synonym for the sexual act itself, the
kinesthetic experience of the listener, to say nothing of the dancer, is
unmistakably sexual. In the blues the lyrics often spell it out in words
of one syllable. Some of the earlier private versions, reserved for the
whorehouse, the saloon and, today, heard only in after-closing-hours
jam sessions, sometimes spell it out in words of four letters, as for ex-
ample in such old-timers as "the dirty dozens."

The sexual in music becomes the therapeutic when it has the effect
of liberating the listener from his inhibitions, something that squares
react to in jazz with fear and fascination. For squares are by definition
angular and rigid in sex, awkward and guilt-laden.

> Their arms are knives, their fingers all nails.
> When they try to make love they hurt each other.
>
> They torture themselves with shame and pride,
> With time clocks and unattainable ambitions.
>
> They drag themselves over miles of broken glass
> And stone themselves with false confessions.[27]

THE HOLY BARBARIANS

When it becomes unbearable they run to the psychoanalyst, to whores, to the Hollywood swamis. Anything except the kinesthetic release of jazz music, because they fear the direct approach to their problem. They prefer that the cure, if any, should have a scientific, medical-sounding name, or be followed by the self-punishment of guilt feelings, or, as in the case of the swamis, come wrapped up in some phony mystical jargon that sounds, to them, like religion. Jazz is too pure for them to take straight.

The sexual in music becomes sacred ritual when it raises sex to the level of the *sacre*, holy, which in turn means wholeness, integration. It is a sacrament when it is socially responsible, when it has the force of an oath between lovers. It becomes sacrilege when it is stolen out of its hierogamic context and used for profit, violence, rape.

For the holy barbarians jazz music is both a therapeutic and a sacred ritual, in addition, of course, to its many secular uses. For them it makes a swinging scene out of the sexual act, before, during and after. That it is considered profane in contemporary Western society makes it no less sacred to them. It has its own temples, back-alley temples and hideaway shrines, not unlike the nocturnal woodland worship which has always marked the outlawed religions. Knowing the language of jazz, its *musical* language, and sharing it with others in a closed company of the initiated, is perfectly in keeping with its secret religious character. Add to this its special hipster jive and you have something very much like a *mystique* of jazz.

To the beat generation it is also a music of protest. Being apolitical does not preclude protest. There are other solutions besides political solutions. Or, if not solutions, then at least some kind of relief. For some things, in the view of the disaffiliate, do not permit of any solution, at least not at the present time. It was the sex, not the protest, that the youth of the twenties looked for in jazz. The youth of the thirties looked for protest in the Negro jazzmen as a member of an oppressed and disfranchised minority, rather than in the music itself, except where it was most obvious, as in the work songs of the plantations and river docks and in ballads like *Stagolee, Mr. Boll Weevil* and *John Henry.* In the forties, anything in jazz, even if it was only a near cousin like *The T. B. Blues* or *Careless Love,* was hailed as united front and anti-Fascist by the swimming pool proletariat. To the present generation of nonconformist youth the simple existence of jazz itself is

protest enough. They see it pitting its spontaneous, improvised, happy-sad, angry-loving, ecstatic on-the-spot creativity against the sterile antiseptic delivery room workmanship of the concert hall that the squares take for musical culture. And they whisper — coolly, quietly but intensely — "Say it, Satch!" "Tell 'em, Gerry!" "Blow a great big hole in the walls they have thrown up to keep man from man." They know that what the Bird is putting down in those one-two punches on the horn is shock treatment with a love as fierce as anger and better than insulin or metrazol. They even welcomed Rock 'n Roll, for *all* its ballyhoo, as a fresh smell of young sexuality in the square's fetid and buttoned-up world. For a little while everything was barbarous again.

They listen to Béla Bartók, too, especially to those compositions where he draws most on Hungarian dance patterns and achieves percussive, dynamic effects which convey a strong kinesthetic impact. The more sophisticated among them dig his polytonal harmony, his dissonances, just as they dig "the Schönberg bit" and flip over Stravinsky's *Rite of Spring*. They honor the old maestro for his early interest in jazz despite the fact that he probably mistook corny vaudeville pit bands for the real thing. The same sophisticates also listen to Paul Hindemith and Darius Milhaud because they know that some of the modern cool jazz musicians studied with them, but they only smile at Milhaud's own "jazz ballets" just as they smile at Stravinsky's 1918 *Ragtime* movement in *Histoire du soldat*. Morton Gould's *Chorale and Fugue in Jazz* and the John Alden Carpenter ballets *Skyscrapers* and *Krazy Kat* are given more respectful attention, as are Krenek's jazz opera *Jonny spielt auf* and Aaron Copland's *Concerto for Piano and Orchestra* and *Music for the Theatre*, but what really sends them is something like Gruenberg's *Daniel Jazz* or Shostakovich's *Suite for Jazz Orchestra*. They dug Aram Khachaturian's "sword dance" till the disk jockeys played it to death, hearing in it, probably, more that was phallic rather than military, but they leave his concertos to the longhairs. The Indian *ragas* interest and excite them more, because they are improvised, like most jazz, on set themes. There is some talk in the pads about Cage, Varèse and Piston, but not much listening. Not enough has been recorded yet to listen to. George Gershwin is strictly Tin Pan Alley to them, and that goes for *Porgy and Bess* as well as *Rhapsody in Blue*, burnt cork minstrel stuff. Their reaction to Leonard Bernstein is confused, positive and negative by turns. After a few turns of *West Side*

Story on the phonograph they may yank it off and put on Marc Blitz-
stein's and Kurt Weill's Bert Brecht record *The Three Penny Opera*
instead, and yank *that* off after the overture, put on Louis Armstrong's
jazz version of *Mack the Knife* and set the repeat shift on the record
changer. I heard as many as ten successive playings of it in some
pads when it first came out. This, they insisted, was the way Brecht
himself would have liked to hear it sung. I doubt that, but the beat
have a way of making their *own* reality by repeating things often
enough among themselves.

Opera the beat will not be found dead with, not even Menotti's or
with scores by Christopher Fry or Wynstan Hugh Auden. Opera is for
squares. A record like Carl Orff's *Carmina Burana* will be passed
around in beatville for a while, but only because its lyrics (cleaned up
a bit) are from poems by those on-the-road twelfth-century beatniks,
the goliards, whose story is familiar to them from the paperback edi-
tion of Helen Waddell's *The Wandering Scholars*.[28]

Jazz, however, remains the staple musical diet. Tastes tend to be
regional, sometimes aggressively regional, among the beat as among
other jazz buffs. And even further divided, by groups and circles. A
full set of the original Library of Congress Jelly Roll Morton will win
you entry into one pad and do less than nothing for you in another.
Opinions differ on what is jazz hot and jazz cool, what is in the main
stream of jazz and what is off course, what is a forward, far-out step
and what is imitative of the past or downright reactionary and, finally,
what is holy.

Is the stuff Mahalia Jackson sings holy? *Careless Love* was what
Mahalia sang but that was before she was saved. "When I was a little
girl . . . all you could hear was Bessie (Smith). The houses were thin;
the phonographs were loud. You could hear her for blocks. . . . I'd play
that record over and over again, and Bessie's voice would come out so
full and round. And I'd make my mouth do the same things. And be-
fore you know, all the people would stand outside the door and listen.
I didn't know what it was at the time. All I know is it would grip me.
It would give me that same feeling as when I'd hear the men singing
outside as they worked, laying the ties on the railroad." Then she
heard somebody called Blind Frank singing the spirituals. "He used to
come around the churches in New Orleans and play his guitar. Places
where the Holiness folks gathered, the Sanctified people. They sang the

way I like it, with free expression. That's where I think jazz caught its
beat. From the Holiness people. Long before Buddy Bolden and Bunk
Johnson, they were clapping their hands and beating their tambourines
and blowing their horns." Mahalia suffered a critical illness in Chicago
and attributes her recovery to God's amazing grace, and what she
learned from Bessie Smith and *Careless Love* she carried over into
Swing Low, Sweet Chariot and *What a Friend I Have in Jesus.* Same
beat, she will tell you. "You know, the Fisk University choir they made
lots of those songs popular. They took out the beat that the Holiness
people gave them and cultivated it. They concertized them, prettied
them up. Not much feeling, but, oh, it sounded so sweet!"[29] No one
puts Mahalia down in beat circles but you won't hear her records in
beat pads for all her holiness. They'd rather get it straight from Bessie
Smith and Ma Rainey. As far as they can see, there isn't any reason why
Bessie Smith and Ma Rainey couldn't have gone straight into *any*
church — *without* being "saved." They *had* God's amazing grace, "from
in front." That is what Stan Winkler and his friends would have told
you if you had questioned the holiness of their Crucifixion Christmas
tree with its all-cultures ornaments and their congas and bongos and
Art Blakey's African drum rhythms and the Bird's alto horn and Miles
Davis' trumpet and Louie's and Dizzy's and Count Basie on the key-
board and bass man Mingus and tenor man Hawkins — and many
among the holy barbarians would add:

> Holy the groaning saxophone! Holy the bop apocalypse!
> Holy the jazzbands marijuana hipsters peace and
> junk and drums![30]

Poetry and Jazz:
Love Match or Shotgun Wedding?

FROM THE FIRST, POETRY AND JAZZ HAS HAD SOME OF THE ASPECTS OF A swinging love affair and a grim-lipped shotgun wedding. It is hard to say which is the bride and which is the groom. Since the initial proposal — some would call it a proposition — came from the poets, I suppose it would be poetry that was the groom. And, as in many shotgun weddings, the bride was willing enough but the trouble came from the in-laws, on both sides. That is to say, from the critics, the schoolteachers and the editors.

No new art form in the last fifty years has been subjected to so much journalistic distortion as poetry and jazz — by its friends as well as its enemies. As far as the newspapers are concerned, anything avant-garde in the arts is news when it can be presented as a freak or a fad. Poetry and jazz was a two-headed calf. Better yet, it was a two-headed calf of which one of the heads was an animal of some other species, which made the whole thing a carnival side show attraction. A monstrous miscegenation.

One reason why it looked, in its beginnings, like a miscegenation is that it was born in a misconception. Ralph J. Gleason, the jazz critic, writing about the San Francisco phase of it in *Downbeat* magazine (May 2, 1957), quoted Kenneth Rexroth as authority for the idea that poetry and jazz was an attempt to supply jazz music with new and better lyrics.

"Jazz tunes, even in their best form, always have been hung up with weak lyrics, according to poet Kenneth Rexroth. And he extends this, saying weak lyrics are found even in the best popular songs, including those of such writers as Cole Porter." It is not surprising, then, that what Gleason heard in the first poetry and jazz at The Cellar was "a fascinating experiment," but, while "extremely successful commercially . . . not completely so artistically."

For the basic problem is essentially that of the lyricist. The words must fit the music and the rhythm or else the music is only an accompaniment in the background in which the poet's voice, far from being an instrument in the band, is a spotlight or leading actor behind which the music goes its own way, even though related emotionally to the poetry.

The problem is that of fitting a preconceived poem to music that is improvised. Until either the musicians learn to think in poet's structures of thought and frames of rhythms or poets write poetry in the format of songs — to be recited against 4/4 time at a steady rhythm — there will be difficulties.

Six months later, after hearing more poetry and jazz with Kenneth Rexroth and Lawrence Ferlinghetti at The Cellar, and Kenneth Patchen with the Chamber Jazz Sextet at the Black Hawk, Gleason reported in the same magazine (November 14, 1957) that it was still "a sort of freak attraction in San Francisco."

When this whole jazz and poetry hassel began last spring, Kenneth Rexroth said he was just trying to start a fad, maliciously, and foresaw the possibility that it might catch on like swallowing goldfish and become the rage.

There seems a fair danger that he was right.

At this point I fairly expect to see a press release announcing that Abe Saperstein has signed T. S. Eliot for a coast-to-coast tour with the Harlem Globe Trotters and that the proceeds of the next World Series will go toward a fund to free Ezra Pound. . . .

The Black Hawk is doing some business but it is all predicated on a dishonest premise, to my way of thinking. Mostly the poets are slumming. Jazz already has an audience and they don't. They're cashing in on the jazz audience but they won't learn anything from jazz or listen to it or try to allow the natural jazz

rhythms they have to come out. Instead they are blithely wailing away with the same sort of thing that lost them their audience in the first place. . . . Not until a poet comes along who learns what jazz is all about and then writes poetry will there be any merger. What we have now is a freak, like a two-headed calf. That's all.

In other words, it was not going to be successful until poets wrote lyrics *for* jazz. Note, also, that Gleason was giving jazz top billing — jazz and poetry, not poetry and jazz. And accusing the poets of stealing the spotlight and exploiting the jazz audience, of slumming for kicks and "cashing in" on jazz. The poets Gleason was hearing in San Francisco, by the way, were working for free or at most for five dollars or so a night, while the musicians were getting union scale. So much for "cashing in." This was to become, as time went on, the party line of the commercial jazz magazines which rely for their existence not so much on their circulation as on the advertising of instrument manufacturers, phonograph and hi-fi manufacturers and the mass consumption record companies to whom jazz is just another department of the music business. When they referred to it at all they called it "jazz-poetry," with or without the hyphen, and in reviewing the records they reserved their praise for those in which the poetry was most like blues lyrics and had the same themes, or was so trivial and brief as not to "interfere" with the music at all. In short, it was a hatchet job the reviewers were doing on this new art form.

My own experience with poetry and jazz disproves many of these allegations. I was approached by Jack Hampton, a theatrical booking agent with a half-interest in the Los Angeles Jazz Concert Hall, to put on a series of poetry and jazz concerts for him at the hall.

Jack Hampton, as I learned on meeting him, is a jazz guitarist and trombonist of the swing era of the thirties whom changing fashions in jazz had passed by, forcing him, ironically, into booking and promoting the new style "baroque Bach" he disapproves of. The "new sound" of West Coast jazz "is actually pretty much of a stereotype," he told me.

"They phrase and they type up, and they've forgotten the basis of jazz which is the beat. When you lose the beat in jazz you're finished, because then it's just like taking sex out of sexual intercourse. Let's face it, that's what they lost. They tried to abstract something out of it. They abstracted an abstraction and out of that they abstracted

another abstraction, to wit: the way the man plays. He improvises on the original theme and then improvises on what he's improvised and then he improvises on a third improvisation and he ends up with a heap of dung. He's pounding the thing like that and thinks he's getting a new sound. So the whole thing completely loses all identification with jazz. I'm not talking because I'm against these guys, but that way a whole culture can become a madhouse instead of helping the individual within it, and I claim that this country is becoming a madhouse. Then up in Berkeley there's a school that believes there's only one guy that ever existed and that's a guy by the name of Bach, so these guys with the ivy league suits, who never played with a jazz band, who never played the one-nighters and who never had fist fights on the street about who lost the beat, and got thrown in jail like I did in Omaha, guys who never played for three bucks a night and jumped seven hundred miles to make it, these guys sit together in these cloistered little goddamn houses they live in on those campuses where it's nice and cool, with their blondes, and they took the seventeenth and eighteenth century music and they put to it that so-called sound and that became jazz.

"The result of all this is that jazz is no longer a dance art. The Consumers Research says that these kids listen six hours a week to jazz records and they spend fifty per cent of their income on albums. But they can't dance to this stuff. Can anybody dance to our friend Shelly Manne? It's only for listening. So I knew the time was ripe, so there could be a concert hall, just for listening. And it proved itself. Except that we didn't get to the audience."

What Hampton hoped for from poetry and jazz was that it might get to a fresh audience and help him pull his concert hall out of the red. He felt that the thing was salable and "when you get to art and culture, boy, you can sell yourself a hell of a deal." He himself had written poems, back in the thirties, that Langston Hughes once called "the best blues poems ever written by a white man." He and his partner, the famous jazz composer and musician Benny Carter, had sunk thousands of dollars into the hall and there would be little cash for production. Would the poets work for free? I told him I had no intention of asking poets to work at all in these first concerts, but if they did they would have to be paid at least the same basic union scale as musicians. I had experimented for more than a year on poets reading

their work with music and found that they lacked not only the musical knowledge to know when to come in with their "solos" but even the rudiments of effective public speech. The best of them possessed either a monotonous deathbed baritone style or the painful "poeticism" of a lyric tenor. Radio actors, on the other hand, possessed technique but lacked warmth and understanding, while stage actors read poetry like dramatic dialogue, either in the realistic Stanislavski style or hammed-up Shakespeare. I was to have at the most a month or so to assemble and train a jazz band in this new art form and find a few voices that could be coached into something like the kind of vocal rendition I had in mind.

As it turned out, before Hampton was able to line up the musicians there was no time for more than a brief conversation with the leader of the band. As for the voices, I auditioned dozens of voices — speech majors from UCLA, actors from the little theaters, professionals of experience and reputation in the movies and on the stage, radio voices, television actors, disk jockeys. I ended up with a movie actor — who reneged at the last minute and had to be replaced with a little theater actor — a disk jockey and three poets, Stuart Perkoff and Saul White of Venice West and Kenneth Rexroth, whom I brought down from San Francisco for the occasion.

We had the most impressive array of first-rate jazz talent anyone could ask for a poetry and jazz concert: Shorty Rogers and his Giants, including such well-known artists as Bill Holman, tenor sax; Ralph Pena, bass; Marty Paich, piano; and Larry Bunker, drums; and an additional band, billed as a special poetry and jazz group, consisting of such jazz greats as Fred Katz, cello; Bud Shank, alto and flute; Barney Kessel, guitar; Buddy Collette, clarinet and flute; and Red Mitchell, bass. But getting jazz musicians to rehearse at all is a thankless and all but impossible task. Two rehearsals were scheduled. To only one did enough of them show up to make a rehearsal possible, and we had only a few hours to put the thing together. No wonder it took three nights and six performances before the musicians began to pay any attention at all to the words and attempt any kind of co-operation between the music and the poetry. But the audiences — capacity crowds — applauded wildly and enthusiasm ran high. I was gratified with the turnout but my satisfaction with the audience response was tempered by the realization that nobody had anything of

the kind to compare it with and therefore no critical standards.

These audiences were *not* just jazz audiences, as Gleason said they were. They sensed that something important was happening, something they *wanted* to see happen because it filled a need they felt, though few among them had any idea what that need really was or what they should be listening for and expecting to hear.

They were coming to hear poetry, the *sound* of poetry, that lost dimension of the poetic art which went out of poetry with the invention of printing.

Poetry and the Vocal Traditions

Before the invention of printing, poetry was still largely a vocal art. Ever since its beginnings in the ritual drama when the poet was prophet, seer, shaman, priest, judge, bard, singly or in varying combinations, poetry was something to be spoken, chanted or sung with music and, often as not, with dance. It was the "spell," a form of words which performed one of the vital functions of ritual. When the arts of ritual drama were secularized and individualized, poetry still retained its oral character.

What we are witnessing today in public poetry readings and in poetry and jazz is a revival of certain lost elements of oral culture, sparked by the electronic revolution in communications, by the phonograph, radio, tape recorder, and the audio-visual media of motion pictures and television. Poets have long felt that writing poetry merely for the printing press was somehow insufficient, that it left the act of communication incomplete. In 1941, Harry Thornton Moore, writing in *New Directions Annual,* expressed the view that "the sound of poetry is part of its meaning." Many poets had forgotten that poetry *has* a sound. When the Library of Congress began its recorded poetry series, many poets, confronted suddenly with the request that they read their work aloud, found themselves tongue-tied and self-conscious to the point of physical distress.

What had lost the poets their audience was not, as Gleason seems to think, an unwillingness or inability to write the sort of jingles that can be ticked off, syllable by syllable, to the four-four beat of jazz — the only kind of jazz, and the only kind of poetry, too, perhaps, that Gleason has any ear for. What lost them their audience was, in the first

place, the decline of oral culture with the advent of the printing press and, as a result, the decline of the poet's skills with voice and music. In the English language this decline was aggravated by the fact that English as a literary language was born at almost the same moment as the printing press. The earlier languages of Britain perished after the Norman Conquest, and their oral literature failed to become incorporated into the main stream of English literature. This was not the case in France, Germany or Italy, where the oral elements of poetry made an orderly transition from the voice to the printed page. In other oral cultures, for example Wales and Ireland where the printing press was later in making its effect felt on poetry, the vocal elements never completely died out. Dylan Thomas, of course, is the outstanding example of a poet who, although he was not writing in the traditional language of his country, was still able to carry over something of the oral tradition into his poetry. Before the present revival in the United States, there were two previous and abortive attempts to restore poetry to the oral tradition. The key figures in these two attempts were Walt Whitman and Vachel Lindsay, and Lindsay was one of the first poets whose voice was recorded on records. Dylan Thomas' records have sold by the tens of thousands, far outselling most jazz records — this by way of a reminder to Gleason, who is worried about the poets of today trying to cash in on the jazz audience.

What Rexroth and Ferlinghetti were seeking, and the poets of Venice West as well, was a restoration of poetry to its ancient, traditional role as a socially functional art allied with music in a single, reintegrated art form. We turned to jazz music because jazz is the musical language of America in our time. Modern poetry was born at the same time as modern jazz was born and both have had a similar history. Both have had the same friends and the same enemies. Both aimed at freeing their art from the strait jacket of the printing press: in the case of poetry, from the printed page, in the case of jazz, from the printed score. They belong together.

The experiments that had been going on in Venice West, with able jazz musicians like Shelly Manne, Jimmie Giuffre and Buddy Collette, were serving to reveal the artistic problems involved in reintegrating poetry and music. We listened to earlier attempts in the same direction by Igor Stravinsky and Arnold Schönberg. In the preface to his

Pierrot Lunaire, where he used the voice within something like the speaking range, Schönberg had written:

> The melody indicated for the speaking voice by notes (apart from a few specially indicated exceptions) is not meant to be sung. The reciter has the task of transforming the melody, always with due regard to the prescribed intervals, into a speaking melody. That is accomplished in the following way:
>
> 1. The rhythm must be kept absolutely strict, as if the reciter were singing; that is to say, with no more freedom than he would allow himself if he were singing the melody.
>
> 2. To emphasize fully the contrast between the sung note and the spoken note, whereas the sung note *preserves* the pitch, the spoken notes gives it at first, but abandons it either by rising or by falling immediately after. The reciter must take the greatest care not to fall into a sing-song form of speaking voice; such is absolutely not intended. On the contrary, the difference between ordinary speech and a manner of speech that may be embodied in musical form, is to be clearly maintained. But, again, it must not be reminiscent of song.[31]

I pondered what had gone wrong with this early attempt of modern music to integrate poetry with an orchestra and decided that the difficulty stemmed from the composer's effort to retain a harmonic relationship between the pitch of the voice and the music and to keep the rhythm "absolutely strict." This caused it to fall between two stools, with the result that both music and speech were blurred. Its success with the critics of the time I could only attribute to the fact that, for one thing, it was a novel and daring thing to do, and for another, there were no longer any standards of comparison for *spoken* poetry used in connection with music. What Schönberg had attempted to do was, in fact, pretty much the same sort of thing Ralph Gleason was asking the poets do with jazz music. Our own experiments were teaching us that this was a blind alley. It was most certainly not the sort of procedure that the poets of the past had followed with poetry and music. Nor what had been done in the early talking blues.

There was no one method, I found, that solved all the problems of integrating poetry and jazz into an art form. When I came to producing my own recording, *Jazz Canto: Volume 1,*[32] I introduced into it

several different approaches to the problem, each with its own merits and demerits.

For example, the poetry of Walt Whitman on this recording has music written without key and "cued" to the voice only at focal points where the mood or meaning of the poem changes. It is not music *under* the voice, or *behind* it, or to *accompany* the voice, or to *illustrate* the poem. It is the poem itself, freshly written by the composer *in a musical idiom*. It runs parallel to the poem and is equal to it in the attention it demands of the listener. Since it is, in a sense, a "translation" of the poem into music, the instruments Fred Katz, the composer, uses are in each passage those which are naturally associated with the *sound* meaning — that long-forgotten dimension of poetry — the acoustical image evoked by the words themselves. Trumpets and percussion, for instance, to go with the prophetic passages of the poem, clarinets for the meditative passages, and guitar in the "pleading" passages.

Nevertheless I regard it as only a beginning. Poetry and jazz — or Jazz Canto, as I prefer to call it — will not be a viable art form until it solves its problems and becomes a part of the standard repertoire of public performance. Nor should it be limited to jazz music. In *Jazz Canto* several types of music are employed besides jazz. Whatever music is suitable to the poem is the right music. When poets learn more about music and musicians learn more about poetry it will be easier to make progress with this new idiom. To this end I have been laying the foundations for a Jazz Canto Workshop where poets will be required to learn how to read music, play at least one instrument, and take voice lessons in order to learn how to use the voice box for the public rendition of their poetry.

The jazz musicians, on their part, will have to learn something about poetry. The poets among the holy barbarians know much more about jazz than the jazzmen know about poetry. In the Jazz Canto Workshop the jazzmen will have an opportunity to work with poets and learn something about the art and craft of poetry. Even the best-educated jazzmen I know read so little modern poetry that every line and every image has to be explained to them before they can improvise or write music for it.

Only a Jazz Workshop, with serious and dedicated young men and women working together, can solve the many problems that this new

art form presents. Notwithstanding all these pitfalls and drawbacks, Jazz Canto will thrive and flourish, I think, because it is part of the growing revival of the oral tradition and, in poetry, a part of the bardic tradition.

The Barbarian is at the Gates: The Literature, Art and Music of the Beat Generation

WHAT IS TAKING PLACE IN THE LITERATURE OF THE HOLY BARBARIANS is something more profound than the emergence of a new school. It is a change in the literary use of language itself.

What is better than reading Vergil or memorizing Goethe (*Aalles Vergängliche ist nur ein Gleichnis, etc.*)? Why, eating outdoors under an awning for eight francs at Issy-les-Moulineaux. *Pourtant je suis à Sèvres*. No matter. I have been thinking lately of writing a *Journal d'un Fou* which I imagine to have found at Issy-les-Moulineaux. And since that *fou* is largely myself I am not eating at Sèvres, but at Issy-les-Moulineaux. And what does the *fou* say when the waitress comes with the big canette of beer? *Don't worry about errors when you're writing. The biographers will explain all errors.* I am thinking of my friend Carl who has spent the last four days getting started on a description of the woman he's writing about. "I can't do it! I can't do it!" he says. Very well, says the *fou*, let *me* do it for you. *Begin!* That's the principal thing. Supposing her nose is not aquiline? Supposing it's a celestial nose? What difference? When a portrait commences badly it's because you're not describing the woman you have in mind; you are thinking more about those who are going to look at

226

the portrait than about the woman who is sitting for you. Take Van Norden — he's another case. He has been trying for two months to get started with his novel. Each time I meet him he has a new opening for his book. It never gets beyond the opening. Yesterday he said: "You see what my problem's like. It isn't just a question of how to begin: the first line decides the cast of the whole book. Now here's a start I made the other day: Dante wrote a poem about a place called H——. H-dash, because I don't want any trouble with censors."

Think of a book opening with H-dash! A little private hell which mustn't offend the censors! I notice that when Whitman starts a poem he writes: — "I, Walt, in my 37th year and in perfect health! . . . I am afoot with my vision . . . I dote on myself . . . Walt Whitman, a kosmos, of Manhattan the son, turbulent, fleshy, sensual, eating, drinking and breeding . . . Unscrew the locks from the doors! Unscrew the doors themselves from their jambs . . . Here or henceforward it is all the same to me . . . I exist as I am, that is enough . . ."

With Walt it is always Saturday afternoon . . .[33]

Note in how many particulars Henry Miller writing in the mid-thirties, and Whitman whom he cites, anticipated the beat generation: the insistence on the spontaneous, the improvised, the importance of living in the present moment, the sensuality, naturalness, contempt for censorship, the sense of holiness, the openness — even to leaving doors unlocked, a common practice among the beat. What is more pertinent at this point, however, is Henry Miller's use of language. And his approach to the problem of the written word. It is not an approach to the written word at all, in fact. It is the spoken word committed to writing. It is oral in structure.

"Oral languages," says Edmund Carpenter, "tended to be polysynthetic, composed of great tight conglomerates, like twisted knots, within which images were juxtaposed, inseparably fused; written communications consisted of little words chronologically ordered. Subject became distinct from verb, adjective from noun, separating actor from action, essence from form. Where preliterate man imposed form diffidently, temporarily — for such transitory forms lived but temporarily on the tip of his tongue, in the living situation — the printed word

was inflexible, permanent, in touch with eternity: it embalmed truth for posterity.

"This embalming process froze language, eliminated the art of ambiguity, made puns 'the lowest form of wit,' destroyed word linkages. The word became a static symbol, applicable to and separate from that which it symbolized. It now belonged to the objective world; it could be seen. . . . Writing didn't record oral language; it was a new language, which the spoken word came to imitate. . . . Gutenberg finished the process."[34]

The written word, written in speech forms imitative of the written word, reached its *reductio ad absurdum* in the Victorian novels. When Thackeray satirized writers like Disraeli and Bulwer-Lytton he was satirizing not only the genteelism of the middle class but the bookishness of their Geneva code language, a style that by the 1890's had begun to burlesque *itself*, unconsciously. Human speech is oral and nonlinear as Carpenter and his associate Marshall McLuhan have demonstrated in their experiments with communications media at the University of Toronto. When it is set down in writing it is merely being recorded for playback. Playback may be by eye and, where the reader is capable of it, by the "audio-imagination," as Eliot calls it, or "the inner ear," Marianne Moore's name for it, but it does not come fully alive again until it is played back by the human voice box. A poem can be mastered, that is, it can be understood on every level of meaning; it can be "explicated" in the manner of the New Criticism, all its allusions traced to their sources and identified, its metrics scanned, its grammar and syntax unscrambled, all of its ambiguities ferreted out and classified according to William Empson, and the act of communication will still be incomplete unless the sound is played back to the listening ear. The inner ear is not enough, no matter how much audio-imagination the poet has or the listener possesses. The printed poem is not the poem. It is only the "score" of the poem, just as in music the score is not the music. It has to be *played back*.

If it is written in the Geneva code it will sound stilted when it is read aloud, no matter how well it "reads" on the printed page. It will sound like the printed page would sound if it could speak: clipped, precise, evenly spaced, no word lighter or darker than any other word, in short, a good job of printing. If it is written as oral language it will play back naturally and convincingly. The same thing is true of prose.

Try reading the following passage from Jack Kerouac's *The Subter-*
raneans silently, then read it aloud and the difference becomes imme-
diately apparent.

It's too much. Beginning, as I say with the pushcart incident —
the night we drank red wine at Dante's and were in a drinking
mood now both of us so disgusted — Yuri came with us, Ross
Wallenstein was in there and maybe to show off to Mardou Yuri
acted like a kid all night and kept hitting Wallenstein on the back
of his head with little finger taps like goofing in a bar but Wallen-
stein (who's always being beaten up by hoodlums because of this)
turned around a stiff death's-head gaze with big eyes glaring be-
hind glasses, his Christlike blue unshaven cheeks, staring rigidly as
tho the stare itself will floor Yuri, not speaking for a long time,
finally saying, "Man, don't bug me," and turning back to his con-
versation with friends and Yuri does it again and Ross turns again
the same pitiless awful subterranean sort of non-violent Indian
Mahatma Ghandi defense of some kind (which I'd suspected that
first time he talked to me saying, "Are you a fag you talk like a
fag," a remark coming from him so absurd because so inflammable
and me 170 pounds to his 130 or 120 for God's sake. . . .[35]

J. D. Salinger had already broken that literary ground, of course, in
the middle forties:

I was surrounded by jerks. I'm not kidding. At this other tiny
table, right to my left, practically on *top* of me, there was this
funny-looking guy and this funny-looking girl. They were around
my age, or maybe just a little older. It was funny. You could see
they were being careful as hell not to drink up the minimum too
fast. I listened to their conversation for a while, because I didn't
have anything else to do. He was telling her about some pro foot-
ball game he'd seen that afternoon. He gave her every single god-
dam play in the whole game — I'm not kidding. He was the most
boring guy I ever listened to. And you could tell his date wasn't
even interested in the goddam game, but she was even funnier-
looking than *he* was, so I guess she *had* to listen. Real ugly girls
have it tough. I feel so sorry for them sometimes. Sometimes I
can't even look at them, especially if they're with some dopey guy
that's telling them all about a goddam football game. On my right,

the conversation was even worse, though. On my right there was this very Joe Yale-looking guy, in a gray flannel suit and one of those flitty-looking Tattersall vests. All those Ivy League bastards look alike. My father wants me to go to Yale, or maybe Princeton, but I swear, I wouldn't go to one of those Ivy League colleges if I was *dy*ing, for God's sake . . .[36]

Catcher in the Rye, the book from which this excerpt is taken, is to be found everywhere on the bookshelves of the beat. Reading aloud, both poetry and prose, is a common practice in the pads. It is not difficult for the beat generation youth to identify itself with the book's hero, Holden Caulfield. He not only *sounds* right to them but the things he says are often the things they say:

If he'd had to shoot anybody, he wouldn't've known which direction to shoot in. He said the Army was practically as full of bastards as the Nazis were.

I swear if there's another war, they better stick me in front of a firing squad. I wouldn't object.

The people who applauded the show-offy, tricky stuff of the night club entertainers were the same morons that laugh like hyenas in the movies at stuff that isn't funny.

George Mandel is another writer who possesses an oral style and is popular in beat generation circles for what he says as well as for the way he says it. Here are some examples from his book *Flee the Angry Strangers:*

Those culture perverts from uptown. *Any*one from uptown. And downtown. Everywhere I go. I tell you our society is at the bottom of its spiral.

The whole commercial scene is animal against animal . . . everybody's mouth going with words like priests and kings and congressmen with words and no understanding . . . You can keep reality. Work is for slaves; I'm free.

The so-called spiritual leaders who are all spirit and no brains, all sky and no earth . . . the jerks with the electric word of official-dom who do nothing but separate people.

A whole nation of people suspending consciousness in whatever way they could: in churches and movie houses, before television

sets, in barrooms and in books . . . The whole world (seeking) hard for its narcosis . . . Dope fiends and philosophers, prostitutes and poets, artists and hoods, darlings, dreamers, derelicts and every American variety of displaced persons . . . Whether praying step by step up tottering towers toward some illusion of heaven, or playing notch by notch down any available avenue of escape, from a stupid movie to a charge of heroin — the whole world is hooked.[37]

One thing is already evident, that if the holy barbarians have their way with the national culture the new American literary tradition, now in the making, is not going to be in the England-via-New England line of descent. The schools and the reputation-making organs are still in the hands of teachers, critics and editors in the England-via-New England tradition, but defections from their own ranks have become increasingly common in the last few years and newcomers into the schools, magazines and publishing houses are changing the picture continually. Where print is still closed to them they either start publishing ventures of their own or take to the oral medium of records. For it is really the oral elements from foreign cultures in which those elements have never completely died out that are being transfused by the holy barbarians into the blood stream of American culture.

The best way to approach the literature of the beat generation is through its antecedents. If you ask the poets they will name Whitman, Mallarmé, Poe, Baudelaire, Rimbaud, Verlaine, Yeats, Eliot, Pound; there will be talk in some quarters of looking into Swinburne again (didn't he introduce Baudelaire to the English-reading world?); Shelley will be quoted, Marlowe rather than Shakespeare (though I have heard *The Phoenix and the Turtle*, attributed to the Bard, praised as "a far-out swinging poem"); Blake's philosophical poems are being eyed speculatively again as they were in the booming twenties when there was something like a Blake boom, even though it was never listed on the big board. These new poets will go on to name Robinson Jeffers, Hart Crane, William Carlos Williams, Kenneth Rexroth, Kenneth Patchen, Dylan Thomas, Edward Dahlberg, E. E. Cummings, Kenneth Fearing and Louis Zukofsky and, judging from the letters I receive and from the behavior of some of my youngest visitors, I, too, am sometimes included as among their literary "ancestors." This is a wide range

of taste, but if you look closely at the list you may notice that nearly all of them have one thing in common: they are not patricians of belle-lettres in the royal roster of the Academy. If they have "made it" with English Lit at all — and some of them have, if they've been dead long enough (literally or literarily) — they made it the hard way, the long way round.

Most of the same people will be named by the prose writers of the beat generation, too. The line between poetry and prose is very thinly drawn in these circles. Many insist there is no line at all. Asked to name their prose ancestors, however, they will usually come up with James Joyce, Henry Miller, F. Scott Fitzgerald, Ernest Hemingway (his early short stories in particular), Sherwood Anderson, Louis-Ferdinand Céline, William Faulkner, André Gide, Franz Kafka, D. H. Lawrence (his poetry as well as his prose), Thomas Wolfe; and some of the older, more political-minded among the prose writers of the beat generation would add Theodore Dreiser and John Dos Passos to this list. All of them have heard of B. Traven but, except for *The Death Ship*, his work is not widely read in beat circles any more.

Admittedly, neither list is complete, but it is representative, I think. Conspicuously missing are such titans of the twenties as James Branch Cabell, Louis Hergesheimer, Carl Van Vechten, and earlier writers who were widely read by the writers of the twenties (and their readers) such as Jack London, Guy de Maupassant, Anatole France and Sigrid Undset. John Steinbeck and Richard Wright lead a kind of twilight existence in the literary experience of the beat generation writers, but Nelson Algren is very vivid, very much in the foreground. If I did not mention him among the "influences" and ancestors it is because he is regarded as a contemporary, along with Salinger and Mailer and Mandel. Dostoevski is, as I have noted earlier, an all-pervading influence that, for this very reason, no one thinks of mentioning. Recently, owing to new reprints or new translations, Nikolai Gogol and Isaac Babel are being read. Gorki is still read in some circles but Tolstoy, Andreiev, Turgenev and Lermontov are known only by name. Chekhov is still read by the short story writers among the beat with pleasure and profit. Thomas Mann and Marcel Proust are honored and unread classics. William Saroyan's early short stories are sought out in yellowing paperbacks, and in some quarters he is listed as an "influence" among beat writers. Henry James is tough going for them, despite the lively press

agent job that has been done on him in recent years. Sinclair Lewis has joined Henry James as "schoolbook stuff," so the younger writers tell me — an uneasy twosome! Mikhail Sholokhov's *And Quiet Flows the Don* has joined Erich Maria Remarque's *All Quiet on the Western Front* as "one of those war books" that one must get around to reading one of these days just to see what all the shootin' was about. Fashions like reading Stendahl or Trollope may make a stir in English classes and among the exurbanites, but not in beat writer circles. The same is true of the occasional *succès de scandals*, like Vladimir Nabokov's *Lolita* or Boris Pasternak's *Doctor Zhivago*. They are read by beat writers but, being translations, they can have little effect on style or content in their own writing. Nabokov's *Lolita*, for all the praise that many critics lavished on its style, is still a foreign language to beat writers, and its shock value is nil, if not actually incomprehensible, in the pads.

The same thing is true of passing fashions in poet-revivals. Somebody writes a critical essay in one of the university quarterlies or in the *Saturday Review* about Robert Frost and the English majors go rushing to the undergraduate library to snatch everything catalogued under Frost, R. off the shelves. Or Carl Sandburg is seen on television once again and the public library has a small run on Sandburg, C. But the beat poets are unmoved by such flurries of interest in writers they have read exhaustively at college or in the public library five or ten years ago and found unrewarding as far as language or the tricks of their craft are concerned. They can learn more from one page of Charles Olson or even a good translation of Zen poems.

Polish, in the classroom sense of "good writing," is no more important to them in a poem or a piece of prose than it is on their shoes. That is one reason why the university-bred poets of the forties have had virtually no influence on the poetry of the beat generation. Of the fifteen poets anthologized by John Ciardi in his *Mid-Century American Poets*, all were college bred and twelve had taught or were teaching in colleges and universities, but none of them has been able to achieve anything like the freedom of style or content that rings a bell with the beat. It is not their college meal ticket or their learning that is held against them — some of the best-educated men and women in the history of American literature are numbered among them. It is just that they can't swing with that beat because they are too conscious of every word they put on paper: you can't dance freely if you have to watch

your step. The security of the academic life can become as addictive as heroin and harder to kick. Besides, there are too many eyes looking in at the mating with the Muse, cramping the creative act. In time the built-in censorship becomes familial, like a loved, benevolent monster who provides everything, everything except the freedom to be a clown or a fool. You can be the court jester on a university payroll but you can't be the all-out, truthtelling bard and still hold the Chair of Poetry. You can't even be an honest critic of literature, lest you fall into the trap of being guilty by association with the truthtelling writer.

For the same plus a few additional reasons, the Robert Penn Warren-Allen Tate-John Crowe Ransome Axis is "nowhere" as far as the holy barbarians are concerned, and the feeling seems to be mutual. Like the Poll Tax Dixiecrats in Congress who hold all the key chairman-ships, this Confederate Bund has bottled up everything that comes out of the beat writing camp and, in the publications they control, nothing of the kind is ever reported out of committee.

Yet the holy barbarians respect learning wherever they find it, on campus or off, but on this point the feeling is *not* mutual. "They never *read* anything," one college English teacher charged during a sym-posium on the beat generation in which I participated. He himself was a Rhodes scholar, had been "named" by the un-American committee and "was allowed to resign." Since then he had made the rounds of the pads in Venice West and San Francisco and seen the bookshelves and attended the readings and yet, when it came to making a public state-ment about it, he reverted to an intramural position, defending the academic gates against the barbarians. Besides, as a Leftist in politics, disaffiliation is defeatism to him, and poverty, voluntary or involuntary, is a crime against the Cause. Rightists and Leftists stand shoulder to shoulder at the gates when it comes to required courses, credentials and degrees.

The position of Poet in Residence, is the university's attempt to meet the challenge of the times and present something in the way of a "creative writing course," but it is looked upon by the die-hards of the faculty as a breach in the walls that may let in the whole horde of barbarians. They need have little fear, however. The position of Poet in Residence, like the more ancient Oxford Chair of Poetry, is already proving to be a potent tamer and refiner of poets. But in the meantime the protectors of English Lit are watchful and regard even a one-shot

lecture or reading on campus by any of the holy barbarians of litera-
ture as a crisis.

For a time it looked as if the summer "writers' workshop" might
become a kind of halfway house between the creative writer and the
university, but the professors and critics were not long in taking over.
Today there are hundreds of these workshops from coast to coast, but
they are little more than off-campus summer courses for amateurs on
the make for credits or publication. The holy barbarians shun them.
They prefer the informal literary gab fests of the pads, and as for pub-
lic performance, they prefer the saloons and coffeehouse readings and
Jazz Canto jam sessions. These are more in the oral tradition and give
the artists more freedom of discussion and expression.

What is the sound these holy barbarians of literature are putting
down that is so frightening to the guardians of the Required and the
Refined? Let us begin with the poets, since it is the poets who are
today, as they have always been in every literary movement, in the
vanguard.

" — Say it, no ideas but in things — "

First, the "ancestors" of these poets. In what are almost the first lines
of his long poem *Paterson*, William Carlos Williams, the oldest living
poet among these ancestors, lays down the beat — and the sound:

> — Say it, no ideas but in things —
> nothing but the blank faces of the houses
> and cylindrical trees
> bent, foked by preconception and accident —
> split, furrowed, creased, mottled, stained —
> secret — into the body of light! . . .
>
> A man like a city and a woman like a flower
> — who are in love. Two women. Three women.
> Innumberable women, each like a flower.
> **But**
> only one man — like a city.[38]

The object mirrored in the poetic image, that comes first. The poet
comes clean; he tells only what he *knows*, what his vision has shown

him, and he tells it starkly, but with energy, energy from the mysterious source of all artistic energy, says it — and stops. It might be a single flower, a cloud, a single person or a city. The principle is the same. "Say it, no idea but in things." Like a Hopper streetscape.

From first to last as in Paterson so in Venice West. Here, for example, is one of the youngest of the holy barbarians, Stuart Z. Perkoff, in some lines from his *Venice Poems*:

> the city itself, what it
> is, a
> city of walking at nite
> city of old and ugly houses
> city of real pain and real children
> city of open sores and open eyes
> city of doom and terror
> city of ocean and animal lust
> city of dying and struggle
> city of Venice, my city, city within a city I do not
> > know or love
>
>
> what a city is/
> > a vision, a
> holy eye, a
> > structure
>
> what a city is/
> > a face, a face of
> > love, of the place, the real
> > place. . . .
> > yes, there is a kind of
> > knowing, it can be called
> > love[39]

If all things are holy it is enough to present the thing, as the poet-seer of the past made holy the objects of the ritual act by a form of words spoken or chanted, without himself, as a person, becoming involved in the act. It is as if everything that "came" to the poet for transmission was postmarked Handle with Reverence, that is, handle

ritualistically, sacramentally. Even the unloading of a boxcar, as in this poem by Perkoff:

> lifting
> a piece
> of black steel
> and carefully
> (conforming to a pattern
> previously set down
> after extensive
> testing)
> placing it on a construction
> of boards
> extending
> certain aspects of bodily structure
> to the limits of tensions
> actions taken
> within a situation
> once calculated
> to destroy all pleasure
> now seen to contain
> evocations[40]

"The trick is never to touch the world anywhere," as William Carlos Williams says —

> Leave yourself at the door, walk in, admire the pictures, talk a few words with the master of the house, question his wife a little, rejoin yourself at the door — and go off arm in arm listening to last week's symphony played by angel hornsmen from the benches of a turned cloud.[41]

Dr. Williams, as a practicing family doctor, was already half a shaman from the start. The kind of "nonattachment" that he describes is traditional with the healer. It is also very close to the Buddhist concept of nonattachment.

"In Buddhism," says Watts, "the four principal activities of man — walking, standing, sitting, and lying — are called the four 'dignities,' since they are the postures assumed by the Buddha nature in its human

(nirmanakaya) body. The ritualistic style of conducting one's everyday activities is therefore a celebration of the fact that 'the ordinary man is a Buddha,' and is, furthermore, a style that comes almost naturally to a person who is doing everything with total presence of mind. Thus if in something so simple and trivial as lighting a cigarette one is fully aware, seeing the flame, the curling smoke, and the regulation of the breath as the most important thing in the universe, it will seem to an observer that the action has a ritualistic style."[42] The ballet-like movements of the western hero of motion pictures come to mind, as he appears mounted, walking, rolling a cigarette. Certain gang leaders, even among the juvenile delinquents, cultivate such a style, made classic on the screen by James Dean, and by Marlon Brando in *The Wild One*. Charles Olson celebrates these ritualistic movements in *The Lordly and Isolate Satyrs*:

> The lordly and isolate Satyrs — look at them come in
> on the left side of the beach
> like a motorcycle club! And the handsomest of them,
> the one who has a woman, driving that snazzy
> convertible
> Wow, did you ever see even in a museum
> such a collection of boddisatvahs, the way
> they come up to their stop, each of them
> as though it was a rudder
> the way they have to sit above it
> and come to a stop on it, the monumental solidity
> of themselves, the Easter Island
> they make of the beach, the Red-headed Men
> These are the Androgynes,
> the Fathers behind the father, the Great Halves . . .[43]

Contrast, the significant juxtaposition of opposites, presenting a picture of the world in all its beauty and terror, is found in the poetry of the holy barbarians in more extreme form than in the more polished and respectable poets. "I walked on the banks of the tincan banana dock and sat down under the huge shade of a Southern Pacific locomotive," writes Allen Ginsberg in the first strophe of his *Sunflower Sutra*, ". . . I rushed up enchanted — it was my first sunflower, memories of Blake — my visions — Harlem/ and Hells of the Eastern rivers,"

bridges clanking Joes Greasy Sandwiches, dead baby
 carriages, black treadless tires forgotten and un-
 treaded, the poem of the riverbank, condoms and pots,
 steel knives, nothing stainless, only the dank muck and
 the razor sharp artifacts passing into the past —
and the gray Sunflower poised against the sunset, crackly
 bleak and dusty with the smut and smog and smoke
 of olden locomotives in its eye. . . .
A perfect beauty of a sunflower! a perfect excellent
 lovely sunflower existence! a sweet natural eye to the
 new hip moon, woke up alive and excited grasping in the
 sunset shadow sunrise golden monthly breeze![44]

Kenneth Patchen is a master of such contrasts:

> O great blind horses squatting above the world
> The reins hang slack in the bitter wind
> The shadows of clouds pass like wounded hands
> O where can the heart of man be comforted
>
> In the valley the wild flowers
> Shake themselves upright again
> The red violets[45]

Things as they *are.* "The commonplace is what we *see*," says Gregory
Corso. To the Zen Buddhist they are *tathata*, viewing things as they
are. To the poet they *are* what he *sees*, his reality. He *is* what he feels
himself to be — at that particular moment of time, in the making of the
poem. As in Corso's *The Last Gangster:*

> Waiting by the window
> my feet enwrapped with the dead bootleggers of Chicago
> I am the last gangster, safe at last,
> waiting by a bullet-proof window.
>
> I look down the street and know
> the two torpedoes from St. Louis.
> I've watched them grow old
> . . . guns rusting in their arthritic hands.[46]

There is still another characteristic that is worthy of notice in these
poets, the sense of the absurd, the role of the clown, the Holy Fool.

"Constantly risking absurdity"

In the cults that gave rise to early Christianity there must have been an understanding of the Fool in the poetic imagination and the therapeutic release of laughter. Not much of it got into the official canon of the New Testament. This element is the first casualty whenever a religion becomes an institution. There are a couple of passages in Paul's First Epistle to the Corinthians which are rendered as follows in the Revised Standard Version:

> For the foolishness of God is wiser than men, and the weakness of God stronger than men. For consider your call, brethren; not many of you were wise according to worldly standards, not many were powerful, not many were of noble birth. But God chose what is foolish in the world to shame the wise, God chose what is weak in the world to shame the strong, God chose what is low and despised in the world, even things that are not, to bring to nothing things that are, so that no human being might boast in the presence of God.

and:

> Let no one deceive himself. If any among you thinks he is wise in this age, let him become a fool that he may become wise. For the wisdom of this world is folly with God.

The British painter Cecil Collins made a cycle of paintings and drawings called "The Holy Fools" and in the preface of a book called *The Vision of the Fool*,[47] in which they are reproduced, he has this to say about Christ the Fool.

> The greatest fool in history was Christ. This great fool was crucified by the commercial pharisees, by the authority of the respectable, and by the mediocre official culture of the philistines. And has not the church crucified Christ more deeply and subtly by its hypocrisy than any pagan? This Divine Fool, whose immortal compassion and holy folly placed a light in the dark hands of the world.

The New Testament Christ is without any question at all a folk hero figure of ritual drama, and Paul's words may point to one act of the

drama in which the Messiah enacted the role of the Divine Fool in some sacrificial rite. The analogous role of the truth-possessed artist is one that poets and painters have recognized for centuries; it is not surprising that it is a frequent theme of the holy barbarians.

In one of Lawrence Ferlinghetti's poems the poet appears as the acrobatic clown, akin to Nietzsche's ropedancer ("Man is a rope stretched between the animal and the Superman . . . a rope over an abyss. A dangerous crossing" — In *Zarathustra,* 4).

> Constantly risking absurdity
> and death
> whenever he performs
> above the heads
> of his audience
> the poet like an acrobat
> climbs on rime
> to a high wire of his own making
> . . . For he is a super realist
> who must perforce perceive
> taut truth
> before the taking of each stance or step
> in his supposed advance
> toward that still higher perch
> where beauty stands and waits
> with gravity
> to start her death-defying leap[48]

The poet on the college payroll can risk religious heresy (except in denominational colleges); he can risk subversion (except in state-supported universities); he can even risk outspoken sexuality (if he doesn't publish it too conspicuously); but he can never risk absurdity. In decent society, even among the best-educated people, it is the cardinal sin. It is something that only the disaffiliated poet of the slum can permit himself. Yet it is traditionally one of the high moments of the poetic rite.

"In a respectable practical society, where everybody is useful," says Collins, "the poetic imagination in man is an anachronism, an irritant which disturbs the chemical sleeping habits of such a society by making it conscious of the degradation of its mechanization, by the appear-

ance of extraordinary desires; by overshadowing it with the supra-reality of poetry, by unsettling it with a thirst and a hunger for eternal beauty, just at the moment when this society thought that everybody was satisfied."[49]

The Clown as Holy Fool is also a familiar theme of the painters among the holy barbarians, and so is the Crucifixion theme, which is always handled in the most unchurchly, unconventional and often quite unchristian fashion. For the Holy Rood is far older than Christianity, going back to tree worship and the phallic cults.

Zen Buddhism, too, is filled with tales of sainted "lunatics" whose antics are parables of wisdom. It is the part of Zen that, more than anything else, commends itself to the beat. Alan W. Watts calls this beat Zen as distinguished from square Zen, but adds that he has "no real quarrel with either extreme."

The extremes of beat Zen need alarm no one since, as Blake said, "the fool who persists in his folly becomes wise." As for square Zen, "authoritative" spiritual experiences have always had a way of wearing thin, and thus of generating the demand for something genuine and unique which needs no stamp.[50]

The poetry and art of the holy barbarians could stand, if anything, more clowning than it already has. Ferlinghetti's work is often shot through with social satire, as in *Dog*,[51] and in *Christ Climbed Down*:

> Christ climbed down
> from His bare Tree
> this year
> and ran away to where
> no intrepid Bible salesmen
> covered the territory
> in two-tone cadillacs
> and where no Sears Roebuck creches
> complete with plastic babe in manger
> arrived by parcel post
> the babe by special delivery
> and where no televised Wise Men
> praised the Lord Calvert Whiskey[52]

More often, as in James Broughton's *True and False Unicorn*, the Fool appears in a mood of self-exploration, even self-mockery:

> And how shall I conceal my nakedness here? —
> white, like a maiden's moonlit belly,
> white, like an undressed Absolute.
> White is the final pure purgation:
> sterile gown of the hospital room,
> winding sheet, skeleton, the ash.
>
> Animate and inanimate, O ambiguous steed!
> In Jabberwock land, or Elysium —
> where am I truly or falsely at home?
>
> I am the charm sought for a miracle,
> I am the harm mocked for a failure.
> I am both savior and scapegoat.[53]

In my own *Fete de L'ane For Buridan's Ass* (on a theme from Kierkegaard, "What the philosophers say about reality is often just as it is when you read a sign at a second-hand store: 'Ironing done here.' If you should come with your clothes to get them ironed, you'd be fooled; for only the sign is for sale,") the Fool is the subject of a philosophical dilemma:

THE HIEROPHANT

> Now in the third hour
> they lead the beast to the enthronement
> garlanded with onion, the fool's rose
> See him stand, between two bundles of hay,
> the epiphenominal automaton
> and bray his blasphemous Amen
> while goliards chant the office of the day

THE POSTULANT

> If rumor is to be believed, the mark
> upon his back is cruciform,
> whereon a veiled figure rides

244 THE HOLY BARBARIANS

But whether the Virgin or the Whore
 it is not given me to see

In matters antinomian the management
 is most discreet . . . I only know

I heard a voice and saw a lifted hand
 ignite a torch and put it to the veil

I think the voice cried Reason!
 and the hand was red
A mere illusion, surely, nothing
 to excite the press, and yet I swear
The air was sharp as urine and the noise
 like noises of the newly dead.

THE HIEROPHANT
This too I see
 The giant spiders loosed upon their prey
 the python coiled around the pig
 the clown they crucified upon the tree

CHORUS OF POSTULANTS
Is it true as they whisper, hissing in your ear,
 the spear was tipped with novocaine?
 Science at an atheist's Mass![54]

Cecil Collins suggests that, "In our age, one of the greatest feast days should be April 1st — All Fool's Day. A day that should be kept and celebrated religiously and universally . . . a holy day given over to the divine fantasy of holy gaiety." If that time ever comes, it will be the holy barbarians who will make the ritual words for it, perhaps with music in the Jazz Canto art form and with dance added, and perform the rite as shaman and bard.

Madness: The Theme of Unreason

One of the things which distinguishes the holy barbarians from the respectable poets is their insistence on the nonrational as a way of knowing and a therapy to overcome squareness. As E. R. Dodds has

pointed out, in *The Greeks and the Irrational,* the social function of the Dionysiac ritual was "essentially cathartic, in the psychological sense: it purged the individual of those infectious irrational impulses which, when dammed up, give rise, as they have done in other cultures, to outbreaks of dancing mania and similar manifestations of collective hysteria; it relieved them by providing them with a ritual outlet."[55] The poets who composed the word forms that went with such ritual dramas of psychological therapy were aiming at wholeness. He who would save his life must lose it, dying to the self, reintegrating the conscious with the unconscious — these are some of the formulations in which it has been expressed at one time or another. Baudelaire and those who followed him, Rimbaud, Verlaine and the whole roster of poets and artists whose path is marked by such developments as Symbolism, Impressionism, Imagism, Surrealism, all served the useful, indispensable purpose of exploring the problem and experimenting with the forms in which it might be resolved. They left their bloody footprints on a road that some of the holy barbarians are now retracing. Zen tells them that they need not retrace it. That there is a more direct approach to holiness. *Satori,* enlightenment, the Zen master tells them, can cut the Gordian knot.

But the road to Zen is harder for the Western mind than it is for the Eastern mind. Since the Renaissance the pursuit of truth as a process of reasoning, of choosing thought, to the exclusion of all other ways of knowing is, consequently, more violent in the West than elsewhere in the world. Poets like Robert Duncan, William Everson (who has become a Dominican friar and writes under the name of Brother Antoninus) and Charles Foster of the Venice West group have frequently given expression to this *agonia,* the conflict between reason and unreason as ways of knowing and paths to salvation and enlightenment. Others, like Gary Snyder and Philip Lamantia, have taken the Way of Zen, although the results are not yet fully developed in their poetry.

Allen Ginsberg may be regarded, I think, as a poet in transition between the *agonia* and the Dharma, which Zen Buddhists define as the method by which self-frustration may be brought to an end. "I saw the best minds of my generation destroyed by madness, starving hysterical naked," he wrote in the opening line of *Howl,* and the critics of the liberal magazines have been having a field day with it ever since. The "best minds," according to them, are the ones who write in the

liberal weeklies and quarterlies, and there are probably no poets at all among them — barring the Great Dead — but only critics and professors. (Exceptions are made, of course, in the case of the Great Nearly Dead.) How can the best minds of a generation, they ask, be described as

> anglehead hipsters burning for the ancient heavenly
>> connection to the starry dynamo in the machinery of night,
> who poverty and tatters and hollow-eyed and high sat up
>> smoking in the supernatural darkness of cold water flats
>> floating across the tops of cities contemplating jazz[56]

Yet it is one of these same minds that, in *Siesta in Xbalba,* on another journey of the Quest, is seen

> . . . in a concrete room
>> above the abandoned
> labyrinth of Palenque
>> measuring my fate,
> wandering solitary in the wild
>> — blinking singleminded
> at a bleak idea —
>> until exhausted with
> its action and contemplation
>> my soul might shatter
> at one primal moment's
>> sensation of the vast
> movement of divinity.

And after those nights "with drug and hammock at Chichen Itza on the Castle," back to the States:

> The nation over the border
> grinds its arms and dreams
>> of war: I see
> the fiery blue clash
>> of metal wheels

clanking in the industries
 of night, and
detonations of infernal
bombs
 . . . and the silent downtown
of the States
 in watery dusk submersion.[57]

Back and forth between Heaven and Hell and, in the process, leaving a record of the journey that is unmatched by any of the best minds among the poets that are approved of by the editors of the liberal magazines.

Even some printers will have no part of Ginsberg. I recall the time when James Boyer May brought me the manuscript of *Howl*, which had been turned over to him by Lawrence Ferlinghetti to send to London to be printed. May told me that the London printer whom he represents in the United States had serious misgivings about printing it and that he, May, thought it was just a lot of filthy words without literary merit. I told him that if John Sankey, the printer-publisher of London who runs the Villiers Press, never printed anything *but Howl* it would probably be the only thing he would ever be remembered for. May asked me to write to Sankey and I did, telling him the same thing. Sankey printed it, Ferlinghetti's City Lights Books published it and today it is a landmark in the literature of the holy barbarians. The few critics who were impressed and moved by it could not help (since then) expressing the fervent wish that neither Ginsberg nor anybody else would write another poem like it. Once is enough for them. It presents them with too stark a challenge and too embarrassing a critical problem.

"A psychological *impasse* is the necessary antecedent of satori," says D. T. Suzuki, "and the worst enemy of Zen experience, at least in the beginning, is the intellect, which consists and insists in discriminating subject from object. The discriminating intellect, therefore, must be cut short if Zen consciousness is to unfold itself."[58]

The problem is nowhere described more searchingly — and more amusingly — than by Gary Snyder in his poem *What I Think When I Meditate*.

Well, I could tell you that I could tell
 you but you wouldn't understand, but I won't
You'd understand but I can't, I mean dig,
 this here guitar is gone bust
 I hate to sit crosslegged
my knees hurt my nose runs and I have to go
 to the crapper
tootsweet and damn that timeclock keeper won't ding.
WHAT I think about when I meditate is emptiness.
 I remember it well
the empty heads the firecracker phhhht
But what I *really* think about is sex
 sort of patterns of sex
like dancing hairs and goosebumps
 No, honestly
what I think about is what am I thinking about?
 and
who am I? and 'MU?' and 'the clouds
 on
 the
 southern mt'
Well: what I really honestly think about, no fooling . . . (etc.)[59]

Fooling, clowning, is one approach to Zen and some of its greatest masters were Fools in the great tradition. Through Unreason the discriminating intellect is disarmed and led to the state of "unknowing" without the violent autovivisection of a Baudelaire or a Verlaine, or any yogic derangements of the autonomic nervous system. As a method, the madness of the Zen Lunatics has much to commend it and the poets among the holy barbarians are learning how to use it, though for some it is harder than for others. In his prose, Charles Foster, for instance, has already taken a long step in this direction, but in his poetry he is still groping for it. "Grass doesn't grow on the floor of my mother's patio" he begins, wryly, his *Preliminary Report on Rerum Naturem.*

 2 x 2 the bricks are laid
 there, parquetted, right angled
 to each other pair, except

near the northwest corner there's
a three foot square trapdoor
to dirt — where God's monopoly,
a tree — is coming up for air.
.
So for the length of a time
exposure, I unshuttered
my eyes — but what developed
was not the green leaves in their
always cadences of three
but unholy 'trinities,'
'triads' punning into 'dryads'
'tryptyching' deciduous
chords from the 'doxology'
(the wood was full of spritely words and
erect and sticky headed
yellow stamen blew up storms
of phallic substantives
while the mutation of a
cliche was grafted in the space
of a single word to the
one ripe orange) and so forth in
finitum ad verbium (and
in the next yard's avocado
Whitman's and Homer's roars were
drowned out by Wm. Wordsworth's)
and I could see this wasn't
my day to pass through the sharp
eye to the workshops of heaven but
there's another now coming soon

(Day to make love to a real
tree, garbage can or a cloud
not of words of my own making
the little yellow flower,
nothing straw in crannied brick
and brown patches, red, rich black
God's loam in many colors.)[60]

It transpires in an instant yet it may take many "another now com-
ing," maybe months, maybe years hence. When the mind is no longer

divided against itself, into the duality of the knower and the known, one "get's hip," experiencing samadhi, awakening.

The Prose of the Holy Barbarians

While the poetry of the holy barbarians is already highly developed, the prose is only in its beginnings. Kerouac, the best known of the novelists in this genre, has published books, no two of them alike in prose style. He comes closest to the authentic voice of the people he is portraying in *The Subterraneans* than in any of the other books. That is why it has drawn more brickbats from the established critics than have his other books. "This *proves* it," cried one of them exultantly, "that the trouble with Kerouac is he can't write." It would set back not only Kerouac but other novelists working in this field, if he permits himself to be touted off the style of *The Subterraneans* by the so-called "good writing" standards of conventional criticism, as he shows signs of doing in *The Dharma Bums*.

Other prose writers like Clellon Holmes, Anatole Broyard and R. V. Cassill utilize the material of the holy barbarians but their style remains largely conventional. Holmes's *The Horn* is a sensitive treatment of jazz musicians, perhaps the best that has been done by anybody so far. Where he employs the language of his characters his ear is good:

> "Man," Edgar was saying, as if imagining what the young mothers and the old men were thinking. "Who's that, that whenever you see him, 's got a goddamn suitcase in his hand, like he's always running late for a bus, coming from no place and going somewhere else? Man, who *is* that?" His eyes stared at the world remotely. "Like, lady, that's a musician, and that's a horn, and he probably got a change of socks, and his razor, and a coupla rubbers, and two sticks of tea, and maybe even a extra shirt in there with his reeds. So you watch out, oh, yes! . . . I mean, that man is a musician, and he's just transporting his horn from one place to another like usual, and probably don't own nothing else in the goddamn world but that goddamn piece of goddamn luggage. I mean, that man is God's own fool, now ain't he?"[61]

In his earlier novel *Go*, Holmes attempted something like a clinical diagnosis of the beat generation: "The end of the ego, the death of

the will! . . . die, give up, go mad. . . . We should expect people (and ourselves mainly, of course) not only to understand why other people think us abhorrent, unbearable, a contagious disease . . . but to accept it as well! Not even to feel humiliated . . . even in the heart!"[62]

Here Holmes felt it necessary to explain what was happening, addressing himself to a square readership. The principals in his books are (with the exception of *The Horn*) squares exposed to contact with the cats. In the work of Anatole Broyard and R. V. Cassill both worlds meet and receive equal emphasis. In George Mandel's work the squares, the others, are present only occasionally, and are always seen through the eyes of the Insiders, the cats. In Kerouac the Others are shadowy, almost mythical monsters, usually alien and menacing, although in *The Dharma Bums* some of them are almost benign.

The lifeways of the beat generation remain almost wholly untouched so far by the novelists. Kerouac has only scratched the surface. *On the Road* depicts the beatnik of the forties, not the fifties. *The Dharma Bums* is confined to a small circle of writers, poets and novelists, and their chicks. Writers and jazz musicians are a part of the scene, but only a small part. It is chiefly the novelists who are responsible for the widespread impression that the beat generation consists of only a handful of writers and artists. Writers writing about fellow writers can make interesting reading but this fails to provide the reader with anything like a comprehensive picture of the beat generation. The "rucksack revolution" of Kerouac's Dharma bums is only a very small part of the scene, and by no means the most significant part. Nor is the life of the jazz musician the whole story either. Holmes's jazz scene belongs to the bop era of a decade and more ago, which is nothing against it, except that the period is not clearly enough specified in the novel so that most readers, unfamiliar with the history of jazz, will conclude that it is contemporary and form an erroneous impression of what the jazzman's life is like at the present time.

Kerouac's picture is misleading in another respect. The narrator in *The Dharma Bums* is constantly fleeing from the city and the problems of livelihood and so are most of the characters in the book. It is made explicit again and again that the altar under the tall pines is bigger and better than the cathedral, and this is quite true, but the general impression left with the reader is that the holy barbarian is a twentieth-century Thoreau. This is true of only a small segment of the beat

generation. The vast majority of them live in the cities and are trying
to solve their problems within the framework of urban life. Nor are
they likely to give more than lip service to Kerouac's notion that "the
only decent activity left in the world" is to "pray for all living crea-
tures." It is a very superficial notion based on a misunderstanding of
the Zen practice of "sitting quietly, doing nothing." The prayer of
intercession, whether for man or beast, is no part of it. Who is any man
to intercede for anyone or anything? There is too much of Hallelujah
I'm a Buddha! Hallelujah I'm a Bodhisattva! in the *The Dharma Bums*.
The Zen elements in the novel stick out like so many unassimilated
lumps. When he has succeeded in making Zen more a part of his
experience Kerouac will be able to handle such material more naturally
— in the lives of his characters rather than as intermittent sermons and
hallelujahs. So far he has been most successful where he deals directly
with his characters, as in *On the Road* and *The Subterraneans*, notably
in the latter. His first published novel, *The Town and The City* (first,
that is, in publishing, not necessarily writing chronology), is a sensitive
picture of the life it depicts — the dope addict, the beat poet, the
criminal hangers-on — but its style, except in the dialogue, is still con-
ventional. In short, Kerouac has still to master his idiom. He is further
along the road to mastering it than any of the other novelists handling
similar material, but he has a long way to go before he can take off
in a direct line, stylistically, from the *Tropics* books of Henry Miller.
My own guess is that the poets among the holy barbarians may yet be
the ones who will blaze the trail with a prose idiom suitable to this
material, as they have with the poetic idiom. A careful and close read-
ing of Kenneth Patchen's *The Journal of Albion Moonlight* will illu-
minate the problems and point the way to such a prose idiom, I think.

The way of life of the holy barbarians, then, is much more fully
developed than their prose literature, which does not "cover" it as
successfully as, say, Hemingway covered the Lost Generation, or Dos
Passos the Generation of the thirties, or Mailer the World War II and
postwar Generation. Henry Miller spans the thirties and the forties
with a body of work that may yet be seen, in the perspective of the
future, as more significant than anyone else's. In poetry, William Carlos
Williams, Kenneth Patchen and Kenneth Rexroth, whose writings span
three decades, may yet loom larger than Eliot or Pound. Certainly their
idiom is more native and their thematic material more relevant. If they

have sometimes shown a tendency to disown their beat generation progeny — Rexroth and Patchen have been particularly testy about it on several occasions — it is nothing new in the inside family history of literary generations.

One tendency in the work of the prose writers, as well as the poets among the holy barbarians, is very marked: the trend toward a combination of poetry and prose. Free verse can now be seen as a step in that direction and, from the other direction, the writings of James Joyce. The oral revolution against the Geneva Code will never be fully expressed in any literary form that draws a hard and fast line between poetry and prose. The early bards and minstrels moved from narrative to poetry and back again as naturally as they moved from the spoken to the sung or the chanted word.

The task is to create an idiom that will bring the word once more back to life. As the oral revolution continues to grow and the word finds its voice again, prose and poetry will draw together. William Carlos Williams, in *Paterson* moves from poetry to prose and back again without any break in the continuity of thought. Louis Zukofsky does likewise in his long poem "A" (probably only a working title), portions of which have been published sporadically and obscurely through the years. *The Journal of Albion Moonlight* is a mixture of poetry and prose. Reading it aloud, it is not always possible to tell when the one leaves off and the other begins. There is no difference in the intensity, the "charge," only a difference in the degree of concentration and the syntax.

Writers like Clellan Holmes go maudlin when they leave conventional prose and try to pass over into poetry. What results is a rhetorical poeticizing that is neither poetry nor prose. George Mandel is more successful in spots. R. V. Cassill, Anatole Broyard and others who have been bracketed with the holy barbarians because of their subject matter, rarely attempt it. It is not an easy trick to bring off. Dylan Thomas might have made it if he had lived long enough to carry a step or two further what he began in works like *Under Milk Wood* and *Adventures in the Skin Trade*. Jack Kerouac may yet bring it off if he can bring himself to approach the problems it involves with more humility than he shows in *The Dharma Bums*. Charles Olson's *Maximus* poems are a step in that direction and his *The Lordly and Isolate Satyrs* a still longer step. Charles Foster approaches it in *The Troubled*

Makers[63], and Robert Duncan possesses the necessary skills in both media to make a very promising try for it.

It is not just a question of straining to do something new and different in the writing arts, or rediscovering and reviving old forms in a contemporary idiom. The simple fact is that the lifeways of the holy barbarians represent such a radical departure from the society that a novel in the style of, say, Saul Bellow or John Steinbeck is totally inadequate to bring the scene to life. It would be like trying to stage an African fertility rite on the stage of a college auditorium.

One thing is certain. There is no guarantee that hallucination, whether induced by trance or drugs, will "bring up" anything more than platitudes and clichés, no matter how "dissociated" or "far-out" the artist may be, unless he possesses an original mind, a great gift and a knowledge of his craft. As in the ritual use of hallucinatory drugs in oral, preliterate cultures, where the emphasis is always on training and control, the Dionysian artist is faced with the difficult problem of maintaining a heart of fire and a mind of ice. Unlike the shaman, the poet in our Western book-dominated culture has no tradition to fall back on. He must create the controls along with the spell, hence the agony of composition. The poets among the holy barbarians are faced with the same problem. Kenneth Rexroth has rejected hallucination altogether. "These peoem are not in quest of hallucination. They owe nothing to the surrealism which was coming into fashion when they were being written," he says in a recent preface to his early book *The Art of Worldly Wisdom*. William Carlos Williams evidently puts no stock in trance or drug-induced hallucination, nor does Kenneth Patchen, although both, and Rexroth as well, have praised wine as a disinhabitant. Dylan Thomas used beer and liquor heavily but those who saw him at work insist that he worked sober. In the years since his death much has been learned about his methods of work. To those poets who think that "out of the unconscious" is the same as drawing words blindfolded out of a hat, it has come as something of a shock to learn that Dylan's work was the result of repeated, often agonizing, revisions.

Our whole system of education is conceived to make squares out of us, to make us fit for the society in which we live. Diseducation and re-education is designed to make us *unfit* for the society so that we are able to stand outside of it and view it with eyes unclouded by the

smog of propaganda and the all-pervading pressures of social hypocrisy. The artists of the beat generation are taking upon themselves the task of presenting a smog-free vision of life.

Painting and Music in Beatland

Among the holy barbarians who pursue the arts nearly everybody paints or plays some kind of an instrument, if only bongo drums or the recorder. And everybody writes poetry. Painting is likely to mean anything from a student sketchbook full of pencil and pen drawings (often with poems on the same theme) to twelve-foot canvases in oils or common house paints. Many a Venice West landlord has walked into an apartment just vacated by some beatnik, who left without giving notice or paying back rent, to find all the walls and sometimes even the floors and doors covered with abstract murals, making it unrentable to anybody else except perhaps another beatnik. Everybody is always drawing everybody else, at readings and at parties, and everybody is writing a book about everybody else. None but a fraction of this artistic activity will ever see completion, let alone exhibition or publication, but it will have served its purpose just the same. It is simply a part of "making the scene."

In more professional art circles among the beat the problem that tries the soul and often makes and unmakes loves and friendships is the problem of whether to school one's talent or not to school it, to improvise or to play and structure, to "chart" or "just blow." Here again Zen Buddhism is an influence, even among those who have been affected by it indirectly, at second or third hand. The jazz musician may not know that his practice is close to that of Chinese music and the painter may not know that his insistence on spontaneity is akin to Zen practice in the arts, but both act upon assumptions that are basically similar. Chief among these assumptions is that the creative process is not an assault upon the materials of the art, a conquest, but an unfolding, a growth from within, as a tree grows. Watts points out that Malraux, for example, always speaks of the artist "conquering" his medium as one might conquer a mountain or conquer space. "To Chinese and Japanese ears these are grotesque expressions. For when you climb it is the mountain as much as your own legs which lifts you

upwards, and when you paint it is the brush, ink and paper which determine the result as much as your own hand."[64]

Some have taken this to mean that anything that happens is the right thing. This has led to a spate of drip and smear paintings that, hung next to one another on the wall of some dimly lighted beer joint, may give a pleasing over-all impression of design and color, like some crazy wallpaper. This is the work of poet-painters and other amateurs and it serves a useful purpose for them, no doubt, but it is not good painting, by Zen standards or any other standards. "The constructive powers of the human mind are no more artificial than the formative actions of plants or bees," says Watts, "so that from the standpoint of Zen it is no contradiction to say that artistic technique is discipline in spontaneity and spontaneity in discipline."[65] Painting that "grows" from within the artist is what makes for the happy accident. As in poetry, the "lucky" accidents happen only to the artist who has made himself, through trained skills, the kind of a person to whom such accidents can happen.

"Art is like a living tree," says painter Art Richer whose studio is on the Venice West canals, "and one must come up from the roots in order to branch out and become individual."

"Art is love," says artist Wally Berman, and his words are scrawled on the walls of the Venice West Espresso Café.

"I never painted for money," says Art Richer. He has worked at many odd jobs — anything that came to hand. At this writing he describes himself as "a bomb-diver at the La Brea tar pits." That is, he goes around picking up littered rubbish with a nail-pointed stick at a small park in Los Angeles which the city has turned into an archeological exhibit. Prehistoric animals were discovered there and were left in situ for the edification of visitors. Recently he acquired a small hand press and is turning out his own prints. When his paintings are exhibited, as they have been from time to time in some of the leading galleries, they sometimes sell at a good figure, but he doesn't want to become dependent on art sales.

Wally Berman issues a magazine, Semina. Other artists make mobiles, decorative tiles and ceramics. John Altoon, one of the finest graphic artists in the country today, designs jazz album covers and teaches young artists whose work seems to him to hold promise. Ben Talbert is going to try to make it as a teacher, he says. But whatever

way they choose to make a living, the painters who are most respected by the holy barbarians are those who are completely disaffiliated from the art game.

The influences that these artists avow are chiefly painters like Mark Tobey, Morris Graves, Clayton Price and Kenneth Callahan, a group that is sometimes described as the Northwest School but which Venice West painters jokingly, but affectionately, call the Arctic School. Art Richer names Rico Lebrun as an influence, although he studied with him only briefly. "Patronage is one thing and the artist's audience is another," says Lebrun. "A lot of us are addressing ourselves to an audience that is unable to purchase paintings but it is the only audience that really matters." The audience Lebrun is referring to here is the knowledgeable audience and also reads modern poetry and loves the modern dance and listens with equal pleasure to Bach and Charlie Parker. The others will come around in due time. "Immediate communication with the larger audience may not be possible in all cases," says Lebrun. "That doesn't matter much to me. That would be graphic journalism. We have seen what happened to the social realists. They were so concerned with what they were saying to a ready-made audience that they paid little attention to the way they said it."

Don Jones, the Venice West painter who received his training at Black Mountain College, names Ben Shawn and Robert Motherwell as influences. Both of these painters taught summer courses at Black Mountain College. He also acknowledges the influence of Joe Fiore, the staff teacher in painting at the college. But one look at Jones's work is enough to prove to anyone that "influences" does not mean imitation. The striking thing about all these painters is that there are no two alike. Their intuitive approach to the medium prevents any such stereotyping. Any resemblances to "school of painting" are purely accidental.

"Although I have always worked intuitively," says artist Abe Weiner, "I was not aware of the surrealistic nature of my process of expression till it was revealed to me by my reading of Wallace Fowlie. When I lay down a color it often conjures up associations of images and feelings. When I lay down a number of colors there begins an interplay of many feelings and images. Soon there emerges one dominant feeling or mood and a corresponding image. From here on it is a matter of discipline, setting down a harmonious juxtaposition of forms and colors."

The result is a dialetic of contrasts, lines and masses in tension, and resolution of tension.

"An artist," says Weiner, "experiences many deaths and many re-births, each an upward climb of the ladder, or, in other terms, an outward-moving from the center."

The net balance is on the side of life, and it is this perhaps that has endeared Weiner's work to Henry Miller, who calls him *le grand maître* — and Henry has known them all, Leger, Chagal, Picasso. Like Miller (who takes his own water-color drawings as seriously as his writings), Weiner works in broad strokes, directly and with contagious enthusiasm.

The tug of war between abstract and representational painting is a critics' war, not a painters', as far as these artists are concerned. For example, in Weiner's studio you will see on one wall an exquisitely delicate female figure floating in waves of pale blue and coral while a Pan sprite fiddles on a stringed instrument; on another wall a series of jazz-inspired paintings; and on the wall opposite a geometrically organized composition of rectangles and circles in complementaries; and on the fourth wall a clown with unforgettable eyes; while on the floor stands a screen triptych in which Warrior, Poet and Priest are abstracted in stained-glasslike formations of line and color that are totally unrepresentational and yet recognizable for what they are meant to convey.

The poet David Meltzer once said of Art Richer's painting that "he dissects the false hangnails of our innermost wincing," and there is point to what he says, but it is not the autovivisection without ether that the French surrealists inflicted upon themselves. As in Weiner's paint-ings the net balance is an affirmation, on the side of life. It is not a question of mirroring life or nature. "I never paint places," says Weiner, "or persons. I paint pictures. I don't paint daylight. I don't paint nightlight. Shadows mean nothing to me. I paint paintings."

The painters paint paintings and the musicians play *sounds*. The sound of jazz is never the same twice, not even from the same musician. As Woody Woodward says in *Jazz Americana*,[66] "It is a broad un-confirmed sound that can be likened to the human voice; each voice possessing a timbre not entirely like any other. Jazz sound is a personal utterance, carrying with it the peculiarities of the individual. Almost any sound an instrument is capable of producing, within the realm of good taste, is acceptable in jazz. Despite this, a characteristic does

exist; the general absence of a 'legitimate' attack. The jazz musician tends not to hit a note right on pitch. He is inclined more to slur or slide up to a note then slide on to the next without much more than passing through the pitch. . . . A classical musician must produce a sound traditionally associated with his instrument. . . . In jazz the same instrument seldom sounds the same. One musician might play with a light vibrato-less tone, another dynamically, with a robust strident tone. The myriad of sounds between these two extremes are as numerous as the musicians playing jazz."

What the holy barbarians see and hear in the painting and the music they make can only be experienced, it cannot be conveyed in words. Zen tradition has it that the Buddha transmitted awakening to his chief disciple Mahakasyapa by holding up a flower and remaining silent.

PART IV

14

Lost Generation, Flaming Youth, Bohemian Leftist, Beat Generation— Is There a Difference?

ONE QUESTION THAT I HAVE ENCOUNTERED MORE OFTEN THAN ANY other in public discussions I have participated in on radio, television and lecture platforms is: What is there that's so different about the Beat generation? This question is always followed by the statement, usually of some length and delivered with some heat, that there is nothing about the Beat generation that is new or different, that it is the same old rebellion against parental authority, against moral restraints, etc., that characterized the Lost generation of the postwar twenties, the flaming youth generation of the Jazz Age and, if the speaker is political-minded, the Marxist generation of the Depression years or the anti-rah-rah generation of the wartime and postwar forties. Having answered his own question the speaker sits down amid a little ripple of applause, content that he has said the last word, that only a willful fool or a stubborn partisan with an ax to grind would dare to challenge his simple, common-sense analysis of the matter. Like most simple, common-sense answers to social questions, it contains just enough of the truth to satisfy simple, common-sense people. Rebellion against authority is a nice, large generality which covers all generations and all periods of history. The important considerations, however, lie not in the likenesses but in the differences between one generation and another.

In the 1920's, Chuck Bennison, for instance, would have quit his

263

advertising agency job, as Sherwood Anderson did, but he would not
in the twenties have shed his necktie, put on Levi's and gone to live
in poverty in a slum, seeking "new ways of knowing" through pot and
trance and far-out jazz as he did in the fifties. Sherwood Anderson's
was not a total rejection of American lifeways and values. The rebels
of the twenties drifted in and out of bohemias like Greenwich Village
or the Left Bank of Paris or Chicago's Near North Side, which was
only in its bohemian beginnings, but they did not think of bohemia as
a slum or of poverty as a voluntary act of dedication. If they shacked
up with a flapper it may have looked like "flaming youth" to the news-
paper sensation-mongers, but to themselves it was romantic love in the
grand manner, beautiful and tragic — Romeo and Juliet were their
models, and Paolo and Francesca — and not, decidedly *not*, the casual
"cool" affair it is to the hipsters and the beat of today. Jazz music was
known to the youth of the twenties but it was not the cult it is today;
it was not what it has come to be among the beat, a way of life.

In the thirties, if Tanya had been an adult, she would have come
into the Communist movement with fewer misgivings and it would
have taken her longer to see through the rationalizations of the Mos-
cow-dominated American Communist party line. She would have had
some experience at working for a living, and her class consciousness
would have been more than a catch phrase in a party pamphlet. As a
second generation radical, Tanya was something of an exception to the
general run of YCL youngsters of the early thirties. For one thing, she
was sixteen. Most of the YCL youth were in their twenties and so many
of them stayed on into their thirties and longer that the epithet
"the bearded youth" came to be a private joke in Young Communist
circles. The Tanyas of the period would not have been "deviationists."
When the defections began after the Hitler-Stalin pact in 1939, it was
not the Young Communists who split with the party; it was the men
and women in their forties who had made many personal sacrifices for
the cause and had the scars to show for it, people who felt let down
and sold out, people like Tanya's father. Those who were in their
teens and twenties at the time moved from the Hitler-Stalin pact into
the "united front" forties — and without any feeling of being let down
by Moscow or sold out by collaboration with bourgeois democratic
parties. When their leaders urged them to join the Democratic party
and take the oath of allegiance to the Constitution and salute the flag

in the newly formed "clubs" that replaced the old party cells, they did it without any feeling of hypocrisy. The Marxist alienation of the thirties was an anti-Fascist movement. It was not confined to Communists but cut across all party lines from Left to Right, drawing its adherents from all classes. Its archfiends were Hitler, Mussolini and, later, Tojo, and its most articulate spokesmen were Marxists, who gave the generation of the thirties its coloring.

In the forties the generation that went into the boot camps and the foxholes of World War II was an alienated generation, even though it remained for the most part untouched by Marxist influence. New Deal liberals in their propaganda, official and unofficial, made it sound like a crusade to save the American Way of Life (which in the mouths of the home front heroes of radio, lecture platform and political oratory became a crusade to save mother's apple pie from Hirohito's "little brown monkeys"), but to the young men on the firing line it was an unpleasant job to be gotten over and done with, as anyone old enough to remember World War II years knows very well. Here was a generation that came home not only to a world it never made but to one which it hadn't even begun to live in. The Welfare legislation of the New Deal with its safety valve provisions against unemployment, the medical features of the GI insurance policies, the FHA building loans and other such measures helped to soften the hardships of a generation that was four to ten years late with its job experience and its schooling. And the GI bill helped to take some of the steam out of the boiling discontent that might otherwise have exploded into violence. But for all that, this was a generation whose sensibilities had been calloused against economic promises and patriotic slogans. It was alienated from the flag-waving, schoolmarm, pollyanna values of hundred-per-cent Americanism to an extent that shocked even the liberals themselves, so mezmerized had they become with their own patriotic oratory.

The veteran of World War II was a tough customer. He knew his lost years were gone forever, but he demanded everything in the way of compensation that he could squeeze out of the politicians and the war-profiteering millionaires, and he wasn't the least bit humble about it. He scarcely bothered to conceal or disguise his contempt for the American Legion's rah-rah boys of World War I. He either refused to join or he formed his own veterans organizations, organizations that

imitated none of the clowning antics of the old Legion but talked turkey to Washington when it came to veteran's benefits, in plain language and without any heroic flourishes. When the Cold War heated up into the brush fire "police action" in Korea, his answer to the call to arms was a cold "include me out." It was not a noisy resistance, just a stony, stubborn No.

These are just a few of the differences between the generations. For a fuller understanding of why the beat generation is far from the "same old rebellion," let's look back at the twenties.

"Children no longer obey their parents and everybody is writing a book."

I don't remember any more who wrote it — it was probably one of those quips that H. L. Mencken and George Jean Nathan used as fillers in *The Smart Set* sometime between 1914 and 1924. It purported to be something culled from a Babylonian clay tablet — or is this something my imagination has added? — and it read: "These be parlous times. Children no longer obey their parents and everybody is writing a book." I clipped it out and it kicked around in my files for years till it vanished into the limbo where all good clippings go if you move around too much or file things away too efficiently. Anyway, it stuck in my memory (in a form that will probably surprise its author if he should chance upon it here). It stuck with me because it expresses in a clever way the notion that "all younger generations are alike," a notion that is cherished by most grownups who have "settled down" and are having problems with their offspring. Older people, faced with a rebellious and disrespectful youth, like to tell themselves that all new generations are the same — "I was just like that myself when I was their age" — that it is only a symptom of the growing pains of the young, that they will settle down in due time, and that, as the French platitudinarians put it, the more things change, the more they are the same.

That things *do* change, and people with them, is something the late Frederick Lewis Allen spent much of his life in documenting. His book *Only Yesterday* is filled with proof of it — and it covered only the first thirty years of the century. Twenty years later in an article in the August 10, 1952, issue the mass-circulation newspaper supple-

ment *This Week*, under the title "My, How You've Changed!" Allen
bore down once more on the astonishingly swift changes which he
had described in detail in his book and then went on to sum up the
half century with the mellow observation that the material progress
was sufficient compensation for the admitted anxieties of the present
and fears for the future. "Even when we take all our dangers and
uncertainties into account," Allen concluded, "these are pretty exciting
days for Americans to be alive in."

A tireless and entertaining chronicler of American lifeways on the
newspaper and "quality magazine" level—he was on the editorial
staffs, successively, of *The Atlantic Monthly, The Century* and *Harper's
Monthly*—Allen made no pretense of probing very far beneath the
surface of the changing mores and manners of the half century. The
more obvious documentable "facts" are all there. The portion of *Only
Yesterday*, for example, which deals with the twenties ("The Revolu-
tion in Manners and Morals") catalogues the period with the complete-
ness of a newspaper clipping morgue and moves before the mind's eye
like a movie montage, but the news is slanted and the camera eye is
focused on precisely those items which the press of the period singled
out for news coverage, and which have ever since remained the "offi-
cial" picture of "the Roaring Twenties." It is the picture that Frederick
Lewis Allen saw in the news clippings. It is the way the twenties
looked to a quality magazine staffer whose views were based more on
reading than experience or participation.

In his preface to the paperback edition of *Only Yesterday* which
was published in 1957, Allen set down some interesting afterthoughts.

> In the original preface I wrote, "One advantage the book will
> have over most histories: hardly anyone old enough to read it can
> fail to remember the entire period with which it deals." That is
> emphatically no longer true. Many of you who will read it now
> cannot personally recall even the end of the period. And therefore
> I should confess that in the effort to highlight the trends of the
> nineteen-twenties — and to enliven the book — I illustrated some of
> these trends with rather extreme, though authentic, examples of
> odd or excited behavior. These may mislead you — in case you
> cannot check such examples against your personal recollections —
> into thinking that everybody must have been a little crazy during
> the nineteen-twenties. If so, will you please take my word for it

that one could gather just such preposterous examples of American behavior today (a selection of some of the wilder comments on the atomic bomb, for instance); that in my humble opinion people in the nineteen-twenties were on the average just about as normal and reasonable as they are today; and that, in short, the period was not conspicuously sillier than any other, but simply silly in somewhat different ways? Whether the human race gains in wisdom as time goes by is uncertain; the one thing we can be sure of is that its absurdities take changing forms.[67]

We have Allen's word for it that the examples of "extreme behavior" he used to illustrate the trends of the twenties were authentic. He had the newspaper clippings to prove it, and the magazines and the books. In a later book, *The Big Change*, which was published in 1952, he admits it was a scissors-and-paste job, as far as his sources are concerned:

> During the years 1930 and 1931, when I had been at work on *Only Yesterday*, an informal history of the United States in the nineteen-twenties, my best sources had been the daily papers and magazines of the period; the books of reportage or appraisal which I really needed to consult could have been ranged on a single shelf.[68]

In 1930, when he was at work on *Only Yesterday*, Allen was forty years old. The youth of the twenties might have been his own sons and daughters. They were a younger generation, as far as he was concerned, yet he seems to have gone to every source but the one living source from which he might have learned something about this generation of the twenties: the young people themselves. If the examples of their behavior which he gave were "extreme" in his own view a quarter of a century later, it is because they were extreme from the start. In other words, they were "newspaper stories," an expression that I find myself enclosing in quotation marks because that is the tone in which the phrase is uttered by every intelligent person today — "just newspaper stories." If they later seemed like absurdities to Allen, it was because they were selected for their absurdity by the newspaper and magazine editors who printed them in the first place — those that weren't contrived by enterprising reporters and posed by news photographers, as many of them were. They were as true as they needed to be for the purpose they were intended to serve — to titillate the sen-

sation-hungry yokels that newspaper publishers have always imagined their readers to be, and to stimulate circulation in order to justify rising space rates on advertising.

I bear down on the sources of Allen's *Only Yesterday* because it became the "accepted" account of the twenties, a kind of official history. In 1932 it was issued by Harper in a college text edition, it went through twenty-two printings of the original hardcover edition and into several paperback reprints. And today, nearly three decades later, it is still being used as a source book on the period by schools and editorial offices, and is widely used, chiefly in journalistic circles, to document the thesis that today's beat generation is nothing more than a carbon copy of the "flaming youth" generation of the twenties, that "it's the twenties all over again." Such superficial thinking leads to new journalistic absurdities, as "authentic" as the absurdities Allen found in the press of his day.

"The Roaring Twenties Roar On"

Ever since Frederick Lewis Allen pasted up his collage of the twenties from newspaper clippings, the newspapers have been rewriting his book to create more clippings for other books based on clippings. This ludicrous process has been going on for nearly three decades, but it remained for *Newsweek* to dish up for its readers what will probably be for a long time the *pièce de résistance* of this kind of journalistic hash. In a feature story titled "The Generation That Won't Die," with a full-color cover depicting, collagelike, the young Lindy with his "Spirit of St. Louis" plane, a copy of F. Scott Fitzgerald's *The Beautiful and Damned,* a dancing redhead doing the Charleston in an above-the-knees sheath dress, Rudy Vallee with his megaphone, and Negro fingers on a saxophone, the editors managed to crowd into something less than four pages a rewrite of Allen's *Only Yesterday,* slanted to make it look as if the history of the twenties was re-enacting itself in the generation of the late fifties.

The opening lines of the article, purporting to be a characteristic contemporary dialogue between father and son, deserve to be rescued from the clipping morgues. They could go straight into the *New Yorker* as one of those filler quotes under some such caption as REAL LIFE SCENE THAT WE DOUBT EVER GOT SEEN OR HEARD.

Scene: A living room somewhere in the U. S. Time: This week. Father, aged 50, is reading his paper. Enter his son, aged 20, whistling.

FATHER: Please stop that infernal . . . say, isn't that "Yes, Sir, That's My Baby?"

SON: That's right, pop. It's a new hit.

FATHER: New hit! Your mother and I won a Charleston contest in 1926 dancing to that "new hit."

SON: I keep forgetting the Charleston goes back that far. Sort of like the minuet, isn't it?

FATHER: (bitterly): Oh, sure. Just like the minuet. (Dreamily.) I'll never forget that night. Of course, we'd had a couple of shots from my hip flask, and . . . (Enter mother.)

MOTHER: I think that will be quite enough of that.

FATHER: Ahem. Was there something on your mind, son?

SON: I was going to ask if I could wear that old raccoon coat of yours to the game next Saturday.

FATHER: If your mother hasn't thrown it out, you can.

SON: Thanks a lot. It'll be a gasser with my new bowler hat. (Exit, whistling "Me and My Gal.")

FATHER: (to Mother): You haven't thrown it out, have you?

MOTHER: Of course not, dear. You were wearing it the first time I met you. You were my blind date, remember? And it was the only time I ever saw Red Grange.

FATHER: Ah, Red Grange. Ah, raccoon coats. Ah, the Charleston . . .

BOTH: Ah, the 20's! (He takes her tenderly by the waist; exeunt, Black Bottoming.)[69]

That noise you just heard was the beat generation applauding — the Zen Buddhist "sound of one hand clapping."

As any novelist knows who has ever invented a sadistic, potbellied, lecherous, bribe-taking ward politician named J. Makepiece Whiffle-dripper, only to find himself being sued for libel and defamation of character by a sadistic, potbellied, lecherous, bribe-taking ward politician by the name of J. Makepiece Whiffledripper, it is always risky to assume that *any* kind of a person, however contrived he may appear to be in print, does not exist. This *Newsweek* writer's Father and Son

might conceivably exist *somewhere* in the contemporary scene, perhaps in one of those exurbias populated exclusively by gag writers, fashion designers, advertising men, press agents and news magazine staffers. In any case, I can assure the reader that if Son ever showed up in beat generation circles in his raccoon coat and bowler hat, the cool cats would give him such a frigid reception that he would freeze to death in his fur benny. I suspect that the *Newsweek* writers who cooked up this story were taken in by press releases from some raccoon fur association and some hard-pressed hatmakers and a too credulous attention to some Paris-by-way-of-Hollywood press clippings from the fashion pages of the women's magazines.

Following this Father and Son bit, the rest of the *Newsweek* story was the usual scissors-and-paste job on the twenties — Greenwich Village, Edna St. Vincent Millay, the young Eugene O'Neill, the little theaters, Prohibition and the speak-easies, pocket flasks, F. Scott Fitzgerald, Flaming Youth, Clara Bow the "It" girl, Charles Lindbergh, Al Capone, Gertrude Ederle, Jack Dempsey, Red Grange, Bobby Jones, Bill Tilden, Graham McNamee, Mary Pickford, Rudolph Valentino, Charley Chaplin, Douglas Fairbanks, Elinor Glyn, the Stock Market Boom, Dr. Coué, Leopold and Loeb, Clarence Darrow, Bryan and the Scopes "monkey trial," jazz, George Gershwin, Hemingway, Jimmy Walker, John Held, Jr.'s cartoons, climbing hemlines — it was all there, and all of it slanted to convey the notion that "in 1958, with its anxieties and uncertainties, the 20's suddenly have become a Golden Era, not only to the oldsters who lived through it, but to the youngsters who can only guess what it was like. . . Maybe the depression was the deserved hangover that followed the 20's glorious spree. But the spree — lawless and irresponsible though it might have been — had still been glorious to many of those who lived through it. It produced some wonderful times and some wonderful people — great creative artists, great athletes, great heroes — and that is the way they remember it and always will remember it. And that is the way, apparently, that it looks to the present generation."[70]

Nowhere in this idyllic picture of Mom and Pop black-bottoming back to the Golden Era of the twenties, with Son off to the football game in Pop's old raccoon coat and the new-old bowler hat that is the rage now to meet his girl in a sack dress that is "a first cousin, if not

closer, to the tubular sheath that the flapper of the 20's wore" — this
picture of "the present generation" — nowhere is there any mention
of a beat generation.

The nostalgia of the oldsters for the good old boom days of the
twenties is *Newsweek's* special and exclusive contribution to the dec-
ades-old stereotype. Otherwise it is all of a piece with the handling
that the press has given the beat generation story. This being the
case, it may be advisable to take Mr. Allen's advice and check his
story against my own personal recollections of the twenties which Mr.
Allen did not include among his sources.

The Democratization of Amorality

Ever since World War I the leveling out of class distinctions, a
process that is traditional in the United States, has been proceeding
with accelerated speed. This is a trend that has been amply docu-
mented by historians of political and social history. Mr. Allen takes
note of it in his books but chiefly on the level of clothing fashions and
other such superficialities. If he had carried it a bit further he would
have discovered that deeper cultural changes can be illuminated by
reference to this leveling process, that graphed on paper it traces a
steadily rising curve that is unbroken, except temporarily in pace and
intensity, by war and peace, action or reaction. Examined closely and
in detail from year to year and recalled as we have experienced it in
living, it presents the classical historic picture of a rising class taking
over the mores of a declining class, in this case the middle class taking
over the mores of the American upper class.

What concerns us here is not the economic or political changes
brought about by this trend but the cultural changes. Wealth and the
economic and political power it brings with it are the foundations on
which a ruling class maintains its position in a class society, but it is
the culture of the group, its lifeways — particularly its special privileges
and prerogatives — that identify the members of the group to one
another and mark them as apart and above other groups. The virtues of
a class — and by virtues I mean here those mores and lifeways which
are prescribed and sanctioned by the larger group, the "civilization"
to which all classes presumably belong — are not usually the most
prized of its characteristics because they are not exclusive to it. It is

the vices of a class — and here again I use the word in the broad, "accepted" sense — that the class prizes most and guards most jealously. And rightly so, for it is the vices, not the virtues, which require money, leisure, social immunity and often legal immunity. It is the vices which mark an upper class as a privileged class.

Churchgoing, patriotism, legal mating, legitimate childbearing, respect for parents, obedience to law and order, observance of the rules of common decency — these were virtues that the middle class shared with the rich, as a matter of principle if not always in practice. Even almsgiving was a shared virtue, although admittedly the rich could indulge in it on a larger scale than the middle class. But when it came to the vices — not the petty vices but the big, juicy vices, like supporting a kept woman, fathering a bastard child (mothering one was another matter), destroying private property with relative impunity, say, in a rowdy hotel party or a swank saloon, going on wild joy rides in the country, sneaking off for a lost week end to a love nest at a mountain hideaway or seaside resort, or on a "moral holiday" to Paris — these were vices that belonged exclusively to the upper classes, if only because they were expensive ones that only the rich could afford. This is not to say that all the rich availed themselves of such privileges, but they were always possible. If the founder of a fortune frowned on them, preferring to devote the best years of his life to larger but less conspicuous vices like plundering the natural resources, raiding the stock market in private behind-the-scenes deals, bribing public officials, floating fraudulent stock issues or ruining competitors by financial mayhem or legal murder, there was usually a son and heir, and sometimes an heiress, who elected to avail himself or herself of the purple privilege of expensive hell-raising on a more personal level.

The middle class, too, had its vices and so did the working class on all wage levels, but they were vices patterned on the resources and special moral values of their class, the vices of their virtues, so to speak. These stratifications began to dissolve during and after World War I. The *Wanderjahr* of travel on foreign soil, where a young man could sow his wild oats in discreet anonymity, had been the privilege of the upper-class scion. Now it was, for the first time in American history, within the experience of any young man in the armed services who got overseas. Or any young woman who enlisted for the nursing services. War wages and the greater mobility afforded by the automo-

bile combined to make it easier than ever before to break home ties. Breaking with family and the home town makes it easier to break through class behavior, through both the virtues and the vices of the class. To be as good as the upper classes you have to be as bad as the upper classes — and get away with it, as they do. What was taking place in the twenties was a democratization of amorality downward through all classes of society, but it was most noticeable on the middle-class level — and most publicized — since the middle class was traditionally the home base of Anglo-Saxon Christian morality and the showcase of everything that was nice and respectable in the lifeways of America.

From a Rural to an Urban Morality

Parallel to the trickle-down process of upper-class vices, another curve can be traced: the transition from a rural to an urban morality. Here the automobile, improved highways, the motion picture and the radio were the chief factors, plus the European war experience, since this was an experience shared by young men and women from the farms and small towns as well as from the cities. In the year 1900 there were only 13,824 automobiles in the United States, and they were owned chiefly by the rich and the well to do. By 1919 there were 6,771,000 registered passenger cars, most of them, I suspect, in the bigger population centers. In the early twenties, when I hitchhiked back and forth across the country, car traffic was largely city-to-city. The short-haul lifts I got were nearly always in old rattletrap cars owned by small-town and farm people. There were still a great many farm wagons on the roads, especially on the dirt roads off the relatively few paved highways.

Other young men and women of my acquaintance, with literary and artistic aspirations and interests, were going to Paris for the "expatriate" experience, but I decided to "See America First." This journey was made possible, not by affluent parents or a rich uncle — my father had died when I was in my early teens, leaving nothing but a five-hundred-dollar life insurance policy — but by the high wages (twenty-five dollars a week) that commercial art studios were paying to talented young apprentices, enabling me to amass a traveling fund of fifty dollars after a year's work. A decade earlier the nest egg, if a boy of

my age and circumstances had been able to accumulate it at all, would probably have gone to buy an engagement ring or help pay off the mortgage on the family homestead. In the early twenties it was *de rigueur* in my "set" to head for Paris on a cattle boat or hit the open road with a copy of *Leaves of Grass* in one's knapsack. Yes, *knapsack* — and a pair of overalls, artfully dirtied-up for the occasion, and, since it was summertime, no hat. Old Walt Whitman had worn his hat as he pleased, "indoors or outdoors." But by the twenties the emancipated young men had already launched the long vendetta against headgear that by the fifties was to send the hatmakers scurrying to Madison Avenue for consumer motivation studies and advertising campaigns to save their vanishing industry. Brought up in a big city, Chicago, I would have to know, if I intended to be a writer, how the other half lived, the half which, in 1920, still lived on farms and in villages.

It didn't take me long to find out that the overalls were a mistake. Trying to keep from looking like a city slicker, I only succeeded in looking like a rube act. The country girls had nothing against city slickers, I discovered. I sent home for my one good suit. I had to forget my avant-garde distaste for hats and invest a buck fifty in a straw kelly. They had caught fleeting glimpses of the rich flashing by — at forty miles per hour! — on the highways in their merry Oldsmobiles, and they knew that the proper summer headdress was a straw hat. I was hitchhiking but the girls were prepared to overlook that if I played the city swell on my dates with them. Morally they expected the worst from me and strove cunningly to bring it out. The girls I dated had sat oggle-eyed in the movie houses before the spectacle of the big-city rich boy wining and dining the poor little working girls and leaving behind him a trail of greenbacks, empty bottles and broken hearts, and they knew what to expect. This was a very different thing from the old skinflint rich of the "Opry House" melodramas who had no vices worth imitating. These were young men who sowed their wild oats, not in faraway places among foreigners, who were probably pagans or papists anyway, but right here at home, defying conventions and flouting High Society for the sake of true love. And if they finally left the poor working girl in tears, well, she had lived, hadn't she, while it lasted? — and wasn't that better than never having lived, *really* lived, at all? Who could tell when some rich city boy might come along — maybe hitchhiking just for the hell of it — and rescue them from the

only "fate worse than death" that was left for the young girl in the twenties: being left to marry and settle down with the boy next door in a one-horse town or, worse, on a farm fifty miles from nowhere. In every small town I hit during those days there was always someone to assure me that it was "the ass-hole of the world." Sinclair Lewis wasn't telling them anything *they* didn't know about the Gopher Prairies of America.

The big city was the golden goal. It was a relative thing. In Chicago we yearned for New York; in Omaha, I found, they were yearning for Chicago. In Lincoln, Nebraska, they yearned for Omaha. Sometimes they took it that way, by stages, and when they had had their fill of New York, some who were harder to satisfy made the golden journey to Paris. But the picture they cherished was the same everywhere: the big city was the place where you could realize yourself and let yourself go, by which they invariably meant sexual fulfillment. Somehow the notion of financial fulfillment was tied in with it, so that it added up to the rags-to-riches Cinderella story of the American Dream, with the big city as the palace and the rich boy as the prince. By the middle twenties the stock market ticker was beginning to look like the fairy godmother, and by the late twenties only a few prophets of doom ventured to assert that the golden coach would ever turn back into a pumpkin again. It was all one big royal ball and midnight would never come.

This was the city view, of course. In the small towns and on the farms it was just a shining vision of far places that could be glimpsed from time to time on the silver screen and on the highways where the city rich went streaking by, en route from love nest to love nest, as they imagined it, or in a momentary, but heady, encounter at the local gas station where these fabulous creatures sometimes stopped long enough to leave behind a whiff of perfume and a flash of two-figure folding money.

Even in towns as big as Omaha I found girls who thought I must be rich because I came from Chicago. It couldn't have been only the blue serge suit and the straw hat that did it. It was the big city — in this case the *bigger* city — fantasy. Cities were growing fast while small towns were remaining static and farm population was dwindling. Fast growth plays a large role in the fantasies of the young, and bigness has always been a virtue in the American dream — everything that is first,

biggest, fastest, tallest, richest — a worship of superlatives that by the forties was to make a word like colossal almost a term of belittlement; everything had to be super or nothing.

I remember Omaha particularly because of Marilee. The name was a compound of Mary and Lena, both too old-fashioned-sounding for an aspiring young girl of the twenties, but if you ran them together into Marilee you had something that *felt* right, more in character with what she hoped she *looked* like, a name that would sound better than Mary or Lena on the lips of the young Lochinvar who would come someday out of the East — nobody expected him to come out of the West in those days; Hollywood wasn't the magnet yet that it became later.

Marilee had "It." I was "It." "It" had many uses. "It" had been promoted from a pronoun to a noun and it meant — we didn't bother to define it; we knew what it meant; it meant everything we wanted it to mean, everything we were making it mean, which is just about the way today's hipsters feel about words like "hip" or "cat" or "dig."

We met on the street by the eye-to-eye-follow-stop-follow-stammer-and-pair-up routine, and an hour later we were on a park bench going through the feel-up ritual. There was too much lamplight and too much foot traffic around for anything more serious. It was one of those little block-square city parks. So we ended up that first night in one of those hot, moist, kiss-and-rub rassles, around the corner from her home so that no parental eye might spot us from under a lowered window shade. A first act without a proper climax, but the verbal fantasy had already begun. I had caught on quick to the idea that Marilee wanted me to be the rich young man from the big city, scion of an old eastern family that wanted me to go into Dad's business, which was okay with me except that I was bent on having my fling first and sowing some wild oats before I settled down with who else but a poor but beautiful small-town girl with plenty of "It" I had run into on one of my joy rides across the country and fallen in love with at first sight and was determined to bring back to the old mansion with me and marry in grand style despite "family objections" and the snobs of High Society, all of which would soon melt, of course, under the magic of her charm; and if it didn't there was always the other way — a romantic elopement, maybe Paris, Rome, hell, the South Sea Islands, if need be, for this was 1923 and *everything* was possible because love conquers

all. BUT — and this was the implicit fourth act of the play which was not even to be mentioned but simply understood between us — the Prince would vanish one day soon and everything would be back to where it was before, till the next blue serge suit and straw hat came along, for after all, it *was* make-believe. But meanwhile there had been those wild, wonderful nights in the park, the big park this time, on the outskirts of town where it was dark and private, and the inevitability of that unmentionable fourth act to come had made it all the more urgent and orgiastic and touched with the sweet sadness of all great and tragic loves. . . .

And so we parted. I knew nothing about Marilee and she knew nothing about me, nothing about parents or friends, not even about nationality, except what we could vaguely guess. I wasn't even sure she had given me her right age. If some snooping rooky cop had picked us up and hauled us off to the clink, we would have been material for another "flaming youth" story in the press. If she had gotten pregnant and fallen into the hands of a bungling abortionist and died, it would have been one more juicy crime story, a *near*-murder, with the smell of sex in it, something to view with alarm in an editorial. The only contraceptives we knew in those days were usually dispensed with by mutual consent after the first few fumbling attempts — and who the hell cared any more on the second time around? So there were times when one had to send frantic telegrams — WIRE FIFTY WILL EXPLAIN LATER — to parents or friends, who didn't need any explanations; fifty dollars was the standard price if it was to be anybody except some hole-in-the-wall quack abortionist with dirty hands and not even a bogus medical certificate.

There had been no joy rides with Marilee in fast cars, and no jazz, except in the original elementary sense in which the word was still being used in the early twenties. Nothing flamed except the headlines — if you were unlucky enough to get caught — and nothing roared except the voices from the pulpit. Jazz music, by the way, was not heard outside of cities like New Orleans, Kansas City, Chicago and New York. And even in these cities nobody except the jazz musicians themselves, and a few students of the subject, knew real jazz when they heard it. Everybody else thought Irving Berlin was a jazz composer and *Alexander's Ragtime Band* was jazz music.

Newspaper reporters used the word as if they were smuggling a sly

piece of pornography into print, along with words like black bottom. They had a vague idea that there were Negro musicians in New Orleans, but when they thought of New Orleans it was Negro whore-houses they were thinking of and gamblers and pimps and razor fights. It was all very "colorful" and made good copy, so they tied it in with youngsters dancing the Charleston, with flappers and petting par-ties and speak-easies, all under the general heading of the Jazz Age, very much as reporters are now doing with Rock and Roll. Most of it was made up out of whole cloth, dreamed up at the city room type-writer, a product of booze and prurience. It was closer to the night life — and in many cases the workday life — of the reporters themselves than it was to the lives of the young people they were supposed to be reporting on. Closer, that is, to the reporter's night life as he imagined it, not as it really was. I knew most of the men who were writing the stuff about the "flaming youth" on the Chicago newspapers in the twenties. Their love affairs were sentimental and sordid. Their taste in music ran to pop tunes. They never danced. Their thinking was sloppy and their journalism was of the slipshod, stub pencil variety that was later sentimentalized into a stereotype of the picaresque Front Page news hawk, a sonofabitch with a bleeding heart, whose veins by turns ran acid and angel milk. The original, as I remember him, ran more to beer and vomit.

Their picture of the new generation of the twenties, such as it was, became Flaming Youth on the rampage in Warner Fabian's book of that name and in the movie that started the flapper cycle, the "It" pic-tures. These journalists rendered a picture, a distorted one, of the city youth; not only the small-town or country youth, but rural youth, too, was caught up in the transition to an urban morality, or rather, amorality, and in imitation of the vices of the rich, though at a slower tempo.

To Hell in a Basket — in Slow Motion

Small-town and farm morality among the youth of the twenties, what was it like?

It was on a high level. There was practically no juvenile car theft. You had to be at least twenty years old before you were strong enough to crank a car, and by the time you got it started, the whole town was up and craning their necks at the windows.

Sexual behavior was strictly controlled. Only girls of high school age were admitted into the basement after school hours for advanced instruction in posture and the French tongue.

Attendance at community gang-shags was limited to those who had passed the test of double-dating performance.

Subteen-agers were restricted to finger exercises.

Nobody went steady if there was any reasonable choice in the matter.

Boys were admittedly more active sexually than girls, which put something of a strain on the girls who *were* active. There was still a recognized distinction between nice girls and bad girls. The initial test was the first kiss. Nice girls held out for the third date. After that it was more a matter of anatomy than arithmetic. Starting at both extremities and working upward or downward toward the middle — the ambidextrous had an advantage here — it became a question of "how far you could go." Bad girls encouraged faster timing than nice girls and nice girls didn't "go all the way" unless there had been some serious talk of marriage. Engagement was the promissory note, and if it wasn't always honored in full on the due date, it was accepted as legal tender of honorable intentions and usually yielded at least a part payment in advance, an arrangement that was accepted by more parents than one would think — to hear them tell it.

They weren't really *all* like that, were they? They never are, of course. It is the active minority, the experimenters, the defiers of convention — whether in city, town or country — who give a generation its characteristic tempo and direction. The rest drag along in the rear and are always one generation behind. In between are those who do and pretend they don't.

In a small town in Illinois, for instance, I boarded briefly in a home where every night or two the daughter of the house entertained her boy friend upstairs in her bedroom. Sitting with Ma and Pa in the parlor I could hear the bed springs creak, but Pa read his paper and Ma did her knitting and everything was cozy. "Myrtle and Bill are engaged," Ma told me one day, apropos of nothing in particular. When I made it with Myrtle one day, as today's hipsters would say, she told me she had been engaged several times. Bill was her current steady and Ma and Pa thought it was all right as long as a couple was engaged. In my case she was making an exception because I was a transient

and not bound by the rules of the house, so to speak. They were nice people, regular churchgoers and well thought of in the community. Myrtle rated as one of the nice girls. There were certain points of delicacy to be observed with Myrtle. I was never allowed to touch her breasts. Her breasts were reserved for her betrothed. All the rest was in the public domain.

Some things were sacred, but not always the same things. In Pennsylvania I ran into a girl who'd make it with you anywhere except in bed. Bed was for holy wedlock. A farm girl near Goshen, Indiana, had persuaded herself that as long as she kept her eyes shut and didn't see "it" she was keeping her mind pure, and that was all that really mattered. A girl whose name I remember because it was Pearly Gates (that was her given name; she had a surname, too) told me that as long as she lay still and didn't help, it wasn't such a big sin. Her folks belonged to one of those evangelistic "holiness" religions. On our second date she confided to me that she'd been making it with her old man ever since she could remember, just that way. It was he who had put the notion in her head. On the other hand I remember a beautiful little Negro girl living on the outskirts of Louisville who thought she was practically a virgin because she was the only girl she knew who hadn't let her pappy get into her. She had heard a camp meeting preacher say that was "unnatural," so she concluded that with anybody else it was just plain natural. Some girls thought it was more sinful with their clothes off, some with their clothes on.

I encountered rebuffs, too, but they were not accompanied by the shocked indignation or hysterics that were recounted in the Victorian novels I had read, nor the face-slapping that my turn-of-the-century elders had told me of in describing their own youthful sex experiences. The rebuffs I met with were regretful, sometimes almost apologetic, at the worst a nervous laugh or a disdainful toss of the head. It wasn't Freud who had brought about this change in rural mores. Nobody I met at that time had ever heard of Freud. (Among the city young people, Freud was an influence, but even there only among the sexual avante-garde.) It was simply the way the small-town or country girl of the twenties imagined a rich girl might act. A rich girl was in a position to take it or leave it. If she took it she took it with relish and pagan abandon. If she turned it down she did it like a lady, not because she didn't want it. The rationalizations and provisos about purity, sin

and sacredness were clearly hang-overs from turn-of-the-century Victorian morality. In the cities, except among farm and small-town girls who had recently moved there, these hang-overs were rarely encountered.

Except in university towns, where town is influenced by gown, I found little of the intellectual and literary excitement among the young that was stirring in the cities. Those who were reading Sinclair Lewis, for instance, were usually literate people in their thirties. The new modern poetry was generally either unknown or disliked by the adults. A few young people could be found here and there who had come upon the new little thin volumes on occasional visits to Chicago or some other big city and brought them home, as earlier generations of venturesome Americans had once brought back paperback copies of Zola from Paris. These youngsters in places like Paris, Illinois, and Grand Island, Nebraska, were only waiting for a chance to light out for the big city. "I'll see you in Chicago — one of these days" was always their wistful good-by, and some of them made it. They would show up one morning at the door of my Near North Side studio with a knapsack or a battered old wicker handbag containing a change of shirt and socks. Some were boys, some were girls — they never came in pairs — and they had the furtive, conspiratorial air of refugees. They had come to join the ranks of the young rebels who were the *real* "flaming youth" of the twenties, but whose story was not being told in the newspapers.

The Holy Barbarians of the Twenties

One reason why the beat generation of the fifties harks back to the literature of the twenties is because it finds a kinship there — not the kinship of the raccoon coat and bowler hat but of the spirit of revolt that was blowing through the studios of Chicago's Near North Side and New York's Greenwich Village and all their tributaries scattered through the larger cities of the land, in *déclassé* neighborhoods of St. Louis, Detroit, Baltimore, Boston and San Francisco where the mansions of the rich (who were moving into the suburbs) had been partitioned into one-room kitchenettes which the young rebels were converting into studios. Here the democratization of amorality, the trickle-down process I have been describing as an imitation of the vices of the

rich, took a direct, literal form. These avant-garde bohemians took over not only the vices but the very houses of the rich and in not a few cases their women as well — in fact, everything but their money, for they were not political revolutionaries, not in the obvious sense or in any organized way, which is another point of resemblance between them and the beat of today.

We — for I was one of them — were expropriating from the upper classes the only things they had which we felt had any value for us: their leisure, their access to the arts — to music, literature, painting — their privilege of defying convention if they wanted to, of enjoying their vices and sinning with impunity. We had heard of the Communist Revolution in Russia and felt that the Czar and his secret police had it coming to them; after all, we had read Dostoevski, Chechov, Tolstoy. Some of us had read Marx and Engels. But we felt that all the Bolsheviks had succeeded in absorbing, so far, were the headaches of the ruling class, the manufacture of *things*, the production and distribution problems and the bookkeeping that went with it. We were expropriating the things of inner gratification and lasting value, and we were doing it without overthrowing the rich. We were bypassing them, going our own way and letting them stew in their own fleshpots. If any of their lovely young daughters — or an occasional frustrated but well-preserved wife — wanted to come over to our side that was all right, too. On our own terms, of course. They didn't have to bring any of the family money with them. The *self*, the inner self, was enough, and that meant body and soul. There was a lot of talk about the *self*, as there is today in beat generation circles, and it meant pretty much the same thing, an inner search for wholeness, i.e. holiness, instead of the soul-destroying pursuit of *things*, the Moneytheism of the plutocracy.

We were seeking relaxation from the pressures of the "success mania" of the boom years. We wanted the leisure that the rich wasted on vulgar orgies of conspicuous consumption (we had read our Veblen), but we wanted it for the enjoyment of finer things. So we had to live by our wits most of the time, not having the money to finance any extended periods of leisure. We clerked in bookstores, did an occasional hitch on the newspapers, took odd jobs of manual labor here and there, and tried house to house canvassing — a lot of us got to see the country that way, selling magazine subscriptions, a kind of de luxe hoboing — and, if all else failed, we took to dropping in on job-holding

friends around dinnertime or pearl-diving (dishwashing) in restau-
rants. The hardest pill of all to swallow was having to go home or write
home for money. Girls could get away with this better than boys, so
if you were living with a girl it was usually she who made this final
sacrifice of pride. Anything to prolong those precious weeks of leisure.

Ours was not the dedicated poverty of the present-day beat. We
coveted expensive illustrated editions and bought them when we had
the ready cash, even if it meant going without other things. We wanted
to attend operas and symphony concerts, even if it meant a seat up
under the roof in the last gallery or ushering the rich to their seats in
the "diamond horseshoe." We had disaffiliated ourselves from the rat
race — we called it Secession, H. L. Mencken's word for it — but we
had not rejected the rewards of the rat race. We had expensive tastes
and we meant to indulge them, even if we had to steal books from the
bookstores where we worked, or shoplift or run up bills on charge ac-
counts that we never intended to pay, or borrow money from banks
and leave our cosigners to pay it back with interest. We were no
sandal and sweatshirt set. We liked to dress well, if unconventionally,
and sometimes exotically, especially the girls. We lived perforce on
crackers and cheese most of the time but we talked like gourmets, and
if we had a windfall we spent the money in the best restaurant in town,
treating our friends in a show of princely largess.

These contradictions finally tripped us up, of course, and some of
us went on into the lean thirties bitter and ready to join any move-
ment that held out a vision of Abundance and Plenty. Some, like F.
Scott Fitzgerald, simply cracked up or sold out to the Bitch Goddess
Success (if they could still find her around anywhere) or committed
suicide in some unconventional but inexpensive way.

To the girls it meant giving up bohemian boy friends and marrying
the Good Provider — with the coming of the Depression that meant
almost anybody with a job — and settling down to a life of quiet do-
mesticity. That was *their* sellout. To hear some of them tell it, it was
their suicide. I remember girls of our circle who took this way out in
the Depression thirties, only to run off for a Mexican divorce with an
old flame from the twenties when the next wave of live-it-up fever
came along in the wartime forties. Those, that is, who weren't trapped
by multiple motherhood or hopelessly addicted to comfort and security.

But while she was still young and pretty, the girl of my youth was
a reckless trail blazer on the American scene. She had run away from

the ugly mission furniture, overstuffed sofas and brass beds and was applying a little of the taste and color and functional design that modern art, since the Armory Show, had been introducing into home décor. In her studio she replaced the brass bed with a studio couch, and it stood in the living room, not in the bedroom. There wasn't any bedroom. All the living space was bedroom, where visitors could lie down and listen to music or make conversation — civilized conversation, we liked to call it. And if the boy friend lay down beside her on the studio couch the arts of music and poetry became subtly integrated with the art of love, a combination that may have been new to American lifeways but was part of the great tradition of all the honored civilizations of the past. It was certainly preferable to furtive backstairs fumblings and hit-and-run love-making.

Together with such girls we brought candlelight back into home use and inexpensive art objects, wood carvings and copies of primitive sculpture and masks, and window drapes that were more tasteful than the machine-woven brocades and dust-catching plush that made the homes we had come from look like undertakers' parlors. If the solid citizens and citizenesses of the twenties said that a divan in the living room was an invitation to carnal dalliance — well, that was the idea. We had brought sex out of the bedroom and made it an art worthy to share the living room with the books of Theodore Dreiser, Sherwood Anderson, T. S. Eliot, Anatole France and Remy de Gourmont on our homemade bookshelves, our Victor Red Seal Records and the abstracts and French impressionists on our walls — color prints clipped from the art magazines, of course.

Those of us who had been through the war, the Great War is the way it was billed at the time — the numbering system that made it World War I was instituted almost before the guns stopped shooting — saw it as a blinding barrage of atrocity stories accompanied by a flank attack of flattery. "America's Fighting Youth. . . . Save the World for Democracy. . . . The Great Crusade. . . . Remember the Lusitania! . . . The Yanks are Coming!" — with kisses for departing soldiers and scowls for slackers and sly, winking promises of French mademoiselles, followed by the brutal anticlimax of the trenches and the sickening hell of trial by battle and the blood and mud that is faked up with flags and God and Country in the war posters and glossed over with glory afterward in the grammar school histories.

Let not the Communists or the ex-Communists of the thirties think

we had any idea it was a war between rival imperialisms; nor the New Dealers of the forties think we were enemies of democracy; nor the religious anarchist beatniks of the fifties think we were wise to "the basic immorality of the State." It was to be years before we could read such books as Sir Arthur Ponsonby's *Falsehood in Wartime* or J. M. Read's *Atrocity Propaganda* or Sidney B. Fay's *Origins of the World War* or Harry Elmer Barnes's *Genesis of the War*. We knew nothing about Baron Hans von Wangenheim's Berlin mistress and the cover-up story he told his wife about helping the Kaiser cook up the war at a fictitious Crown Council. Or why Lloyd George wanted to hang the Kaiser. All we knew, those of us who possessed a little sense and sensitivity, wás that there was a bad smell in the air, and instinctively we turned away from it.

The liberal historians and the "chroniclers" of the twenties, Allen among them, say we were shocked and disillusioned by the Treaty of Versailles and the failure to win the peace, and that this was one of the principal reasons why we went on a wild rampage in the twenties, whooping it up for Babe Ruth and Lucky Lindy, lushing up Prohibition gin and trying to find forgetfulness in the arms of flat-chested flappers. Even if we pleaded guilty on all counts — sure, there were some of us who did one or another of all the things they say we did; there were a lot *of* us and all kinds — it would still not explain why the main currents of the time converged into a cynical contempt of the whole business civilization. For all its booming Prosperity, for all our seeming compliance and emulation of the rich man's vices, which we somehow succeeded, I think, in transforming into an orgastic affirmation of life, we were parties to a paradox that I summed up in three lines of a poem at the time:

> If we acquiesce in all things?
> Do not be deceived;
> It is because we despise you.

We were a minority of the younger generation of the twenties but we were the articulate part of it, saying and doing the things the others could give expression to only in an awkward and limited way. We were, as a group, no better educated than the others of our generation, as far as formal education is concerned. Many of us, including myself,

were almost entirely self-educated. That meant simply that our teachers were teachers we had selected from among the thousands who had written books on the subjects we wished to study, rather than teachers who happened to be on the faculties of high schools and universities we might have gone to. For no one is really *self*-educated. He is educated by the authors of the books he reads. I was systematic about my solitary study. Others were desultory and sporadic, with periods of intense application and periods of loafing. I had my periods of loafing, like the rest, and I can report that whenever we did our loafing together, as we often did, it was not just time-wasting or sloth. It was loafing to "invite the soul," as Walt Whitman had recommended. Education, self-education and loafing to invite the soul — in these respects it is we who have survived the twenties and gone through the further development of the thirties and forties, it is we who, in turn, feel a kinship with the beat generation of today. It is this which draws them to us, and it is this which makes it possible for us to understand, appreciate and sympathize with them, better perhaps than those whose youth and young adulthood fell in the thirties and forties.

Nevertheless, young people like Tanya Bromberger, Chris Nelson, Chuck Bennison, Itchy Gelden and Angel Dan Davies cannot be entirely understood in the light of the twenties experience alone. It is necessary to take into account the experience of the thirties and forties.

On the Road in the Thirties

The Expatriation, with which the name of Henry James is associated in its earlier phases and Ernest Hemingway and the Lost Generation writers in its post-World War I phases, was followed by the Secession, which recalls such names as H. L. Mencken, Malcolm Cowley, Sinclair Lewis, John Dos Passos and F. Scott Fitzgerald. After the crack-up — the economic one, of which Fitzgerald's was only a personal example — we witnessed an alienation of the Marxist variety.

It was not something confined to card-carrying members of the Communist party, as the un-American committee witch-hunters later tried — and failed — to prove. It was the Secession of the twenties gone Left in the thirties. It marked the end of Mencken and the beginning of Marx as the patron saint of an emerging bohemia of the Left. When Mencken, sensing the change in the intellectual climate among his

followers, tried to laugh off the Depression and kept thumping his drum against the booboisie, the New Deal and the "fraud" of democracy — the notion, as he put it, that a million blockheads are wiser than one, that the voice of the people is the voice of God, and the Congressional Record is the Bible — he found fewer and fewer people listening to him. The young college people who had been among his most faithful devotees now deserted him in droves. The highbrows of the twenties, broke and out of work, unloaded their first editions of Joseph Hergesheimer, Sinclair Lewis and James Branch Cabell onto the secondhand book dealers. Out went Mencken's own *Damn — A Book of Calumny* along with the collection of anti-Mencken calumnies which he himself had collected under the title of *Schimflexicon*. By 1933 a new alienation was in the making. It attracted to itself all sorts of rebels and far greater numbers than Menckenism had ever recruited. The story of those rebels who joined "front" groups has been pretty well covered by now in the newspapers and magazines, on radio and the television screen. What the un-American committees failed to tell has been told by many of these joiners themselves in breast-beating confessions that leave them looking more like betrayed saints, more sinned against than sinning. But what has not been told is the story of the unaffiliated fellow-traveling bohemians, the beat generation of the thirties.

They came from everywhere, from the Dust Bowl farms, from the boarded-up, bankrupt stores of the small towns, from shut-down factories in Detroit and Pittsburgh, from slums and hobo jungles and college campuses. They wore, not sandals, but work shoes, down at the heels and full of holes, and if they were bearded it was not by choice. They lacked the price of a shave, or they hadn't been near a hot-water tap and a cake of shaving soap for weeks. Soiled blue jeans, work shirt and lumber jacket made up the rest of the outfit, or, in the winter, a ragged overcoat, turtleneck sweater and ear muffs. For the girls it was bobbed hair, a holdover from the twenties, skirts and blouses and, if they belonged to the arty set, homemade peasant costumes.

In Communist circles these young people were called The Youth and every effort was made to recruit them into the YCL. Some joined, or drifted in and out as their interest waxed and waned. But the bohemians among them remained too foot loose to be pinned down to any organized party work or too independent-minded to be held to a

party line. Youngsters in their teens and twenties, they would band together in some broken-down old mansion of the departed rich, but instead of partitioning the rooms into individual studios, as they would have done in the twenties, they lived together in a kind of free union that was their idea of a Russian commune. Those who happened to latch onto a job for a few weeks threw their earnings into a common fund for groceries and rent. The girls kept house when they were not out working, and the boys kept the place in repair and tinkered with the old jalopy which was their common conveyance. Everyone did his own laundry in the bathtub or the kitchen sink and the place always smelled of drying clothes in the winter and unwashed dishes all year round. It was "a free life."

Free living and free love. The term was still in use among them, as it had been for decades among the Socialists who took their morals from Johann Most rather than from Karl Marx. Communist party officialdom frowned on it in public and winked at it in private and all in all it was a kind of underground morality that was never mentioned in open discussion or the party press. Among party members it was considered a private matter. Not till the New Deal united front was launched, to help save the world from nazism and fascism, did the sex life of party members come under strict party supervision, but that story belongs to the forties. During the thirties it was still an area of private choice, and any "scientific" support that the free-loving youngsters of the period needed they found in Freud. Some were already dipping into the anthropologists, and a volume or two of *The Golden Bough* sometimes stood beside *Das Kapital* and Morgan's *Ancient Society* on the bookshelf. The *kolkhoz* was often built around somebody who owned a good library of anthropology, psychology, Socialist and Communist literature and the Russian novelists, together with well-thumbed copies of Jack London, Lincoln Steffens, Upton Sinclair, Theodore Dreiser and John Dos Passos. Girls who came to read often stayed to talk half the night and spend what was left of it in bed with the host or a boy friend. Others would join the group and there would be talk of "taking a place together," a house big enough to hold the books and provide sleeping room — not necessarily private if available funds did not permit — for two or three couples. I remember houses where as many as twelve or fifteen lived together in four or five rooms during the worst days of the Depression.

The word for it was "comrade," whether you belonged to the party

or not. If a Leftist writer came to town to deliver a lecture, the houses
vied with one another to entertain him as a house guest, and a girl
comrade could always be found to offer Eskimo hospitality to the
visitor. If the writer was famous enough there was often lively competi-
tion among the girl comrades for the honor. The Communist party
committee on arrangements for a visiting party functionary sometimes
called on the talents of these bohemian girl comrades, much as a busi-
nessman on the make for a government defense contract in the forties
might have drawn on female talent to help him sell a visiting general
on the merits of his product — and deducted the fee from his taxes as
business expense under the heading of entertainment. In the former
case, however, no money changed hands. It was purely a matter of
love, or, if the girl comrade was a party member, of service in the
line of duty.

Clothing was shared among the girls of these "collective" houses,
and sometimes the boys, too, shared articles of wearing apparel. You
were supposed to ask, but if no one was around you helped yourself
and thanked the owner for it afterward, but this was not obligatory.
Evenings were spent in reading and discussion and week ends in party-
ing of a nonpolitical nature. If there was any music it was likely to be
a folk-sing. Later in the decade the army songs of the Spanish Civil
War, brought back by young veterans of the Lincoln Brigade, were
sung on such occasions. Anyone who could sing *The Four Insurgent
Generals* in Spanish was sure to be the life of the party. The highest
compliment a girl of the *kolkhoz* could aspire to was to be nicknamed
La Pasionata, after the beautiful and famous firebrand of the Spanish
Loyalist Army. If Rhonda Tower or Barbara Lane had come of age in
the thirties she could have found in this Leftist bohemia something of
what she is now looking for. In the middle forties Barbara wouldn't
even have had to leave Beverly Hills; she could have found it among
the swimming pool proletariat of the Hollywood studios.

The sincerity and sense of dedication among these young people of
the thirties were as great as that of the beat generation of today. Life
was free, but it was also earnest; love was free, but it was also pas-
sionately devoted while it lasted. There was no promiscuity in the
bourgeois sense, except among girls who would have been promiscuous
in any other environment. If a couple gave any sign of being "serious,"
nobody tried to cut in. If they decided to get married and wanted

greater privacy, they could stay on in the *kolkhoz* and have the bedroom if there was any. In some cases the house was organized by an older married couple, who thereafter acted as a kind of house mother and foster father to the single members. Some of the attachments formed in these houses lasted for years. Their loyalty to one another was strong, often to the point of self-sacrifice.

Their attitude toward the Cossacks — their term for the police — was identical with that of the beat generation of today toward the "heat." They left their doors unlocked most of the time, just as the beat do in the pads of Venice and elsewhere. Their houses, however, were not confined to the slums by choice. Only by necessity.

When the Federal Arts projects were established, the nonconformist minority of the generation of the thirties, that portion of it which belonged to the bohemian Left, got a taste of security — on a very low level but a monthly paycheck none the less — and were never satisfied afterward to shift for a living in the traditional bohemian fashion. They went into the forties as government agency clerks or took jobs in the defense plants in what was for them a common front against fascism. Some of the artists on the projects went on to the more ample paychecks of the advertising agencies where art is also a weapon — in the war for the consumer dollar. Others got teaching positions in the art departments of the universities. A few, on the strength of their WPA murals, got cover assignments from *Time* and ended up as "artist in residence" at a university. Some of the writers managed to latch onto editorial jobs or become English instructors at the smaller colleges. A few of the girls on the drama and dance projects made good later on the strength of "sugar daddies," philanthropic grants and endowed "experimental groups." It was onward and upward with the arts all along the line. But bohemianism was a thing of the past for them.

The United Front

The period of World War II marked something like a truce on the cultural front. For some, born around the turn of the century, those were the best years of their lives, the Golden Age of the Egghead. Antifascism was the official cause. The Pursuit of Happiness meant a radio program on which you heard Paul Robeson in a poem, *Ballad for Americans,* with music by a young minstrel in overalls, Earl Robinson

by name, who went around the country singing his compositions and accompanying himself on guitar or piano. Burl Ives was a ballad singer who could be heard on the radio in Robinson's *The Lonesome Train,* an elegy for Abraham Lincoln. (And, as it later turned out, for Franklin D. Roosevelt, at whose death it was heard almost uninterruptedly for twenty-four hours on all the networks.) Ballad singers in blue jeans sang at parties in the White House. The American Story was not the saga of Cash McCall or the Man in the Gray Flannel Suit, but a thirteen-week serial in poetry by Archibald MacLeish, a poet, who was also Librarian of Congress. You could openly admit to being a Democrat and carry a book of poetry to work into a public building without arousing suspicion. If you were a postal employee you could even receive *The Nation* through the mail without being questioned about it. Radio actors were not obliged to slip — without so much as taking a breath — from the big dramatic scene into the slick dramatic sell. The folk ballad was not yet a singing commercial with Burl Ives peddling flashlight batteries and "Satchmo" Armstrong singing the blues to boost beer sales. And the big moment of the week for eggheads, middlebrows and all but a few hard-to-please malcontents — mostly pacifists and anarchists — was the moment when you tuned in your CBS station and settled back to listen to one of Norman Corwin's or Arch Oboler's radio plays on the Columbia Workshop, "the theater of the mind, dedicated to man's imagination" — without singing commercials.

It was not until the end of World War II and the GI bill in the late forties that the conditions once more existed for the emergence of a new generation of alienated nonconformists with anything like common characteristics and a recognizable direction. It was the beginning of the Disaffiliation. And once again it was the artists, chiefly the writers, who were the vanguard of the new alienation. It was no less than a secession from the business civilization itself.

15

The Social Lie

"Since all society is organized in the interest of exploiting classes and since if men knew this they would cease to work and society would fall apart, it has always been necessary, at least since the urban revolutions, for societies to be governed ideologically by a system of fraud."

This is the Social Lie, according to Kenneth Rexroth.

"There is an unending series of sayings which are taught at your mother's knee and in school, and they simply are not true. And all sensible men know this, of course."

Does the rejection of the social lie imply a rejection of the idea of a "social contract"?

"This," says Rexroth, "is the old deliberate confusion between society and the state, culture and civilization and so forth and so on. There was once a man by the name of Oppenheimer who was very popular in anarchist circles. He said the state was going to wither away in a sort of utopia of bureaucrats who serve the state. And you are always being told that your taxes go to provide you with services. This is what they teach in school as social studies. There is nothing contractural about it. There is an organic relationship which has endured from the time that man became a group animal and is as essential a part of his biology as his fingernails. That other thing, the state, is fraudulent. The state does not tax you to provide you with services.

293

The state taxes you to kill you. The services are something which it has kidnapped from you in your organic relations with your fellow man, to justify its police and war-making powers. It provides no services at all. There is no such thing as a social contract. This is just an eighteenth century piece of verbalism."

And what of services like sanitation, water and, in some communities, also public utilities like gas and electricity?

"These are not functions of the state at all. These are normal functions of the community which have been invaded by the state, which are used by the state to mask its own actual activities, like the mask that the burglar wears. Conceivably a burglar could wear a mask of Kim Novak but this doesn't mean he is Kim Novak, he is still a burglar. The state has invaded and taken over the normal community relations of men. Now, it is true that if the state was suddenly to give this up today, people would probably go out and chop down all the trees in the national forests and kill all the bears in the national parks, catch all the fish in the rivers and so forth and so on. But this is due to six thousand years of exploitation and corruption by the state, not due to anything inherent in the community of man."

In rejecting the social lie, what is the disaffiliate disaffiliating himself from?

"He isn't disaffiliated from society, he is disaffiliated from the social order, from the state and the capitalist system. There is nothing unusual about this. It's just that in America there is an immense myth which is promulgated by the horrors of Madison Avenue and Morningside Heights, by the professors and the advertising men (the two are now practically indistinguishable), that intellectual achievement lies within the social order and that you can be a great poet as an advertising man, a great thinker as a professor, and of course this isn't true. There happens to be a peculiar situation in literature due to the fact that literature — and this is true of Russia too — that literature is the thing that sells the ideology. After all, just as the scribe knew in ancient Egypt, writing and handling words is the thing that sells the ruling class to the ruled. So departments of English are particularly whorish. On the other hand, a philosopher like Pitrim Sirokin can say at a meeting of a philosophical association, of course we are operating on the assumption that politics attracts only the lowest criminal types — he happened to be speaking of the president of the United States —

"The entire pressure of the social order is always to turn literature into advertising. This is what they shoot people for in Russia, because they are bad advertising men."

What is it, then, that holds the natural community of men together?

"The organic community of men is a community of love. This doesn't mean that it's all a great gang fuck. In fact, it doesn't have anything to do with that at all. It means that what holds a natural society together is an all-pervading Eros which is an extension and reflection, a multiple reflection, of the satisfactions which are eventually traced to the actual lover and beloved. Out of the union of the lover and the lover as the basic unit of society flares this whole community of love.

"Curiously enough, this is Hegelianism, particularly the neo-Hegelians who are the only people who ever envisaged a multiple absolute which was a community of love. It is unfortunate that the Judaeo-Christian wrath of Marx and the Prussianism of Engels has so transformed us that we forget that this is what lay back of the whole notion of the Hegelian absolute. But, irrespective of the metaphysical meanings, this is what makes a primitive society work. The reason that the Zunis all get along together is that they are bound together by rays which are emitted from one lamp and reflected from one lamp to another and these rays are ultimately traced back to their sources in each lamp in the act of the lover and the beloved. So the whole community is a community of lovers. This sounds very romantic but it is actually quite anthropological."

To counter this cohesive social force the state employs the social lie.

"The masters, whether they be priests or kings or capitalists, when they want to exploit you, the first thing they have to do is demoralize you, and they demoralize you very simply by kicking you in the nuts. This is how it's done. Nobody is going to read any advertising copy if he is what the Reichians call orgastically potent. This is a principle of the advertising copy writer, that he must stir up discontent in the family. Modern American advertising is aimed at the woman, who is, if not always the buyer at least the pesterer, and it is designed to create sexual discontent. Children are effected too — there is a deliberate appeal to them — you see, children have very primitive emotional possibilities which do not normally function except in the nightmares of Freudians. Television is designed to arouse the most perverse, sadistic, acquisitive drives. I mean, a child's television program is a real vision

of hell, and it's only because we are so used to these things that we pass them over. If any of the people who have had visions of hell, like Vergil or Dante or Homer, were to see these things it would scare them into fits.

"But with the adult, the young married couple, which is the object of almost all advertising, the copy is pitched to stir up insatiable sexual discontent. It provides pictures of women who never existed. A guy gets in bed with his wife and she isn't like that and so he is discontented all the time and is therefore fit material for exploitation."[71]

To avoid the pressures of advertising and the slanted propaganda of the State in the "news" pages and on the radio and television, the beat generation rarely buys newspapers or news magazines and rarely tunes in to radio or TV. With very few exceptions, all the young people I interviewed said they never read newspapers at all, glance at *Time* or *Newsweek* now and then, but only at the back of the magazine, passing up all the news, domestic and international. They all own radios but listen only to the jazz programs and an occasional newscast when something interesting is going on like the launching of a space rocket. The few who own television sets use them only to watch the two or three programs a month that offer adult shows, like "Omnibus," or a jazz program. If there are any commercials they are never too lazy or too lost in pot or contemplation to get up and cut out the sound till it's over. I have known them to deliberately pass up merchandise that is advertised in favor of an unadvertised brand, regardless of merit.

The Social Lie of Militarism

To the beat generation advertising is the No. 1 shuck only because it is the most ubiquitous. There are others which are equally if not more important. There is almost universal agreement among them that militarism and war is the biggest shuck of all. As long ago as 1951 *Time* reported that among the younger generation "hardly anyone" wanted to go into the Army and there was "little enthusiasm for the military life . . . no enthusiasm for war." But the draft boards could rest easy, *Time* concluded, for when they are called "youth will serve."[72] By 1956 *Life* was selling military service to the youth as "job opportunities," in line with the official posters — Plan for a Brighter Future,

Learn a Trade, etc. — and offering advice on how to "break it up in a number of ways" by serving "as little as six months at one stretch of active duty," by enlisting and getting a choice of duty, etc.[73] For *Time* it was still the Silent Generation, eager to conform and ready to serve.

But the Army knew better. It knew that behind the façade of silence lay a sullen resistance to soldiering and everything connected with it. It was not confined to any disaffiliated minority. It was quite prevalent among the youth in the armed services. As early as the middle forties Colonel (now Brigadier General) S. L. A. Marshall had called attention to it in the *Infantry Journal* and, in 1947, he published his findings in a book, *Men Against Fire.*[74]

> He (the normal American ground soldier) is what his home, his religion, his schooling, and the moral code and ideals of his society have made him. The Army cannot unmake him. It must reckon with the fact that he comes from a civilization in which aggression, connected with the taking of life, is prohibited and unacceptable. The teaching and the ideals of that civilization are against killing, against taking advantage. The fear of aggression has been expressed to him strongly and absorbed by him so deeply and pervadingly — practically with his mother's milk — that it is part of the normal man's emotional make-up. This is his great handicap when he enters combat. It stays his trigger finger even though he is hardly conscious that it is a restraint upon him. Because it is an emotional and not an intellectual handicap, it is not removable by intellectual reasoning such as: "Kill or be killed."

The disaffiliated among the beat generation would not take issue with the general's premise that the teaching of our civilization is against killing, against taking advantage. The preaching and the teaching *is* against it, but in practice our whole civilization is a perfect school for killing and taking advantage, they would tell him.

> Line commanders (the general goes on to say) pay little attention to the true nature of this mental block. They take it more or less for granted that if the man is put on such easy terms with his weapon in training that he "loves to fire," this is the main step toward surmounting the general difficulty. But it isn't as easy as that. A revealing light is thrown on this subject through the studies

by Medical Corps psychiatrists of the combat fatigue cases in the European Theater. They found that fear of killing, rather than fear of being killed, was the most common cause of battle failure in the individual, and that fear of failure ran a strong second.

It is therefore unreasonable to believe that the average and normally healthy individual — the man who can endure the mental and physical stresses of combat — still has such an inner and usually unrealized resistance toward killing a fellow man that he will not of his own volition take life if it is possible to turn away from that responsibility. Though it is improbable that he may ever analyze his own feelings so searchingly as to know what is stopping his own hand, his hand is nonetheless stopped. At the vital point, he becomes a conscientious objector, unknowing.

The disaffiliated of the younger generation are those who are conscious of their objections long before they are confronted with "Kill or be killed." They have analyzed their own feelings searchingly and know perfectly well what is stopping their hand. If they do not always make conscientious objector it is not from lack of awareness. There is no party line in this matter. "Pacifism is not something you talk about, it is not a matter of 'principle,'" they will tell you. "You don't know what you will do about killing or being killed till you are confronted with it. Pacifism isn't something you believe in or don't believe in. It is something you *do* or *don't* do. It is an *act,* not a statement."

But all the young men I have spoken with are doubtful that they could bring themselves to fire a gun if the enemy were in view, or kill at close quarters unless it became a question of He or I. In this, apparently, they are no different from the majority.

Now I do not think (continues the general) I have seen it stated in the military manuals of this age, or in any of the writings meant for the instruction of those who lead troops, that a commander of infantry will be well advised to believe that when he engages the enemy not more than a quarter of his men will ever strike a real blow unless they are compelled by almost overpowering circumstances or unless all junior leaders constantly "ride herd" on troops with the specific mission of increasing their fire.

The 25 per cent estimate stands even for well-trained and campaign-seasoned troops. I mean that 75 per cent will not fire or will not persist in firing against the enemy and his works. These men may face the danger but they will not fight.

These figures will not come as any surprise to the men who were drafted for service in the Korean "police action" at about the same time that *Time* was assuring the draft boards that they would serve. They did, but with what results? Here are some excerpts from a report by Bill Davidson in *Collier's* of November 8, 1952.

In pursuing the question of why soldiers don't shoot, I spoke with dozens of scientists, Army historians, combat commanders and noncommissioned officers who had just returned from the Korean front. Nearly all told the same story. At Fort Dix, in particular, I had a revealing series of bull sessions with a group of noncom heroes of the U.S. Infantry.

"It was rough," said Master Sergeant Nicholas Smith, of Washington, D.C., a recent Distinguished Service Cross winner in Korea. "Sometimes you sent a squad to cover your flank and, instead of nine rifles firing, you only heard two or three."

"That's right," said Sergeant Thomas McGrath of Haddon Heights, New Jersey (Silver Star, Bronze Star, Purple Heart). "Of the nine men in my squad in Korea, I never could count on more than four or five to fire, even when it meant saving their own lives."

"Time and again," said Master Sergeant John S. Williams of Flushing, New York (two Silver Stars, three Bronze Stars, five Purple Hearts), "I had to expose myself and crawl from foxhole to foxhole to get half of the platoon to fire. Sometimes I'd practically have to sight the rifle and pull the trigger for the guy." . . . One of the most clear-cut cases in Korea involved a platoon of the 38th Infantry Regiment; it had collapsed, allowing a serious enemy break-through. The platoon came back with virtually all its ammunition unfired . . . Brigadier General S.L.A. Marshall, who has been described by high Army sources as "undoubtedly knowing more about this subject than any other living man" . . . recently spent five months in the front lines in Korea analyzing Chinese tactics for the United Nations forces. . . .

Marshall learned that of the more than 1,000 men in the reinforced battalion (the 3rd Battalion of the 165th Infantry Regiment) only 37 had fired their weapons. He just thought the outfit was green. But a few weeks later, on Chance Island in the Marshalls, he did a similar group investigation of a gallant action by the crack Reconnaissance Troop of the 7th Infantry Division. Of the 100 men in the fight, only 14 had done all the firing that routed the enemy. . . . I went to the University of Michigan to talk to two

outstanding military psychiatrists: Dr. Raymond W. Waggoner is head of the university's department of psychiatry and an advisor on psychiatric problems of the draft to Director of Selective Service Major Lewis B. Hershey; Dr. M. M. Frohlich is a psychiatrist who, as a lieutenant colonel during World War II, handled thousands of combat-fatigue casualties at the 298th General Hospital. They cited case after case of soldiers developing actual paralysis on the battlefield the first time they were required to fire.

Dr. Frohlich suggested there are at least three ways "preferably to be used in combination" of removing these inhibitions temporarily so that soldiers will shoot. The most efficient is to prompt them to lose their individual identities by promoting a mob psychology. People in a mob override their inhibitions and act as they would never dare act as individuals. A second approach is to make the man feel that because he's in uniform and because he's an integral part of a group of men he likes and respects, somehow it is all right to join them in setting aside one's life-long inhibitions against killing. The third tack is to provide a man with a father-like leader who, he can believe, is supremely strong, wise and just; so that he will accept his leader's orders to set aside temporarily the taboos against killing.

Any member of the beat generation can tell you, without any coaching from a psychiatrist, that the first tack is in regular use in the South, among lynch mobs, but it works only where the individuals of the mob are sure they outnumber the quarry by at least a hundred to one, something you cannot always promise the men on the firing line. Something of the sort was tried, nevertheless, by trying to make out the enemy to be "niggers" of a sort — "gooks" was the name for it in the Korean War; in World War II it was "them little brown monkeys" on the Pacific front.

The second approach is to be found in its most successful form among the juvenile delinquent gangs. And the third tack was the one used with the S. S. elite guard by Hitler and with the Red Army by Stalin.

The most dramatic innovation has been talking-it-up — the yelling in combat which has accompanied many of our most heroic actions in Korea. . . . "Let 'em holler," Marshall advocated. . . . "The yelling . . . can stir up chain reactions that will convert lambs into lions on the battlefield."

Grant Flemming, home on Christmas furlough from basic training, had this comment to make on the way Marshall's "Let 'em holler" training technique was working out in the year 1958.

"In bayonet practice we are told to make the bloodthirstiest sounds we can with every thrust. Every now and then the sergeant yells 'What's the spirit of the bayonet?' and we're supposed to yell back 'To kill.' I try to get away without saying it and so do some of the other boys, and when we do we smile to each other when we do it. Like it's just a shuck and we make a joke out of it. Then again they'll turn it the other way around. They'll tell us that the aim of warfare is not to kill but to take enemy-held ground, and to think of the enemy positions as the enemy — trying to depersonalize and dehumanize the act of killing. They tried that in Korea, too. Some of the re-enlisted men at the base went through the Korean action and they tell me that what they did was keep firing their rifles in the air just to make a noise to satisfy their commanding officers."

After three months of basic, much of the time spent in the hospital with ailments that may well be diagnosed as plain malingering, the Army was satisfied to transfer Grant to a medical unit. "Now it's round-about-face for me. Instead of learning how to destroy life I am learning how to save it. How that is going to work out under fire, if it ever comes to that for me, I don't know. It will probably turn out to be the same old shuck."

A somewhat older disaffiliate, who describes himself as a veteran of World War II and who also served his country for a few days in the county jail, turned up in Venice West for a visit and left with me an interesting document of his own version of pacifism as a revolutionary, nonviolence resistance movement.

It is a Questionnaire for a Peacemaker (one of the pacifist organizations) Directory and Personal Resources File which he filled out. After giving his name, address, birth date and other information, he answered the remaining questions in this fashion:

6. Present vocation (specific description):
 Fanning flames of discontent, translating, arguing, speaking.
7. Past employment (specific descriptions): Helped to load junk on and off junk wagon as employee; junked as self-employed paper boy; collector of charges for newspaper delivery; cleaned desks and helped (?) mechanical drawing students as NYA worker; loaded

mail bags on skiffs; cleaned canning machines; peeled carrots; loaded cans on conveyor belts; shoveled coal; domestic work (cleaned floors, waxed furniture, etc.); taught the alphabet; picketed for union.

8. Education (how long: where: subjects):
B.A. June 1952, Roosevelt College. Sociology major, Psych minor.

9. Skills not being used in vocation at present:
Student skills, if any, are not being used.

10. Avocational interests and skills:
Table tennis, swimming and digging the sound.

11. Eventual vocational aims:
Are you kidding? What can one plan for under threat of global thermonuclear war?

12. Do you own your own home? No. Rent? Sort of. Live with relatives? Yes.

13. Do you own a car? No. Truck? No. Farm machinery? No. Tools and machines needed in vocation? Describe:
Pen (preferably ball point) note and address book, English dictionary, more dictionaries, paper, carrying case, literature, envelopes, stamps, chewing gum . . .

14. Do you have room in your home and are you willing to put up traveling Peacemakers? (State any limitations as to time, space, finances, etc.):
My brother Joe has not very long ago returned from Lexington, Ky., where he kicked the habit. He is using the extra bed until he can get back on his feet. Ergo, no room for traveling Peacemaker (at this writing).

15. Are you or were you a draft refuser? Yes. CPS? No. Prison? No. (Give details): I refused to register in 1948; automatically registered in 1950; publicly burned classification card (5-A) and questionnaire in July 1951; I am a veteran of 1941-45 war. (However, I did spend a few days in County Jail in Dec. 1943, occasioned by unwillingness to report for induction. I did not go to big house because I lacked courage to follow thru on convictions.)

16. If over draft age or a woman, do you openly counsel draft refusal? Yes. Does your spouse? I reject compulsory monogamous mating. Affirm free love. Tend toward the sexual revolution theories of Wilhelm Reich.

17. Are you a tax refuser? No, too poor. Would you be if your income were large enough? Yes. If your taxes were not withheld at sources, etc? Yes. I cut out movies two or three years ago in order to avoid the treasury contribution collected at the box office.

18. In what activities do you participate in your local community? (PTA, labor union, Farm Bureau, Rotary Club, church, pacifist groups, etc.)
Peacemakers, CORE, IWW socials and picnics, Liberation Socialist Comm; Washington Park Forum. And when afforded, the wild life at Whitman House.

19. Do you consider yourself permanently settled in your present community, or are you willing to or actively interested in moving elsewhere?
Am considering moving off a target such as Chicago to some place of no strategic value. (A non-violent revolution can alter this perspective.)

20. Would you be interested in joining a Peacemaker Unit of a permanent type? Possibly. Of a training type? Possibly. (Give details): Am not altogether sure what all this may involve, but do have predilection for this sort of thing. See Ques. 19.

21. Are you interested in any particular state or region in this country? The unexplored wilds of Idaho. See Ques. 19.
A foreign country?
Lower California. See Ques. 19. Would be interested in southern Chile for same reason, only I don't know how I would get there since I don't believe in asking State for permission to travel.

22. Do you prefer to live in a rural area? Small town? Small city? Large city?
Used to large city. Don't know about other places, tho I expect they might be boring.

23. In what types of Peacemaker activity are you most interested and do you consider yourself most fitted to participate?
Interested in Direct Action, violating national boundaries, lawbreaking aspects of Peacemaker activity.

24. Do you live in or are you interested in living in a status of "voluntary poverty?" A communal set-up where all assets, income are pooled and funds for needs taken from common purse?
I do live in a condition of poverty which is probably voluntary,

since I have not been seeking work. I might be too extravagant to fit in successfully in a wholly communistic set-up tho I am willing to try it.

25. Do you feel personally able to live communally with a group of other families and individuals, perhaps in the same house? Or do you feel you and your family need private living quarters?
Me and my "family" have no need of private living quarters, which is to say, I would live communally, *sans* family, as it does not share my views enough.

26. Do you belong to some mutual aid group or have you definite plans for your family in case you are sent to prison? No.

27. If both you and your wife were sent to prison, what would you do or want to do with your children?
See Ques. 16. As for children, I imagine they would be left to the vicissitudes of the American Way of Life, if there were no Peacemaker provision for them.

28. Any additional information which would be of value to Peacemaker committees and to individual members:
I am anarchist. I think the correct response to arrest is to go limp and make no distinctions between being arrested and being drafted. Am vet of WW II. I regard myself as a stateless person of the world, cosmopolitan. I make no distinction between anarchism and (the non-violent type of) pacifism.

29. Comments on present Peacemaker program, your part in that program:

 The Peacemaker publication is very disappointing to say the least and the kindest. It does not nearly enough reflect the aggressiveness, intransigeance, non-conformity and subversiveness that one should expect from a revolutionary pacifist movement. There is too much God, too much law, and too much World Government. There are too many lifts from *Peace News* and other publications and not enough "internal discussion." Peacemakers should forge toward a bootleg economic system in order to circumvent hidden taxes. Taxation *as such* should be rejected on non-violent grounds.

Our visitor — I am sure he will reject this anonymity and I am doubly sure he would resent any pseudonymity — was dressed as near to Gandhian simplicity as the weather permitted, carrying all his pos-

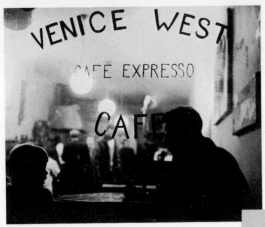

a real beat generation
coffeehouse that tourists
haven't discovered yet. . . .

ANTON

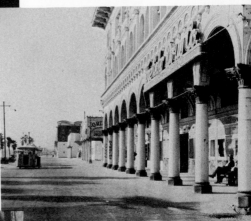

in Venice West,
"slum by the sea". . .
old Venice imitated
in iron pipe and plaster
. . . peeling now. . . .

ANTON

where a disaffiliated, dedicated
poverty is a way of life in the
pads of the holy barbarians. . . . [a]

on the banks of
green-scum-covered
canals spanned by wooden
footbridges. . . .

ANTON

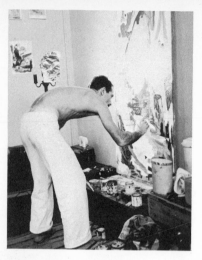

or in store-front pads where
anything with a paintable surface
is the artist's canvas. . . . b

ANTON

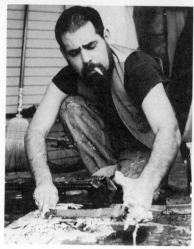

ANTON

and anything, including nuts and
bolts, is material for
"junk sculpture". . . . c

and the poet stands up to his
typewriter on a packing case . . .
amid today's wash and
yesterday's dishes. . . .

ANTON

or listens with rapt attention to
jazz on the hi-fi. . . . d

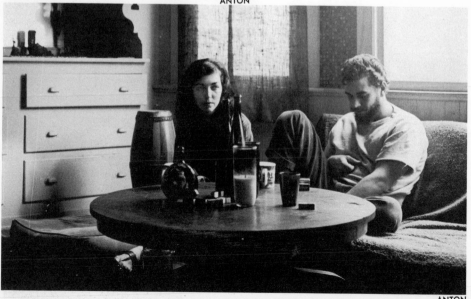

ANTON

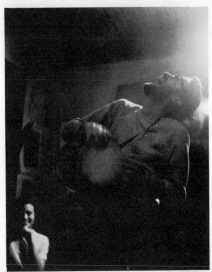

or beats out his own rhythms on
the conga drums, like Dionysus in
the Greek Bacchanalia. . . .

and makes a ritual of listening
to the jazz combo. . . . e

ANTON

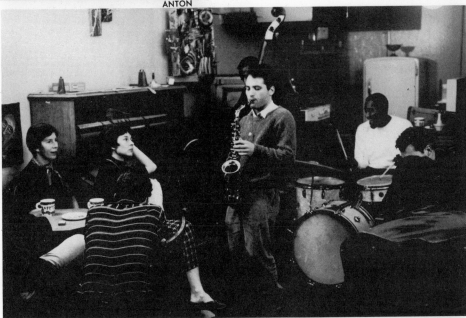

ANTON

with poetry and jazz in a new
holy reunion of the arts. . . . f

ANTON

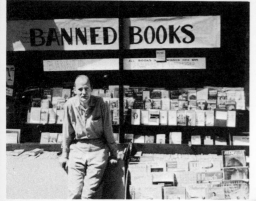

and reads all the banned books,
old and new from Boccaccio to
Henry Miller. . . . g

creating a "new apocalypse"
of jazz-inspired poetry and prose
and painting. . . .

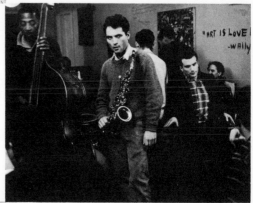

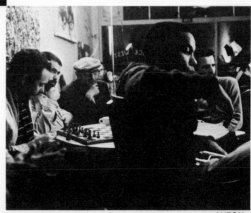

to which "art is love is God"
is the key equation. . . . h

A quiet game of chess, conversation,
or contemplation. . . .

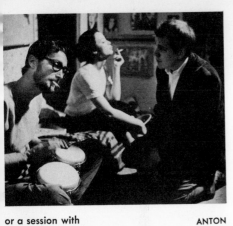

or a session with
the conga drums. . . .

ANTON

ANTON
or listening to a poetry reading
is all part of "making the scene."

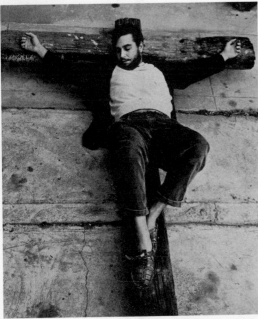

The painter-sculptor, planning a
Crucifixion piece, contemplates
his theme by "reliving" it. . . . ⌐

and relaxes with friends afterward
in a fellow painter's pad. . . . ⌐

ANTON

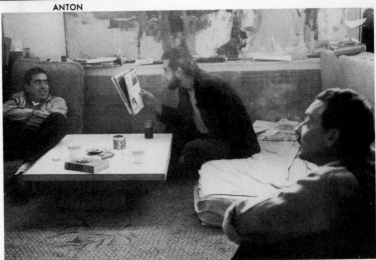

ANTON

The children of the holy barbarians
grow up in the pads unashamed of
nakedness . . . surrounded by
love and simple living. . . .

ANTON

CLAXTON

Jazz Canto in the Cosmo Alley
coffee shop. . . .

is a listening experience of ritual,
and religious intensity. . . .

CLAXTON

and inspires the painter-poet who listens to music on records while he views his unfinished canvas. . . .

ANTON

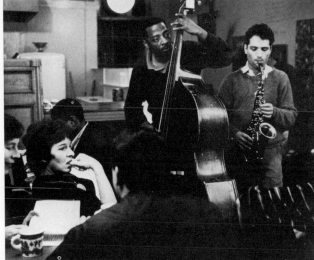

in the world of jazz, as in the pads, racial integration is taken for granted on all levels of human intercourse. . . .

ANTON

the joy of life is celebrated in wine. . . .

ANTON

ANTON

and in poetry as a living, breathing art for the human voice. . . . k

Kenneth Patchen . . . "O where can
the heart of man be comforted." REDL

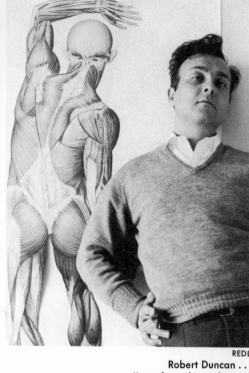

REDL

Robert Duncan . . .
"transform the audience."

Kenneth Rexroth . . . "what holds
a natural society together
is an all-pervading Eros." SKEETZ

REDL

Henry Miller . . .
"everything is barbarious again"

sessions in a cloth shopping bag. He asked for nothing and accepted only simple refreshment. Holy, but no barbarian, he presented the classical picture of the lean, weather-beaten, ascetic desert-prophet of the Bible illustrators. Your true holy barbarian is no ascetic. Some of the answers in the Questionnaire will be better understood by the reader if he bears in mind that the minority status of my visitor is further complicated by the fact that he is a Negro. How the practice of "going limp" on arrest works out in practice the reader can judge for himself by the pictures he has seen in the press from time to time of Direct Action war resisters being carried off limp by policemen and military guards from missile-launching sites and other military installations where they were staging a nonviolent protest demonstration. They measure their success by the amount of publicity such actions produce, depending on the power of action and example rather than principles and manifestoes.

They do not altogether disdain the power of the word, however. One such resister, Albert Bofman of Chicago, carries on a constant letters-to-the-editor campaign and reports the most astonishing results in a mimeographed letter that he sends to anyone requesting it. These letters sometimes run to ten or twelve single-spaced, legal-size pages and contain news of pacifist activities all over the world, the latest figures on war appropriations, digests of election platforms of all parties and reams of other information of use to war resisters and their friends and sympathizers. These letters differ from other such literature in the modesty of their requests for contributions. "Unused postage stamps acceptable" is the usual request, and the prices of the pamphlets they offer are rarely over a nickel or a dime. Bofman reports publication of his "letters to the editor" in hundreds of newspapers, some of them among the most reactionary in the country. Editors of such Vox Pop columns are, as everyone knows, very liberal in what they accept for publication. It all comes under the heading of human interest, I suppose.[75]

Nonviolent war resisters like my visitor are received hospitably in beat generation circles and treated with respect as disaffiliates who are wise to the social lie of war and militarism and practitioners of the dedicated independent poverty. In some respects they are regarded as squares. Their asceticism does not go with the Dionysian love of life that the beat cultivate. Their religion, though anticlerical in some cases,

is in the main churchly. The conscientious objector among the beat may base his objections on religious grounds but not as a member of any church. A few have won their cases in the courts on such grounds, although the law does state that church membership is required as ground for exemption.

The Social Lie of Politics

That the typical member of the beat generation does not regard himself as a citizen in the usual meaning of that term is clear from all my observations and interviews. He does not value his right to vote, although he would be opposed to any move to take it away from those who do. His attitude toward the ballot is simply that it is usually meaningless; it does not present such vital issues as war and peace to the voter nor give him any voice in — or control over — such important matters as wages, prices, rents, and only the most indirect and ineffective control over taxation. His choices at the polls are limited by such tricky devices as conventions, gerrymandering, legal restrictions on party representation on the ballot, to say nothing of boss rule, back room deals and big campaign contributions. Elections are rigged, he will tell you, and the whole political game is a shuck.

He does not have to spend a dime for a newspaper or waste reading time in order to document his thesis that politics is a social lie. All he has to do is glance at the headlines as he passes the newsstand. Or listen to any five-minute summary of the news on the radio. Or — the plainest giveaway of all — look at the face and listen to the voice of any office-seeking politician on television. As for national conventions on television, the spectacle is too much for even the squares to take. They tuned out by the millions on the last convention broadcasts.

A beatnik busted for smoking pot could entertain you for hours about the lawbreaking of the lawmakers. And the law enforcers. For an apolitical he often displays a surprising knowledge of the above-the-law, around-the-law and against-the-law activities of policemen and politicians.

All the vital decisions, he will tell you, are beyond the control of the electorate, so why go to the polls? The decision makers and the taste makers are nonelective and nonappointive. They elect themselves and their ballot is the dollar. Moneytheism is not only a religion but a

form of *Realpolitik*. The moves of power politicians, once covert, are now open. Even the businessman in politics no longer feels constrained to mask his motives or his methods. More and more the show goes on the boards without props and without disguises.

The voter has no control over the uses to which atomic energy is being put by the businessman and the politician. Cold wars are launched without declaration and are well under way in the Pentagon and the State Department before he is told that they are even contemplated. The war machine is fed billions without any by-your-leave on the ballot. He is presented with a choice between a general with a folksy grin and a governor with an egghead vocabulary. Voting becomes a mass ritual, but an empty one without any art or healing in it. It was once a kind of popular revel at least, a saturnalia on a low and vulgar level, with whisky for a libation and broken bottles in place of phallic ikons. But even that is now forbidden, thanks to the prohibitionists who have made Election Day their last stand and only national triumph.

The voter, the beat generation will tell you, does not have any control even over the air he breathes. What's good for General Motors is proving to be poisonous for the American air. And what's good for the defense industries, and is conned up to look good in the employment statistics, is proving poisonous to the atmosphere of the whole globe. "Have you had your Strontium 90 today?" is a greeting you will hear any morning among the beat.

The list of shucks that the disaffiliate can reel off for you would take many pages to repeat here. A few, on which there is more or less unanimous agreement, will have to suffice.

First in order is the shuck of war, hot or cold, and the "defense" industries that are maintained to feed and perpetuate it, which the beat call Murder, Incorporated.

A close second is the shuck of "business ethics" and the morality of the businessman, the wide profit margin between his pretensions and his practices. Even the youngest among the beat generation are thoroughly familiar with the call girl sell, for instance, the bedroom bribery by which the businessmen bribe (and blackmail) buyers to the tune of millions of dollars. The older ones among the beat have not forgotten the cost-plus racket on defense contracts that created bulging bank accounts for the new war millionaires while the boys were fighting a

battle of another kind of bulge in the Ardennes and planting Old Glory on a hilltop on Iwo Jima.

Another widely recognized shuck is the "Our" shuck. *Our* national safety . . . *our* natural resources . . . *our* railroads . . . *our* security . . . *our* national honor . . . *our* foreign trade . . . *our* annual income . . . *our* representative in Congress . . . *our* side of the iron curtain . . . It's *ours* when it's our sweat and blood they want, but it's theirs when it comes to the profits, the beat will tell you.

They didn't need Philip Wylie to tell them about the shuck of Momism — or Popism, either. Academicism was an open book to them long before it became a theme for faculty exposés in novels and what's-wrong-with-our-educational-system articles in magazines.

All of these shucks, and many more, are known to millions. The difference between the beatnik and the square is that the beatnik *acts* on his knowledge and tries to avoid the avoidable contagions.

"Cynical" is a word that the sensation-mongering newspaper and magazine writers like to tag onto their stories about the beat generation. If the beatnik lives in a state of voluntary poverty, he isn't being sincere about it — how can anybody turn down a buck? — so he must be cynical. If he turns his back on the installment-slavery of Madison Avenue's "engineered public consent" and phony "customer demand" propaganda, and tries to do without kitchen machinery and keep off the car-a-year pay-and-trade-in treadmill, he isn't being sincere about it. How *can* he be? He must be cynical, just trying to put on a show of superiority by sneering at all the things that make life really worth living and which he secretly yearns for but hasn't got the get-up-and-go to acquire for himself. That is the "party line" and you will find some form of it in all the mass circulation magazines and newspapers whenever they refer to the subject.

Another gambit of the mass circulation media is: They just don't like to work. Out of perhaps a hundred beatniks there may be one, usually an artist, who is so ridden by the Muse that he is utterly unfit for any steady job and tries to make it any way he can without having to punch a time clock. The other ninety-nine are not artists. They chose "the life" because they like it better than what Squareville has to offer. They work, full time or part time, but without any of that good old stick-to-itivness and never-watch-the-clock devotion that was the slogan of the boomtime twenties — and ended for the go-getters in breadlines

and apple-peddling. The beatnik of today who adopts the dedicated poverty is simply honoring the old Polish proverb: He who sleeps on the floor has no fear of falling out of bed.

In a society geared to the production of murderous hardware and commodities with built-in obsolescence for minimum use at maximum prices on an artificially stimulated mass consumption basis, poverty by choice is subversive and probably a sin against Jesus Christ who was, according to Bruce Barton, the first Great Salesman. It makes monkeys out of all the soft-soap-sell radio newscasters and commentators who slip so glibly from the horror tales of the mushroom cloud and death on the freeways into the fairy tales of Success by hair oil and Beauty by mud pack, thrill points, homogenized beauty cream or whatever the latest shuck happens to be. It is no wonder, then, that simple-living beatniks come in for vicious tongue-lashings by hucksters posing as reporters and pundits.

It is the voice of Business speaking. Business has its song of Prosperity Unlimited to sing while it picks your pockets, and the razzberry obligato of the holy barbarians and their dedicated poverty is a jarring note.

The editorials and the ads and the speechmakers keep telling youth that the world is his, the future is his, and in the next breath cries out with alarm that "the other side" is plotting to blow up the world with hydrogen bombs. The holy barbarian's answer to all this can be summed up in the remark of Itchy Dave Gelden when he dropped in one day with an evangelist leaflet that some "christer" had shoved into his hand, announcing that the world was coming to an end —

"*Whose* world is coming to an end?"

Not the holy barbarian's.

Notes

1. See *In Secret Battle*, a novel by Lawrence Lipton (D. Appleton-Century Co., New York).
2. *Songs by Earl Robinson* (Alco Records, Hollywood).
3. D. T. Suzuki, *Zen Buddhism: Selected Writings of D. T. Suzuki*, edited by William Barrett (Anchor Books, New York).
4. *Chicago Review*. See particularly Autumn-Winter, 1956, "The Hour of Man" by Henry Miller.
5. *archie and mehitabel: A Back Alley Drama*, narrated by David Wayne, featuring Carol Channing and Eddie Bracken, based on stories of Don Marquis (Columbia Records, ML 4963).
6. Dexter Martin, "D. H. Lawrence and Pueblo Religion," *Arizona Quarterly*, Autumn, 1953.
7. Branislaw Malinowski, *Magic, Science and Religion* (Anchor Books, New York).
8. E. Doutté, "Magie et religion dans l'Afrique du Nord," from *The Myth of the State* by Ernst Cassirer (Anchor Books, New York).
9. *Time*, September 26, 1955.
10. Alan W. Watts, *The Way of Zen* (Pantheon Books, Inc., New York). By permission of the publisher.
11. Allen Ginsberg, *Howl and Other Poems* (City Lights Books, San Francisco).
12. Watts, *op. cit.*
13. *Ibid.* "According to tradition," says Watts, "the originator of Taoism, Lao-tze, was an older contemporary of Kung fu-tze, or Confucius, who died in 479 B.C. Lao-tze is said to have been the author of the *Tao Te Ching*, a short book of aphorisms, setting forth the principles of the Tao and its power or virtue (Te). But traditional Chinese philosophy ascribes both Taoism and Confucianism to a still earlier source, to a work which lies at the very foundation of Chinese thought and culture, dating anywhere from 3000 to 1200 B.C. This is the *I Ching*, or *Book of Changes*."
14. Michael McClure, "Peyote Poem," *Semina 3*.
15. *Coastlines*, No. 10, Spring-Summer 1958.
16. Wendel C. Bennett and Robert M. Zingg, *Tarahumara, An Indian Tribe of Northern Mexico* (The University of Chicago Press, Chicago).
17. Ginsberg, *op. cit.*
18. The Mayor's Committee on Marihuana, *Marihuana Problems* (The Jacques Cattell Press, Lancaster, Pa.).
19. Patrick Mullahy, *Oedipus, Myth and Complex, A Review of Psychoanalytic Theory* (Grove Press, New York).
20. Sigmund Freud, *Beyond the Pleasure Principle* (The Hogarth Press, Ltd. and Institute of Psycho-Analysis, London).

21. Kenneth Rexroth, ed., *The New British Poets: An Anthology* (New Directions, New York).

22. *The New York Times Book Review*, September 2, 1956.

23. Lawrence Lipton, *Rainbow at Midnight* (The Golden Quill Press, Francestown, N.H.).

24. Rudi Blesh, *Shining Trumpets* (Alfred A. Knopf, New York).

25. Joseph "King" Oliver, *Doctor Jazz* (Melrose Music Corporation, New York).

26. Blesh, *op. cit.*

27. Lawrence Lipton, *A Funky Blues for all Squares, Creeps and Cornballs.* Unpublished.

28. Helen Waddell, *The Wandering Scholars* (Anchor Books, New York). Also Carl Orff, *Carmina Burana* (Decca Records, DL 9706).

29. *Downbeat*, December 11, 1958.

30. Ginsberg, *op. cit.*

31. Rgon Wellesz, *Arnold Schönberg* (E. P. Dutton & Co., New York).

32. *Jazz Canto: Vol. I, An Anthology of Poetry and Jazz* (World Pacific Records, WP 1244).

33. Henry Miller, *Black Spring* (Obelisk Press, Paris).

34. Edmund Carpenter, "The New Languages," *Explorations*, No. 7, March, 1957.

35. Jack Kerouac, *The Subterraneans* (Grove Press, New York).

36. J. D. Salinger, *The Catcher in the Rye* (Little, Brown & Co., Boston).

37. George Mandel, *Flee the Angry Strangers* (The Bobbs-Merrill Company, Inc., Indianapolis).

38. William Carlos Williams, *Paterson* (New Directions, New York).

39. Stuart Z. Perkoff, from *The Venice Poems.* Unpublished.

40. Stuart Z. Perkoff, *On Unloading a Boxcar.* Unpublished.

41. William Carlos Williams, *Kora in Hell* (City Lights Books, San Francisco).

42. Watts, *op. cit.*

43. Charles Olson, "The Lordly and Isolate Satyrs," *Evergreen Review*, No. 4.

44. Ginsberg, *op. cit.* "Sunflower Sutra."

45. Kenneth Patchen, *Shadows and Spring Flowers* (Padell, New York).

46. Gregory Corso, *Gasoline* (City Lights Books, San Francisco).

47. Cecil Collins, *The Vision of the Fool* (The Grey Walls Press, Ltd., London).

48. Lawrence Ferlinghetti, *A Coney Island of the Mind* (New Directions, New York).

49. Collins, *op. cit.*

50. Alan W. Watts, *Beat Zen, Square Zen and Zen* (City Lights Books, San Francisco).

51. Lawrence Ferlinghetti, "Dog," *Pictures of the Gone World* (City Lights Books, San Francisco). Also on *Jazz Canto: Vol. I.*

52. Lawrence Ferlinghetti, *A Coney Island of the Mind.*

53. James Broughton, *True and Falso Unicorn* (Grove Press, New York).

54. Lawrence Lipton, *Rainbow at Midnight.*

55. E. R. Dodds, *The Greeks and the Irrational* (Beacon Press, Boston).

56. Ginsberg, *op. cit.*

57. Allen Ginsberg, "Siesta in Xbalba," *Evergreen Review*, No. 4.

58. D. T. Suzuki, *op. cit.*

59. Gary Snyder, "What I Think When I Meditate," *Ark III* (San Francisco).

60. Charles Foster, *Preliminary Report on Rerum Naturem.* Unpublished.

61. John Clellon Holmes, *The Horn* (Random House, New York).

62. John Clellon Holmes, *Go* (Charles Scribner's Sons, New York).

63. Charles Foster, "The Troubled Makers," *Evergreen Review*, No. 4.

64. Watts, *op. cit.*

65. Watts, *op. cit.*

66. Woody Woodward, *Jazz Americana* (Trend Books, Los Angeles).

67. Frederick Lewis Allen, Preface to *Only Yesterday* (Bantam Books, New York).
68. Frederick Lewis Allen, *The Big Change* (Harper & Brothers, New York).
69. *Newsweek*, November 24, 1958.
70. *Ibid.*
71. From Lawrence Lipton's tape-recorded interview with Kenneth Rexroth.
72. *Time*, November 5, 1951.
73. *Life*, May 14, 1956.
74. S. L. A. Marshall, *Men Against Fire* (William Morrow & Company, New York). By permission of the publisher.
75. Bofman's Telegram "To: Peacemakers and Overtaxed Americans" is issued from A. Bofman, 6327 South May Street, Chicago 21, Illinois.

FOOTNOTES FOR PICTURE ESSAY

a. Painter Arthur Richer and family.
b. Poet-painter Charles Newman.
c. Poet-painter Stuart Z. Perkoff.
d. Painter-sculptor Ben Talbert and wife.
e. Rahmat Jamal, drums, Abdul Karim, piano, Everett Evans, bass, Paul Freidin, Alto sax, Jerome Lindsay, trumpet.
f. Poet Cythea Harrison.
g. Poet-publisher Lawrence Ferlinghetti in front of his City Lights Bookshop in San Francisco.
h. Painter Anthony Scibella and friends.
i. Painter-sculptor Ben Talbert.
j. Left to Right, novelist Michael Wilson, Ben Talbert, and painter Donald Jones.
k. Stuart Z. Perkoff.

Glossary

Ax — Any musical instrument.

Ball — As a noun, a good time; as a verb, sexual intercourse.

Bennies — Affectionate diminutive for Benzedrine pills.

Blow — To sound (see Sound), to give voice to by word, music or any aural means.

Bread — Money, as in "Could you lay some bread on me?" meaning lend or give some money.

Buff — (also aficionado) An authority on jazz.

Bugged — Bothered, bedeviled, unstrung.

Busted — Apprehended by the Heat (police). Only a cat is "busted"; a square is "arrested."

Cat — The swinging, sex-free, footloose, nocturnal, uninhibited, non-conformist genus of the human race.

Chick — Just what you think it means.

Cool — Said of anything that sends you, whether cool jazz or a cool chick — unless you like 'em hot (see Hot).

Connection — Contact man for drugs.

Cop out — To settle down, go conventional, in the sense of "sell out" or "cop a plea." In some circles you may be charged with copping out if you shave off your beard.

Crazy — Anything from mild to wild that meets with a cat's approval. "Dig that crazy short." (see Short)

Cut out — To take one's leave.

Dealer — Drug-seller, pusher.

315

Dɪɢ — Understand, appreciate, listen to, approve of, enjoy, do you dig me, man?

Dʀᴀɢ — A bore, disappointment. A political convention is a big drag. An evening with squares is a sad drag (see Drugg).

Dʀᴜɢɢ — Brought down from a high (see High). Depressed, bored, frustrated, blah.

Dʏᴋᴇ — A highpower Lesbian. Variants: deisel-dyke, bull-dyke.

Fᴀɢ — Short for faggot, as in "flaming faggot." A male homosexual.

Fᴀʟʟ ɪɴ — Arrive, show up, make the scene.

Fᴀʟʟ ᴏᴜᴛ — Pass out from an overdose of drugs.

Fᴀʀ ᴏᴜᴛ — If it sends you and you go, you may swing far out, if no one bugs you and you get drugg — or go *too* far out and flip your wig. Also avant-garde, on the experimental frontiers of any art or experience.

Fɪx — A shot of heroin or some other drug.

Fʟɪᴘ — Anything from a fit of high enthusiasm to a stretch in the laughing academy (mental institution).

Fʀᴀɴᴛɪᴄ — Frenzied. Anything from hot pants to holy vision or any combination thereof.

Fʀᴏᴍ ɪɴ ꜰʀᴏɴᴛ — First. From the beginning.

Fᴜɴᴋʏ — Old French, *funicle,* terrible. Latin, *phreneticus* (see Frantic). In the forties, Mezz Mezzrow defined it as stench, smelly, obnoxious. Today it means "that happy-sad feeling," according to some jazz musicians.

Gᴀɴɢ-sʜᴀɢ — The principle of the car pool or the common dish applied to sexual intercourse.

Gᴀs — Supreme, tops, the most. A gasser.

Gᴀʏ ʙᴏʏ — Homosexual.

Gᴇᴛ ᴡɪᴛʜ ɪᴛ — Comprehend, understand, participate, dig?

Gɪɢ — Any gainful enployment, as distinguished from work (see Work).

Gɪᴍᴘ (gimpy) — Lame.

Go — When you're swinging you feel sent and when you're sent you Go! (see Gone)

Gᴏɴᴇ — The most, the farthest out. If you go far out enough you're gone — "out of this world."

Gʀᴏᴏᴠᴇ — As in groovey and "in the groove," meaning on the beat, swinging. A hip chick is a groovey chick.

Hᴇᴀᴅ — A marijuana user, pot head.

Hɪɢʜ — In euphoric state, whether from drugs, alcohol, esthetic ecstasy or sex.

Hɪᴘ — To know, in the sense of having experienced something. A hip

cat has experiential knowledge. A hip square has merely heard or read about it.

HIPSTER — One who is in the know. A cool cat.

HOLDING — To have marijuana or other drugs in your possession.

HORSE — Heroin. Also called H, and in some circles, affectionately, shit.

HOT — Said of anything that sends you whether a hot lick (jazz) or a hot chick — unless you're a cool cat.

HUSTLE — To engage in any gainful employment (see Gig).

HYPE — A heroin user. A contraction of hypodermic.

JOINT — A place, a penis, a marijuana cigarette, preferably a combination of all three.

LAY — To give, as in "Lay some bread on me."

LATER — When you're ready to leave the pad you cut out and say, "Later."

LIKE — The theory of relativity applied to reality. "Like that's *your* reality, man."

MAKE — To act, as in "make the scene." To "make it" may be said of anything that succeeds, whether a dental appointment or a crazy chick.

NOWHERE — If you're not with it, you're nowhere (see With it).

O.D. — An overdose of drugs.

PAD — A cat's home is his pad.

PICK UP ON — Get hip to, understand, appreciate.

POT (or pod) — Marijuana. Also called tea and at various times and places, muta, muggles, the weed.

PUSH — Sell, handle or purvey drugs. Pusher.

RELATE (to) — Establish mental and emotional contact with a person, communicate.

ROACH — A small butt of marijuana.

SCENE — The world and the lifeways of the beat generation. To "make the scene" is to fit in, to be accepted.

SHACK UP — To cohabit, in every sense and sex of the word.

SHORT — A small, foreign sports car.

SHUCK — As a noun, a falsehood, deception, fraud; as a verb, to deceive, swindle or defraud. I wouldn't shuck you, man.

SLAM — Jail. Also slammer.

SOUND — To voice an opinion, recite a poem. To inquire, as in "I sounded the cat was he holding."

SPADE CAT — Negro. The holy barbarians, white and negro, are so far beyond "racial tolerance" and desegregation that they no longer have to be polite about it with one another.

Split — As in "I've got to split," a form of leave taking.

Square — Conformist, Organization Man, solid citizen, anyone who doesn't swing and isn't with it. Also called Creep and Cornball. Man, if you still don't dig me, you'll never be anything but —

Stoned — High, loaded.

Swinging — Liberated, uninhibited. Like if you don't swing that thing it don't mean a thing.

Turn on — To get high. To introduce somebody to anything, as in "He turned me on to Zen."

With it — If you're in the know you're with it. If you ain't with it man, you ain't nowhere no how.

Wig — The mind, as in "wig out" or "flip your wig," meaning out of your mind.

Work — Sexual intercourse (see Gig).